P9-CDK-816

From the

Library of

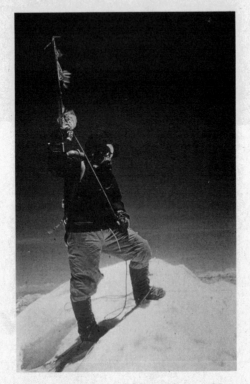

Tenzing Norgay on the summit of Mount Everest, May 29, 1953,
during the first ascent with Edmund Hillary.

HIGH EXPOSURE

An Enduring Passion for Everest
and Unforgiving Places

D AVID B REASHEARS

SIMON & SCHUSTER PAPERBACKS

NEW YORK LONDON TORONTO SYDNEY

SIMON & SCHUSTER PAPERBACKS
Rockefeller Center
1230 Avenue of the Americas
New York, NY 10020

Copyright © 1999 by David Breashears
All rights reserved,
including the right of reproduction
in whole or in part in any form.

SIMON & SCHUSTER PAPERBACKS and colophon are registered trademarks
of Simon & Schuster, Inc.

For information about special discounts for bulk purchases,
please contact Simon & Schuster Special Sales:
1-800-456-6798 or business@simonandschuster.com.

IMAX® is a registered trademark of Imax Corporation.

Designed by Robert Bull Design
Maps by Paul Pugliese

Manufactured in the United States of America

3 5 7 9 10 8 6 4 2

The Library of Congress has cataloged the hardcover edition as follows:
Breashears, David.
High exposure : an enduring passion for Everest and unforgiving
places / David Breashears.
p. cm.
1. Breashears, David. 2. Cinematographers—United States
Biography. 3. Mountaineers—United States Biography. I. Title.
TR849.B74A3 1999
796.52'2'092—dc21
[B] 99-31159
 CIP
ISBN-13: 978-0-684-85361-1
ISBN-10: 0-684-85361-2
ISBN-13: 978-0-684-86545-4 (Pbk.)
ISBN-10: 0-684-86545-9 (Pbk.)

For my mother

and

my peerless and indomitable companions on
Mount Everest in 1996

Robert, Ed, Araceli, Jamling, Sumiyo, Wongchu, Jangbu,
Paula, Liz, Audrey, and Brad

A little learning is a dangerous thing;
Drink deep, or taste not the Pierian spring:
There shallow draughts intoxicate the brain,
And drinking largely sobers us again.
—Alexander Pope

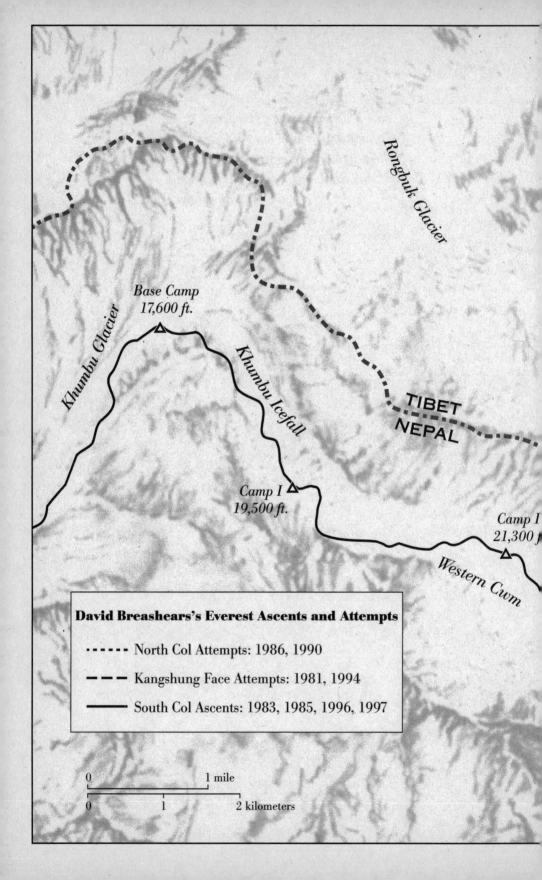

Rongbuk Glacier

Base Camp
17,600 ft.

Khumbu Glacier

Khumbu Icefall

TIBET
NEPAL

Camp I
19,500 ft.

Camp I
21,300 f

Western Cwm

David Breashears's Everest Ascents and Attempts

••••• North Col Attempts: 1986, 1990

– – – Kangshung Face Attempts: 1981, 1994

——— South Col Ascents: 1983, 1985, 1996, 1997

0 1 mile

0 1 2 kilometers

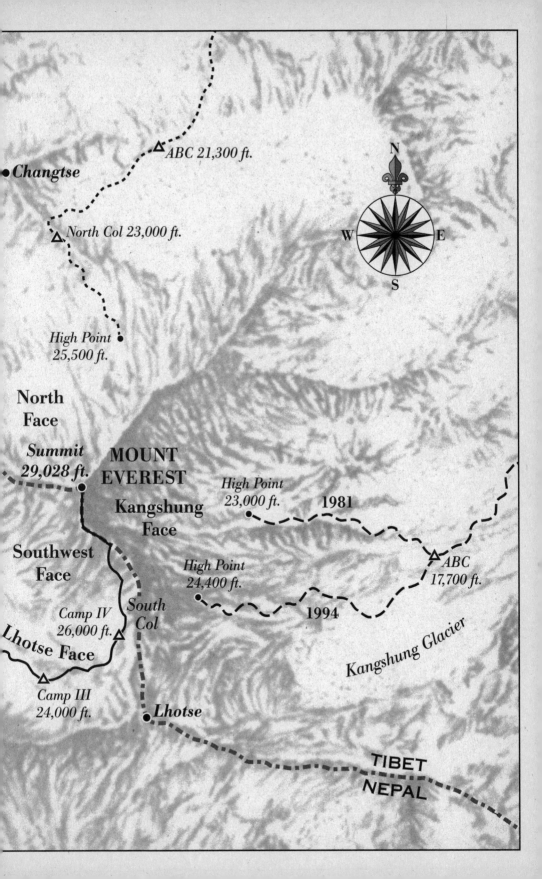

CONTENTS

FOREWORD

Most of the world knows David Breashears as an uncommonly intrepid filmmaker: the guy who brought back spectacular IMAX footage from the top of Mount Everest. Others associate his name primarily with *Red Flag Over Tibet*, the disquieting, Emmy Award–winning documentary about the Chinese occupation of the Buddhist homeland, which he made for the PBS series *Frontline*. Among a handful of Hollywood insiders he is celebrated, as well, for being the guerrilla cinematographer who smuggled a 35mm Arriflex into Tibet and surreptitiously filmed scenes that lent crucial authenticity to the big-budget epic *Seven Years in Tibet*.

The renown that Breashears has earned for his work in film is certainly deserved. But to a small, immoderately idealistic community of rock climbers who lived in Colorado in the 1970s (a community of which he and I were part), his most remarkable feat has nothing to do with making movies. Some of us believed—and still believe—that Breashears's defining moment was his authorship of a little-known climbing route, name of Perilous Journey, which rises in the foothills outside Boulder, Colorado. The large-format film, *Everest*, the Emmy Award, his four expeditions to the 29,028-foot summit of Everest—they all pale in comparison with his first ascent of this obscure rock climb, which measures scarcely 100 feet from bottom to top. If you want to understand David Breashears—if you hope to comprehend what really makes him tick—you need to know a little about Perilous Journey.

The forested hills south and west of Boulder bristle with precipitous crags that have long attracted climbers from around the globe. In July 1975, Breashears—then a climbing-obsessed nineteen-year-old casting about for a suitable challenge—latched on to the idea of pioneering a new route on one of these crags, an out-of-the-way cliff called the

Mickey Mouse Wall. The route he envisioned scribed a line up a swath of untrammeled sandstone that, to the casual observer, appears much too steep and smooth to climb. But after careful study of the cliff's geologic idiosyncrasies, Breashears became convinced that the rock had a sufficient number of surface blemishes—feldspar crystals, dime-size divots, and tiny pebbles of conglomerate protruding from the vertical plane—to allow upward progress, at least in theory.

It was obvious that if the route could be climbed at all, it was going to be exceedingly difficult, right at the limit of what was physically possible at the time. It was also obvious that the absence of deep natural fissures would preclude the placement of aluminum nuts to safeguard his passage over the route's most severe section. If he lost his purchase on any of the minuscule finger- and toeholds, he would plummet into the jagged boulders that line the base of the cliff.

As it happens, the broad ledge that marks the summit of Perilous Journey can be reached via a routine scramble up a broken section of cliff nearby. Before attempting the route, it would have been a simple matter for Breashears to rappel down the cliff from the top, rehearse all the moves with a safety rope from above, and drill a series of expansion bolts that would erase all the danger from his ascent. But according to the climbing subculture's unwritten ethical codex, the practice of pre-drilling bolts on rappel and unlocking a climb's secrets with a top rope constituted a despicable sort of cheating. The whole point of doing a route like Perilous Journey was to test one's mettle—to challenge not only one's physical skills, but take measure of one's judgment and nerve as well. The nonexistent margin for error was soberly acknowledged, but it was celebrated rather than lamented. In our youthful, self-absorbed zeal, we liked to imagine that the gravely serious stakes set climbing apart from lesser pursuits (such as mainstream sports, or working for a living). No climber in Boulder believed more passionately in the unforgiving tribal ethos than Breashears.

On the chosen day (as he recounts later in this book), he bushwhacked up to the bottom of the Mickey Mouse Wall at dawn, accompanied by his friend Steve Mammen, who'd agreed to belay him. The morning smelled of pine and juniper. Nobody else was around. Breashears laced up his painfully tight climbing shoes, tied a rope to his

waist harness, and dipped his fingers into a pouch of gymnast's chalk. Then he stepped up to the cliff and laid his hands on the brick-red sandstone. The climbing became diabolically difficult almost immediately. Crimping lentil-size pebbles with his fingertips, Breashears muscled and balanced his way slowly upward, shifting his weight from hold to minuscule hold with meticulous care, unraveling the route's defenses inch by vertical inch. Although the physical strain on his digits and forearms was nearly overwhelming, he maintained his poise and Zen-like focus, betraying none of the tremendous effort required simply to grip the rock, to say nothing of making upward progress.

Twenty feet above the talus, in the middle of an overhanging bulge, Breashears arrived at the route's first substantial hold: a shallow, angled slot wide enough to grip with both hands. This hold also presented him with his first opportunity to place protective hardware: He managed to wedge a nut into the slot, albeit not very securely, clipped a carabiner to it, then ran his rope through the carabiner. In the event that he fell, the dubious nut would almost certainly be plucked from the rock like a berry from a vine, but, Breashears recalls, "It was oddly comforting to see the rope running through that solitary, useless piece of protection."

The difficulties resumed immediately past the slot, and continued with scant respite for another twenty feet. Then, unexpectedly, he encountered a square-cut shelf about as thick as the spine of a hastily written book. When he pulled himself up to its relative security, he had reason to believe that the climb's major trials were over. The shelf stuck out from the wall no more than an inch and a half, but above it the cliff leaned back at an angle slightly less than vertical. By standing on the shelf and pressing his chest tightly against the rock, he could actually drop both hands to his sides and give his arms a desperately needed rest after twenty minutes of intense, nonstop effort. Better yet, the sandstone above his head was pocked with a series of Swiss cheese–like holes that looked big enough to accept his fingers to a depth of half an inch or more. Perilous Journey seemed to be a fait accompli.

When Breashears reached up and felt the lowest of the pockmarks, however, he was alarmed to discover that it was much smoother

and shallower than it had appeared from below. He reached higher, and then higher still, but none of the holes provided the kind of handhold he was willing to trust his life to. He was four stories off the ground. A slip from this point would send him hurtling into the boulders below.

The gravity of his circumstances inspired him to redouble his concentration. A more thorough examination of the wall overhead turned up a rounded, jelly bean–size blister that he could wrap two fingertips around. Awkwardly reaching across his body until his right hand was above his left shoulder, he clenched the jelly bean, levered his body upward, and stretched as far to the left as he could. He smeared the soles of his boots onto a nearly featureless patch of sandstone, shifted his weight onto his left foot, and thereby managed to touch a small scoop that was slightly deeper than the other pockmarks were, and had a tiny ridge across its lower lip on which he could hook the callused pad of a fingertip. Twenty inches above this pathetic hold was a substantial ledge. Committing his life to the tips of two fingers on his left hand, he cranked for all he was worth, snaked his right hand up to the ledge, and wrapped his paws securely around its reassuring contours. A glance overhead revealed that the rest of the route was covered with large, in-cut holds. Within minutes he stood triumphantly atop Perilous Journey.

It was a visionary ascent, one of the boldest achievements in the annals of North American mountaineering, done in impeccable style. A handful of other climbs of comparable difficulty existed, but seldom, if ever, had such extreme difficulties been undertaken in circumstances where the climber was unlikely to survive a fall. Yet, to nobody's surprise, Breashears wasn't hounded by journalists for interviews. No mention of Perilous Journey appeared in any newspaper, local or otherwise. He received no remuneration or formal recognition of any kind. Word of the climb, however, filtered gradually through the mountaineering grapevine. His ascent was reenacted in pantomime, move by move, in climbers' camps from Yosemite to the Tetons to the Shawangunks of New York. He had achieved something he valued much more than wealth or fame: the respect and admiration of his peers.

In writing this foreword, my intent is not to nominate Breashears for sainthood. I have spent enough time in his proximity to know that he is impatient, driven, incredibly tightly wound. I have witnessed his explosive temper; indeed I have felt the sting of it firsthand. But he possesses, in abundance, a quality perhaps best described as "character." And I admire this trait even more than I admire what he has achieved in the arenas of film and mountaineering. Although I have disagreed with him both publicly and privately, I have always been impressed with his willingness to act on his convictions—even when his ire has been directed at me.

Two decades after I first met David Breashears on a crag above Boulder, chance brought us together again on the slopes of Everest during what turned out to be a very bad season. When disaster struck, he placed the most important film project of his career in jeopardy, without hesitation, in order to provide assistance to those of us who were in trouble. That the creator of Perilous Journey emerged as one of the heroes of the 1996 Everest calamity came as no surprise to me.

Jon Krakauer
Boulder, Colorado
February 1999

EVEREST 1996

High winds scour the Southwest Ridge of Mount Everest.

As a mountain climber, I've always felt more drawn to the top than driven from the bottom. I was twelve years old when I came upon the famous picture of Tenzing Norgay standing atop Mount Everest. From that moment on, I equated climbing Everest with man's capacity for hope. Indeed, there's nothing so exhilarating, so purifying, as standing on its summit more than 29,000 feet above the sea, surveying the planet below. Before May 1996, I had climbed Everest twice, and each time I had experienced the singular sense of rebirth that the mountain has to offer.

But Everest also offers the finality of death. On the morning of May 10 my *Everest* IMAX® Filming Expedition resolved to go up the mountain and help bring down survivors of an icy calamity that had left eight people dead. Over the next several days our expedition climbed up Everest, struggling with bitter cold and bitter truths and a deeply felt grief for our friends who would lie frozen in death forever. There's no place to bury the dead on an ice-bound mountaintop.

In the week following Everest's cruelest disaster, other expeditions broke their siege and went home. Why did we stay on and ascend the mountain once more? On reflection, I think it was because I felt a strong kinship not only with the dead but with the mountain itself. I hated seeing it stand in disarray, under scrutiny from the world's media; I wanted redemption from the tragedy. I couldn't accept leaving, not after all my years on the mountain, not with reasonable weather and our enormous stock of equipment and human skill, not without trying one more time. Call it a specialist's pride: I felt it was up to us to finish—safely—this unholy episode. I wanted to prove that Everest was—in its grandeur—an affirmation of life, not a sentence of death.

So, with the aid of a London-based weather service, we watched and waited for a break in the weather at the top. The jet stream, which sweeps across Everest in the spring, was howling around the summit, and no man-made instrument can accurately forecast when it will blow off the mountaintop and move north over the Tibetan plateau. For days, there was little change. I was dismayed but not astonished; I've seen the jet stream pound Everest for fifty uninterrupted days. Still, I searched reports for the tiniest shard of hope, anything to signal a positive turn. Nothing.

Eventually we decided it was time to move out from our Base Camp at 17,600 feet: better to face the mountain in our boots than sit around in our tents brooding about it. On the slopes, we'd see for ourselves what the mountain held for us, and we'd let the mountain tell us when to climb—or not to climb. So we struggled into our gear and headed up—the entire IMAX filming team—camp by camp.

We climbed back to the upper camps with the threat of the wind roaring ominously above at eighty to ninety miles per hour. In mountain climbing, it's not the wind around you that frightens you, but the wind that awaits you. Much of our trepidation was, to be sure, psychological. After all, skilled Everest veterans had died up there just weeks before.

At dusk on May 22, the day we reoccupied the high camp, Camp IV at 26,000 feet on the South Col, the winds died out. It was a rare and welcome moment as we pitched our tents; we could actually stand upright, and we could continue that night toward the summit minus a goodly portion of our fear.

The sun descended and the tent walls darkened. Though we were utterly exhausted, none of us could rest. Throughout the evening we readied our climbing gear and the film equipment and melted ice to drink. There's no malingering at the South Col camp. It's too high, too barren, and the air is too thin. There's no earthly reason to be there except to gain Everest's summit. We'd spent two years preparing for this summit attempt, training our bodies and minds, making checklists, customizing and winterizing and lightening the massive IMAX camera and everything else within our grasp.

Now the weather had given us the break we needed.

At 10:35 P.M. I unzipped my tent.

No matter how many times I've made this journey, it always begins in the same way. It's pitch dark outside as I unzip the door. What little heat has pooled inside spills out into the frigid night air; the sense of safety and security I feel in the tent vanishes with the warmth. On my hands and knees I crawl into one of the world's most hostile envi-

ronments, into my ultimate arena—the last 3,000 vertical feet to the summit of Everest.

The stars were out that night but there was no moon. It was dark and cold, minus 30 degrees; the night was still. Looking above, I could barely see the outline of Everest, a dark, lopsided pyramid cut out from the stars.

I sat on a small rock to put on my crampons (sharp metal spikes attached to my boots), which dug into the snow and ice. Bare-handed, I checked and rechecked to make sure the heel and toe clips were biting through the thin neoprene of my overboots, an extra layer of insulation over my climbing boots. I hadn't planned on using overboots up there. But after the catastrophe I felt inordinately vulnerable, not just to the cold, but to my own mortality. I've always relied on strength of mind to drive my body, and the body has always been good with plenty of horsepower. But the deaths in that disastrous climb reminded me that I was forty years old now. I had borrowed the overboots from a friend, Jon Krakauer, who had survived the May 10 storm.

I walked among the nylon domes of the heavy-weather tents, hoarsely shouting that it was time to go. The tents were already alive, sides huffing out with the movements inside, zippers scraping in the silent night. Sherpas and team members gathered their gear, and I mentally ran through my own checklist one more time: two full bottles of oxygen, spare mittens, ice axe, and, most important, my compass fixed with a heading so that even in a storm I could find my way home. There was no idle chatter in the air, only tension and focus on the mission.

The South Col is a broad expanse of rocks, a hard, flat, forbidding surface. I knew that the featureless terrain had been a deadly problem for the descending climbers on the night of May 10 because, without a compass to guide them, there were no directional clues in the blizzard's whiteout. Lost and desperately searching for high camp, eleven climbers had collapsed at the edge of the 8,000-foot precipice of Everest's Kangshung Face overlooking Tibet. There, a few hundred yards from safety, one woman, Yasuko Namba, had frozen to death, and a Texan named Beck Weathers had suffered mutilating frostbite.

I crossed the South Col to the first icy incline, awkwardly duck-walking on crampons scraping against fist-sized rocks and bulletproof ice. Like my team, I knew I was hypoxic (starved for oxygen), severely sleep-deprived, dehydrated, and malnourished. Yet here I was, commanding my body to work as hard as it had ever worked. That makes for tough going. But after an hour of robotically placing one foot in front of the other, I finally found my rhythm. All I could hear was the raspy sound of my labored breathing as I inhaled and exhaled through my oxygen mask, my breaths keeping pace with each step.

Yet this time there was no matching sense of purpose and exhilaration, only the grim knowledge of the littered battlefield we would find as we climbed higher. I'd been involved in body recoveries on Everest before, but there had been nothing in my training to prepare me to pass through the open graveyard waiting above: This time the graveyard held friends.

There are other bodies—bodies of people I'd never met—scattered from Advance Base Camp to points near the summit. Several hundred yards below Advance Base Camp, at 21,100 feet, a climber lay near the route, wrapped in a blue tarp. And for years, before the wind finally blew her remains over the Kangshung Face, every Everest expedition climbing on this route had passed Hannelore Schmatz, a skeletal landmark just above the South Col with her brown hair streaming in the wind.

Also near the South Col camp lay a Czech and, higher up, a Bulgarian. Years earlier, on the glacier below, I'd gathered the frozen bodies of two Nepalese climbers.

The North Col route, on the Tibetan side, was similarly strewn with climbers who had never come down. In 1986 I'd helped carry a Sherpa friend buried by an avalanche to Rongbuk monastery for cremation. And one of my documentaries followed the search for the most celebrated of the dead, British legend George Mallory, who vanished near the summit in 1924. Wherever they lie, the dead mutely testify to the sinister ease with which a day on Everest can come undone.

Despite the snow and ice, Everest is as dry as a desert; the sun and wind quickly mummify human remains. They come to resemble nothing so much as that ancient iceman discovered years ago in an Italian

mountain pass. I've dealt with them before, and hardened myself to the harsh knowledge that the line between life and death is mercilessly thin in the frigid and rarefied air of this unforgiving place.

But this night was different; those waiting ahead were people I had known and respected. We knew exactly where one of the best-known Everest guides, Rob Hall, had died, due to his final radio transmissions. From other reports we had a good idea where Scott Fischer lay. Doug Hansen died near Rob and we thought we'd find him, too. But Andy Harris was still missing. Our team had had nearly two weeks since the tragedy to face our fears and sorrows and anger. Still, it's one thing to deal with your demons at the foot of the mountain, quite another to see comrades lying dead in the snow.

Hours passed as I resolutely climbed higher and higher, with little sense of gaining height because of the darkness beyond the circle of light from my headlamp. I felt alone and detached, in a trancelike state, as I always have on these summit slopes. But when I looked back I could see the shafts of light from my companions' headlamps, and it was comforting to know that they were there, making their solitary journeys with me.

Sporadic gusts of wind swirled loose powder snow and I would pause with my head bowed east, away from the icy spray. Prior to dawn, at 27,100 feet, below the gully that leads to the Southeast Ridge, I was startled by a blue object off to my right. I was hypoxic and briefly confused. From Anatoli Boukreev's report I'd known that Scott Fischer would be near this spot. But the intense effort of the night had smothered that thought. And now my dulled brain struggled to make sense of it: How could someone as strong and resourceful as Scott end up here? It seemed dreamlike; it couldn't be real.

I didn't go near him. On this day I needed to conserve myself, and distance was a defense. By the light of my headlamp I could see that he was lying on his back across a narrow snow-covered terrace, one leg outstretched, one bent, and his arm tightly clenched across his chest. His body position was awkward, slightly contorted. I could readily imagine Scott resisting to the end, his strength and will to live slipping away, until finally he lay back and death stole over him. Anatoli, who tried to save Scott on May 11, had lashed a backpack over his friend's

head. I was grateful for that. I didn't want to see the ruin of Scott's handsome, friendly face.

I turned, climbing onto the Southeast Ridge at 27,600 feet. It's a vivid sight, peering over a knife-edged crest down two vertical miles of the Kangshung Face into Tibet. It seemed as though I could see halfway across the continent from this vantage point. Sun rays lit the tallest summits of the Himalayas first, one at a time, like candles glowing above ink-dark valleys. To the east, the world's third highest peak, Kanchenjunga, stood rimmed in crimson. And much closer, Makalu, the fifth highest, shimmered orange and pink.

Three hard hours later we reached the South Summit and the traverse to the Hillary Step, a forty-foot cliff at 28,700 feet. The route here is wild and exposed, along a narrow corniced ridge, the last barrier to the summit. I had planned to film this dramatic traverse as a centerpiece for our film. At its start, between a wind-blown cornice and a rock wall, lay a red-clad figure. He was lying on his side, buried from the shoulders up in drifted snow. His left arm rested on his hip and his hand was bare.

It was Rob Hall; no mistaking him, even from a distance. He was wearing a red Wilderness Experience jacket like one I'd owned. His red Patagonia bib overalls bore a distinctive checkerboard pattern in the weave which I had noticed two weeks earlier when I descended past him and his party of clients. He was facing east with his back to the wind.

My first thought was that—typical of Rob—the site seemed well ordered. It was clear that he had made a determined attempt to survive. He'd removed his crampons to prevent them from conducting cold through his boots. His oxygen bottles were arranged carefully around him. Two ice axes were thrust vertically into the snow. One I knew belonged to Rob, the other—we later learned—to his assistant guide, Andy Harris.

The last thing you want to do in a storm is lay down your ice axe. Snow will cover it, or it will slide away, or you'll simply forget where you put it. Upright and at hand like this, the axes showed that Rob and Andy—or at least one of them—had been thinking clearly in the early hours of their desperate bivouac.

I knelt in the snow next to Rob. I couldn't see his face and so felt a little distant from him. Then I looked at his bare hand, still undamaged by the elements. What was a seasoned mountaineer like Rob doing without a glove? A glove is a climber's armor. How had Rob's vanished?

I looked down at my own heavily mittened hands and pondered sadly. So much of Rob's life had mirrored my own. We were roughly the same age, with a similar level of experience, ability, ambition, and confidence. Both of us were driven to make a life in the mountains, a life on Everest. But now he lay dead.

Studying his bare hand, I suddenly understood the dread Rob must have faced, the terrible knowledge that he was so cold and weak that he'd lost control of his own life. He'd been alive and uninjured, but the wind and cold of that awful night left him hypoxic, hypothermic, and frostbitten, and so he'd lain trapped in this remote outpost, utterly unable to save himself. I couldn't imagine a worse nightmare.

Mingled with my sorrow, I must confess, were feelings of anger toward Rob which I had carried with me all the way from Base Camp. I knew in my bones that the mistakes of May 10 could have been avoided, that hubris had likely doomed Rob and his party. Of all the guides, Rob had been the most outspoken about his prowess, and the most proprietary about the mountain. He had sometimes acted as if he were a part-owner of Everest, an attitude I found disturbing. Everest is many things to many people, but owned is not one of them.

His clients had come for a climb, not to take serious risks. Rob's expertise was supposed to be their warranty against danger and Rob had let them down. There was an ugly premonition of disaster. We'd watched fifty-five people swarm the fixed ropes to Camp III before their summit push. That was the day I'd decided to take our expedition back down the mountain and wait for the weather—and the crowds—to clear before attempting the summit ourselves. So I was angry at the sorrow and chaos caused by these tragic deaths. That's not how things are supposed to work for clients paying to climb this great mountain.

I looked at Rob, and at the bare, open hand that would never draw on another mitten or hold an ice axe again. I held up a handful of snow and let it blow away like ashes. As I sat with Rob and thought

about his valiant attempt to save a client and the questions that needed answering, I saw myself lying there: Would I have done the same?

Suddenly the Sherpas appeared, coming up the ridge carrying my camera equipment. *Time to move on,* I silently announced to Rob. I couldn't film this spot. His death had made it hallowed ground for me; this was one piece of Everest he could, at last, call his own.

I stood and put on my pack. Then we began to climb the final sweep of the mountain.

THE KID

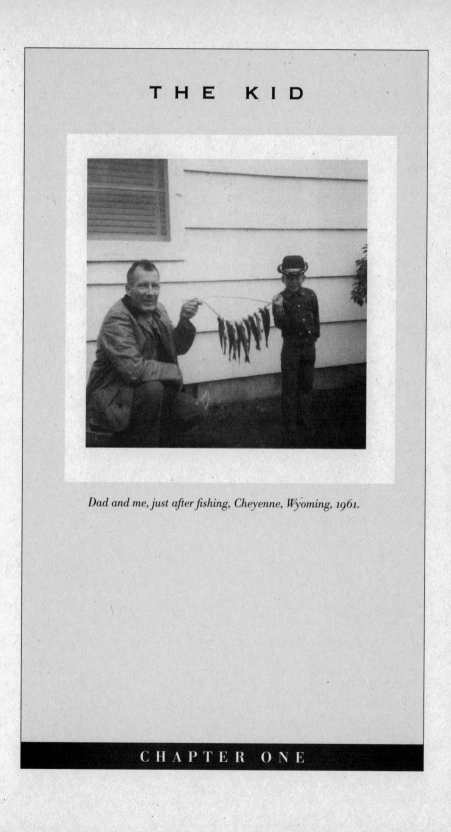

Dad and me, just after fishing, Cheyenne, Wyoming, 1961.

CHAPTER ONE

From the moment I first saw the picture of Tenzing Norgay, I've felt the tug of Everest. We were living in Greece at the time, when my family was still a family; and it was both the best and worst time of my life. It takes a twelve-year-old's wide-ranging imagination to see his destiny in a picture of a mountain and a stranger atop it, but that is exactly what I envisioned that morning.

Greece was just my latest home. My father was a military officer, a major in the United States Army. That made me a military brat from day one; by the time I had graduated from high school, I'd lived in towns from Georgia to Greece to Colorado. I have a dim early memory of an afternoon in Fort Benning, Georgia, with tiny white clouds of parachutes emerging from the rear of a shiny twin-tailed troop transport, and my mother and I trying to guess which parachute carried my father. I loved my mother. She was Scottish and English, proud, resilient, and strong-willed. Back then, though, it was my father who was my hero. He jumped out of airplanes. He wore a uniform and carried lethal weapons. He trained men to fight and prepared them for battle. Beyond that, he was an old-fashioned outdoorsman who hunted, fished, and by God drove a pickup truck. In short, he was the perfect uniformed, spit-polished role model—until the time came when I had to look behind the olive drab and the major's gold insignia.

In my family I was the third son and two years older than my sister. What mattered to my father was that I was the runt of the litter, Major Breashears's scrawny little kid, the comic-book ninety-eight-pound weakling right out of the Charles Atlas ads. I lacked the athlete's grace; in playground games, when they chose sides, I was always the last one picked. I made my mark in school by being clever and, later on, even a little feisty. But the truth is that until I reached seventeen, there was scarcely a muscle on my body.

My father believed, literally, in the philosophy of swimming or sinking. When I was five and we were living in Cheyenne, Wyoming, I was too small to touch the bottom of the pool at the Francis E. Warren Air Force Base. So one day Dad simply threw me out into the pool and ordered me to swim back. I kept sputtering and thrashing toward the side where he stood—and he kept bending down and throwing me back

out. Finally, after choking down a few mouthfuls of chlorinated water, I decided to flail over to the pool's opposite side and cling to the gutter.

"David!" he roared. "David! Swim over here right now."

But I hung on for dear life. It was one of the first times—but definitely not the last—that I didn't want to go near him.

So I was a shy little kid when I started elementary school in Cheyenne. It took me a long time to get my footing in school. Among other things, I simply didn't like being indoors. No, the glorious moments of my boyhood came outdoors, when we went camping near Jackson Hole, farther north in Wyoming. The first great mountain I ever saw was the Grand Teton, standing against the Wyoming skyline. I was astonished at how high and jagged the peak was. It looked like some impregnable castle—and yet a ranger told us that climbers had cracked its riddle and were scaling the mountain at that very moment with pitons and ropes. I remember squinting into the sun over the mountain to try to spot these marvelous creatures but of course I couldn't see anyone. All I could do was marvel at what an amazing thing that was to do: climb a mountain.

Otherwise my brothers and I fished and played in the lakes and streams around Jackson Hole. That should have been fun, but my father usually wasn't interested in fun, only whether something was done right. That's the military mind at work—the least foul-up can cost lives in the platoon. If one of us didn't cast a line properly or committed some other minor infraction, he'd treat it as if we had violated an order and punish us, using a belt on my brothers and a thunderous scolding or rolled-up newspaper for me. I remember thinking that my sister and I were his favorites because he spared us that pigskin belt.

When I was ten, my dad was transferred to Greece, where he worked with the Joint U.S. Military Advisory Group. This was in 1966, when the Cold War had boiled over into Vietnam, and Greece itself was caught up in political turmoil. But for us the craggy country was a great adventure and it was a time of discovery and unbounded energy. My friends and I were allowed to camp out alone, to explore ancient ruins or climb around bombed-out World War II German fortifications. Across the bay from our apartment rose snow-clad Mount Olympus,

and I remember longing to climb it and search for traces of mythic gods and ancient warriors.

Soon after we arrived in Greece, the military staged a coup, the one made famous in the Costa-Gavras film *Z*. There were tanks in the streets and soldiers with machine guns. The aircraft carrier USS *America* of the Sixth Fleet sailed into the harbor at Thessaloníki to protect American citizens and evacuate them if necessary. It was the biggest ship in the harbor. They docked the admiral's launch where my friend Van van Meter and I spent weekends fishing off the pier. We soon talked the sailors into giving us a tour of the carrier and a ride in the admiral's launch. I was a major's son.

This was when I first began leaving our apartment alone. We lived in the densely populated, hilly area of Thessaloníki, an old city of winding, cobblestoned streets, narrow alleys, and little gates. It was a manmade maze, the ideal training ground for a boy to find new routes—and then find his way home. Each time I ventured out I went farther and farther afield, training myself to always memorize the way back to the apartment, to never overlook a landmark. It was all the more challenging because I didn't speak Greek and few of the locals spoke English. I'd see a ruin on a far-off hill and try to find my way to it, always mindful that a safe trip home depended solely on my memory. I didn't know it at the time, but this marked the beginning of my mountain training.

Meanwhile, I was still getting lessons in the bare-knuckled ways of my father. One Saturday he made slingshots for Van and me out of wood and bicycle inner tubes.

"Whatever you do with these, David," he warned, "don't break any glass." He knew what tempted young boys.

I was attending a private American school at the time, Pinewood, and each day our bus climbed a steep, winding road to the school's secluded location in the forest. Van and I immediately jumped on a city bus and rode up into the hills near our school and hiked to an abandoned house concealed in the forest. We tried to shoot out the windows in the building with the slingshots, but the rubber bands were too stiff to draw, so we decided to knock out all the windows by the more direct method of hurling rocks.

We were so engrossed in our assault that we didn't notice a thickly built Greek man approaching us. Suddenly he appeared at our side, grabbed us by the ears in an iron grip, and hauled us off into the forest. Van started bawling and pleading as four other men gathered with our captor in a circle around us. I just wanted Van to stop; showing fear wasn't going to get us anywhere. It seemed the louder he wailed, the madder they got.

They talked over our heads in Greek, deciding what to do, and then dragged us down to our school and had the gatekeeper there telephone our parents. I was terrified, not of the Greeks any longer, but of my father. I feared I'd just earned my first whipping with the pigskin belt.

Van's father picked us up at the school gate. Back home I sat in my father's study explaining everything to him in a quavering voice. He sat silently until I was finished. Then he stood up, leaned his hands on the desk, his face close to mine, and said, "David, I want you to take me up there and show me that man."

My father was trained in hand-to-hand combat, and he was said to have carried that training into bars now and again. He'd been knocked unconscious once in a barroom brawl in Germany, but more often than not it was he who came out on top. He had a reputation for being a very tough and determined man.

We drove back up into the hills. The Greek who'd caught us smashing windows walked out of the woods to meet us; he was the owner of the abandoned house. It was clear that he was thinking this American was going to teach his son a lesson. When he got out of his truck, my father turned to me and calmly said, "Wait here." The two of them walked off into the forest. A short time later, my father returned alone.

I quickly got the picture: No Greek was going to push Major Breashears's kid around. This wasn't a matter of paternal protectiveness but of primitive pride, and it frightened me.

My father's harshness escalated. Returning from a day trip to assess Greek defenses near the Bulgarian border he tried to run over a dog that chased our truck through a village. It was a bizarre scene, my father and I in his truck, swerving back and forth, a battle between my

dad and a dog. I was mortified when he circled back to try again. As I look back on it, for me it marked the beginning of the end of our family life.

The violence in him boiled over one night when we heard him and my mother arguing furiously in the kitchen. Soon my mother was screaming for help. My brothers charged down the hall with baseball bats to attempt her rescue, but my father just flung my brothers back down the hall. Finally one of our neighbors summoned the local police. Dad threw them out, too.

At that point I made the ostrich's decision: I simply refused to acknowledge what was happening because to acknowledge it was to admit that my world was falling apart. But I also know that I made a more profound decision, deep down inside: Don't become what you behold.

My father's erratic, abusive behavior continued for several days and nights and at one point things became quite dangerous; my eldest brother found my father's handgun and was ready to defend our family. Blessedly it all ended one evening, without violence, when my father sat us all down on the living room sofa. Pointing at my mother, who sat in an armchair next to us, he said evenly, "I don't care what you say, Ruth. Our children are going to decide whether I go or stay."

I couldn't speak. I wanted desperately for him to leave, but how do you order your own father out of the house? My brothers sat in silence while I sobbed; my sister got up and sat on my mother's lap. My father just stood there, watching us, awaiting our response. Finally he stormed out the front door, slamming it behind him. None of us moved; we sat still, staring at the closed door. An enormous sense of relief coursed through me and I stopped crying. Would he simply disappear? I wondered. Could it really be this easy?

Moments later the door was flung open and there he stood, angry and terrible. "Wait a minute!" he shouted. "This is my house. I don't have to leave my own house!"

The scene fades to black after that, like the ending of a sad movie. I don't remember what we did; I don't remember what my father did. I simply blanked it all out. I know that he continued to share our house for some weeks.

Through the years, my father's shadow hung over me like a male-diction and became a source of deep and abiding fear. Grim memories would periodically surface. I used to have profoundly disturbing dreams in which I was groping my way out of that dreadful darkness toward some sliver of light glowing in the distance.

To this day, my brothers and sister and mother and I have never spoken of the chaos he wrought in our lives. I only know that, before my eyes, the hero of my young life had transformed, full-blown and bellowing, into a monster. That was the end of our family's life as I had known it.

It was during this bleak time that I discovered the book *Mountains* and the photo of the Sherpa Tenzing Norgay atop Mount Everest. I was transfixed. Tenzing's pose on that barren slope of rock and snow—the highest point on the face of the earth—bespoke honor and hope and transcendence. It imparted directly to me a promise that up there, on that forbidding mountain, lay a path of clean and simple nobility.

I clung to that sturdy image. I'd open the book and there was my security, my sanctuary. No matter how difficult my family life was, Everest somehow offered hope. I was enthralled by accounts of earlier attempts on the mountain from the Tibet and Nepal sides. I memorized details of the first successful ascent in 1953. Other boys imagined they were Namath or Seaver; I dreamed I was Norgay.

It wasn't long before my mother packed us children into our Pontiac Bonneville and drove off. We slept in the car that night—it was safer there—then soon boarded a plane for the United States. My father flew to Arkansas where his mother lived, thinking we were headed there. But my mother rerouted us to Canada, where we found haven with friends from Greece, Grace and Ralph Volks, who lived in the beautiful farm country along the banks of the St. Clair River.

My mother was worn out and traumatized and needed to rest. After two months by the river she felt stronger, and we returned to the familiar landscape of Cheyenne. Old friends from our previous stay there, Colonel Roy Wasson and his wife, Liz, opened their home to us and for several months we lived out of suitcases in their basement while my mother looked for a job.

Money was our biggest problem. My father had kept all of our furniture, all of our possessions, including my *Mountains* book. He never sent one check for alimony and only a few for child support. Moreover, because he'd been sent overseas as a military adviser, he couldn't be served with legal papers. The dismal truth is, we rarely heard a word from him. It seemed that by stepping out the door of our apartment in Greece, we had ceased to exist for him.

My mother soon found a job. Though she hadn't worked for some time, she had the necessary skills: She could type ninety-five words per minute. Within two months she had passed the civil service exam and landed a good post with the secretary of state at the state capitol. Slowly, we began to reconstruct a normal life.

That meant another new school for me. I quickly became reacquainted with my grade-school friend Danny Oakes, also the son of divorced parents and a blessedly kindred spirit. Every man remembers his first woman, of course; but even further back than that, he remembers his first real boyhood pal, and the adventures they shared. Danny and I glued model airplanes together, worked on go-carts, hunted for gophers with pellet guns. But what we really liked to do was build bombs.

We had Danny's basement for a laboratory and, since firecrackers were practically free in Wyoming, a ready supply of gunpowder. We started with small stuff, for example launching plastic ships loaded with cherry bombs out on Sloan's Lake. Then we graduated to more serious business. In those days you could order underwater fuses from the back pages of comic books, giving us the capacity to make two-by-five-inch pipe bombs. After unloading countless strings of firecrackers, packing in the powder and slowly screwing on the ends—we knew to soap the threads to reduce friction—we had the bombs ready for transport to our detonation area.

My mother had rented a house across from the rodeo grounds which annually hosted Frontier Days, a regional rodeo dubbed "The Daddy of 'Em All." We cut a hole in the fence, and down where the broncos and Brahman bulls tested their riders during the summer months, Danny and I tested our carefully assembled creations. After burying the bombs in the dirt, we'd run fifty feet of wire to a nine-volt

battery to trigger the explosions. We were careful—even scientific—about it and never sought to destroy property—just to create gigantic craters out of the soft, loamy earth.

The rodeo grounds proved useful for one other passion of mine: winter survival and camping. As Arctic fronts buried the arena in snow, I would tunnel deep into tall drifts and practice hollowing out a snow cave until my icy jeans were as hard and stiff as armor.

Every fall as I awaited the fierce wind and the biting cold of the Wyoming winter, I read stories of the great mountain men and trappers of the American West. They were often misfits, isolated by choice and supremely self-sufficient. They had a keen sense of weather and of danger—and how to avoid problems with both. They weren't thrill-seekers. They didn't plunge over waterfalls. They didn't ride the rapids in a crude log canoe unless they had to. The idea was to stay alive.

I'd joined Danny's Boy Scout troop, mainly for the chance to explore the wilderness and climb rocks. I really couldn't get enough of it. Even when there were no troop outings, Danny and I would badger his mother into driving us twenty-five miles out to Vedauwoo in the Medicine Bow National Forest, where we'd spend whole weekends scouting the woods and mountains. Deer were plentiful and so were the predators. Danny and I spent one very long night trading off as sentries after a mountain lion loped past our pup tent.

At an age when we most needed guidance, each of us had to find his own way through the wilderness. From the distance of time I can see now how the camping trips and even the bomb experiments were ways to invent our own reality as we engaged in the kind of adventures we imagined we might have enjoyed with our fathers.

I managed to get my hands on a coil of old hemp rope for climbing. Neither of us knew a damn thing about mountain climbing, of course; all we had to guide us were pictures in library books. One Sunday, I opened the Cheyenne newspaper to a photo of a man rappelling over a cliff in that classic alpine style called *dulfersitz*, with the rope run between his legs and looped across his shoulder. We immediately applied ourselves to replicating the procedure on the rocky pinnacles scattered around Vedauwoo—and came home with nasty rope burns on our necks and hands for our troubles. Although we could mimic the

pictures, we didn't know how to wrap the rope securely around our bodies or—for that matter—the first thing about safety precautions. It's lucky my mountain career didn't end in Vedauwoo that day.

Descending was one thing, getting up another. Danny was more interested in fly fishing and duck hunting than climbing, so my first real ascent was done alone, unroped. I left Danny in camp and started up a 150-foot spire of randomly stacked granite blocks. The climbing was more like scrambling but a slip would end fatally. Twenty-five feet from the top, the rock reared up nearly vertical and I suddenly found my next handholds hanging out of reach. I tiptoed onto a half-dollar–size ledge, leaning against the wall of the cliff. I reached high—and stopped. I saw that once my toe left that hold I risked being unable to climb back down. Even then, I understood that retracing a risky route could be perilous if not impossible.

I weighed the risks against the gain and made my choice. As I had done in the Greek mazes, I carefully memorized the way back—and stepped up. The moment my toe left that rock I experienced a tingling surge of feelings: the flush of fear, the intoxication of the unknown, and, above all, the exhilarating pleasure of self-discovery.

From the top I waved down to Danny as if I were Tenzing poised on the summit of Everest. It was the first time in my life I remember doing something that I thought was extraordinary.

Near the end of junior high school I persuaded my mom to let me go to the National Outdoor Leadership School (NOLS) in Lander, Wyoming. The course was too expensive for us, so I wrote to the legendary founder, Paul Petzoldt, who granted me a partial scholarship. My mom put me on a bus in Cheyenne with my brand-new Kelty frame pack from the L.L. Bean catalogue. I was feeling self-assured when I stepped off the bus in Lander, proud of my climbing experience and my new pack. But I was a little scared, too; I had no way of knowing how I'd measure up.

NOLS was a remarkable experience. Traversing the Wind River Mountains we learned how to backpack, how to cook, how to build a fire in the rain, how to use a compass and read a topographical map. It was my first experience with a real ice axe, and I learned how to climb snow and how to self-arrest, a vital technique for stopping yourself

when sliding down a snowy slope. And I finally learned how to rappel properly and spare myself the rope burns.

We grew more fit by the day as we traversed the steep mountain trails. At one point a course-mate injured his ankle and had to be evacuated. I was deemed too small to help carry his stretcher out over the high passes. That hurt. But near the end of the six-week course I was chosen to lead our patrol. With no instructors to guide us, and no food except some flour and whatever fish we could catch, our team had to chart a twenty-mile route to the trail head. We made it.

I hated to leave—especially, I think, because my family in the interim had moved again, this time to Denver. Once again, I found myself a stranger in a new school. Still, my mom's new job in advertising sales steered me into the mountains. It seemed that an acquaintance in her new office, Ward Woolman, was an amateur climber. When my mom told him about my interest, he invited me to join his friends to climb on a small cliff near Golden. It was a cold, blustery day and the air was rich with the smell of hops from the Coors brewery. I was wearing wool knickers and old-style Austrian climbing boots called *Kronhoffers;* I must have looked like an alpine waif with a rope. But I dearly wanted to impress these adults so that maybe they'd take me along again. We spent the day climbing with ropes on short, steep routes, and, for the first time, I realized that I could do some things that grown men couldn't—and that I earned respect because of it. I started training in earnest.

Every day after school, while other kids went to football practice or swam laps, I went buildering. Derived from the term bouldering, which is the art of climbing short, extremely difficult routes unroped on relatively low rocks or boulders, buildering was the urban climber's training. The brick walls of our three-story apartment building provided practice routes. The masons had placed the bricks haphazardly, creating hundreds of quarter-inch holds. I climbed on them daily, building finger strength, discipline, and precision in my footwork. When I mastered the brick wall, I searched Denver for other challenges, discovering training grounds hidden in plain sight beside city sidewalks. My favorite spots were the natural stone walls of the Observatory near Denver's Botanical Gardens. Natural undulations and fis-

sures in the large sandstone blocks and the curve of the thirty-foot-high walls made it like climbing a real cliff.

Meanwhile, I attended Thomas Jefferson High School, a radical departure from my school in Wyoming. Everything was bigger, louder, faster. I was so used to being the outsider I didn't even bother trying to fit in. I was physically and psychologically unsuited for team sports; I couldn't possibly answer to a coach—or any sort of male authority figure, for that matter. I answered only to myself and sometimes to my mom. If I wanted *A*s in class, I got them; but I felt no need to excel on anyone else's terms.

It was a jangled time, the age of The Who, Led Zeppelin, and Deep Purple. Pink Floyd was huge in high school; we were all explorers on the Dark Side of the Moon. There was marijuana for some, LSD for others. The drugs were turning harder and meaner all the time, and I avoided them.

Besides, I was otherwise hooked. I spent my spare time bouldering, buildering, and reading about climbing, figuring out what I'd need in order to test my skills on a real mountain. I'd replaced my virtually useless hemp rope with Gold Line, 150 feet of stiff twisted nylon, which purportedly stretched to absorb the force of a climber's fall. I'd also bought a few carabiners—metal snap links for attaching the rope to anchors in the rock—and several pitons—alloy spikes placed in the rock as anchors to stop a fall. Then I studied the guidebook to select a route that seemed about the right degree of difficulty for my first real climb.

A friend, Henry Barbier, and I got a ride from his mother to the Dome, a granite outcrop near the mouth of Boulder Canyon. Our target was a climb called the Bulge, rated a solid 5.7 on a scale that went up to 5.11. The guidebook assured us it was easy except for a protruding bulge near the middle of the first rope-length. But as we crossed the river on a length of irrigation pipe, the 200-foot-high hump of rock rising before us looked anything but easy. I'd thought my training in belaying and rappelling at NOLS would be sufficient to tackle the Bulge, yet as I watched the climbers on a different route using pitons, I understood that our shiny new gear revealed how little we knew. I realized that my brand-new Gold Line might not be my safety line at all, but only a sort of useless decoration for whoever was leading.

Both of us wanted to take the sharp (lead) end of the rope—but we were each afraid. Leading your first climb is a moment of high anxiety. Finally we agreed I should take the first lead.

Wind whistled down the canyon as we set off. Back then climbing harnesses were still a luxury, like specialized rock shoes; thus the rope was tied around my waist with a bowline knot, and my feet were encased in my 1950s-era *Kronhoffers*. Bravely imitating pictures of seasoned belayers, my friend paid out hanks of rope while I scrambled up a low-angle crack.

Soon I reached the dreaded Bulge. Mercifully a piton had been hammered into a crack and left there. I used one of my carabiners to clip the rope in, then delicately climbed and traversed eight feet higher until I was awkwardly bent over the Bulge, stuck, unable to go up, and unable to see my feet. I clung there for several forlorn minutes with a sharp wind buffeting me about, searching the rock for clues to the puzzle, fully aware of my precarious position, but unwilling to retreat.

Suddenly I was airborne. The piton held, but Hank had fed out too much rope and I plummeted a good twenty-five feet, smacking into the steep slab below. Without a harness to spread the shock, the rope around my waist dug in and nearly cracked my lower ribs. So I hung there, too embarrassed to feel any pain and unable to breathe, until Hank finally lowered me to the ground. He was badly shaken; it's often worse to watch a fall than to take one. He asked if we should quit and go home. I wanted to but said no. I knew I had to go back up or risk losing my nerve. I'm sure it wasn't pretty, but I managed to get over the Bulge on the second try, climber's passion intact.

I started scuffling around the cliff formations near Boulder and met David Waggoner, the only other boy at my high school who climbed. Like Danny Oakes, David was being raised by a single mom. We were in the same class and shared the same birthday. When I became old enough to drive, I'd borrow my mother's car and tell her that David and I were going over to the Observatory to practice for a few hours. Then I'd disconnect the odometer and we'd race forty miles northwest to Boulder.

While our classmates went to football games and homecoming dances or took advanced placement courses for college credit, David

and I gained experience on increasingly difficult climbs high above Boulder or in Eldorado Springs Canyon. We were consumed with our training, with learning the craft and technology of safe ascent, and with reading about the legendary climbers. It wasn't the usual high school fare but I thought that our adventures, esoteric as they were, called for more character and control than it took to knock helmets on a football field. Some of the most profound satisfactions in life come at those moments when your destiny—your immediate destiny—hinges strictly on your craft and abilities. After all, our mistakes carried serious consequences.

Occasionally we encountered veteran rock climbers who owned more reliable Kernmantle ropes, racks of modern equipment, and had authored first ascents of routes we could only dream about. At the base of Cob Rock one day, we caught our first glimpse of a pioneering climber named Pat Ament. We got to meet a few legends, too: the most prominent was a math professor named John Gill who applied gymnastic training to rock climbing. I'd read about him. He was more than six feet tall, could do one-finger pull-ups, and had fashioned dozens of the most difficult short climbs in the U.S. while soloing, unroped, during family vacations. I was struck by his modesty and his discipline; many of his climbs have never been recorded or repeated.

Another serious influence on my developing style came via the Chouinard climbing equipment catalogue of 1972, a slender publication with a Chinese landscape painting on the cover. Its author, the revered rock and ice climber Yvon Chouinard, called for "clean" climbing, proposing that climbers disavow pitons and bolts that scarred or otherwise altered rock. Instead, he advocated the use of metal nuts of various shapes and sizes which slotted into cracks without damage to the rock and could be recovered by the second climber on a rope. He reminded readers of the edict of John Muir, the late-nineteenth-century poet–environmentalist: "Leave no mark except your shadow."

This ethic of purism and self-control made a profound impact on the climbing community—and on me as well. It was one more life lesson I was gaining in the mountains that another teenaged boy might learn from his father. This made my climbing bittersweet: I was learning to enjoy and respect the outdoors but without my father to bear witness.

My most memorable climb back then was a multipitch route in Eldorado Springs Canyon christened the Great Zot. It was pure adventure, a youthful foray into the unknown. Neither David nor I had ever attempted such a long route or stood on top of the sandstone prow called TI, short for Tower One, at its finish. The climbing was more time-consuming and more devious than we had the experience to plan for. It was pitch dark by the time David joined me on the summit 600 feet above the river, and we had no lights or any clear idea of how to get down. It never occurred to us to call for help; that's the last thing any climber wants to do. There was no one to hear us anyway. And so we started down what we hoped was the descent gully, rappelling over short drops, tiptoeing blindly along a scant ledge, clinging to small trees and shrubs, guided mainly by gravity and touch. Suddenly a magnificent harvest moon rose up from the plains, lighting our way as if it were high noon. What a gorgeous sight, looking back up at the summit aglow in the light of that moon. I felt a deep sense of accomplishment as we crossed the footbridge to the dirt road and descended through the vast, empty canyon.

Two years passed. I paid the barest lip service to school. I got average grades. I didn't go to the senior prom. I didn't even bother to have my picture taken for the yearbook. Climbing was all-consuming. It wasn't a lifestyle for me, it was a way of life—reality etched in a craggy vertical landscape, exotic and mysterious. Up there, you needed special skills to survive. Climbing had a language and a literature all its own and rules which led to reward or punishment. Climbing held the consequences of one's own actions—something I'd never seen my father face.

I was a climber and a climbing aficionado. After school I'd take the bus to the Denver Public Library, dig out books about mountaineering and read them during class, on the bus, and before falling asleep at night. An obscure book entitled *The White Spider* by Heinrich Harrer was one of my favorites. It recounted one of the most daring climbs ever made, the first ascent in 1938 of the treacherous, ice-plastered North Face of the Eiger. Another significant influence was Hermann Buhl's *Nanga Parbat Pilgrimage: The Lonely Challenge.* Buhl, an Austrian, was one of the great Himalayan climbers, celebrated for soloing the final slopes on the first ascent of Nanga Parbat (26,660

feet). Reinhold Messner's *The Seventh Grade* was a particular inspira-
tion. Published in the 1970s, Messner's book caught my attention for
its stress on moving from one level of ability to the next, from mastery
of rock to mastery of ice, from short climbs to big ones. Further, he was
uncompromising about the benefits of physical training, something
most American climbers were just beginning to take seriously. He also
verged on being branded a lunatic because of his astonishing ability
and bold solo climbs but he was never reckless. He was the first man to
solo Mount Everest and to climb it without supplemental oxygen.

I became a student of Everest, absorbing everything possible
about the earliest attempts on the summit and on through the saga of
the big siege-style expeditions of the 1970s. Tom Hornbein's *The West
Ridge*, filled with dazzling photographs and evocative prose about the
first ascent of Everest's West Ridge in 1963, is a masterpiece. And,
again, that picture of Tenzing Norgay continued to stir my blood. If any-
thing, I was more impressed than ever by Tenzing and Hillary's climb.

Books about climbing led to books about explorers and discovery.
Everest was called the Third Pole, so I scrutinized man's struggles at
the other two poles. Looking back, I can see I'd embarked on a search
for a moral code. I was intensely curious about the way people behaved
in extreme situations, and what constituted right and wrong in the
wilderness where the laws of civilization no longer existed. I wanted to
know how others had responded to the stress and chaos of an adven-
ture gone wrong.

I was riveted by Captain Scott's account of his ill-fated journey to
the South Pole in 1911 and 1912. Scott's British expedition hoped to
beat Norwegian Roald Amundsen's team to the South Pole and claim
for Britain a glorious first. In the end, however, after months on foot in
subzero temperatures, they reached the Pole thirty-five days after
Amundsen's party had planted the Norwegian flag. They all died on the
return journey, three of them within eleven miles of their next supply
depot. Scott kept writing till the very last and his diary spoke to me as
if it were the voice of a ghost. I was deeply touched by the self-sacrifice
of the frostbitten man Captain Oates, who knew he was a burden to the
team. "I am just going outside and may be some time," he said to his
comrades. Then he walked out onto the ice.

Despite Scott's legend, I admired even more another explorer, Ernest Shackleton. It was Shackleton who returned home from an Antarctic epic with every one of his men alive. In *South* he describes how their ship was crushed in the pack ice, and how he managed to lead his crew to safety on Elephant Island, then set off in a small open boat across the world's worst seas for a journey of 800 miles. Three months later he returned to Elephant Island to retrieve his men, as he had promised he would.

I rounded out my reading with books about Rudolf Nureyev. I was thoroughly impressed by his grace, sense of craft, and dazzling skill. I was already beginning to look on climbing not just as a sport, but as a form of expression. The quality of the ascent was becoming as important to me as the ascent itself. When you first begin climbing, it's natural to sweat and lunge and slap your way to the top. But young as I was, I was no longer a novice. I wanted to make my climbing an expression of competence and grace.

Lunging for holds was especially unappealing to me. In climbing vernacular, a lunge is a dynamic move, or dyno. Some made dynos a specialty, suddenly exploding upward to slap for a hold. I'd rarely seen it done gracefully. To me it was a desperate act, lacking purpose and control, ill-suited for the routes I aspired to climb. It also seemed a little flamboyant. I was much too shy then to pass judgment out loud on anyone else's methods, but for myself and my technique I practiced static moves, carefully reaching to the next hold in a controlled manner, over and over and over again. I was rewarded much sooner than I expected.

Late in the spring of 1974, David and I drove up to Eldorado Springs Canyon. Graduation day was drawing near for our class. Some kids were going on to college, others were lining up jobs, some were even getting married. Vietnam was over, so the draft was no longer a concern. In my case, the future was a blank slate.

Hiking along the trail that snakes beneath the overhangs of Redgarden Wall, David and I stopped to watch a pair of climbers attempting to free climb an old aid route called Kloberdanz. During the 1950s and 1960s many of the steepest, most difficult climbs had been

accomplished with aid, i.e., by driving pitons into cracks in the rock and attaching nylon stirrups, a short rope ladder, to stand in. By the 1970s the trend was to free climb those classic routes by climbing without aid, using only your hands and feet on the rock. The rope was not to be used for any assistance, only to catch a fall. Kloberdanz was one such challenge.

The crux, the most difficult section on the climb, was an overhanging ten-foot roof which had repulsed numerous free-climbing attempts. Naturally, then, it was the challenge of choice that season. One man, Steve Wunsch, had managed to finish it after several days of effort, with a series of swinging dynamic moves. No one, including Wunsch, could duplicate his performance.

On this particular afternoon, an extraordinary climber and track athlete named Roger Briggs was dangling forty feet above the trail, having his go at Kloberdanz. Roger and his brother Bill were among the elite climbers of Colorado in those days, and they walked that walk around Eldorado Springs.

Taking wild swings out from the wall, Roger kept peeling off the lip of the roof and falling, his rope catching him each time. Looking up, I thought that it didn't look too difficult. I mentioned my observation to him and Roger surprisingly suggested, "Why don't you give it a try?"

David was a little nervous as I tied into the rope; he was sure I'd lost my mind, but I was focused and intent as I climbed up to give it a go. On my first attempt, I tried Roger's technique, making a dynamic lunge for the lip. I got hold of the lip but it was awkwardly downsloping, and my fingers rotated off the hold as my body swung wildly out from the roof. I dropped onto the rope and could see that Roger and his partner were a little amused. *Who's this skinny kid?* they seemed to be saying.

My own thought was, *Why try it their way?* On my second attempt, I reversed the approach, hooking my heel behind a small projection and lowering my body out horizontally instead of swinging. No one thought I was going to make it, but I got both hands on the lip, and a moment later I pulled myself over the roof. It was a defining moment for me. The first time I had visited those walls I could barely manage a

pull-up. Now I'd just polished off the year's designated climbing dragon.

Roger saluted me and his crowd later gave me the nickname The Kloberdanz Kid, then dropped the Kloberdanz. The nickname and the moment lifted me off the earth and elevated me into their rarefied realm. At last I belonged. From that moment on I was no longer Major Breashears's skinny little kid. I'd become, simply: The Kid.

PERILOUS JOURNEY

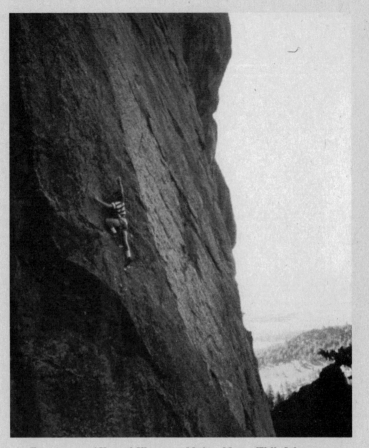

First ascent of Krystal Klyr, 5.11, Mickey Mouse Wall, July 1975.
Perilous Journey follows the blank wall to the right.

CHAPTER TWO

The Kid didn't go to college. Most of my classmates did, many of them to the University of Colorado in Boulder. Frankly, I failed to see what academia had to offer me. I believed I was in the process of creating myself. Like Gatsby, I thought that I alone heard the drums of my own destiny, that I could become the product of my own imagination.

And my imagination focused squarely on the mountains. In them I saw the possibility of a life which fully engaged my talents and ideals, a life that suited my hopes and followed the path of my heroes. I'd continued reading about all of the great mountain climbers: Buhl, of course, and Messner, and the celebrated Frenchman Maurice Herzog, who in 1950 was the leader of the first expedition to climb the world's tenth highest peak and who wrote about it so vividly in *Annapurna*. For each of them, the mountains had provided a path and now the mountains would provide mine. The quest for excellence and self-knowledge that had driven those men would be my guide.

On a fall day in 1974 I packed the same military footlocker I'd left Greece with years before. In that wooden box I packed up all I owned: some clothes, my climbing gear, and my mountain books, including the latest my mother had given me as a graduation present. It was a hefty, portfolio-sized book called *Himalayas*, full of beautifully reproduced photographs with facts about those stupendous mountains I would someday conquer.

David Waggoner drove me to Boulder, railing at me for the full forty miles down the turnpike about how foolish I was to move and pay rent when I could live at home for nothing. He had a point; I had all of $300 in my pocket but I had no doubt I was doing the right thing. I stayed with friends in Boulder until I found a cheap apartment to share, and went out every day to climb the rock walls of Eldorado Canyon.

The canyon lay just beyond the town of Eldorado Springs, a ramshackle enclave of houses and run-down honeymoon cabins. There, along a corrugated dirt road, past the barking hounds and junk cars that decorated the town's streets, lay a world of sandstone towers, some reaching as high as seventy stories into the Colorado sky. Before the sun rose to heat them, the dark, jagged overhangs seemed to hide all

the human shadows that had traversed their walls. Small white hand-prints of climbers' gymnastic chalk dotted the stone, testimony to sweaty hands, slick with fear and exertion, duly dried by a dip into the chalk bag which hung from nearly every climber's waist.

On my first walk up the canyon, I felt like an early American Indian reading petroglyphs, hearing the stories the rocks had to tell. The walls were indeed like some ancient world, with barely visible routes snaking up their vertical faces. Each bore a name. Some were straight-forward, like Redgarden Wall and the Naked Edge. Others were whim-sical: Blind Faith, C'est la Vie. Eagle's Bier stands next to Beagle's Ear. Schizophrenia leads into Neurosis, which in turn parallels Psychosis.

I stared up from the canyon floor, tracing the routes in my mind. I slowly began to realize that what really captivated me about Eldorado was the light. For a long time that morning I examined the walls with their patterns of darkness and huge panels of shifting light. As I watched, the sun on the rock revealed the pageantry of the upper walls and their range of colors, from a soft darkness to deep reds and tans, lit with brilliant neon lichens. It was the architecture—ridges, peaks, val-leys—that gave the rock character and mystery. I couldn't wait to climb, to unlock the secrets in these mute rocks.

A tribe had congregated at the foot of these great walls, a close-knit subculture with its own manners and mores, idioms and literature, taboos and personalities. I'd been determined to move to Boulder be-cause, after my debut on Kloberdanz, I felt accepted by this clan. At the base of Redgarden Wall one day I'd overheard climbers I didn't know exchanging stories about what a young unknown climber, The Kid, had done on Kloberdanz. That first morning, sitting at the base of those comforting walls, I felt for the first time in my life that here in the canyon I would dwell among people who understood me, who knew my passion. I'd arrived a native.

I wore what all climbers wore in the 1970s: white painter's pants, loose for climbing, a rugby shirt, also loose for climbing, and long hair. Climbers were easy to pick out; they were the guys throwing their hands high in the air, configuring their fingers to mime holds in the rock. Those were the days before aerobics classes, Nautilus gyms, or StairMasters, so the climbers looked very different from the townsfolk

around them. They looked rather like post-hippie gymnasts, the kind of misfits and iconoclasts no team coach would put up with for long. They seemed ascetic to me but their veins bulged above the hard muscles in their arms and they had scabs forever healing on their knuckles.

Like everyone else in the Eldorado crowd, I knew I'd have to find a job to support my passion: No one paid climbers to climb. Climbers made do pounding nails on framing crews, painting houses, or working on oil rigs in the off-season. The lucky ones landed instructor jobs with NOLS or taught skiing at Aspen or Jackson Hole in the winter.

Myself, I mucked concrete for a flatwork crew, making sidewalks, driveways, and basement pads. I liked the muscular outdoor work. It was the first of many temporary jobs I held over the next few years. I'd climb until I was out of money, then sign on for another job. We all lived hand-to-mouth in Eldorado Springs Canyon. The first summer I got used to living on cottage cheese and honey, peanut butter from the jar, and rice and beans for dinner. It was a spare life, no doubt about it, but I didn't mind a bit. It allowed me to climb.

My routine was to climb a multipitch route nearly every day, then go bouldering two or three times a week. Bouldering was the foundation of my training and I usually went to Flagstaff Mountain for the misshapen boulders and small walls which lined the roadside. Unlike climbing, which requires a long, sustained effort to get from the bottom to the top of a route, bouldering allowed me to practice certain moves over and over again: a particular way of clustering my fingers on a small nub of rock, a certain stretch of my leg to utilize widely spaced toe-holds, the exact way I could squeeze—or jam—my fingers or fist into a crack in the rock to support my body weight while I worked toward the next set of holds. Bouldering was my rehearsal call; climbing was my performance.

Bouldering was also an easy way to get better acquainted with other climbers. There were spots some of us preferred to others, so we created practice circuits, and you'd see the same people time and again. That first summer I met Jon Krakauer bouldering on Flagstaff. At the time, of course, he wasn't a best-selling author, just one of the Boulder tribe struggling to make a dime and keep climbing. Krakauer was a car-

penter by trade, and the day I met him he wore only shorts and climbing shoes. He had a wrestler's build: compact with legs more heavily muscled than what was typical of most rock climbers. I remember watching Jon work on a boulder problem above me; he was aggressive, tenacious, and self-assured.

Off the rock he had an easy, quiet manner. He didn't talk a lot, but when he did, you got a strong sense of intelligence and focus. Since then I've never been surprised to read about his achievements as a climber or writer. He lived by a regimen that he had mapped out for himself; he practiced climbing and practiced writing, striving hard for excellence in both. Few climbers have reached Jon's literary acclaim, but most of the ones I know have an ample supply of inquisitiveness that spills over onto the rocks.

Steve Mammen was my climbing partner and soul mate for the summer. We were well matched in physical characteristics and mental intensity. We both liked the acrobatic and technically difficult climbing of Eldorado Springs Canyon, and we enjoyed endless hours of bouldering on Flagstaff. More importantly, we shared a conviction about the way climbing should be done: as proficiently and gracefully as possible. Steve was by far the better boulderer.

We judged ourselves and others more by the style of the ascent than the difficulty. Rock climbs are classified using a rating system. Most of the routes we climbed were rated 5.10. The 5 signifies fifth class, or free climbing, in which the climber, protected by rope and gear, uses no aids, only his hands and feet. The number following the decimal point indicates the difficulty of the climb, on a scale of 0 to 11. (In 1974 the most difficult climbs were rated 5.11; today that scale goes up to 5.14.)

Then, as now, no official body set the rating of a route; a route was rated by consensus among climbers. While it would be difficult to explain to a lay person what exactly constituted a 5.10 climb, each of us would recognize a 5.10 when we were climbing it. There's no magic in progressing from one level to another, and the climber himself decides when he is ready to step up a grade. It's fundamentally an act of will. One day a climber who has become comfortable on 5.9 routes decides to try a 5.10, as when an intermediate skier takes his first plunge down

an expert slope. He climbs or falls on his own merits and his own determination. I love that about climbing.

Steve and I naturally got to know more of the Eldorado Springs Canyon tribe as the summer wore on and, from time to time, we attempted routes with other climbing partners. Jim Erickson, a pivotal figure in one of the most radical schools of climbing, was instrumental in helping me refine my own climbing philosophy. His code was best summarized in a phrase he coined: *You fall, you fail.* In other words, you didn't get to recover from your fall and continue to climb—or if you did, you couldn't credit yourself with a climb. A tiny band of purists followed his strict, uncompromising ethic of self-control on the rock. He also refused to use gymnastic chalk because it discolored the rock and provided an unfair advantage.

Jim had a shy, farmboy's grin, but his forehead crinkled tightly when he talked about climbing. He had studied music theory in college and worked that summer making slingshots at the Wrist Rocket factory. He lived in Boulder's student neighborhood called The Hill with his girlfriend, Nancy, a violinist with straight black hair and freckles. Their apartment was a hodgepodge of thirdhand furniture with climbing gear heaped in the corners. I'd go there for dinners which usually featured rice, beans, and Mozart.

And endless mountain talk. Jim would invariably get into his fall/fail philosophy, and I had to admit that there was a stern logic to it. The idea was that you made the mountain an equal partner in the contest by giving yourself one chance to climb a route. Moreover, he said, if you fell without a rope, you might well have died. The climber was obliged to acknowledge the possible consequences; ergo, he had to abandon that route. At the very least, a fall while leading meant that the climber must lower himself down on the rope and start over from the bottom.

I was powerfully drawn to this notion that we should climb as if there were no rope, as if our lives depended on each moment and each move we made. This was a code of excellence—unforgiving—and I concluded that anything less made climbing a pointless exercise.

Our dinner discussions at Erickson's would stretch on for hours as we argued over the details of our personal climbing philosophies:

the meaning of a fall, the merits of the kind of climbing hardware we'd use to stop a fall—bolts and pitons which marred the rock, or wedge-shaped metal nuts which slid tight and harmlessly into slots and cracks. We'd talk far into the night, Erickson and I and usually a couple of other climbers such as Steve Wunsch, Art Higbee, and his girlfriend, Carolyn Gomez.

Higbee had a scraggly goatee, surfer bangs, and thick muscles, a legacy of his days as an all-state wrestler. He'd gone from studying philosophy at the University of Colorado to driving heavy equipment. Higbee's climbing style was bullish and aggressive. So was his debating style. In our discussions he had strong convictions and would charge ahead to make a point. Higbee agreed passionately with Jim about the fall/fail idea, even if embracing it might mean we couldn't climb certain routes. "If that's the case," Higbee said to me one night, "then it's better to leave those routes unclimbed, awaiting others more talented than we." We rarely broke our self-imposed edict.

Wunsch disagreed just as passionately. Tall and lean, with the powerful legs of a dancer, Wunsch was scrupulous on the rock. But he believed that if it took a prolonged siege on a certain route, including falling and trying over again, then doing so constituted a consistent climbing ethic. That, he argued, was how he unlocked a route's secrets. To halt once you'd fallen struck Wunsch as a way to avoid discovering your true potential as a climber.

Around and around we'd debate the philosophy of the possible and the impossible, deep into the night. Finally we'd go home, and maybe days or weeks later we'd see each other up on the canyon walls, spidering through sunlight, on a panel of rock.

My apprenticeship as a climber was advancing with every climb. I studied my companions on the rock and worked hard practicing their technique and training methods. I had studied Nureyev, but watching Erickson, Wunsch, Higbee, and the others I began to see climbing as even more dancelike than gymnastic. Gymnastics is regimented and repetitive; dance is interpretive. Each climber brings a different interpretation to each route, every boulder. Like dancers we use the same steps, but create distinct performances.

Wunsch, who indeed moved like a dancer when he climbed,

taught me the value of footwork and flexibility. He explained to me that the dancer's technique translated directly to the rock, where you gained enormous advantage in balance and endurance if you could keep your hips close to the rock, over your feet. By relying on leg and foot strength, he said, you saved your finger strength for those desperate moments when it was dearly needed.

It was a life by the fingertips and I needed strong arms and fingers. On Flagstaff I used to spend hours at the Monkey Traverse, a long wall sloping slightly downhill, where, mimicking Messner, I could climb back and forth hundreds of feet, working through the cramps in my forearms.

By summer's end, I decided that it was time to move the bar a notch higher and attempt Psycho, a slanting overhang that required the climber to move along a piece of rock jutting out ten feet from a vertical wall, then work his way up and over the edge of the roof to complete the climb. Like Kloberdanz, the route had traditionally been done with dynamic moves, with climbers lunging out to reach the big holds at the lip. I wanted to do it static.

I climbed the steep face below the roof while Steve Mammen belayed me from the ground, paying out rope as I needed it. If I were to slip, he'd be able to catch me simply by tightening the rope around his waist. Sixty feet up I reached the crux, a roof overhanging the wall by ten feet. I clipped my rope through a bolt anchor in the roof, then pulled up onto the underside of the roof like a lizard, latching on with my hands and feet.

Slowly I stretched an arm outward, my fingers reaching for a thin flake of rock the size of a spatula. I slotted my fingers behind the flake, pulled up hard, and reached with the other arm. Suddenly the whole flake snapped off in my hand and whirled to the ground far below. Shocked, I fell onto the rope. Where the flake had been, an ugly wound now marred the rock.

After all my earnest talk with my fellow climbers about clean climbing and respect for the rock, I had just permanently defaced a cherished test piece. It dawned on me, miserably, that I'd closed the door on Psycho forever. Without that crucial hold, I feared, no one could ever repeat the route.

My partner lowered me to the ground. After I untied I spent the rest of the afternoon searching the slope beneath Psycho for the flake. Needless to say, it's a needle-in-a-haystack enterprise to hunt for a rock in a rock pile, but I found it. It had a coating of white chalk notably absent from the other rocks at the base of the route.

I returned to the scene several days later with the flake and a tube of epoxy glue. I know this sounds like some mad mountain guy trying to reattach a piece of rock back onto a cliffside, but you have to understand that I felt like I had desecrated a shrine, and that I had to restore the precious stone at any cost. After climbing up to the roof and assessing the damage, I saw the futility of what I was trying to do. I was never going to get that little rock to stick to that big rock.

I never tried the route again. But months later, to my intense relief, I heard that someone had found a way to free climb Psycho without using that hold.

If my Psycho episode had Anthony Perkins overtones, it's because my Eldorado Canyon tribe was truly a pack of fanatics. How could we be otherwise? After all, we voluntarily walked a no-man's-land between the material world of solid ground and the bottomless abyss. Imagine standing on the edge of a nickel and looking down 500 feet between your legs. That's what many of our climbs were like. Friends outside the canyon said that our lives were at risk when we climbed, but we didn't look at it that way. We weren't in this for cheap thrills; daredevils didn't last long up in the rocks, not at the levels we were climbing. We held the deep-seated belief that our knowledge and skills mitigated the dangers.

That's not to say we never fell. Every one of us did at one time or another. Each of us had tales to tell; stories about falling were a vital part of our oral tradition, fuel for campfires and full moons. They were part ghost stories, but they were also instructional, cautionary tales about how not to set an anchor or clip into a rope.

The great falls were the stuff of legend. Perhaps the most famous fall was one of the earliest recorded, the disaster that befell the first men to climb the Matterhorn in 1865. Led by Edward Whymper, a twenty-five-year-old British illustrator and mountaineer, the party of seven triumphantly reached the summit just after midday. But on their

descent, one of the climbers slipped. Since the whole team was roped together in a single chain, the falling man's weight yanked three of his comrades down the mountainside with him. Those four died. Whymper and the two others were spared only because their hemp rope broke during the calamity.

This tragedy occurred in the infant days of mountaineering, and the loss of four lives in a frivolous quest to gain a mountaintop shocked the world. An inquiry was launched from Zermatt, and it is said that Queen Victoria seriously considered banning British subjects from the sport of climbing. We all knew the story of John Harlin, the golden boy of American alpinism who died climbing the Eiger's North Face when the fixed rope he was ascending, nicked by a rock, parted under the stress of his weight and he plummeted 3,000 feet to the slopes below. We traded stories about Jim Madsen, a Yosemite veteran who rappelled from the top of El Capitan to rescue some friends. It seems the safety knot he tied in the end of his rope was too small, and as he hung on the rope, the knot slipped through his rappel device and he fell to his death.

Everyone knew of someone who'd suffered a fall clear to the ground, which we called, in our gallows humor, cratering. Some climbers I knew had been obliged to gather up the remains of friends who'd cratered, not a pretty task. Once on El Capitan, a pair of climbers were ascending the Zodiac Wall when an anchor bolt failed. A climber below heard heavy swooshing sounds and assumed someone must have dropped his haul bag. He turned just in time to see, to his horror, two men hurtling toward the ground below.

Not all the stories ended in disaster. There's the one about a climber who will remain nameless, who looked down in mid-climb to find his shoelaces untied. Thinking he was secured to the wall, he leaned down to tie his shoe only to realize that he'd forgotten to clip into the anchor. He toppled backward and sailed toward oblivion. Mercifully, he lived to tell the tale himself—his rope caught him after a 165-foot plunge.

The lore of the mortal fall was magnified by Hollywood in its inimitable style. *The Eiger Sanction*, the 1975 Clint Eastwood movie, put the fear of God in us. The climbing scenes were rife with improbabilities and inaccuracies, but the falling scenes left us shaken. It's odd,

looking back, that a bunch of hard-core climbers would buy into the artifice of stunt falls on the screen. I suppose it was that sense of seeing, in a brutally real way, our very lives pass before us.

I knew a thing or two about falls that Hollywood directors apparently did not. First, I've never heard anyone scream as he fell. Sometimes there's a last warning shout to the belayer. Usually it's something you might expect, such as "Falling!" or "Watch me!" But no one I know has ever witnessed that long, receding scream of terror you hear when movie characters fall. In my experience, falling is usually a silent accident, except for the jangle of loose hardware and maybe the peculiar creak of stretching rope.

There are two kinds of falls. The first, like my short drop on Psycho, occurs unexpectedly. A flake snaps off or your toe slips and suddenly you're off. I've seen stop-action photos of falls in which the climber looks as if he were still on the rock, arms and legs frozen in place, even his fingers arranged just so . . . but he's actually five feet out from the wall, in free fall.

Hollywood's slow-motion falls aside, falling is governed by the laws of physics. Objects begin falling in space at a constant acceleration of thirty-two feet per second per second. Most falls cover less than thirty feet. That is to say, the fallen climber has barely enough time to blink, let alone to cry out.

Then there's the second kind of fall.

This is the fall with an excruciating, dreadful buildup when, suddenly, too exhausted to hang on, you realize you're about to fall. That was the kind of fall I took from a nameless climb one summer afternoon. I'd noted a possible route during one of my drives through Boulder Canyon and decided to give it a try with a friend. We crossed Boulder Creek, I tied into the rope, put on my snug-fitting climbing shoes, and started up the crack in an overhanging corner, sequentially wedging my hands and feet into the narrower slot at the back. It was easy at first.

The climb was unimportant, a casual bit of practice. But as I worked higher on the rock, my day took a more serious turn. The stone began to close me out. I'd brought a bandolier of different-sized nuts. The idea was that if one size didn't fit a crack or opening, another usu-

ally would. Or, if not in this crack, then in one a little higher. But a little higher led to a little higher, and I still couldn't find a placement for my protection nuts. Nothing I had seemed to fit.

When you're twenty feet above your last piece of protection, the last nut or piton anchor you've placed in the rock, you can fall forty feet, more like fifty feet with the rope stretch. Long falls usually end with only minor abrasions as long as you don't hit the ground or a ledge. But without protection the rope is almost useless. I was now thirty feet above my last piece of protection, so in this case the rope was mostly an ornament. Since my partner was still on the ground, I at least wasn't going to be dragging anyone but myself off the rock.

The climb was becoming steeper and more difficult. It's relatively easy to reverse yourself and climb down if the rock is vertical, or nearly so. Unfortunately, by the time I fully recognized my predicament, the rock had become severely overhung; my back was hanging out over the creek we'd crossed an hour before. At that point, down-climbing was no longer an option.

Thus I was quite literally caught between a rock and a hard place. I couldn't climb up, and I couldn't climb down. I couldn't place any protection in the rock, and my finger strength was vanishing. I was facing a sixty-foot plummet to the end of my rope with the distinct possibility of hitting the ground.

I felt my forearms swell and cramp, engorged with blood and lactic acid from the effort of hanging on. As the lactic acid continued to build, my arms felt as if they'd caught on fire. My legs were all right, that is, they hadn't begun to tremble and stutter, to turn into what we aptly call "sewing machine legs." It was my arms that were going to betray me.

As my breathing sped up, breaths becoming quick and shallow, I hung from one hand to shake out the other arm, giving it a rest for fifteen seconds or so. I then changed hands, shaking out the other arm. I kept repeating the exercise, resting each arm for ten seconds, then five. Finally I reached the point where I couldn't take either hand off the rock; neither hand could hold my weight any longer while the other arm rested.

I was going to fall. I tried to subdue the first flushes of chest-

tightening fear. I concentrated on my respirations, forcing myself to breathe easily, deeply, but I was running on empty just the same.

Before a fall, a climber locks into a curious set of priorities: Don't look down; look up. Scan the rock again for the missing pieces, search for the holds you didn't see the first dozen times you looked. Then the inevitable sense of futility sets in, and the climber at last looks down to see what he's going to hit.

Which is just what I did. There, I saw a desk-sized ledge just twenty feet below. If I missed it I might survive a sixty-foot fall halted by the rope. If I hit it I'd probably break my legs or my back.

Some climbers might have opted for one last lunge upward, hoping for a glory hold. I chose to rehearse my fall. Not that I could guide myself away from the ledge. Just the same, I banked on missing that ledge. And then I fell.

There is an instant sensation of release when you fall. Abruptly, your struggle is over. There's nothing to think about, nothing to hold on to, just the peculiar freedom of the fall. You're no longer in control but are at the indifferent mercy of unseen hands. That's how it was for me.

I fell backward, somersaulting through the summer air. With a muffled thud and a groan, I hit the ledge. I should have sustained severe injuries, but two things saved me: I landed squarely on my back, thus distributing the shock; and my head cleared the ledge.

I lay there for a time, numb and confused, unable to breathe, silently taking stock. When a few tentative movements suggested that nothing was broken, I sat up and began to gather my equipment. Finally I pulled in my rope, found a way to anchor it, crawled over the ledge, and my companion lowered me down.

I was so sore, it was two weeks before I was able to climb again, and to this moment, twenty-five years later, there are days when my back reminds me of that frightful afternoon in Boulder Canyon.

Early in the winter of 1975, I'd planned a road trip to some desert climbs in Joshua Tree National Park in southern California. Most experienced climbers headed to Yosemite in the summer, but I wasn't

quite ready for its huge granite walls. For me at that stage, the smaller granite climbs in the desert would be a good first step away from the sandstone of Eldorado Springs Canyon. I couldn't wait.

Two weeks before the trip, my father died.

I'd known from my mother that he had throat cancer. But since leaving Greece with the rest of the family, I'd seen him only once in six years, for all of five minutes, when I was fourteen years old. He'd located us in Cheyenne and flown there without a word, dodging the court summons for failure to pay child support. I was in class when the principal summoned me to his office. There sat my father, the last person on earth I was prepared to see. Clearly he wanted to connect somehow with his children, or at least with me. But he evidently determined to connect on covert terms, because no one in the family knew he planned a visit that day.

Those five minutes remain a blank. All I remember is running to the phone to call my mother and warn her that he was in town. But by then, he wasn't. As swiftly and mysteriously as he had reappeared in my life, my father disappeared again, this time for good.

Now, on hearing of my father's death, I still felt completely alienated from him. Yet his death affected me. Whatever else he was, he'd been my father. Just as I pretended that the chaos in our house had nothing to do with me, so I now pretended that my father's death had nothing to do with me—in any way.

My mother didn't forbid any of us from going to his sickbed or his funeral. But she didn't go and, out of loyalty to her, I didn't either. One of my older brothers went to the funeral. I didn't stay home because I despised the man; I simply had no capacity for sorrow. To this day, the only two emotions I attach to him are fear and pity. He had bullied and terrorized us, but with time I'd come to feel sorry for him. All bullies are cowards, and in the sum of things, that's what my warrior father had been: a terrible coward.

At any rate, now he was dead. I felt no joy, no sorrow, no relief. Nothing. We scarcely ever spoke of him again. I don't know where he's buried.

I turned away from his death and took off with friends for California. We drove an old Volvo station wagon across Nevada past signs

warning of dehydration and heat. It was snowing all the way. Unhappily, the trip was a bust. The rocks at Joshua Tree were too cold to climb, so we piled back into the station wagon and continued west to the Pacific Ocean. We finally managed to do a little bouldering on the sea cliffs in La Jolla.

I returned to Boulder in September. Entering the university was an option since the military benefits from my father's death would have paid the tuition. But I clung to the notion that I had to make my mark in my own way. It wasn't clear to me at the time, but I have come to understand that my father's death made it vitally necessary for me to prove to myself that I was more than his image of me. And the first and best way for me to do that, I reckoned, was to create my own route, a genuine signature piece which would stand the test of time.

I began to look to an old Eldorado aid route called Jules Verne, another of those great sweeping roof routes. That was the next prize among our group of purists—to free climb Jules Verne. We discussed it one night at a backyard party at Roger Briggs's house. Steve Wunsch told me he had already made several attempts to free climb Jules Verne. He didn't say it in an unfriendly way, but he was quite firm. He told me he'd been up there deciphering the moves and that he'd left some protection in place. He didn't tell me not to go there, and I knew I could try it if I really wanted to—that went on all the time. But Steve was my friend, so I diverted my energies to another project.

That was what led me to the Mickey Mouse Wall, high above and to the south of Eldorado Springs Canyon, so named because it stands against the horizon with two rounded slabs that look like a Mouseketeer's cap perched on the mountainside. Few people went up there because the approach required a long, tedious hike, so I knew I'd have the wall to myself.

Art Higbee and I decided to explore Mickey Mouse. We hiked up to a railroad track that bore trains west through the Rockies. It gave us a terrific view of Rocky Flats, the government facility which made plutonium triggers for nuclear weapons. We followed the track—quickly—through a long tunnel and soon arrived at our destination: the huge

vertical panels of sandstone which were Mickey Mouse's ears. The formation was a giant fin of sandstone embedded in the sloping hillside, like a discus lodged upright. At its southern edge, the wall was 400 feet high. We walked up the steep talus slope along the front of the formation to reach the western shoulder.

There I had my first look at an unfinished Erickson route, a creation called Dead Bird Crack. Next to it lay a route called Duncan Donuts, put up by the renowned face climber Duncan Ferguson. One of Duncan's specialties was the long run-out where he climbed high above his protection, running out the rope and thereby risking a long fall. Studying Duncan Donuts, with its scant opportunities for placing a nut, I could envision the extraordinary mental control he'd exercised.

Higbee and I tried Dead Bird Crack without success. We managed to do Duncan Donuts, then called it a day. I was coiling a rope at the base when the light changed. I thought I saw a route in the middle of that blank wall.

I'd been studying rock for several years now and was learning its nuances. After a while you get to understand the character of a wall just by observation. You can tell by its texture whether it's likely or not to bear holds. Certain kinds of rock provide sharp thin edges, while others offer only small bumps and depressions. Most smooth granite walls can be climbed only by finger- and hand-sized cracks. Reading vertical terrain is a subtle art, but it comes over time.

This particular wall wasn't that big, only eighty or ninety feet high. To the naked eye, though, it was featureless: no crack to follow, no dramatic jutting overhang. It was just a blank piece of rock. There was an elusiveness to it.

Standing there, I realized that the blank section wasn't entirely barren of holds; sandstone rarely is. The question was, Were there enough holds up there to connect into a climb? It was like a movie screen before the movie starts, empty and yet full, playing on the audience's sense of anticipation. That was the beginning of a route I would one day call Perilous Journey.

I didn't start the journey that day. I returned to Mickey Mouse a number of times over the following months. From different vantage points along the talus slope, at different hours in different light, I began

to envision the route. First I had to imagine it, part by part, hold by hold. Most of today's climbers would simply rappel down from the top, preplacing protection bolts with a battery-powered drill, and previewing the prospective route. Back then, however, we approached routes strictly from the bottom up and never placed bolts.

It was nearly a year before I felt ready. I continued climbing other routes, bouldering, and training. As winter forced us off the rock walls I took up ice climbing on small frozen waterfalls. But all the while Perilous Journey was taking shape for me. It wasn't just a tier of stone, it was my tabula rasa, ready to be inscribed.

Of course, the route wasn't mine to inscribe unless I made the first ascent. But the beauty of my project lay in its anonymity: My Perilous Journey was on nobody's hit list. Indeed, almost nobody knew about it, and even if anyone had hiked up, he'd find nothing obvious to pursue, no spectacular roof problems—no history, in fact, at all.

The name Perilous Journey came from a Yosemite tour guide, who used to tell his charges on the tour bus, "There is El Capitan, and here is the famous Camp Four where the climbers prepare to embark on their perilous journeys." In the spirit of mountain mockery, Pat Ament and I once named some pitifully easy climb Perilous Journey. Now I appropriated it for my serious work-in-progress.

As I prepared for Perilous Journey I knew that there would be no place to slot a nut into the rock; the wall was blank. That meant running the rope out, possibly to the top, with no protection in between. No protection, of course, meant that if I slipped there was nothing between me and the ground.

I didn't really mind, in fact that was the allure. I enjoyed being high above my last piece of protection—it made the climbing more serious and demanded more control. I'd always experienced an almost blissful sense of detachment on climbs where mistakes had grim consequences. In those moments of jeopardy, the senses become narrowed and focused. Only the language of survival is engaged, all other dialogue stops. Your physical and psychic energy are tightly constrained and conserved, carefully directed.

At last it was time to make the climb. Steve Mammen and I chose the day and began the long hike up just before dawn. I was very fit by

then, keenly aware of what Perilous Journey would demand. I'd decreased my bouldering workouts three days prior to rest my muscles. Also, I was conserving my fingertips. When you boulder on rough sandstone, the rock acts like sandpaper, leaving your fingertips tender and prone to sweat.

There was a good reason for our early start that July morning. Mickey Mouse faces almost due south, which means that until eight o'clock or so, the wall stands in shadow. The temperature would be optimal then. Also, after eight, the sun would work over the summit rim and we'd be looking straight up into blinding light. I'd failed on another climb because of light like this, so we factored it into our plan.

I always follow the same ritual before starting a climb: carefully and tightly lace my climbing shoes, three wraps around the waist with my harness, attach my chalk bag at the small of my back, tie into the rope, then allow for one last mental rehearsal and review of the route. I estimated the crux was forty feet up, after which the angle eased to slightly off-vertical. I dipped my hands into the chalk bag, dusted my fingers, and started off.

The holds were tiny, some sloping and rounded, others sharply edged. A few quartz crystals studded the wall, deceptively inviting: These crystals were brittle and ready to snap. I largely stuck to my plan, using the holds and sequences of movement I'd been memorizing for months from the ground. It would have been nerve-racking work had I allowed myself any nerves to rack. But I knew I had to concentrate on the moment itself, to control my every flutter of emotion. Up there nerves, not pride, goeth before a fall.

As it turned out, there was only one place to set a nut on the entire climb. Although I could tell at once that it wasn't going to hold anything more than a three-foot fall, as a gesture, I went ahead and wedged in a small nut, clipped in my rope, and continued higher. It was oddly comforting to see the rope running through that solitary, useless piece of protection.

It was remarkable how closely the reality of Perilous Journey paralleled my contemplation of it. Just as I'd concluded from my read of the minuscule shadows, each hold led to another hold in reasonable order. I'd wondered about the thin edge at mid-height, whether it was

more shadow than substance. Once I arrived there, I found it was just enough to allow me to pause. Further, after a slight bulge forty feet up, the wall relented, making the climbing easier.

Near the top I pulled from the shadows into the sunlight and something peculiar happened: I felt lifted from my darkness. It was a profound feeling that would eventually fade but, for a brief moment, the chaos in my soul subsided. In the years to come I would find the same measure of spiritual relief and self-awareness at other moments on the world's mountaintops, in havens of light.

Steve followed in perfect form, no falls, no slips, an ideal first ascent. At the time, we had no idea of the significance of our accomplishment. By noon we were back in Eldorado Springs Canyon, careful not to bang the drum too loudly. We rated it 5.9+ out of a possible 5.11. Later, other climbers who ventured up came back to pronounce Perilous Journey a 5.11X (X for extremely serious) because it was bereft of protection. As it happens, few people have led it in the quarter century since that July day.

I still don't think the climb was that exceptional. Few people bothered to actually go up and look at it. I honestly believe that if the route had stood down in the canyon where climbers could readily try it, Perilous Journey would never have enjoyed the reputation it has today. But it became a small legend all the same, proclaimed by climbers as an ideal manifestation of the "you fall, you fail" ethic.

Ironically, Perilous Journey also marked the beginning of the end of my single-minded dedication to rock climbing. Never again would I express such dedication to a rock climb. I continued to boulder, climb hard, and put up first ascents. But Perilous Journey embodied everything that rock climbing had come to mean for me, and I realized it was time to move on. My vision began to shift to greater mountains and higher places.

WORM

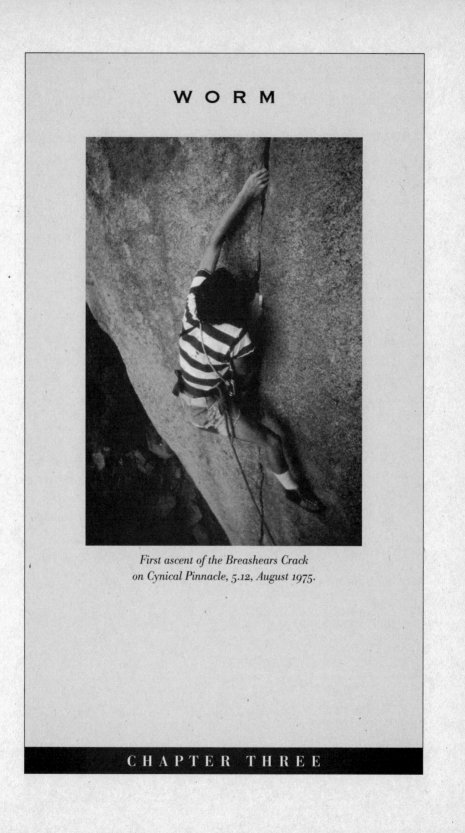

*First ascent of the Breashears Crack
on Cynical Pinnacle, 5.12, August 1975.*

CHAPTER THREE

It was on a bitter early January day that I headed north to the Wyoming barrens to hunt work in the oil fields. Returning from climbing, I'd wrecked my mom's Plymouth Duster and was badly in need of ready cash. Wyoming was a favorite place to look for jobs among my clan; roughnecking was an occupation of choice among rock climbers, mainly because the pay was so good.

I rode a Greyhound from Denver to Gillette, the coldest and most northerly of Wyoming's boomtowns. The oil fields were set in rolling hills and deep ravines. From the highest vantage points you could see into the Black Hills of the Dakotas.

Wyoming appealed to me for reasons other than high wages. Everyone has a favored landscape. I loved the high plains with their grand spaces and soft palettes of light. A howling wind, forlorn as it is, has always sounded like home to me. Wyoming compelled me, as Tibet later would, with its vastness and the blue-gray slate of its enormous sky.

But money was my main objective. I'd been making a few bucks an hour as a bellhop at the Denver Marriott, and that wouldn't do with car repairs to pay for. Meanwhile, friends had returned from Wyoming with tales of extraordinary job opportunities. Alaskan pipeline jobs had tapered off, and Wyoming had become a boom state. An experienced worker could make $15 to $20 an hour in the oil fields.

The job I really wanted was in seismic mapping. I'd heard that oil companies wanted climbers because of our navigational skills in the mountains, our cognitive ability to find routes with a map and compass. As stories had it, the companies would chopper you into some desolate area with packs of food and equipment. For days you'd string out wire line with explosive charges attached. They were then detonated to create subterranean snapshots, revealing the oil below. That's the kind of job I wanted: to be paid for my solitude in the wilderness.

It was around midnight when my Greyhound rolled into Gillette, a town of mom-and-pop stores and run-down bars. A blinking motel sign announced the temperature: minus 40 degrees. Inside the motel was a Mr. Coffee machine. The coffee was strictly for paying guests. A motel was out of the question for me. I had no place to go, and all of $25 to go there with until I got my first paycheck. So I stood there, get-

ting colder and colder, staring at Mr. Coffee. This was one of those down-and-out moments in life when you simply have to go where your feet point.

Lifted along by the wind, I wandered down the empty street and strayed into a dark lumberyard near the railroad tracks. I found a space between two pallets of plywood just large enough to accommodate me. Pulling a loose sheet of plywood across the top, I fashioned myself a sort of crude soloist's base camp. As it turned out, that frigid cubbyhole would be my home for the next wintry month.

I squirreled into my down sleeping bag, waited to quit shivering, and tried to sleep. All night long the ground rumbled with trains carrying coal and petroleum. Listening to their shrill whistles, I probably slept for an hour.

There's nothing poetic about dawn in Gillette—or any other boomtown, for that matter; they all share a squalid sameness. Cheap trailers dotted the flats. Motel neon flickered over the parking lots already emptying into the distant fields. Eighteen-wheelers lumbered down Main Street. The coffee shops were easy to pick out; they were the spots on the road clustered with oil company trucks and pickups from the surrounding Indian reservations.

My first day was almost my last. You didn't find work in a place like Gillette by reading the want ads; you had to track it down on foot. I drifted from coffee shop to coffee shop, and the news was always the same: There was plenty of work for experienced help but not for a young rock climber/bellhop. The roughnecks, drillers, and truckers looked me over, returned to their fried eggs and sausages, and never looked my way again. Their contempt was intended to be disheartening, but I'd been through this kind of dismissal before with the rock climbing elite. I persevered.

I was thin as a reed from my rock climbing, so I didn't promise much to these sturdy, seasoned men. In preparation for my trip I'd gone shopping at a Denver Kmart to buy the requisite Lee bluejeans, a plaid Woolrich shirt, and a pair of heavy-duty pack boots. My choice of clothes was strictly oil-rig regimental, but the jeans still had that telltale store-bought crease. If there's such a thing as a drugstore rigger, I was it. Honestly, I wouldn't have hired me.

Along about noon I switched my search from the greasy spoons to a local watering hole called the Stockman's Bar. No potted ferns or Bee Gees tapes here. This was the kind of bar where most of the guys seem to clutch pool cues and are called Sonny. Stockman's was all rough-neck bar business, and over the next days and weeks it became my second home, a place where I could mingle with the oil-field gang and nurse a beer for hours. I got to know the place all too well—it beat the hell out of my plywood cave.

Stockman's had four pool tables, a few well-worn booths, and stools at the bar. It was an odd assortment, cowboy hats mixing with hard hats. You could actually smell the crude oil wafting off men's boots and overalls. For some reason, probably because they were there first, most of the railroad men were big, tough Sioux Indians, and they stuck together. The rest of the clientele was on its own. It included everyone from unemployed bull riders and ranch hands out of Montana, to Vietnam vets still in their jungle fatigues.

I walked through the door into a permanent twilight. It was barely lunch hour and men were already working hard on their beer bottles and shot glasses. One guy was passed out on the bar. I learned quickly that it never mattered what time it was outside; inside the lights stayed dim and the smell of stale beer and cigarette smoke permeated everything. Eventually I'd learn how to distinguish night from day: The customers didn't fight until after dark.

I began with the less fearsome of the men. Excuse me, sir, I'd say, do you know of any jobs on the rigs? But it was the same as in the coffee shops. Without experience, I ranked in the local pecking order down around roadkill. Finally, in desperation, I dispensed with the truth. All day I'd been picking up the vocabulary, and by then I saw no reason not to lie to get my foot into the door.

I'd noticed a man who had a foreman's bearing; he kept his own company and wasn't a high school drunk. I decided to give it a shot.

"I'm looking for work," I said, plunking down next to him.

He surveyed me carefully. "What kind of work?"

I'd heard of something on a drilling rig called the crow's nest. "Well, up in the crow's nest," I offered.

"Been up there, have you?"

"You bet."

That was as naked as lying gets, and he knew it. He stood up, six feet, three inches, in a dirty red beard and glared.

"You lying SOB," he said. "If your mama was here I'd rip your head off and stick it down her throat."

He got hotter by the heartbeat, and I grew equally as frightened. In the middle of his barrage of curses a terrible thought came to me: This man likes violence. He would gladly have beaten me half to death for the sheer fun of it. In fact, a month from that dreadful moment, I'd see him do just that to another kid in the parking lot.

I got out of there fast, grateful that he was into only his second Wild Turkey. Sandwiched back in my hovel, I was dazed by my brush with a near-thumping. What had made him so angry? But then I thought about the oil rigs and the unforgiving jobs they called for. It was hot, slippery work, done in icy temperatures; a lot of opportunities for disaster there. And on a rig, as on a mountain, there's no substitute for experience. It can literally mean the difference between life and death. I breathed softly in the cold and tried to look at my antagonist in that forgiving grim light.

My second morning I heard about a labor lash-up called Pool Drilling, about a half-mile walk out of town. I hung out for most of the morning while bona fide derelicts were chosen for temp work over me. I began to feel like Marlon Brando in *On the Waterfront*, when the bosses wouldn't hire him because he was a stoolie. Some of the men were hungover, and not a few bore the marks of the beatings they'd suffered the previous night. Still, they were deemed more valuable than I was. It was a humbling notion; none of my artistry or expertise on Perilous Journey amounted to a hill of beans here.

On the third morning I showed up at six A.M. Soon a Ford F-250 Twin Cab showed up. The driver rolled down the window and stared at me for a long, hard minute. At last he said, Okay, you. I clambered into the bench seat behind three other men in the truck.

My on-the-job training began immediately. It was sixty miles to the site, and none of the men spoke to me the entire ride. They didn't talk about work, even among themselves; they just listened to country music wailing on the radio. After a while, lulled by the warmth of the

cab and exhausted by three nights of icy wind and railroad whistles, I drifted off to sleep. Suddenly the truck squealed to a halt, somebody banged on the ceiling, and the driver hit the horn. I was certain we had at the very least crashed into a deer or antelope. Turned out, it was all a joke on me. Not that they thought it particularly funny; it was just a wake-up call. When I drifted off again, they played their prank for the second time. It wasn't as if they wanted me awake for any reason. They just didn't want me to sleep.

That was the way they taught things on the oil rigs. The English language played little part in their training manual. Their method was more like how you work an animal with nudges and gestures and hard looks. I took in the lessons. *Never relax around these men. Never let your guard down. Shut up. Watch. Listen. Do your work and keep your place.* The protocol was profoundly simple.

We turned off the highway and drove down a corrugated dirt road for miles. I had accepted that they weren't taking me out to a nifty post on one of the big rigs, those stately steel islands on the prairie, from which you'd see lights twinkling at night while the drill sinks a mile and deeper into the earth. Instead I was to earn my spurs on a lowly workover rig.

Finally we arrived at a portable derrick lying flat on a truck bed. Several men were waiting for us. Clad in my spanking new padded oversuit from Kmart, I looked every bit the rube as I crawled out of the truck. There was no welcome, no acknowledgment, no handshake. The men I'd ridden with went straight to work, leaving me to stand there very conspicuously. I hadn't a clue what was expected of me.

Eventually I figured out, from his dour expression every time he looked at me, who the boss was. I walked over to him.

"You're going up in the crow's nest," he said to me.

Whatever that meant, it was fine with me. Foolishly I stuck out my hand and said, "Hi, I'm David." I might as well have tried to introduce myself to a New York City cop. I intended to tell him how grateful I was for the job, but his expression, changing from dour to disgusted, told me to put a sock in it. He didn't take my hand.

"No, you're not," he replied. "You're Worm."

"Sir?"

He didn't bother repeating himself; he just spit some Red Man tobacco juice into the dirt.

Thus I became Worm, the generic term applied to all newcomers on the blocks, like Rookie in sports. Worm became my Christian name, my rig handle, my rank in the hierarchy. I could have resented it, I suppose; but strangely enough, I came to like it. There was no friendliness or sense of kinship in it, as there had been with The Kid. Still, it represented to me the start of another challenging apprenticeship, a new way of knowing the world. Starting at the bottom and working my way up through the ranks made perfect sense to me. The method had worked in rock climbing, and would eventually pay off in mountaineering and even cinematography.

Workover rigs were basically giant roto-rooters. It was fast and dirty work which required enormous concentration but, especially at my bottom-feeder level, little real training.

In the order of things, a big rig drills down to the producing formation—oil or gas—and a pump is set in place at the well bottom to tap the crude oil. These hydraulic pumps are what you pass along the road as they rhythmically dip their horse heads to the earth. They're very close to being perpetual motion machines, since their motors are fueled by the natural gas they pull up with a sucker rod and rod pump. Eventually their parts wear out or sand jams the flow and the well requires servicing—or a workover.

The job is deceptively perfunctory. On the back of the workover truck you set up the derrick, a fifty-foot-high, open-trussed steel tower. You open the well, haul out 7,000 feet of metal rod, replace the pump, lower the pump back to the bottom, close it up. Then you move on to the next well. But in a boom patch like Gillette, there were more workover rigs than wells needing service. Independent workover rigs competed for quickie contracts. For the guys employed on the workover rigs, that translated into cutting corners for the sake of saving time. So what was essentially big-league toilet plunging became high-risk work. And since there was surely no place more dangerous in the operation than the crow's nest, that's where they sent their cannon fodder—namely, me.

The crow's nest was a metal platform atop the derrick. The der-

rick was tilted upright from the back of the truck and positioned directly over the well head. To prevent this thin steel tower from rocking or tipping over when pulling out thousands of feet of pipe or rod, the derrick was supposed to be secured in four directions by guy lines running from the top out to anchor points in the prairie.

In addition a fifth line, called the Geronimo Line, was supposed to be anchored even farther out onto the prairie. It would run from the crow's nest, where a small, two-handed wheel device was stowed. If there was a fire or explosion or the derrick began to fall, the man in the crow's nest could bail out by grabbing the hand wheel, jumping free, and riding the Geronimo Line to safety below.

That was the theory anyway. In practice the crew rarely bothered to securely attach the four guy wires, much less the Geronimo Line. There simply wasn't time.

The designated Worm could climb a ladder into the crow's nest or, as on my first ascent, hitch a high-speed ride from the deck to the crown with one foot on a cast-iron block. The crow's nest had a railing on the outside and a hole in the middle which looked down over the well. It was my job to lean out over the hole and wrangle the pipe and rod coming up or going down. This looked like a reasonable enough assignment when it was demonstrated to me in slow motion. But once I was left alone and the crew got up to working speed, the job turned swift, slick, and nasty.

The cast-iron block moved up and down in constant motion. If you got your hand tangled in its cable, the block could tear off your fingers or your entire arm. A frayed leather safety belt ensured you didn't pitch fifty feet to the ground below—or so you hoped. There were at least a dozen other grisly consequences to any mistake I might make. For one, I could accidentally drop a forty-foot section of metal pipe, which, from that height, would become a spear that could stab five feet into frozen earth. So I was as responsible for the safety of my fellow workers down below as I was for my own.

I'd heard about the risks of roughnecking, of course. They were part and parcel of the oil man's romance. I considered myself familiar with risk from my years on vertical rock. I knew its language—or at least thought I did. Climbers like to subdivide their dangers into two broad

categories: objective and subjective hazards. Objective hazards are those generally beyond the climber's control, such as storms, avalanches, and falling rock. Subjective hazards are those you're meant to overcome: fear, weakness, hubris.

On a workover rig, however, the most serious hazard falls into the single "time is money" category. From morning till night the entire crew was dedicated to the proposition of getting it done an hour ago. My personal ambition was to learn, earn—and not get mangled in the process. And to prevent lethal weapons from dropping out of the derrick: pipe, rod, tools, what have you. It was a peculiarity of my climber's mind-set that I wasn't worried so much about dying as I was losing toes or fingers to a piece of wayward machinery. I saw enough men around me with stubs for fingers to keep me sharp.

At the end of my first day I rode back to Gillette in the rear of the cab. The rig foreman hadn't fired me, so I showed up again the next morning. I worked because they needed me. When they didn't need a man anymore, they let him go. It was as simple as that. I worked on five or six crews over the next month. The faces, colors, and accents of the men shifted a bit, but in most respects the crews seemed identical. Every morning men traded guttural grunts instead of conversation and ate Camels and thermoses of coffee for breakfast.

The crow's nest was my fixed position by their choice. But sometimes it was a joy to be up there alone, away from the worst of the engine noise, away from the sullen, overworked men. In slack moments I could relax and watch jackrabbits, antelope, mule deer, and coyotes on the prairie fringe. I was even able to see Devils Tower, a place I'd always wanted to climb and one of the few real landmarks in northern Wyoming.

I grew adept in the crow's nest. I was agile, had a climber's solid strength-to-weight ratio, and no fear of heights. And, in fact, some of the discomforts of the job were instructive. For instance, I used only thin gloves in the fierce cold because you just can't handle pipe and rod with thick gloves—and one slip can spell disaster. I learned how to handle very cold metal objects and still keep my hands in good working order—a valuable lesson for mountaineering.

When the storm fronts blew in from Canada and sheathed the struts and cables with hoarfrost and ice, the derrick would creak and I'd climb down the slippery ladder as quickly as I dared. Sometimes the weather meant the end of the workday. But just as often the rig foreman would soon order everyone back to work, storm be damned. The crew would cuss and fume, but the foreman held the last word. I'd climb back up, rationalizing about the lesson I was learning in the heart of a snowstorm.

A greenhorn like me had the least value to the crew—if I got chewed up in the machinery or scared off, there was always another Worm ready and waiting at the labor pool. But my low rank didn't fully sink in until the night we spun off the road. Another northern storm, an Alberta Clipper, had blown over our rig, this time in late afternoon. The foreman called it a day and we started back to town. I was perched, as usual, in the back of the cab. Up front a bull rider with a rodeo belt buckle sat with the foreman, a twelve-step program survivor, behind the wheel.

As the storm grew worse the foreman slowed to a crawl, searching in the driving snow for the next road marker. Darkness descended. Soon our snowstorm became a ground blizzard. In Wyoming, high winds blow snow horizontally across the prairie, so that six inches of snow as measured by the TV newsroom can transform into drifts of four and five feet on the highway.

Veering to miss one such dune, the foreman slid the truck into a ditch. We all got out to push—pointlessly, as it turned out. The winds were gusting at sixty miles per hour, and we had no goggles or flashlight. A first aid kit, a two-way CB radio, but no flashlight. We climbed back into the truck and took stock. The foreman had a set of chains in the truck bed. If one of us could lash them onto the back tires, he said, we just might be spared a night on the prairie.

No question who was going back out into the storm: Worm. I didn't volunteer and they didn't ask; I just got out. I did the best I could with the shovel and chains. But without a flashlight I had to dig in blank darkness by feeling for the tires. Moreover, I didn't dare stray beyond arm's reach in that weather, lest I disappear into the Wyoming

night forever. I crawled back into the cab every five minutes to warm my frozen-stiff, cast-iron hands.

Finally I managed to chain up one tire. The foreman tried to rock the truck out of the ditch, but succeeded only in driving the wheels in more deeply and wrecking the transmission. We were stuck. He made a radio call to Gillette.

Gillette told us to stay put and stay warm, that a tow truck would come for us in the morning. Luckily there was plenty of fuel to keep the engine running all night. So we settled deep into our jackets, tuned into the country and western station twanging its way up from Rapid City, and checked our watches every twenty minutes or so.

It was a long night, but the warm cab was a luxury to me. Back in Gillette, I would have been spending the night wedged between two pallets in the lumberyard. But it was eerie all the same, with the snow blowing outside and the silent men huddled in the cab with me.

A tow truck arrived after dawn and hauled us the eighty miles back to Gillette. There I won my first grudging acknowledgment for my futile efforts in the snow. At least I had tried.

I had resigned myself to being a permanent stranger among these men. Their remoteness wasn't personal; they remained strangers to one another. I've never seen so many ghostly figures in one place. In this corner of Wyoming the sense of estrangement was just another aspect of the landscape.

I had to be keenly aware of all the dangers in my orbit—on the rig and during off-hours. As the winter wore on I developed a routine: From dawn to dark I'd work on the workover rigs, then go back to town, have a hot meal at one of the cafes, and finish the evening in the Stockman's Bar.

In Stockman's I mastered the art of nursing a beer for hours. It was one way, at least, to keep warm before burrowing into my lumberyard bed. But Stockman's had something else for me, a particular ghost who haunted me, who I wanted to understand. I'd caught glimpses of him in the field, where men bullied machines and each other with an almost pathological fury. But it was in the Stockman's Bar that I really began to understand my father.

If an anthropologist ever wanted to study violence, Stockman's would provide an ideal focus group. The territorial imperative was always strong there, right down to the bar stools reserved for particular brooding giants. There were plenty of laughs at Stockman's. The trouble was, hilarity could turn to hostility in the twinkle of a maniac's eye. These were, after all, drunken, overworked men who carried rage around with them in duffel bags. There was no love gained or lost here either. In all my nights there I never saw more than two women in Stockman's—one with Tammy Wynette bangs, the other with Dolly Parton hair. There was no TV at Stockman's; it was a jukebox joint.

The violence was random and volcanic. It was virtually impossible to tell how any single fight started. And these weren't the kind of squared-away fights you see in movies. These were fights where guys beat the living hell out of each other.

Occasionally the bouts ended quickly, as in the night I saw a Sioux smash a pool ball against another man's temple, then go on shooting stripes-and-solids next to the crumpled body.

More often, the brawls turned into extended bloodletting. The men went at each other like wild animals, grappling and grunting, biting and clawing, ripping each other's shirts to shreds. They used every makeshift weapon at hand: broken chairs, beer mugs, bottles, even their hard hats. Once a knife suddenly flashed and someone was stabbed.

I quickly learned the proper etiquette for keeping my eyes clear and my nose in place: mind your own business, avoid all eye contact, and never, ever, raise your voice. Even so, passivity didn't always save you in Stockman's. One night a Goliath in bib overalls and a matted beard slowly poured his bottle of beer on my head. No reason for it, he just wanted to fight and I was handy. He was a good seventy pounds heavier than I and about two miles meaner. Discretion and valor being what they are, I slunk off to the bathroom to wipe my scalp dry and let him find someone else to maim.

Two things were truly frightening about Stockman's. One was that these men who knew violence so intimately took it so thoroughly for granted. It was a way of life: They knew they could take a savage beat-

ing and still get up and go to work in the morning, busted teeth and all. In Stockman's this translated into a stoic disregard for pain.

The other thing that struck me deeply about the violence there was how hopelessly wrong it was. It wasn't about defending yourself; indeed, it had no purpose at all. I began to realize that these men had lost all control of their lives and in fact all sense of personal identity. It seemed to me that the only way they could distinguish themselves from the mirror images all around them was simply to obliterate the rival faces.

And in this fundamental weakness I began to see definable reflections of my father. It further deepened my pity toward him.

But I had little time for pity; I had to look out for myself. I'd begun to notice a subtle buddy system operating in the barroom dynamic. It wasn't friendship; the idea was a mutual backup in case of trouble. Not that a man counted on his buddy to join a fight. But if matters got wildly out of hand, you at least had someone else in the bar to jump in on your side. I needed someone who'd at least follow me into the alley if I ever got dragged into a fight.

Cultivating a backup was no simple task. In Stockman's you didn't just walk up to a man, buy him a beer, and say, "How 'bout them Broncos?" Such an overture might in itself have inspired a beating. Still, the burden lay on me to forge an alliance. There was one prospect.

He was Puerto Rican, with black, curly hair, a thin mustache, and an easy, open manner. His name was Mike Rosa. He had an odd fearlessness about him, different from everyone else's. It had nothing to do with size or his status on the rigs. He simply had no fear of those men, and that, combined with his unwonted friendliness, triggered my curiosity.

Mike became a regular. You could find him in Stockman's at all hours, cheerful as a jaybird and ready to chat. He never seemed to work, never got into fights. And, I noticed, he drank even less than I did. In fact, he did nothing according to Stockman's bylaws. But something about him caused the other men to leave him alone.

It took me a few days to accustom myself to Mike's hearty goodfellowship, but he finally drew me in. After a one-month dose of clini-

cally mute companions, it was hard to resist someone who actually asked my name and remembered it. What incredible naïveté on my part. For the sake of a few moments of human congress I violated the first rule of Stockman's: Never let your guard down.

I started hanging out with Mike. We'd eat at the diner and talk. I always had the same budget meal—a hamburger and a glass of water. Mike thought that was funny. He thought my lumberyard housing facility was funny. He thought just about everything was funny, and he had a great sense of humor. He'd been in Vietnam, he told me, but I didn't believe it. He was too ready with the claim, and too vague about his service there. But I wasn't about to try to pin him down.

He asked questions about my life and paid attention to what I had to say. Pretty soon he asked if I knew where to score some marijuana or speed. I didn't, but just to be asked seemed like an article of trust. Here, it appeared, was my backup.

On my days off I went to the local YMCA to exercise and clean up. Mike invited himself along. In the meantime I'd made friends with some of the Sioux railroad men, which led to a new residence for me. They told me about an unheated—and unused—car in the railroad yard, luxuriously appointed with wooden bunks. They started leaving it unlocked for me on condition that I not fire up the wood stove or otherwise advertise my presence.

So things were looking up. I was making $5.05 an hour, with an extra $3 for overtime. Since I had been in Gillette, I had sent nearly $800 back to my account in Boulder—not yet enough to pay for the damage to my mother's car. Mike asked if I meant to stay on in the oil fields. Stick with it, he said, and in a year's time I might be making some real money on the big rigs. There was a certain rude temptation to the prospect. I was learning the value of a dollar here. And, at age twenty-one, I had no other paying profession. I didn't like the lonely, violent lives these men led—but then, neither did they. That's what their country songs were all about: brute work, punishable sins, and broken hearts.

The cops raided Stockman's one night. Mike burst in with them; he was a narc, an undercover narcotics agent. It wasn't necessary for

him even to point a finger at users at the bar; he had already identified them at the stationhouse. A number of the regulars were handcuffed and led away. Mike then cast an easy smile at the room and walked out.

I was flabbergasted. In a world where trust was forbidden, I'd trusted Mike. Over the next few weeks his betrayal hounded me, and I began to question my judgment of people.

That wasn't the worst of it. After the raid the remaining regulars began questioning me with more than the usual threat in their demeanor. *What had I been doing with Mike all that time? Was I a narc, too?* I'd become a pariah overnight, unable like so many philosophers before me to prove a negative—especially not to the symposium at Stockman's.

I never saw Mike again. He couldn't have stayed in Gillette, of course, or someone would have killed him. Eventually someone did kill him. The next year Mike was shot between the eyes in the back of a squad car in Rock Springs, another Wyoming boomtown. He'd been subpoenaed to appear before a grand jury investigating allegations of corruption and vice.

I'd had my fill of Gillette. Spring was coming on. I'd worked hard to stay in shape for rock climbing, knowing all the while that rock climbing wasn't a future but, then, neither was Gillette. I hitched a ride out of Gillette and headed back home to Colorado in the back of a pickup truck.

CAMERA OBSCURA

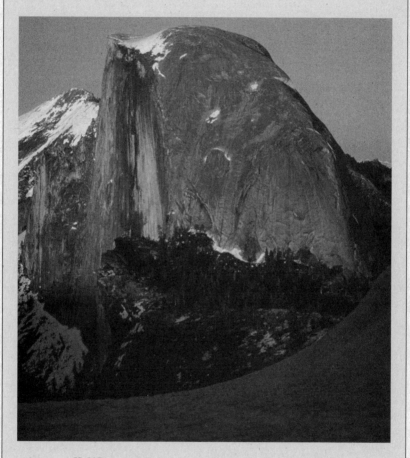

Half Dome, with the vertical Northwest Face on the left.

CHAPTER FOUR

My first job in filmmaking had little to do with film and everything to do with retreating from the oil fields and getting back to climbing. I went from worm to gofer, happily hauling camera equipment and provisions up to the east shoulder of Half Dome, an enormous hump of granite which dominates the landscape in Yosemite National Park along with its rival, El Capitan.

I'd been hired by Bob Godfrey, an English climber and writer. He lived in Boulder and was intent on filming a documentary about climbing Half Dome, to be called *Free Climb*. The pay was extravagant, $50 a day, and I quickly became the gamest gofer his film crew had ever encountered. I was fascinated by film and its possibilities in the mountains. That was almost a contradiction in those days, given my climbing training. The climbers in Eldorado considered cameras expensive, delicate, and burdensome—a nuisance. But we were pleased when photographers came around to take pictures. I'd first met Bob when he was working on his book about Colorado climbing titled *Climb!*, but none of us ever considered doing our own shooting. Twenty years ago, cameras were just extra weight on our climbs.

Yet already there were those making a craft, and eventually an art, of documenting on film climbing's vertical world. I think it was partly out of respect for their expertise and their commitment to a vision that we admired some of those early climber–filmmakers: Pat Ament, Tom Frost, Greg Lowe, and, later, Bob Godfrey.

I noticed Pat first. His climbing guidebook, *High Over Boulder*, had been part of my life and lore since I was fifteen. By the time we met, Pat was past his prime as a rock climber, but a considerable presence nonetheless. He was something of a Rocky Mountain Renaissance man, a climber and writer, a musician who played piano, sang, and produced records, a gymnast, a speed chess champion, and a martial artist. He had the look of a modern prodigal son: a bit of Bob Dylan, a hint of William Blake. Every now and then Pat would show up with a 16mm spring-wound Bolex to shoot us in action on a climb.

Pat rarely used a tripod or sound recording equipment, and his editing had the choppy vérité feel of a filmmaker on a tight budget in a rented studio. But if the resulting work wasn't very polished, it was thoroughly beguiling. When we gathered for showings in the University

of Colorado chemistry building, we found his movies gave us a strong sense of our own short history as well as our identities as climbers.

I was particularly struck by the power of imagery. That single picture of Norgay on Everest had borne me into the clouds. Pat's movies, however rudimentary, told me that ours was an experience of breadth and beauty which almost demanded to be captured and preserved on film.

Before gofering, my first experience with a camera was in front of the lens. One day Pat decided he needed some local talent to flesh out one of his movies and asked if he could film me on a climb. He said he'd recruited a friend of his, Tom Frost, to help with the filming. I'd never met Tom, who was a good deal older than I was, but I certainly knew about him. During the 1950s and 1960s he'd been one of the great pioneers of Yosemite climbing and was a skillful still photographer.

Thoroughly flattered, I drove up Boulder Canyon that morning to prepare for my film debut. I met Pat and Tom at the base of a crag named Castle Rock. Tom was thin with short-cropped hair graying at the temples. His manner was calm and thoughtful, much what I'd expect from a climber of his stature. As I grew to know him, I realized that he refused to worry about anything; he was simply imperturbable. He'd turned back, climbing in high winds just below the summit of Annapurna in the Himalayas. Although he knew he could have reached the summit, he hadn't been sure he could get back down.

Pat wasn't recording sound; the film would be pure image, he explained to me. Pat handed his camera to Tom, and, on Pat's signal, I proceeded to climb a test piece called Country Club Crack, rated a stiff 5.11. I admit to feeling a little confident; just to show my skill, I wore beat-up old sneakers instead of climbing shoes. I climbed the crack without much trouble. Afterward we all shook hands and congratulated one another on a fine piece of filmmaking. My fledgling actor's payment was a hamburger at a student hangout on The Hill.

And then I earned my keep with Godfrey. Like Ament, Bob Godfrey was talented, highly motivated, and preternaturally persistent. Transforming his garage into a studio, he began work on his film *Free Climb*, which would change the way climbers saw themselves and the way the world saw climbers.

Bob approached *Free Climb* on a scale grander than any of us had seen before. He recruited a film crew, created a story, and chose two stars who were both photogenic and articulate: my friends Art Higbee and Jim Erickson. He gave supporting roles to their girlfriends, Carolyn and Nancy. Their goal, the heart of the film's story, was to free climb a Grade VI wall—in this case, the Northwest Face of Yosemite's Half Dome.

In the American climbing system, climbs are rated not only by the degree of difficulty (e.g., 5.9) but also by length and commitment; that is, how much time a given climb should take and how serious an undertaking it is. A Grade III climb, for example, has multiple pitches (or rope lengths), but it can be accomplished in a day. Grade V climbs generally take two days and require a single night's bivouac en route—which may mean sleeping on a ledge no wider than your body, clipped into protection placed in the wall at your back. If there's no such ledge to be found, the climber may wind up sleeping in a hammocklike contraption, clipped into protection and hanging suspended thousands of feet off the ground. Grade VI climbs are big wall climbs, usually longer than 2,000 feet, which may take three or more days. In the U.S., excepting Alaska, only Yosemite contains walls big enough to merit a Grade VI, Half Dome included. No one at that point had ever free climbed a Grade VI wall.

We drove through the night to Yosemite, stopping only to gas up and lose some money in Nevada casinos. Past the tunnel into the park we pulled over to take the classic tourist shot of the valley. El Capitan and Half Dome stood like two giant bookends at opposite ends of the valley. El Cap is the largest granite cliff in the lower forty-eight and, because it faces south, its walls are washed in hard bright light. Half Dome faces northwest and is shaded for much of the day in varying hues of gray and blue.

While Bob and his cameramen lined up the shots they wanted, Jim Erickson, who'd climbed in Yosemite before, explained to me the significance to climbers of the different colors of light on the walls. El Cap's walls can work like a solar reflector, he said. By early summer the temperature can exceed 100 degrees, meaning it's nearly impossible to climb. Half Dome's Northwest Face remains cool in the shadows, he

added, making it much easier to work with in the warmer months. During the colder seasons climbers rarely bothered to go up there at all, so we had the wall to ourselves in the late spring.

In those days the Yosemite Valley climbers dominated their turf like a warrior mountain clan. Rivalries were fierce. It didn't matter how good you'd been elsewhere, you had to prove your abilities there in the valley to be accepted. Once again, Perilous Journey meant nothing. The Yosemite climbers felt a distinct sense of superiority over other American climbers, partly because they cultivated their own legend so brashly and partly because of the jaw-dropping terrain they occupied. Big walls were the great frontier back then, and the inhabitants of the valley considered themselves ordained gatekeepers.

We descended on Yosemite like a tactical invasion force. Our entire crew was a Colorado import. In Godfrey's hierarchy he was at the top and I, cheerfully, held the bottom. He had two cameramen, a sound recordist, riggers, and load carriers. To my surprise Godfrey had chosen to employ practically no local California talent. In essence, we were showing up with the bald intent of stealing Half Dome from the Yosemite climbers by becoming the first to free climb its walls. The welcome mat was cold in the valley that spring.

Deep in the trees behind a Chevron station near the end of the valley stood a tourist campground run by the National Park Service. Dubbed Camp Four, it served as headquarters for the hard-core local climbers. It had the look of Robin Hood's Sherwood Forest retreat. Bags of food hung from tree boughs high above the reach of bears, and the array of makeshift shelters indicated that many climbers lived in the campsites year round. Despite its humble appearance, Camp Four was a serious training ground. Large granite boulders were smeared with chalk. Climbers had erected pull-up bars and overhanging rope ladders on the rocks and trees. Rusting free weights lay about, and chains were stretched between trees on which barefoot climbers improved their balance like tightrope walkers training for the circus.

The park rangers left the climbers to police Camp Four themselves. They might well have reconsidered that cavalier position. One year some of the vagabond climbers were living quite handsomely off the remains of an airplane, a Lockheed Lodestar, that crashed into a

frozen lake high above the valley floor. It seems the plane was crammed full of marijuana, and Camp Four's fortune hunters had enjoyed a highly profitable midwinter salvage operation. I'd been envious, seeing a few Yosemite climbers with the spoils of their efforts: a new Volkswagen van and a thousand-dollar Italian racing motorcycle. (Their misadventures later served as the basis for a novel, *Angels of Light*, and the subsequent movie, *Cliffhanger*.)

At the parking lot we set off up the trail carrying a half ton of food and gear. Five miles in, we reached our campsite high on Half Dome's eastern shoulder. We pitched our tents in the trees near a small clearing. From this camp, we could descend on foot in twenty minutes to the base of the wall, which begins 2,500 feet above the valley floor. Or we could simply scramble up the "tourist route" to the sprawling, rounded summit and rappel down to the route below.

This was my first visit to Half Dome. It was majestic from a distance; up close, as I placed my hands on its gray stone, the face was breathtaking. The huge northern shield of granite looks like it was laid open with a single clean slice, though in fact it had taken tens of thousands of years of weathering and glacier scouring to create its superb natural architecture.

We began to shoot the next day. While Erickson and Higbee prepared their climbing gear, Godfrey's camera team began assembling equipment. They had opted to climb the Northwest Face route, known as the standard route because of the frequent attempts it attracted. Famous mountains often have such trade routes.

Half Dome's Northwest Face route followed a series of cracks that meandered up the left side of the face into steeper terrain. After a short pendulum in the center, the route turned dead vertical; near the top it ran into an overhang called the Visor. Here, climbers traditionally worked their way up several finger- and hand-sized cracks known as the Zigzags by using aid-climbing techniques, standing in nylon stirrups attached to pitons or nuts placed in the crack.

But Higbee and Erickson would be free climbing. They would safeguard falls with a rope and occasional nut and piton placements. Otherwise, they would have to depend on their fingers, toes, and ability to gain vertical ground. They could not pull on the rope or rest on

the protection. This was free climbing and no major wall in America had ever been climbed in this style.

There is a long history of notable impurists in our field. In 1970 an Italian alpinist named Cesare Maestri had climbed a difficult Patagonian tower called Cerro Torre by boring hundreds of holes far into the rock with a compressor drill powered by a gasoline generator. In 1970 a climber named Warren Harding had spent almost a month on El Cap's Wall of Early Morning Light, drilling hundreds of holes into which small hooks and bolts were set. I've never opposed the use of bolts for environmental reasons, but when the bolts become means of ascent they remove the element of uncertainty from climbing. I've always been motivated by uncertainty. Ever since my days of finding my way home through the maze of Greek streets, I've counted on the unknown as my greatest teacher.

Reinhold Messner, the first alpinist to climb Everest solo and without supplemental oxygen, called the modern dependence on bolts and technology the "murder of the impossible." Erickson, Higbee, and I shared his philosophy.

I wanted nothing more out of this mission than to watch Erickson and Higbee at work. But I quickly realized I couldn't do that if I was constantly humping loads of equipment up the trail between the valley floor and our shoulder camp. Somehow I needed to attach myself to the camera crew so that I'd be on the ropes just a few feet away.

Godfrey had hired two of the best climber–cinematographers around, Tom Frost and Greg Lowe. Luckily, I knew both of them from Colorado. Greg was an extraordinary combination of athlete, inventor, and businessman. Like Tom, Greg was quiet, thoughtful, and cautious. Several years earlier he had invented the first internal frame pack, which later became the industry standard and a prototype for the military packs used by troops today. At the time, he was president of Lowe Alpine Systems, a mountain gear manufacturer. On the side he was a photographer and cinematographer.

The camera team was assigned to work at three different levels—below, beside, or above the two climbers. The film crew stayed abreast of Erickson and Higbee by ascending ropes earlier fixed alongside the climbing route. In the morning the camera team would head out ju-

maring the line of ropes. With stirrups attached to the Jumars, hand-sized mechanical ascenders which slide up the rope but not down it, the fixed rope could be quickly and safely climbed.

In a matter of days the shooting moved hundreds of feet off the ground. The higher we went, the more time jumaring consumed. At the top of the fixed ropes, the camera team would often hang for hours, waiting for the right light or action.

I always made sure I was there when Tom or Greg needed help. I'd carry loads of camera equipment up to them, or bring up gallons of water in the taped, recycled Clorox bleach bottles climbers use to hold water. Finally they began to teach me the important trade of assistant cameraman.

Like the worm on the oil rig, an assistant cameraman performs the most basic jobs on a crew. He sets up the tripod, places the camera on it, and changes the lenses. But the first technical task Tom taught me was how to change film. Once a roll of film has been shot or exposed, it has to be removed from the magazine and replaced with a fresh roll. Experienced assistants do that in a lightproof device called a black bag, but Tom started me out with a dummy roll of film stock, practicing in the light, so that I could see what I was doing. He showed me how to thread in a new roll, set the length of the loop, and make sure the magazine was tightly closed when I was finished. After a single demonstration he tossed the can of film to me. "Now you do it," he said.

As assistant cameraman, I was expected to jumar up the fixed ropes behind the cameraman and stay close while I supplied him with full magazines, or handed him different lenses, or helped adjust the ropes. Basically I was learning the care and feeding of cameras, and was deeply impressed by the respect Tom and Greg showed for their equipment and for the medium. It was akin to the meticulous care I'd learned in my climbing training. In addition to double-checking my knots and personal climbing gear, I was now double- and triple-checking my work with the camera and its accessories.

Even when they weren't directly instructing me, I considered every move they made. For instance, climbers have an exaggerated way of handing things to each other when they're high off the ground, a sort

of "Got it?" pause before letting go of the object. In climbing cinematography, the pause is even more pronounced. When you're shooting in vertical conditions, with an entire team taking hours to jumar up and down ropes to get certain shots, expense and risk increase considerably. The simplest slipup could result in dropping a magazine of exposed film 1,500 feet, ruining an entire day's work for the whole team.

I wore a pack on my chest and jumared next to Tom or Greg, reloading the magazine right there on the ropes. While the two climbers did their dance in the cracks of Half Dome's big wall, I performed my own apprentice's routine, tiptoeing against the rock and manipulating the film and the magazines in the black bag. Tom and Greg meanwhile twisted themselves into awkward and acrobatic positions to get the optimum perspective or camera angle. This was filmmaking, and the image was as important as the climb.

The more I watched Tom and Greg work, the more interested I became in the mysteries of the camera. I'd always been fascinated by a well-crafted object or machine, and cameras have to be one of the most exquisite creations of man. Every possible resource goes into the alloys and construction and design, whether it's an Arriflex or a Bolex or a Nikon. A good film camera can cost tens of thousands of dollars; a single zoom lens may cost as much as a small car.

I began not only to see the camera as an instrument, but also to view working it as a discipline. There's a science to its use, but also an art. As with climbing, camera work has an internal logic and demands responsibility. Above all else it is a persuasive form of artistic expression, and it became apparent to me that each cameraman brings a unique personal vision to the craft.

I wanted badly to look through the viewfinder but I was too low on the totem pole to ask. At last, several days into the climb, Tom invited me to do so. I set my eye to the viewfinder, and instantly the landscape around me was transformed. My reaction verged on revelation. I saw in that moment that a cameraman could redefine the world, investing a scene with both the reality of the landscape and whatever visual definitions his imagination could bring to it. A certain angle, a particular shade or hue of light, and the landscape would speak differently to the viewer. Seeing and comprehending all this as I peered into

the viewfinder, I knew that I could explore both the visible world and my imagination with a camera. As I straightened up and surveyed the horizon once again, I suddenly saw my mountain experience taking on a profoundly new dimension.

As Erickson and Higbee worked their way up to midpoint, Godfrey gave the order for the camera team to retreat from the wall. We retrieved all our fixed ropes and hauled our gear back to shoulder camp, where we had a perfect shot across the wall to the climbers. We could stand on flat ground and use telephoto lenses to capture the action. Once the climbers reached within 300 feet of the summit, we switched strategies again. Now we lowered ropes from the summit and began rappelling down to the climbers. We'd hang there in our harnesses a mile from the valley floor. Hundreds of feet below us Erickson and Higbee looked marooned, armed only with their threads of rope against the massive wall.

Watching them, I realized that I'd lost some of my fascination with the climb itself. It was a little dizzying, my leap from one reality to another. I'd become more compelled by the craft of the filmmaker than by the climber–actors and their feats. We all knew the general outline of the story, but there were no scripts or storyboards (the cartoon sketches that portray a scene). It fell to Tom and Greg to create small vignettes to carry the tale forward. I loved hearing their impromptu banter. *I need the wide shot to show this climber and the belayer a hundred feet below him. Now I need a tight shot of the lead climber's face to show what he's thinking and feeling. Now I need to go back wide to show how far down it is to that little river below. Now I need inserts of fingers jammed into a crack to support the climber's weight and then reveal the strain in his face.*

Eventually Erickson and Higbee reached a ledge called Big Sandy just a few hundred feet below the summit. It was one of those curious places that seem to pop out of nowhere in the mountains, a straight ledge just wide enough for a man to lie down parallel to the wall. It was forty feet long and covered with fine gravel. Erickson and Higbee told us it was the nearest thing Yosemite offered to a king-sized mattress.

Just above Big Sandy hung the Zigzags, the set of cracks capped by the huge overhang called the Visor. Here climbers had always re-

sorted to using aid-climbing techniques and stirrups to climb those cracks. Erickson and Higbee dispensed with the stirrups and struggled, free climbing upward, through the Zigzags. We hung on beside them, filming as Higbee jammed his fingers and the toes of his shoes into the thin cracks, repeatedly falling at the crux. Erickson tried and fell several times, too, with the finish so close he and Higbee were willing to amend the "you fall, you fail" ethic. Higbee had always said that you start with an absolute and modify it along the way. At last he pulled onto a slab of granite above. They had free climbed nearly 2,000 feet; now the summit lay just a rope-length above. The climb—and Godfrey's film—looked like a wrap. Then the climbers ran smack into a dead end.

Over and over again Erickson and Higbee took turns trying to figure out the sequence of delicate moves needed to overcome the blank slab. They could have resorted to stirrups and aid, but that would have violated the whole spirit of the enterprise. So the free climb of Half Dome ran out of steam. No teeth-gnashing, no histrionics, no regrets about the days of toil which had brought them within a few moves of free climbing Half Dome. When the two of them agreed that neither could make any progress on the rock's smooth surface, they surrendered the climb for that day. We threw them a rope, and picked up and went home.

A year later I returned to Yosemite to climb another route on Half Dome. My partner was a valley climber named Ron Kauk. He had climbed a dozen big walls and, along with John Bachar, was one of the finest free climbers of his generation. This was to be my first big wall climb and I wanted to learn all I could about how valley boys did things. Ron was the ideal companion. I had no qualms about using stirrups and aid. For one thing, our route was more technically demanding. For another, I wanted to acquire every climbing skill possible, including big wall aid-climbing techniques.

We spent several days making our way up that looming, blue-lit face. To our left, I could see the Northwest Face route Erickson and Higbee had climbed; to our right, vast black and white striations banded the granite like zebra stripes. At the top of each pitch we switched leads; first Ron, then me, and so on. There were twenty-five

pitches on our route. We moved up methodically, bearing the burden of our haul bag.

On big walls you take a haul bag—variously referred to as the Pig, Whale, or worse—filled with such essentials as water (at nine pounds per gallon), food, parkas, hammocks, and sleeping bags. Hauling the Whale, Ron and I reached Big Sandy ledge—only to find Erickson and Higbee there. Once again they were doing battle with that blank slab above the Zigzags, but this time without Godfrey's film team to distract them. And, once again, they were on the verge of defeat.

They greeted our arrival with an offer. If either Ron or I could successfully piece together the final moves on that insidious slab they'd buy us a case of beer. It was an intriguing offer, not so much for the beer as for the opportunity: They were offering to share their quest. But our feet were swollen from standing in stirrups for so many days, and anyway, neither Ron nor I was psychologically prepared for such a demanding free climb. We declined and finished the route on aid, leaving Erickson and Higbee to face the recalcitrant slab they never did subdue.

It took two years of Godfrey's editing before we could see the fruits of our work. Bob turned the disappointing ending into a dramatic statement of principle. *Free Climb* went on to win critical praise and awards at mountain film festivals. In a single flourish, the film significantly elevated the standard of climbing cinematography.

The next spring, after filming Free Climb, I took a job with another film crew which once again included Greg Lowe. It was 1978. The subject was an extreme skier's attempt to make the first ski descent of the Grand Teton above Jackson Hole, Wyoming. The producer was a climber and cinematographer named Bob Carmichael, an ex-football player from the University of Colorado with massive shoulders, surgically reconstructed knees, and a gridiron enthusiasm. Greg Lowe was also producer and cinematographer. The story focused on a mountaineer and a skier named Steve Shea, a fireplug of a man with a thick beard and blue eyes. He'd been a racer on the University of Denver ski team, and now owned a ski shop in Aspen. Steve wanted to be the first

to ski the steep snow slopes and gullies of the Grand Teton from top to bottom. To ski its rough-hewn terrain was an impressive goal.

The four of us—Carmichael, Lowe, Shea, and myself as gofer and assistant cameraman—comprised the entire team. Personalities aside, work on the shoot bore an eerie resemblance to the dynamic of the workover rigs. We had to go in lean, mean, and efficient. First we had to make base camp in the Jim Smith Hut. Perched on the Lower Saddle at 11,000 feet, the Jim Smith was an old army surplus Quonset hut which could sleep fifteen and had been used for years as a way station by mountain guides.

It was late May but the winter had been long, with very heavy snows. Our legs made postholes thigh-high in the deep snows of the forest. Higher on the approach we had to kick steps into hard crust. The hut was a mess and full of drifted snow. It looked as if no one had occupied it since the previous fall. And this was going to be home for the next five weeks.

Periodically more snow fell, and the wind blew cold and hard over Fourth of July weekend. The local guides hadn't felt it was safe to guide the Grand Teton yet, so we had the mountain to ourselves.

We went out every day despite the miserable weather. Our locations were steep slopes and deep gullies for Steve's skis. Greg and Bob went over the game plan: why they needed what scene, how they were going to shoot it, and what part it ought to play in the film. Greg especially took me under his wing and talked for hours about film, light, composition, filters, and different camera moves.

When I wasn't working with the film crew I was humping loads to the shooting sites or going to town for more supplies. I'd arise in darkness and descend 5,000 vertical feet through snowfields, then drive fifteen miles into Jackson. There I'd fill my pack with sixty or seventy pounds of food and carry it back up the 5,000 feet to Lower Saddle. Sometimes I couldn't carry all of the supplies at once and had to go back down the mountain again to the trail head to carry up another load.

The trail time was illuminating. I was gaining my own sense of snow in all different kinds of conditions—how to move in it, how to travel great distances in the mountains. It was great physical training,

and the experience added icy volumes to my knowledge of living and traveling on foot in the mountains.

Not until we neared the end of the shoot did the film finally receive its title *Fall Line*. Because of the Grand's jutting architecture, Steve Shea was largely confined to skiing in steep, narrow snow gullies whose walls were bare rock. Steve had to follow the fall line—that imaginary line of direct descent—without falling. A fall in this case meant almost certain death. Wearing a helmet didn't jibe with the image of an extreme skier.

We'd been living in the hut for five weeks, filming nearly every day. Most of the film was in the can. On this day Greg was across the valley getting a telephoto shot straight into a gully Steve would descend. The sky was clear and I was hidden from the camera behind a rock. From that vantage point, I watched as Steve began his powerful jump turns at each side of the trough. He'd execute a bounding hop and turn his skis to face the opposite direction and take on the next turn.

Suddenly Steve blew a turn and fell headfirst downhill, disappearing some 500 feet lower in the gully. He was wearing a slick shell of nylon outerwear; once his skis popped off and he started sliding, there was no way he could stop. He hit an outcrop of rock on one side and ricocheted like a pinball to another outcrop. Alternately bouncing and sliding, he struck more rocks, picking up speed down the mountain. Tumbling like a rag doll, he finally slid to a halt. He lay there motionless as I glissaded down the mountainside after him.

Expecting to find a battered corpse, instead I found Steve starting to move. Miraculously he had survived, banged up and bruised but without a broken bone in his body. His eyes were the immediate problem, though. The flying snow had packed icy clots underneath his eyelids. His eyeballs were lacerated; he was momentarily blind and in severe pain. I gently pushed the snow from under his eyelids, then led him back to camp. Bob gave me a wad of bills and told me to take Steve down to Jackson, get him whatever medical care he needed, get him fed and drunk if he wanted—then, if humanly possible, get him to return and finish shooting.

Steve returned, all right, eyesight intact. In the end *Fall Line* was televised on ABC Sports' *American Sportsman* and nominated for an Academy Award in the live-action short subject category. I received a check for six weeks of work at $50 a day.

Fall Line moved me further up the road toward those giant mountains. It was like watching the story line of my own life develop. I knew rock climbing; I knew how to survive in the mountains; I'd begun to learn ice climbing as well as climbing on mixed rock and ice terrain. I'd been laying the foundation for a trip to the Himalayas. All I needed now was a chance to go.

Back in Colorado, I heard from Tom Frost and Greg Lowe that they were going on an expedition to Nepal. ABC's *American Sportsman* was producing a film about climbing on Ama Dablam, a formidable mountain not far from Everest. I implored Tom and Greg to take me but they said it was out of their hands. Still they gave me the phone numbers to call.

With nothing to lose I called the director of the Ama Dablam film. His name was Roger Brown, and he lived in Aspen. I made my pitch very simple: *Take me—please.* He asked after my credentials, and my answers sounded suspect even to me. To him, I was a nobody, strictly a gofer from Goferville. Brown passed.

Desperate, I offered to work for free. When that didn't sell him, I volunteered to buy my own airline ticket. I gave no thought to the hard truth that the trip would cost more than a thousand dollars, or all the money I had in the world. Roger said he'd call John Wilcox, the *American Sportsman* executive producer in New York City in charge of the project, and see what he thought.

"There isn't much to think about," I told Brown before we rang off. "If things don't work out, you won't even have to fire me. I'll just become a tourist."

I telephoned Brown the next day.

"Okay," he said. "We leave in two weeks."

HIMALAYAS

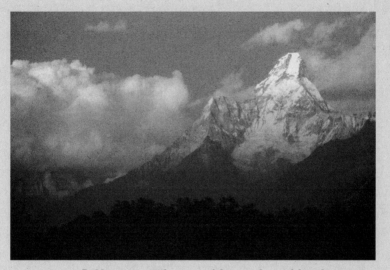

*Ama Dablam, 22,494 feet, one of the most beautiful peaks
in the Nepal Himalayas.*

One thing you never forget about Asia is its scent. It was early morning when I walked down the steps from the plane to the tarmac at the Kathmandu airport, and the smell of the place rose up to greet me, pungent and enveloping. The odors charged my imagination, and it seemed that with each deep breath I was drawing in the essence of a distant century. These alien, unnamed smells were like nothing I'd ever experienced, but they didn't alienate me. In a curious way, I felt they welcomed me.

I stood for a moment on the tarmac before heading into the terminal. The morning air was rich, almost tangible, simultaneously sweet and acrid. During the coming weeks of our expedition, I would soon discover the sources of the odors penetrating my senses: cooking oil simmering over kerosene stoves and wood fires, the perfume of rhododendrons in the countryside, the burning of choked irrigation ditches by area farmers. Together these odors gave a lushness to the air, telling of an ancient and fertile land.

Before landing, there had been quite a stir on the plane as we approached Kathmandu. It was the last leg of a long journey, and I was dozing in my seat when the commotion woke me. Half the passengers were up and out of their seats, crowding against the windows on the north side of the plane, pointing and exclaiming. "There it is! No, not that one, *that* one."

I craned my neck to see and, of course, they were all looking for Everest. My first view was a mix of recognition and disappointment. Expecting the majestic skyline I'd been memorizing from books since childhood, the distant bumps were barely distinct from the clouds. I'd been prepared by glossy photographs of towering giants and the reality looked a little different from high in our plane. The signature shapes in the distance were all correct, however. I oriented myself with ease, working left to right along the Himalayan horizon from Dhaulagiri to Annapurna to Himalchuli. Everest was lost over the horizon.

Still, it wasn't Everest I was looking for on this trip, but Ama Dablam. I knew that from this angle, if you found Everest, you'd find Ama Dablam. It nestled just below and directly in front of the highest mountain on earth. A modest 22,494 feet, Ama Dablam would be my testing ground, my first Himalayan peak.

My disappointment vanished as we descended through the clouds. Kathmandu airport was not much more than a single long landing strip, no larger than a typical county airport in the U.S. There were a couple of big hangars but they were for Nepalese military planes and helicopters. In the small terminal building, I experienced another first: a taste of a culture that relied on human labor rather than machines. Huge carts full of luggage and climbing gear were hauled in by hand and dropped onto a steel luggage shelf that gleamed in the dim light, polished by unnumbered bags. We scrambled to find ours, collecting and stacking them on handcarts. Then we plunged outside the building, where porters clustered around, jostling to get a load.

A beat-up old Indian bus came crabbing down the road toward us, tilting to one side, belching black smoke. While the porters thrust our bags into the bus through the windows and onto the roof, I squeezed on with the rest of our team. I took a seat near the driver to see out the big front windows.

The ride to our hotel was my first Asian adventure. Ours was just one of hundreds of careening buses, trucks, and cars filling the streets of Kathmandu, at that time still a city belonging more to the past than to 1979. It had a modern ring road built by Chinese engineers which made a sweeping circle through farmland and around the city, then quickly gave way to narrowing lanes. Roads and alleys bristled with traffic. The random style of driving—drifting in and out of lanes of traffic—is done in a calm manner that makes Westerners crazy. Though it seemed like chaos, there was a prudence to their method. There was, after all, a lot to maneuver around: pushcarts powered by old men, wandering cows, people on bicycles, animals pulling carts piled high with fresh-cut grass. To travel, one has to dart into oncoming traffic with one great leap of faith that the oncoming traffic will get out of the way, and it generally does.

One interesting thing about the Hindus and Buddhists who live in Kathmandu is that they never seem to inject their egos into their driving the way Americans do. The beep of horns is incessant, but you're not likely to see Nepalese drivers jumping out of their cars yelling at their roadway rivals. Their rules may be complex, confounding, and unenforceable, but at least everyone seems to know and obey

them. The person who has to get out of the way this time is likely to carve the right-of-way the next. It is a very Eastern quid pro quo.

The bus arrived at the Star Hotel in Thamel, a quaint, ancient neighborhood not far from the center of Kathmandu. One or two trekking shops did business then with a limited supply of used climbing gear and clothing to offer. There were only a few places in Thamel to have a Western-style meal; one was K.C.'s, started by a New Zealand woman and a Nepalese entrepreneur. This was the gathering place of the real Third World ramblers, the haunt of serious travelers on a budget. You could find expedition climbers, trekkers, tourists, and those inevitable leftover hippies with beards white as hoarfrost. Timberland boots, Lowe packs, and Patagonia jackets hadn't arrived yet, but the folks weren't hard to sort out by clothing.

World travelers had generally come overland, across Asia, following the drug trail to this cul-de-sac at the foot of the Himalayas, and therefore looked like the archetypal 1960s dharma bums and drug addicts, with earrings, necklaces, shoulder-length hair, and sandals on their feet. Climbers weren't fancy dressers, but usually wore a clean T-shirt and neat hiking shorts rather than baggy tie-dyed punjabi trousers or slim vests with no shirts. It was easy to see who was there for the hash and who was there for the Himalayas.

During our week-long stay at the Star Hotel, we met every morning in the hotel parking lot to gather our gear and go into the streets to film. I went along to load magazines or carry equipment for the crew. One of them, Jonathan Wright of Aspen, who'd joined us in New York, was a still photographer who'd been to Asia, and Kathmandu, many times. I admired and envied him, partly because he was going to be filming, but also because of his expertise about Buddhism in India and Nepal. He was quite generous, talking to me endlessly about what was important in this place, what life was like for these people who lived at the foot of the greatest mountains on earth.

"The key is, everything here happens either very early, or in the late afternoon when the light changes," Jonathan explained. He made sure we got up before sunrise and were at Swayambhunath, the monkey temple, to film the worshipers, ambulators, and prostrators at dawn, when the light was most beautiful. He also made us get out into

the markets, into Asan Tol, in the early morning when vendors were hawking vegetables.

I'd head out on my own from time to time, pedaling a rented one-speed Indian bicycle around Kathmandu. The city was an enchanting hybrid of medieval Asia and the twentieth century. Electric lines threaded among three-tiered Hindu temples. Honda motorcycles yielded to ambling sacred cows. Ancient shrines peeked out of dusty brick walls or rose from crowded squares. Since 1949 when its borders were first opened, Nepal has offered its spiritualism to pilgrims, its roller-coaster trails to trekkers, its peaks to climbers, and its hospitality to every tourist. Nepal has long appealed to the Western imagination as a landlocked island of tranquillity ruled by a wise king and his beautiful queen. In fact, with an annual per capita income of around $200, Nepal is one of the poorest nations on earth.

I threaded through the ancient labyrinth of crooked alleyways, exploring serpentine, intersecting byways that twisted and turned back on themselves again and again. I was completely at home. Kathmandu felt like paradise, a place that held an improbable kind of magic to which I longed to find the key. I was enthralled by it, the sights, sounds, and smells. The streets provided constant, jarring theater, one moment seducing you with the beauty of the trade jewelry and silken scarves for sale in the Asan Tol, the next shocking you with deformed beggars and ragged children.

Tom Frost introduced me to an old friend of his, a Sherpa guide named Ang Temba. Tom had been with him on Annapurna in 1969, and Ang Temba was going to be the sirdar (Sherpa leader) of our expedition. I took to the Sherpas right away, as Westerners often will, because of their humility and lack of affectation. I was also lucky to be with intelligent and sympathetic people, particularly British climber Martin Boysen and Jonathan Wright, who'd been around Sherpas and appreciated their culture. They told me bits and pieces of Sherpa history, how they had migrated over the Himalayas from Tibet nearly 450 years ago and settled in the Khumbu region of northern Nepal, which includes Everest. Sherpas had brought with them their yaks, pack animals which also produce milk, butter, and hides; and an ardent faith in

the Nyingma sect of Tibetan Buddhism; and their centuries-old knowledge of the Himalayas.

After a week of shooting around Kathmandu we took off for Lukla, a village at the foot of the Himalayas in the Khumbu. The airstrip at Lukla was built in 1964, graded out of a sloping mountain field by anthropologist Jim Fisher and Edmund Hillary in order to transport building materials and supplies for the construction of a hospital and school in nearby Khunde and Khumjung in 1966. Today, Lukla and its airstrip serve as the gateway to Sagarmatha National Park, whose boundaries include many of the world's greatest mountains—including Everest, or Sagarmatha to the Nepalese. Only about a dozen trekkers walked into the Khumbu through Lukla in 1964. By the late 1990s, 15,000 or more trekkers and climbers were passing through the village every year.

Flying the 100 miles from Kathmandu to Lukla was my first experience with a Twin Otter. The inside of the fuselage on this plane consisted of one row of flimsy nylon seats on each side. We flew east out of Kathmandu, flying at about 14,000 feet, paralleling the Himalayan range and tracing the path that Hillary and Tenzing Norgay had followed on foot when they climbed Everest in 1953. On the left side of the plane, towering mountains showcased their dramatic peaks. Far below, one river system after another flowed south out of the Himalayas toward the distant Indian Ocean, soaking hundreds of miles of terraced fields that were just beginning to turn green with the spring.

We turned north at the Dudh Kosi (or Milk River, named for the milky glacial silt it carries from the base of Everest). As the land elevation increased, the fields gave way to forested ridges, and you could almost see where the Indian subcontinent dove beneath the continental plate supporting the Himalayan range. I'd already read just about all there was to read on Everest and this region, and it was strange to behold these behemoth mountains and know that they were still growing. The thrusting of the Indian subcontinent beneath the continental plate constantly pushes the Himalayas upward, if only a millimeter or two per year.

This was the SoluKhumbu, the south end of the valley that ends with Everest. As soon as we turned north, everyone on the plane leaned

into the aisle to catch a glimpse of the big mountain through the pilot's window. I couldn't see Everest from where I sat, but I noticed the villages below had prayer flags flying from tall poles, a sign we'd left the predominately Hindu region of Nepal and were now flying over Buddhist Sherpa villages.

Soon, the pitch of the plane's engines roared higher as the pilot lowered the flaps, adjusted the propellers, and reduced our air speed. The nose of the plane dropped and we began a steep descent into Lukla and its one-way-approach airstrip. Built over old livestock pasture at 9,200 feet, the airstrip lay perpendicular to the village and ran straight up to a sheer 5,000-foot wall that formed the base of a mountain. Through the front window of the plane, the airstrip looked like a slender bandage on a cut in the surrounding grass.

The airstrip was tilted uphill at about 8 degrees, and the pilot would have to come in sharp and practically flare the aircraft upward to land. Unfortunately, looking out my window on the right side of the plane, I was treated to the sight of the wreckage of a plane that hadn't made it through its rough Lukla landing. I visualized the Twin Otter landing, connecting with that thin target in the sea of mountain meadow, just like a jet landing on an aircraft carrier. We hit the target hard. There was a tremendous noise as we slammed into it then bounced in the air and hit again. After the second bounce, we were rolling forward on the dirt airstrip, climbing the hill up to the flat terrace that served as the open-air departure and arrival area. The plane's engines groaned again as the pilot powered it up the slope, spun it around at the crest of the hill so it was in position for the next takeoff, and abruptly cut the engines.

After the roar of the plane and the thrill of the landing, we all sat still, glued to our flimsy seats. It took a couple of minutes before the silence settled on me like a soft blanket: This place was absolutely quiet. For days in Kathmandu, there'd been taxis with revving engines and blaring horns, dogs barking incessantly, the clamor of a city. Before that we were in Delhi, and before that London and New York. Now I was struck by the stillness of this immense place. Sherpas and porters looking for baggage gathered on the wall at the end of the parking area where the plane sat. It was the antithesis of the hectic scene which had

greeted us in Kathmandu. Walking through the cool air toward the Sherpas, I could just hear their murmuring. I turned away from them and gazed at the mountains. I felt as if I were about to meet old friends.

We pitched our tents in potato fields there in Lukla. We were acclimatizing—getting used to the altitude—and waiting for the rest of our gear to arrive from Kathmandu. We weren't filming yet, so it was a break for us. Toward the end of the airstrip, we discovered several very large boulders, covered with lichen, which we would use for intense bouldering sessions. In his day, Martin Boysen had been England's finest rock climber. I was in good shape as was Jeff Lowe. Jeff's brother Greg, no matter what kind of shape he was in, was highly competitive.

Greg was a gifted athlete with a gymnast's build. He was enormously strong though he never seemed to train. I watched him on the largest of the boulders, calmly finding minute holds, very controlled. He was methodical, moving logically from one hold to another, no emotion, no slipups. Greg was practical and efficient in everything: the way he dressed, the way he moved, the way he climbed.

Jeff was another sort altogether. He was lanky and a bit awkward, but compensated in his climbing with passion and tenacity. He was more of an iconoclast than his brother, a free spirit who cloaked his drive with a goofy, self-deprecating wit. But you could always depend on him. Skillful rather than graceful, he was the best ice climber of the 1970s.

After two days of bouldering we shook off the lichens and packed up to leave for our approach march to Ama Dablam. It was easy to get used to the treatment from the Sherpas. They'd travel ahead of us, and by the time we got to the predetermined spot for lunch, they'd have laid a cloth on the ground, and they'd be boiling water for tea and frying up omelets and potatoes for lunch. Not a bad way to live at 10,000 feet.

There's a long and often hot and dry hike up the Namche trail to the Namche Bazar village, which takes you from about 10,000 feet to 12,000 feet. It's a hard, dusty walk switchbacking through a pine forest. About two thirds of the way up, I happened to be walking with Martin when we came around a switchback. There before us was an opening in the trees. As we all stopped to rest, looking up the drainage of the Imja Khola River, Martin pointed at a mountain peak above. "David," he said, "that one up there is Everest."

We weren't looking at the whole towering mass of Everest, because from this angle Nuptse and Lhotse blocked most of the view. But there, twenty miles away, jutting up over the Nuptse-Lhotse ridge was the upper 2,000 feet of Everest, with its springtime plume flying off the top like a misty banner. By God: Everest.

Martin and I walked on together. It was a difficult hike that day up to Namche. Martin had been there four years before, and although Namche was very pastoral and undeveloped then, without electricity even, he knew an agreeable place to take a break, a guest lodge called the Himalayan Footrest. At the top of a narrow, dark stairway we found a tiny dining room where we feasted on yak steak and a couple of glasses each of *chang*, a rice beer.

It's an hour's walk from Namche Bazar to the next village, Khumjung, which was Ang Temba's village. From Khumjung I was at last looking directly across to Ama Dablam, one of the most beautiful peaks on earth. We set up camp in a fallow field across from a school Hillary had built, and then we filmed in the area.

It fascinated me to gaze at Ama Dablam from this close range. The upper part of the mountain looks like a spire or a tower. Its flanks are cloaked with steep granite buttresses and dead vertical walls of ice, thousands of feet high. The upper Southwest Face is protected by a broad, hanging glacier. In fact, Ama Dablam means "mother's amulet box," because the hanging glacier, that big block of ice on the front face of the mountain, looks like the heavy silver necklaces called *dablams* that the Sherpa women wear.

The sides of Ama Dablam are very steep and from my perch at Khumjung, it looked nearly inaccessible. It's a stand-alone type of mountain, which is rare in the Himalayas. Most mountains—like Taweche, for example, directly across the valley from Ama Dablam—have ridges that descend and then quickly rise to form another peak. Or they're part of a massif, a clump of peaks such as Kangtega, just south of Ama Dablam. But Ama Dablam is different. Every ridge retreats to the bottom of the valley and the mountain stands there alone, surveying the entire Khumbu valley.

I could see why this mountain was important to the locals. But I also knew that to many Western climbers Ama Dablam was not consid-

ered a prized peak. It rose to a mere 22,494 feet: I wasn't going to be on a Himalayan giant, not this trip anyway. Still, this mountain was the perfect place for me to see how I'd deal with altitude. I'd wondered a lot about that; I'd never been much higher than 14,000 feet in the Colorado Rockies and knew that even the fittest climber could fail on these big mountains. Physical preparation and training could easily be overwhelmed by some genetic quirk that wouldn't allow the body to function properly up in the clouds. We all knew the symptoms of altitude sickness but no one knew how to predict who might be stricken. Ama Dablam would likely provide the answer for me.

I would never have been so brash as to have jumped ahead to climb something higher, like a 26,000-foot peak. I knew I wasn't ready. Everyone had a great deal of respect for these mountains, and twenty-three-year-olds were not, for the most part, going off and climbing the giants. I was fortunate to be there with a handful of experienced climbers. And I saw this mountain as a necessary step on which I would gather the tools, like self-confidence and conservation of energy, that I would need to function at high altitudes.

As I sat in camp at Khumjung and looked at Ama Dablam rising up from the valley miles away, I felt both satisfied and inspired at the same time. Satisfied that I was entering the Himalayas the way I thought they should be entered, from the bottom up; and inspired by the challenge of testing myself on Ama Dablam's steep slopes.

From Khumjung we made a wonderful hike up the valley, descending first to the Imja Khola River and then climbing up a hot, dusty trail, 1,800 vertical feet to the Thyangboche monastery. Ama Dablam was now much closer and it looked intimidating. But it was the monastery before me that captured my attention. Jonathan Wright had told me that the Thyangboche monastery, which sits atop a glacial moraine at nearly 13,000 feet, had been built in 1912, destroyed by an earthquake in 1934, and then rebuilt. I'd not given much thought to the existence of sacred places before that day, but the moment I crossed the threshold into the main meeting hall I could immediately appreciate what sacredness meant to the devout.

We'd been invited to receive a blessing from the monks to aid our journey in these mountains. Around two sides of the room were two

dozen monks with shaved heads, sitting calmly, wrapped in maroon robes. In the dim light thrown by dozens of tiny butter lamps, I could see black streaks of soot rising on the walls above them. The lamps burned yak butter, important as an offering because of its value to the locals. More yak butter was smeared around the altar, its sour scent mixing with the mustiness of ancient wool carpets and robes and the sweet tang of incense that hovered in smoky clouds over our heads.

It was cold inside the building. A monk gestured us forward, and we, too, sat on cushions arranged on the floor, our legs crossed. A young monk brought in a huge teakettle, and the monks began chanting, led by the abbot, an incarnate lama who sat on a raised platform at the end of the hall. That was my first experience with yak butter tea. The young monk picked up a wooden bowl, wiped it out with one hand while spinning the bowl on his other palm, then set it down on the floor and poured tea into it. He passed it to me, smiling, and the aroma was not like anything I'd ever smelled, and it didn't smell like anything I wanted to drink. Later Jonathan explained to me that they make it from bricks of black tea, which is slightly bitter to begin with, then they add salt and chunks of yak butter.

If you drink this tea in the summer, which is the milking season, the butter can add a rich, fresh flavor. But in winter, the butter that was made the previous summer is turning rancid, giving the tea a repulsive flavor to the uninitiated. I imagine it didn't evolve as a beverage as much as it did as sustenance—the fat and salt are essentials that Sherpas might not get anywhere else in their diet.

I held the bowl sniffing the concoction, not entirely disposed to drink, knowing I was supposed to take three sips and have the bowl re-filled three times or be considered impolite. I managed my three ritual sips, smiling at the monk who watched me expectantly, refilling the bowl each time. I was pleased that he was pleased, and just as pleased that only three sips were required.

Some of the monks commenced chanting, gazing calmly ahead as they repeated the rhythm of the words. The chanting softened, and a low moaning rose from one side of the room. I felt it more than heard it at first. It reverberated in my chest, the peculiar sound of the long brass horns, their ends resting on the floor a good seven feet in front of

the monks. Then the higher-pitched whine of smaller, oboe-sized instruments joined in, underscored by the steady, rhythmic clash of hand cymbals and drums.

Suddenly the instruments stopped, and the chanting began again, until a jingling bell quieted the monks and the lama spoke alone for a moment. Then the monks resumed their chanting. I had no idea what they were saying and knew nothing about the significance of the music, but I could feel the power of their reverence. One of the monks draped a *khata*, a white silk scarf of blessing, on my shoulders and a thin, knotted, red braid—a protection cord for my safe passage—around my neck.

The next day we embarked on a long walk, past the village of Pangboche, the last leg of our journey to the base of Ama Dablam. We stopped briefly at the village monastery, where the monks brought out the scalp and hand of what they said was the Yeti, the legendary Himalayan abominable snowman. I didn't see either of them; only the filmmakers were allowed to look on those unusual objects and film them. But I caught the spell of the tale all the same. I was in the Himalayas, a place of stupendous climbs, bizarre characters, and abominable snowmen.

By late afternoon we reached a lovely flower-strewn meadow, the site for our Base Camp. At 15,000 feet, we were staring right up at the summit and the route we would take. The plan of ascent was to fix ropes as the climbers established our three camps along the route to the summit. Jeff and Martin fixed most of the rope. Tom did some. I did none. I was never a lead climber on this trip. Along with a Sherpa named Lhakpa Dorje, I was relegated to load carrying. I was also to load film magazines and support the film crew. Those weeks gave me a lasting appreciation of the hard labor Sherpas perform for foreign expeditions.

The climbing was exhilarating because the rock was good and the route so precarious. A lot of it involved traversing along a ridge, then climbing a tower using a previously fixed rope, then traversing again and climbing the next tower. I learned about conservation of energy at altitude, about not working too hard when you didn't have to, about moving at a relatively slow but steady pace to stay within the bounds of my own resources. We placed high camp, Camp III, at 20,750 feet on a large, flat snowy area half the size of a football field. Three weeks had passed swiftly. Now, suddenly, it was summit day. We left after the morn-

ing sun struck our tents. Climbers make a habit of the so-called alpine start, heading out just before dawn while the mountain is still safely frozen, to maximize the daylight hours. Cold and sluggish from the altitude, we started later than we ordinarily would have that morning.

I was wearing lightweight, leather single boots commonly used in the world's lesser ranges, not the insulated, heavier double boots usually worn in the Himalayas. It was a cold, gusty morning that made the group's movements seem much slower. Standing at the end of the first pitch, my toes grew numb, and I feared frostbite. I rappelled down, walked back to camp, and took my boots off to warm up my feet. When they felt all right, I headed back up the face and easily caught the slow-moving group.

From the beginning, this promised to be a long day. The snow and ice was a steep 55 degrees so we had to take care to fix proper belays and anchors, and we were able to climb only as fast as our slowest member. Two-thirds of the way up we encountered a bottleneck—a hanging glacier, the *dablam*, on one side and a ridge on the other. That narrow ice gulley slowed us as we filmed and climbed through, one at a time. Snow and mist swirled around us, and the light was failing when we reached the summit at five o'clock. Jeff, our climbing leader, announced that it was too late to be on top and there was no time for filming—a disappointment to all of us after that long day.

There was nothing for us to do but gather our gear and begin rappelling down. We were a large group as summit teams go—eight of us in all. We descended the same way we'd gone up. But we had stopped fixing ropes at Camp III, so there wasn't any line of rope to follow. We knew we had to descend through that hourglass notch, and then bear right on the rappels. Eventually, we'd hit the area where our camp lay. Greg and I started off first, setting the rappel anchors in the fading light. Halfway down, at the bottleneck, we lost the rest of the light. The sun was completely gone. It started to snow lightly and we were rappelling in total blackness; I could scarcely see the ice in front of me. I didn't have a headlamp.

Jeff, the only one of us with a headlamp, was looked on as the lead climber of our group. He now went first, setting the rappels in the dark, placing the ice screws for anchors, clipping the rope in, and mak-

ing sure each would hold a climber's weight. We were all working as fast as we safely could, but Martin began yelling at people to hurry up on the rappels. He'd had frostbite before and now his feet were painfully cold. His voice drifted up to me, urging the next climber on as I stood on each ledge and waited my turn. For hours, one by one, our team rappelled down. Then Jeff would set another rappel, and we'd each follow him to the next ledge. The night seemed endless; not only was there no moon, but no starlight either to guide us on the rock or to help us judge the passage of time. I had only the rope in my hand and the dark ice beside me.

There's a certain type of patience you need to cultivate for mountain work. It takes patience to wait for your fellow climbers and occupy yourself only with the tasks at hand. I knew I had to conserve my psychic energy. There was no reason to let my emotions exert any undue pressure on me. Fear was my enemy and details were my friend. I realized it wouldn't help me to worry too much about the fact that we were climbing down in the dark. I was far better off concentrating on the next rappel, on tying a figure-eight knot correctly into my rope by feel, clipping it to the anchor, and taking myself off the line to make way for the man coming down behind me.

As I waited in that black night, it seemed I was engaged in a kind of Braille exercise. I became hypersensitive to the feel of the rock and ice around me. Every contour mattered, every feature was a clue as to which way the route should go. During the day, a single glance down would have shown me how many thousands of feet I was from the valley floor. Now, because I couldn't see it, the exposure of this climb was no longer an issue. My world was confined to the twenty-or-so-foot beam that Jeff's headlamp could throw in the few moments when he was nearby. Without a headlamp, my movements would have to come from sheer intuition reinforced by that special sort of insight you gain when your senses are heightened.

It was an unnerving trip down but, finally, around ten P.M., we stumbled back into our tents and collapsed, exhausted and dehydrated, into our down sleeping bags. I'd learned one hard lesson: Always carry a headlamp.

Our descent in the dark had a certain romantic cast to it. I knew

even then that this experience would serve me well in the future. I'd heard of other expeditions in which climbers had to descend in darkness, and to have done it and gotten past the fear that comes with it was itself a triumph. I marveled, too, at how everything that allows you to find your way down, a familiar bump of rock, the slab of ice where you previously stopped to rest, can utterly disappear when the sun goes down. It was as if we'd been on an anonymous peak that we'd never climbed before.

Afterward I'd associate climbing my first great Himalayan peak with a descent through the darkness and link it to another descent from my past—the one I made that dark night off the Great Zot in Colorado. Each has always been a source of great pride for me and probably did more for my emerging climber's self-confidence than anything else. I also discovered that my body and mind work well in higher altitudes. After an initial headache due to the overexertion of youthful enthusiasm, I'd functioned fine. I returned to Base Camp feeling my body had been designed for the challenge of the thin, cold air.

Most of our crew left Ama Dablam to film several of our kayaking teammates as they attempted the first kayak descent of the Arun River in eastern Nepal, but I was going home. As I was leaving camp, Roger Brown hurried over and handed me a large black fiber case filled with our film.

"Since you're going home now, why don't you deliver this to John Wilcox in New York?" he asked. Then he gave me a white envelope. "Just a note for John about the trip," he added. "Be sure you give him this, too."

I was pleased to be entrusted with that precious black case. Our expedition had worked hard and taken risks for those images. In John Wilcox's midtown office at ABC Sports, I handed him the case and the letter. Wilcox opened the letter, read it, then looked up at me with a quizzical expression. "Reimburse you?" he inquired politely. "You should pay us for the privilege of working for ABC Sports."

It caught me flat-footed. I hadn't known that Roger was requesting I be paid for my airline ticket. I just stood there speechless. Wilcox told his assistant to cut me a check for my airfare. He even added a $1,500 freelance fee.

EVEREST

The 11,000-foot Kangshung Face of Mount Everest, Tibet.
The route follows the prominent prow in the middle of the face.

I got my first crack at Everest in 1981. I was visiting a friend who lived in an old stone Pony Express station outside Eldorado Springs. At the end of a day of rock climbing, I arrived home to find a note: Call John Wilcox, ABC-TV, asap.

Wilcox was engaged in contractual discussions with a team of American climbers going to the East Face of Everest. He was proposing that ABC-TV's *American Sportsman* make a film about the expedition. The climbing team was not convinced of the merits of having a film team along—some saw it as unnecessary, others as potentially danger-ous. Although the expedition had a sharp angle—attempting the first ascent of the last unclimbed face of Everest—it was still in need of an additional sponsor. In the end the expedition decided in favor of the film, but with an important stipulation: The film team would be com-prised of experienced climber–filmmakers and would not go above Base Camp without permission from the expedition leader.

The expedition was leaving in a matter of weeks, Wilcox said. Would I be interested in going as an assistant cameraman and sound recordist under Kurt Diemberger? Because it was Wilcox, who had made me wait for an answer about Ama Dablam, I forced myself to tell him I'd have to think about it. John just chuckled.

I got acquainted with the American climbers on the flight from San Francisco to Hong Kong. A California cardiac surgeon, Jim Mor-rissey, was the deputy leader; Dr. Lou Reichardt, a neurobiologist, was climbing leader; Andy Harvard, a trial lawyer, was film coordinator. All were Himalayan veterans. They were savvy about forming expeditions and had chosen some serious talent for the project.

One was John Roskelley, a well-regarded high-altitude climber from Spokane. Just as Yosemite and Colorado bred their own mountain subcultures and specialties, the Pacific Northwest—with Mount Rainier and Mount Hood in its backyard—was known for its strong, durable climbers. Roskelley was considered America's most capable Himalayan climber at the time. Right behind him was George Lowe, a cousin to Jeff and Greg. Climbing must run in their genes, because George, like his cousins, was an extraordinary alpinist. A cosmic ray physicist by profession, he was analytical, cautious—and very funny. He was just the sort of guy you'd want as a partner in the mountains.

There were a number of other accomplished climbers on the team, including Sue Giller, a software engineer from Colorado; Chris Jones, who had written a history of North American mountaineering; and Kim Momb, a mountain guide and skier, built like a boxer. Dick Blum, an entrepreneur who in 1979 founded the American Himalayan Foundation and whose wife, Dianne Feinstein, was mayor of San Francisco and later a U.S. senator, was our leader. It was a very strong team.

On the long flight I began an enduring friendship with Kurt Diemberger, a fifty-year-old Austrian cinematographer whose early climbs had established him as a forerunner in Himalayan exploration. He was to have several roles on our climb: cameraman, historian, elder statesman. Diemberger had climbed Everest, Makalu, Broad Peak, and Dhaulagiri, Himalayan peaks all higher than the magic 26,250 feet. I felt a special link to the man because he had been with one of my heroes, Hermann Buhl, on the day Buhl died in 1957. I knew the story well. Descending from an attempt to make the first ascent of Mount Chogolisa, a 25,110-foot peak in Pakistan's Karakoram range, unroped and in mist, Buhl had walked right off a cornice, falling thousands of feet. Kurt's grim photograph of Buhl's tracks disappearing over the edge was a stark warning to climbers of descending in poor visibility.

Our expedition hoped to make the first ascent of the virtually unknown East Face of Everest, the Kangshung Face in Tibet. Very few people had ever seen it up close, but Dick Blum had secured the first permit from the Chinese Mountaineering Association to try to ascend it, and Andrew Harvard had made a reconnaissance trip to the face the year before.

Everest is like a pyramid with three sides. Most Westerners are familiar with the Southwest Face, which stands in Nepal. This holds the South Col route by which, in 1953, Edmund Hillary and Tenzing Norgay made the first ascent of Everest. In 1963, an American expedition partially sponsored by the National Geographic Society also climbed on the Nepal side, repeating the South Col route and creating a new route on the forbidding West Ridge. Years later, in 1996, the South Col route would be the site of the disaster depicted in Jon Krakauer's *Into Thin Air* and the large-format film *Everest*.

Less familiar to the public are Everest's northern approaches. In the beginning of this century, British surveyors drew a map of Asia with a boundary line running along many of the highest points of the Himalayan chain, which placed half of Everest in Nepal and half in Tibet. Since then, because of the turmoil in Asian politics, Nepal and Tibet have taken turns serving as forbidden kingdoms. Until 1949, no climbers were allowed into Nepal; all access to Everest was through Tibet. After 1951, when the People's Republic of China invaded Tibet, that access was closed. Luckily for climbers, Nepal had decided to open its gates, and the world came to know Everest by its south side.

George Mallory, the climber who, when asked, Why climb Everest, purportedly responded "Because it's there," made his attempts on the North Face, as did other British mountaineers. But before settling on their North Col route, Mallory made a reconnaissance of this little-known mountain in 1921. Scouting for the best approach and climbing line, he first glimpsed the Kangshung Face—and promptly rejected it as too dangerous to climb because of its steep expanses of snow and hanging glaciers. Sixty years later, we were hoping to prove him wrong.

Our first stop was Hong Kong, where our team was joined by Sir Edmund Hillary. He had been invited by Blum to accompany our expedition as an honored Everest alumnus. Hillary was then in his early sixties. I was struck by his height, his robust demeanor, and the mischievous twinkle in his eye.

The world is impressed by Hillary. The moment people recognize his name, a reverence falls over them, whether it's a bartender, a bellhop, or a government official. This isn't tawdry rock-star celebrity. When people shake Sir Edmund's hand, they know they are shaking the hand of one of the century's authentic legends.

Hillary had been a beekeeper by trade. I think the Brits would have preferred it if a true blueblooded Englishman had made it to the top first. Instead, they got an unpolished commoner from New Zealand. So much the better for England. Hillary had accepted something about climbing Everest—the magnitude of that achievement—and turned it into a celebration of the human spirit. What has particularly impressed and inspired me about Hillary is not what he did on the mountain but

what he accomplished later. He maintained a lifelong devotion to mountain people, especially to the Sherpas. For me, his legacy will always be the schools, bridges, and clinics he built in Nepal.

The first morning after our flight, we crossed the border into China, flying from Hong Kong to Chunking, now called Chongqing. We landed on the same airfield Major General Claire Chennault's famous Flying Tigers had used on World War II missions against the Japanese. Looking out my window, I witnessed one of those time-warp scenes you sometimes encounter in Asia. There on the runway the air force of the People's Republic of China was practicing touch-and-go landings—in World War I–style biplanes.

From there we flew to Chengdu, a major industrial city that is the Chinese launching point for travel into Tibet. We stayed in the Jinjiang, an immense, gray, concrete hotel. In the early 1980s, China was not set up to cater to Western tourists. I'm not generally squeamish, but at times the food they cooked was a bit out of the ordinary. They kept the animals alive until the last minute, eels, fish, turtles, ad nauseam. Duckbill soup comes with floating duckbills. Order chicken, and that's exactly what you get, chopped up with a cleaver, bones and all. You'd spit the sharp bone bits into the sawdust on the floor, and they'd sweep it all up at the end of the day. It was in Chengdu that I developed my repulsion toward the rubbery white dumplings that seem to come with every meal.

We attended several mandatory banquets hosted by the Chinese Mountaineering Association. I learned to drink *mao-tai*, an alcoholic beverage which tasted suspiciously like Chinese aviation fuel. By the third banquet I started to dread the tradition in which small cups filled with this absolutely repellent alcohol would arrive toward the end of the meal. With a hearty *ganbei*, it was bottoms up. As it turned out, there were several fervent anti-communists in our group who saw it as a patriotic duty to not be put under the table by the Chinese. Their country owes them a great debt.

We were allowed to leave the hotel on our own and go on short foot excursions. The coal-fired factories lay an impenetrable pall over the whole city, making Chengdu a dark, mysterious place. You could readily see the Soviet influence, starting with the city's ugly, monoto-

nous, concrete buildings. Walking down a big, wide boulevard, you could have been in Moscow; but the forty-foot-high statues were of Mao, not Stalin. Total conformity was the rule right down to the dress code of gray and blue Mao suits and caps. Everyone rode the same design bicycles.

In Chengdu our team was joined by a climber named Wang Fu-chou, one of the three Chinese who claimed to have made the first ascent of Everest's North Ridge in 1960. Whether you're climbing Everest from the Nepal or Tibet side, every expedition is accompanied by a government official called a liaison officer. Sometimes they're soldiers or bureaucrats, but we were actually getting a mountaineer—and Wang Fu-chou no less. Like Diemberger and Hillary, he was past his climbing prime and starting to look grandfatherly. Wang had a slightly pockmarked face, with a crew cut and jowls and a ready laugh full of crooked buck teeth.

He was missing parts of some fingers and toes from frostbite; there was no doubt he'd paid a dear price up on Everest. But twenty years after the climb suspicions remained, especially in British circles, about whether Wang Fu-chou and his comrades actually reached the summit as they claimed. According to the Chinese story, three climbers including Wang Fu-chou had been blocked from the summit by a short rock wall at the Second Step, at 28,800 feet, near the same spot where Mallory was last seen. Night had fallen, and they took turns trying to climb a crack in the step, but no one could get up. Finally, the story goes, drawing on the power of Marxist ideology, one of them took off his boots and socks and climbed the obstacle in his bare feet.

Climbing through the night, Wang Fu-chou and his companions had allegedly reached the summit in the night . . . when it was, of course, too dark to take a photograph. They descended with no physical proof of their deed.

Coming as it did a year after the final Chinese invasion of Tibet, when the Dalai Lama had been forced to flee to India, plenty of people believe the 1960 Everest claim was just one more way for China to cement its hold on Tibet. Certainly the People's Republic was engaged in a massive act of cartographic aggression, altering the maps of Asia and renaming non-Chinese places in Mandarin. There's no doubt Everest

was a pawn on the geopolitical chessboard in 1960. Whether or not you believe the claim of the 1960 climb (their claim is now generally accepted in mountaineering circles), the Chinese definitely climbed it several years later in 1975, and this time took a brace of photos and made a film to prove their conquest. They even left a red survey tripod anchored on the summit.

Western doubts aside, Wang Fu-chou was a man venerated in his country who had risen to the upper ranks of the Chinese Mountaineering Association. No one in our group was about to challenge him. If indeed the ascent was Chinese propaganda, we knew there was plenty of American propaganda foisted upon the East as well.

On an August morning, before the monsoon clouds built up, we boarded a Russian Aleutian, a four-engine turboprop, and flew to Lhasa. These puddle-jumping segments connecting our journey reminded me of the dot-to-dot map in the 1930s movie *Lost Horizon*. We were one of the first groups of American climbers to ever enter post–Cultural Revolution Tibet. It was all the more romantic to be flying over range after range of unclimbed peaks. Gorgeous territory rolled by below, emerald green. We crossed the drainages of some of the mightiest rivers on earth, the Yangtze, the Mekong, and the Salween. The deep valleys they cut were draped in thick forests, and there were practically no roads. If you looked carefully, you could pick out tiny Tibetan villages.

We were flying above the eastern province of Tibet known as Kham, the home of the famed Khampas, horseback warriors who'd been backed by the CIA in the 1960s. In fact CIA pilots in C-130 cargo planes had flown night missions over this region, dropping supplies and Tibetan commandos, some of whom had been trained in the Colorado Rockies.

Gradually we gained the vast Tibetan plateau that sits at an average of 15,000 feet above sea level. We descended out of clouds above an alluvial plain bounded by brown hills. The Himalayas were small white teeth on the far horizon.

The airstrip lay miles outside of Lhasa along the Tsangpo river. After landing we unloaded our gear into the backs of creaking Jiefang

trucks. They were the quintessential work vehicle, a Soviet design with a long snout. It was a magnificent, utilitarian idea to have a fleet of identical trucks to simplify transport throughout this vast countryside. If you broke down, chances were another driver would have a part to fix your problem. They were fueled with gasoline because diesel fuel would gel in the extreme cold of the plateau.

More Chinese officials greeted our team. We were bundled into a mini-bus and driven across a massive concrete bridge spanning the Tsangpo punctuated by guard posts with small portals for machine guns, and sentries manning either end. The bridge was heavy and wide enough to support tanks, our first sign that we were now inside an occupied country.

As we drove northeast along the Kyichu river, I tried to imagine the early Western trespassers on the roof of the world. Through the large glass window at the front of the bus, we finally saw the Potala, the Dalai Lama's traditional winter quarters. The sun struck its golden rooftop, making it visible from five miles away.

We were taken to an army compound northwest of town, where they put us up in Guest House No. 3. During the day we were driven in to Lhasa to see the sights. At the Potala, we walked through room after room finding the signs of the Chinese occupation: statues broken, walls defaced. In the town square, which in Lhasa was circular, we visited the Barkor. A kor is a circular walk for meditation or prayer, and it's always walked clockwise. Some kors go around mountains or even around the whole country. Lhasa's Barkor was a circular walkway that girdled the Jokhang temple, the religious heart of the country. Along the Barkor were dozens of stalls and displays where nomads, farmers, and traders bartered for items as common as salt, as exotic as medieval Tibetan swords, and as practical as a long needle for sewing wool grain bags closed. On this and other kors, I felt the spirit of an older Tibet there, a calm insistence on their ancient traditions despite the Chinese occupation.

Neither Tibetan monks nor locals spoke English. Our guides were all Chinese, and they couldn't translate for us because none of them had learned Tibetan. There was no international Free Tibet movement

back then. Few Americans had any idea what was happening here. Anyway, we were there to climb, not to agitate for human rights, even if we had been able to figure out the politics of the place.

Lhasa had one final surprise for us. A trekking group arrived at our compound, led by Tenzing Norgay. Here was the very man whose image had ignited my interest in Everest and the Himalayas. Tenzing looked dignified in a British-style driving cap. He was striking, taller than the average Sherpa, with a broad face and his trademark smile. I really didn't know what to do. I stood, dumbfounded, between Tenzing and Hillary, to have my photograph taken. I was struggling to put that immortalized image of the man standing on Everest together with the man in front of me. It was as if Tenzing in the flesh couldn't exist for me.

In a convoy of trucks, a bus, and a tiny Beijing jeep, we headed west out of Lhasa on the dirt road toward Everest. The mountain was only 400 crow-miles away, but the journey took nearly a week. Monsoon rains had carved gullies in the road, military checkpoints were everywhere, and we were still acclimatizing. On the way, we stayed in guest houses and lodges, and I was glad for the extra rest days and time to acclimatize before we started the real physical work.

Shegar was an old Tibetan village nestled against a bare brown mountain, a traditional way station for all the early British expeditions going in to Everest. We stayed there for a couple of days. Each morning we were awakened by loudspeakers blaring Chinese indoctrination messages and tinny songs into the village. By our wristwatches, the time was six A.M., though the sun was two hours from rising. Despite the fact that we should have been two time zones to the west of the capital, there's officially only one time zone in China: Beijing time. We were starting to understand the numbing sameness of Chinese communism.

On a hill outside Shegar, a steep ridgeline at the top held the ruins of a fortress with a long, serpentine wall rising to the summit. George Lowe, Kim Momb, and I decided to investigate. Besides satisfying our curiosity, a day hike up that hill would help us acclimatize. In Tibet, relative to the greater Himalayan peaks, we call a small mountain like this a hill, even though it goes up to 15,000 feet. We set off above town on a trail that wound around the cliffside and passed

through a massive stone gateway. We spied a virtually abandoned monastery socketed among the rubble, and continued higher, following the ruined wall of the *dzong*.

It was as if a section of a medieval fortress had been transported to the middle of nowhere and dropped, from a great height, onto this mountainside. Here and there the wall rose to twenty or thirty feet, and was honeycombed with rooms and chambers, some still bearing Buddhist murals. Everything was in a state of decay. It reminded me of the Greek ruins I used to explore as a boy. The destruction we were seeing, however, was scarcely twenty years old and gaping holes testified to the explosives and artillery the Chinese had used here. Years later I would see photos from George Mallory's expeditions in 1921–24 and later shots as well, all showing the *dzong* and monastery intact.

Four or five hundred feet up the ridge, the spirit of competition got the best of us, and we unwisely headed straight up a set of slabs. The slabs were coated with loose gravel that acted like ball bearings under our feet and hands. I looked over my shoulder once, and I knew that a single slip would send me somersaulting down through the ruins. It wouldn't be a clean death, like falling from a cliff. Having flown halfway around the planet to scale Mount Everest, we suddenly faced paralysis or mutilation from a ridiculous scramble. Even so, retreating didn't occur to any of us. We reached an overhang at the top, pulled ourselves to safety . . . and into a sea of prayer flags—a hidden world.

On the top of the mountain perched a small structure. Its roof had been destroyed, and the cobalt sky yawned above. A minute ago, we'd been climbing for our lives through a chaos of ruins. Abruptly everything was serene.

We stood in a room filled with prayer flags on slender bamboo wands. There were hundreds of the thin cotton squares, each stamped with prayers intended to rise into the heavens with every flutter. A small altar with a place to burn juniper branches as a consecration stood on one wall. I was touched. I looked over the shattered masonry and far below lay Shegar. The Tibetan quarter was bordered by ugly, square Chinese barracks that housed soldiers and bureaucrats admin-

istering the occupation. Religion was forbidden. And yet, clearly, Tibetans visited this small summit room and sent their prayers to the sky.

The views are magnificent in every direction. From that height, you can see Everest to the southwest and the way Mallory and the British would have approached across the valley floor. To the north, you get a view of the wild geology of the Tibetan plateau. Layers of chocolate brown and ocher earth in the surrounding hillsides are shot through with black rock veins. When the sun shines through the low monsoon clouds and hits them, the hills seem to shimmer with their own light source.

Living and working around cameras, my eye was being educated to the light. Summer weather in Tibet is in constant flux, with low clouds sweeping by and the light changing every few minutes, drawing the eye from point to point. From my perch on top of Shegar Dzong, one instant my eye was drawn to the sun spotlighting a field of barley 900 feet below, like an iridescent green oasis. A puff of breeze, and the barley flexed and rippled, the colors racing off it. The next instant, my focal point was the dark gray clouds of a hailstorm galloping sideways five miles distant. Then it was gone, replaced by the sprawling panorama of the Himalayas.

Everest stood forty-seven miles in the distance. Viewing the Himalayan range from the Tibetan side, I was confused by the shapes and silhouettes of the big peaks I knew from photographs taken in Nepal. The mountains seemed reversed and distorted to my eye. From the Nepal side, Everest rises up in the company of other pyramids, like a skyscraper in the middle of Manhattan. From the Tibet side, Everest is isolated, almost lonely-looking, with a long horizontal shoulder shearing northeast from the summit. George and Kim and I stayed up there in that sacred room for a long time, deciphering this alien mountainscape.

With evening coming on, we finally started back down to the village. We took a winding footpath that led down the back of the hill, and along the way found ourselves with a bird's-eye view of life in a Tibetan village. Its sounds drifted up to us: a dog's bark, the rushing stream, the tinkle of yak bells. Off to the east, lines of villagers were singing in unison while they cleared an irrigation ditch. In the village itself, people were going about their tasks on the flat rooftops. Westerners don't use

their rooftops much, but in Tibet they're a key feature of the house, like in a Navajo pueblo. The mud roof is surrounded by a three-foot-high wall to cut the wind and make it habitable, and firewood is stacked there. Shanks of meat hang in the dry air, and barley is fanned out and winnowed. Babies crawl around and women spin wool. On this day, blue smoke leaked through holes in the roofs, sending up the scent of burning yak dung and sweet juniper. I was enchanted by the smells and the sounds, by the rhythm of life here.

From Shegar, we took trucks across a 17,200-foot pass called the Pang La. The Chinese had built the rough dirt road to supply their 1960 expedition to the North Face. We stopped on top of the pass, and Everest rose some thirty-six miles away. We had to be patient, waiting for glimpses of it through the layers of monsoon clouds moving in and out of the valley. It was much more impressive-looking than from vantage points I'd had in Nepal, because here we could see 7,000 vertical feet of its North Face.

Our view was also intimidating. Through our telephoto lenses we noticed something that instantly sobered us. During the summer monsoon months, when precipitation comes up from the south and bumps against the Himalayan range, the mountain becomes absolutely inundated with snow. And heavy snow means avalanches.

Kharta, a Tibetan settlement, was the end of the road. From here, we would have to walk for ten days before reaching Everest's Kangshung Face. Mallory and the British had visited here in 1921. Except for a team of French climbers who'd passed through the year before us, ours was the first Western expedition to visit Kharta in six decades. The French had made a reconnaissance of the Kangshung Face in 1980 and retreated, pronouncing it a death trap.

Kharta, a poor, remote Tibetan farming village, was where Tenzing Norgay was born. The French must have given away lots of food and gear on their way home, because when the locals saw us they thought the circus had come to town again. For two days we camped there, sorting out loads and hiring a yak team, and the villagers were a constant presence, alternately curious and aggressive. From their point of view, I'm sure we looked vastly wealthy with plenty of surplus.

On the morning of August 22, we put on our packs and started up

the trail with our yaks. This was my first experience with a Tibetan yak caravan. I've come to like yaks; they're mischievous and very alert. They have terrific hair, and their long tails (black, tan, or brown), which almost touch the ground, used to be sent to America in the 1950s and were bleached for use as bristly Santa Claus beards. The males are fixed and used for transport; the females, called naks, bear more yaks and produce milk.

The yaks weren't hard to keep up with. Each carried two seventy-pound loads, one on either side of a small wooden saddle, along with a big bag of hay, their own food. The herders take great care of their animals, giving them long rests and sometimes hand-feeding them at high altitudes. On the trail the herders call out melodic commands to them, which mingle in a sort of mountain music with the tinkle of the bells around the animals' necks.

Occasionally a yak will get spooked and bolt from the line. On our expedition a yak fell off the trail, did a couple of flips, and ended up standing on its feet. In 1986, on an expedition to the North Ridge, one of our yaks fell into a crevasse and died. We hauled the yak out, butchered it, and ate it over the next month.

We walked for five days, over a pass and down into Karma Valley and a completely undisturbed forest. Juniper trees grew three and four feet in diameter and the rhododendrons were lush. The streams here flow into the Arun River, which cuts south through Nepal. With the thick vegetation and misty air it would have been easy to get lost.

I liked to walk with Kurt Diemberger. He was alive to our surroundings and could point out Makalu and other peaks all around. He carried a worn Millet canvas rucksack, wore gray wool knickers and red kneesocks. Kurt had faced the same question as Hillary had: What do you do as an encore after Everest? Hillary had devoted his life to the Sherpas; Kurt had continued as a high-mountain wanderer and film-maker with his Leica and Arriflex cameras. Both mountaineers were treated as benevolent elder statesmen by the other expedition members.

In a sense we were also accompanied by George Mallory. We had his book about the 1921 reconnaissance with us and were continually referring to passages in it. One night we stayed in one of his campsites. Following the same path as he had, we turned due west and headed up

and out of the Karma Valley onto the Kangshung Glacier. Having lost altitude in the valley, we now gained it again, trekking above the tree line, and passing small herds of wild Tibetan blue sheep.

At last we began to see the Kangshung Face, though only in snatches between the monsoon clouds. The vast, wide face rose 11,000 feet above us. Before we even reached it, there was intense discussion among the climbers about the snow poised up there like a booby trap.

Kangshung seemed all of what Mallory had once said of it: "It's for other men less wise." There's nothing else like it in the Himalayas. The mountain face comes straight up out of a glacier and rises two miles high. Not only is it big, but portions of it are blank, with miles-wide expanses of snow and ice that don't have a blip of rock showing. Above the lower buttress—the prow of projecting cliffs—the climbers would be faced with whiteness. We saw no pronounced ridges or cliffs to protect a tent from an avalanche.

With all the monsoon snow piled on the towering slopes, it looked like a lost world up there, with glaciers from the Ice Age still in place. As a rock climber and an ice climber, I was horrified. I didn't like snow climbing. Snow moves. It's alive. Not only that, but we were dealing with an east face. East faces are notorious for poor-quality snow, because they get the first sun in the morning, which heats the snow for hours. When it refreezes at night, the snow has poor consistency. If you're climbing on a thin layer of snow covering rock or ice, you can dig down and place an ice screw or piton. But in waist-deep monsoon snow like this, there would be no hope of an anchor.

None of this seemed to bother Hillary. Long ago, he'd cut his teeth on Mount Cook in New Zealand, where terrible snow conditions prevail. He kept his opinions to himself, however, fully aware that he wasn't going to have to do the climbing. He simply kept walking and chatting in his affable New Zealand way, now and then pointing out places on the ridge high overhead which he'd passed on his way to the summit.

Thankfully, as we got closer to the face, we spotted a slight vertical hump in the middle of all that whiteness. It was shaped like a dome, and we noticed it because of the shadow it cast in the afternoon sun and because the avalanches passed to either side.

We placed our Base Camp at 17,000 feet, seven miles from the face. On a flat, grassy space next to the glacier, we unloaded the yaks, pitched our tents, set up kitchen and dining tents, and once again sorted our gear. Over the next week, a team of climbers set off to scout the face and find a place for an Advance Base Camp, or ABC.

We were going to be using what climbers call a siege strategy, which relies on an archipelago of fixed camps and ropes and lots of manpower. Unusual for a big Everest expedition, there were no Sherpas, so the climbers would carry all the loads up the mountain. Ideally we'd be setting camps, each one higher than the one before, every 2,000 to 3,000 vertical feet along our route. The alternative strategy, not common then on Himalayan giants, is called alpine style. It usually consists of two or three climbers moving up rapidly, using few, if any, camps. If there was ever a climb that needed siege tactics, it was the Kangshung Face. A pair of high-speed alpinists would have been swamped in that vastness.

A week later we established ABC on the glacier at 17,700 feet, beneath the buttress cliffs that led up to the Helmet, where we wanted to place Camp III. Imagine a giant ship emerging from inside the mountain, ramming its prow out and stopping. That immense prow would be our buttress, rising 4,300 feet, taller than El Capitan in Yosemite. Near the top, rock and ice cliffs hang over the buttress. On top of it all, at 22,000 feet, rested the Helmet. From there, the amorphous, snowy face rose another 7,000 feet to the summit. We hoped to cross that huge expanse to join the Southeast Ridge following Hillary and Tenzing's route to the summit. The buttress promised the steepest and most difficult climbing. Ironically, its steepness promised to make this the safest way to get a toehold on the face: It was too steep to hold snow that could bury us in an avalanche.

The initial climb from ABC was more like a steep walk. The fixed rope provided a hand line in case there was a storm. Above that, steeper slabs made the fixed rope more necessary. About 1,500 feet above ABC, the climbing entered mixed terrain of rock and ice, leading into an ice gully bombarded by falling rock.

At the top of this gully, dubbed the Bowling Alley for all the rock fall, we placed the next camp. We were the pins in the alley, prompting

someone to dub it the Pinsetter Camp. It was nothing much, just a couple of platforms carved from the ice for a few tents. From there, the climbing turned serious. You had to go straight up that steep gully—fast and early in the morning, while the loose rocks were still frozen to the wall—before taking on the vertical and overhanging climbing at 20,600 feet. Fourteen hundred feet higher sat the Helmet, where the next camp was supposed to be located.

This was the wildest place I've ever been. One night I was outside when a large rock and ice avalanche came roaring down Lhotse's Northeast Face above me. Huge rocks came tumbling down with the ice, showering sparks into the darkness like a meteor storm as they hit the face. The avalanche hit ground a mile away but it was unnerving to be there just the same. I've read that soldiers get used to the sound of gunfire on a battlefield. But I never did adapt to the sound of avalanches thundering day and night. We were getting big weekly snowstorms. Most avalanches occur within twenty-four hours of snowfall, and on the morning after a snowfall, when that blazing, early morning sunlight hit the East Face dead on, the really big releases would commence. It was terrifying and awe-inspiring.

Everest's famous summit plume stretches over the Kangshung Face. Like clockwork, the plume begins every morning and steadily lengthens to the east. I'd watched the plumes while approaching Ama Dablam two years earlier, and like many people, I had thought they were composed of snow blowing off the summit. Not so. When the sun hits the Kangshung Face of Everest, it heats the whole amphitheater, releasing moisture from the snow. Like steam rising from a giant cauldron, the warmed air moves up and is met by cool western winds racing over the summit. As the two masses of warm and cold air collide, the moisture condenses, creating a cloud—or plume—which the wind carries to the east. You can gauge the ferocity of the wind by the length of the plume. Veterans can even estimate the wind velocity with a glance at the summit. Some days the plume stretched for miles high over our heads, a thin white pennant above Base Camp.

But wind was not our problem that year. It was just a wet season and the unrelenting snow and storms bogged us down. We spent as much time shoveling snow off our collapsing tents as we did climbing

through two to three feet of fresh snow. The day after a big storm, the Kangshung Face would look like a cake smeared with too much frosting. It always slid off.

In my position as assistant cameraman and sound recordist, I provided support for the two cameramen, Kurt Diemberger and Mike Reynolds. Kurt was there to film the climb, Mike was there to film at Base Camp. I loaded film magazines in the black bag, recorded sound, and carried batteries, lenses, extra film, the tripod, and other necessities. Kurt had shot the expedition's progress to ABC. But once the technical, roped climbing began, things changed.

As we all had agreed, the film crew's access to the mountain was determined by the expedition leader. With the climbers locked in a struggle with the dangerous climbing on the buttress, access to the route was tightly constrained. It was the nature of the sinister place—everyone was wary—and the expedition needed to focus on pushing the route.

Our segregation from the mountain had a tremendous impact, not only on the kinds of shots we could get, but also on my attitude toward the climb. Since I wasn't needed to lead any of the climbing sections, or permitted to occupy the upper camp (there was no space), or even register an opinion about the climbing, I concentrated on what I could actually influence: my own education in these extreme conditions and the success of our filming.

On September 22, the mountain released what was incontestably the largest avalanche I've ever seen in my life. I was at Base Camp when we saw it begin to blossom like an enormous white flower on the Kangshung Face. To our shock, it grew larger and wider, falling thousands of feet. Finally it hit the ground and exploded out from the base, a tidal wave of snow and wind. The avalanche pushed a wall of air before it, and as we watched, a cloud of powder snow crossed the glacier and reached us at Base Camp, rattling the tents and blotting out the midday sun. I couldn't believe its power. We were sure ABC had been destroyed and the climbers there would be dead or injured. Someone got on the radio and reported to us. The tents were all flattened, but miraculously, no one had even been injured. Kurt had been at ABC and captured some of it on film.

After the avalanche, two of our strongest climbers, John Roskelley and Kim Momb, decided the face was too dangerous and departed. That knocked a decided dent in the team's morale. Edmund Hillary had had a bout with altitude sickness and had left the expedition earlier. Dick Blum had returned to the U.S. to tend to his businesses and Morrissey was now the leader.

Unexpectedly, Kurt handed me the camera and told me to go shoot the buttress climbing. Ever since setting eyes on the forbidding buttress above ABC I'd sensed Kurt's wariness. Kurt was one of the great Himalayan filmmakers. He was an acclaimed mountain photographer and his cinematography had grown out of that. His long apprenticeship had been grounded in respect for the craft. Part of that respect involved paying your dues out in the world. You didn't seize the torch from your pathfinders; you waited for it to be passed.

On September 25 Kurt took me aside. "I've climbed Everest before," he said in his thick Austrian accent. "Why don't you give it a go?" He handed me the camera.

I had no illusions. They weren't sending me up there because of my filmmaking abilities. I'd never shot more than a couple of rolls of film in my life. They were sending me as a last resort. But I kind of liked that, being the one who was called upon at that moment. It gave me a trust to live up to. Over the next weeks, while dangling from ropes thousands of feet above the glacier, I prayed to the gods of the mountains and the film industry that I wouldn't make a fool of myself with the camera. It wasn't only Kurt's expectations that I wanted to meet. I had challenges all my own. I was prepared for the climbing, that was the easy part. But when they opened the film cans and developed my footage, would there be an image of my camera's world worth seeing?

For five years I'd made it my job to watch filmmakers and ask questions. My cinematic eye had become more refined. I also felt I had an innate sense of composition. But there were all kinds of other things to consider, from the light to the selection of shots and basic camera techniques.

Kurt gave me some basic ideas of what kinds of shots to get, and I had a few notions of my own. The next morning I set off on my debut with the seminal question in mind: How do I tell a story with this camera?

Time and weight were crucial factors. I wasn't going to be able to shoot everything, and what I did shoot was going to be held to the highest professional standards in the editing studios back in New York.

There was no space for me at the Pinsetter Camp at 20,500 feet, so I slept at ABC and climbed the fixed ropes up 2,800 vertical feet—about two hours of climbing—to film the climbers above Pinsetter. I had to cover another 400 vertical feet before reaching the action at the front end of the ropes. Usually it was a pair of climbers, carefully pushing the route higher toward the Helmet, fixing rope as they went. George Lowe led the most difficult rock sections, inspiring the team to dub the headwall the Lowe Buttress.

Over the coming days, I got up hours earlier than the others to ascend the ropes and be ready for the climbers. It became my own game of catch-up. The climbers were on their own schedule; no one was waiting for me to render his portrait up there. At the end of the day, I'd rappel all the way down and return to ABC. A few mornings later, I'd get up and do it all over again, ascending and descending, the same repetitive ritual, always alone. In a way, my time on the Grand Teton had prepared me for this. I found a rhythm in my solitude.

In the mountains dawn breaks on the summit long before it reaches the valley floor. I could tell the time by the moments when the sun first illuminated different landmarks. Everest's summit was the first to light up. Then, off to the left, Lhotse's immense face would catch fire along the upper rim. The granite of Makalu's northeast flank would burst into bright pink and yellow flames. One by one the lesser peaks would get their own share of the light. Meanwhile, the valleys remained dark and inky. Above me, at Pinsetter, the climbers would still be in their sleeping bags, and below me ABC was frozen and silent.

In those moments I was the only one out on the ropes, the only one taking those deep breaths of air. At that hour the wind ceases on the mountain. Everything falls absolutely still. Tiny drops of water stand frozen on the rope sheath.

Slowly the light poured down the walls. And within minutes, wherever the sun touched it, the mountain came alive and turned dangerous.

The first clues were the icicles. A drop would sweat free and begin trickling down the shaft of the icicle. A bank of snow didn't just sparkle, it would shift and pour over a wall of ice. A puffball of snowflakes might roll an inch. These were the little premonitory whispers I heard each morning. Soon enough the roar would come.

During our fourth week on the mountain we neared the top of the buttress. Some mornings an eerie mist clung to the wall and dragon's teeth of icicles hung down around us. The rope vanished upward, attached to the mist. In the distance avalanches fell and thundered.

When filming on Half Dome, we'd strung a second line of ropes to one side. Here we were sharing the same rope, which limited my vantage points. I was unable to get far enough away from the climbers to establish their place on the buttress and give scale to this huge mountain wall. I did what I could.

At last, in late September, George Lowe led through the final overhangs and reached the Helmet. They hauled enough gear up to establish a camp. Perched in the snow at the top of that jutting prow of rock, the Helmet camp was safe from avalanches.

Now that we'd reached the Helmet, the technical climbing was finished. The climbers had only to gain two more camps farther up and they'd be within reach of the summit. Sue Giller and George Lowe were the first to set out above the Helmet, hoping to find better snow. Instead they found atrocious conditions. We could have waited in hopes the weather would clear. But it was late in the season. With our luck that year, winter would come early, bringing with it the jet stream's high winds. In truth, the expedition didn't have much punch left. It had suffered from dangerous snow conditions, horrible weather, too much waiting. The climbers had made a splendid effort but we all knew we'd reached the end. It was a defeated team that left the mountain, vowing to return another year to finish the route. We'd gotten no breaks that year, not from the weather, not from the mountain.

My first big expedition experience was not a successful one. Back in New York, John Wilcox was disappointed that the expedition had gotten only to 23,000 feet. But redemption lay in the exposed film; it turned out that we had a lot of terrific footage and there is often as good a story to be found in failure as in success. I sat in the editing room with Ted Winterburn, an ABC editor, and got a running critique of every single shot in the film. He was fair with me. He said, "For a guy who just got handed a camera, you did a good job. But here's what you could have done to make it better." For instance, I had filmed several minutes of Kim Momb climbing the free-hanging fixed ropes, spinning in space with a slender twenty-five-foot-long icicle suspended behind him. Ted said, "David, if you'd just turned around and filmed out across the glacier far below, we could have seen not just what you were seeing, but what the climber was seeing." He was teaching me about removing myself from the story.

Despite the bad weather and unfinished climb, Kurt Diemberger, Mike Reynolds, and I won a Sports Emmy for best cinematography. It seemed I might actually be able to earn a living while making a life in the mountains.

THE BROTHERHOOD
OF THE ROPE

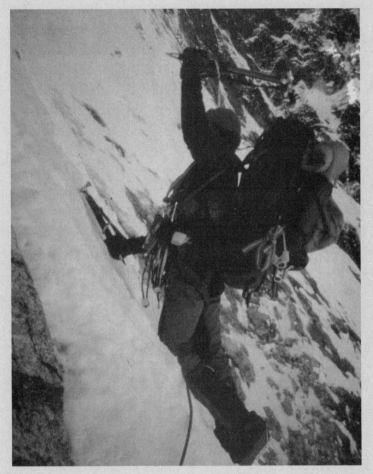

Starting a lead at 18,000 on Kwangde.

CHAPTER SEVEN

The first and last time I climbed in the Himalayas without a movie camera was in 1982 on the north face of Kwangde. In certain respects, this inconspicuous bump of stone in the shadows of much higher and more renowned peaks was the finest climb of my life. I had the ideal partner, my friend Jeff Lowe, and we had the ideal calling, an outlandishly difficult ice climb in early December.

Jeff had the idea to try Kwangde in the winter, just the two of us. I hadn't noticed the mountain on my expedition to Ama Dablam in 1979. It's not a big peak at 19,720 feet, but the north face holds 4,500 feet of steep ice and rock. You can't climb it in the summer because runnels of water course down the face. But in winter the runnels freeze, which provided Jeff the inspiration for a winter first ascent. The idea resonated with me as the missing piece of my Himalayan apprenticeship. Kwangde was a challenging, highly technical ice and rock climb on a route which had never been considered, much less climbed. We'd attempt it alpine style, which meant there'd be no string of camps, no siege tactics. We'd climb it straight, in one sustained effort—or we'd fail. A wall this size—twice the height of Half Dome—would require at least four bivouacs before we made the summit, either in hammocks or on tiny ledges we'd carve from the ice, plus one more during our descent. The climb would be a testament to how we thought climbing should be done.

On Kwangde I would find a lot of the same types of puzzles and technical challenges that rock climbing offered, so in some ways it felt familiar. But ice climbing requires skills and technology all its own. For starters, you're using knife-sharp tools in the place of your fingers and toes. For the hand tools, specialized ice axes or hammers with slender, drooped ice picks. For the feet, the Foot Fang, a foot-sized platform, with teeth along the bottom and toes, which clips onto your boot instead of being strapped on like conventional crampons. Another Lowe Alpine Systems invention.

I had a strategic reason for this climb as well. Everest always lay in the back of my mind. As we planned our trip, I realized that if we could put up this first ascent, I'd have all the confidence and experience necessary to attempt the world's highest mountain.

Kwangde is located four days by foot from the airstrip at Lukla. Before arriving at Kwangde we needed to get fitter and adapt to the mountain air. We hiked on steep trails up to the village of Khumjung—the same trail I would use to approach Everest's South Col route. We spent several days climbing on the surrounding peaks to acclimatize ourselves. One week had passed when we embarked on a four-hour walk to the village of Hongu. With our bright tents and exotic climbing hardware, we became instant celebrities among the dozen or so residents of the village. Hongu wasn't on the way to anywhere, and visitors were rare. The poverty and poor health of the villagers in this dead-end valley at the base of Kwangde stood in sharp contrast to the more prosperous villages of Namche Bazar and Khumjung, both of which showed material benefit from contact with Western trekkers and climbers who gravitated to Everest.

We set camp in a fallow potato field outside the village. Our sirdar and Sherpa friend, Nima Tenzing, quartered himself with the family who owned the field. At the family's urging, Jeff and I joined them for meals in their tiny stone house during the few days we rested in the village. There, Nima's kerosene lantern illuminated a wizened blind Sherpa who claimed to be ninety-eight years old, the oldest man in the Khumbu region. He and his wife, a kindly woman, told us that in the last twenty years only a half dozen or so Westerners had walked through their village.

Woodcutters' paths led to the base of Kwangde's wall, winding through cold, dark, heavily wooded terrain, choked with thick rhododendron bushes. My first glimpse of the big wall was intimidating. Sheets of black granite rose straight out of the ground, dark and sunless for more than 4,000 feet. We examined the face carefully, piecing together a continuous line of ice runnels through the vertical rock bands which crossed the face. Then we listened for the high-pitched hum of falling ice and rock, but heard nothing. The shadowed face was frozen, silent and safe.

It was a vast surface, the bottom of which was thousands of feet wide. Three great parallel fingers of ice ran 1,500 feet up the face, with about 200 feet of rock between each. One of these thirty-foot-wide ribbons of ice would be our pathway for the first several days of the climb.

We chose to start on the ribbon furthest left, which appeared to provide the most direct route to the summit. We could see that up higher we'd likely climb on mixed terrain—rock, snow, and ice.

From the ground it would be 1,500 vertical feet—an impossibly long day—to the first bivouac where we could hang our hammocks. We set out on the ice ribbon, which ascended in a graceful sweep, a slight curve up the face. We took turns leading, each of us with a forty-pound pack on his back. Even though carrying packs made climbing more difficult, we didn't want to haul them up after us, Yosemite-style, because that took extra time, and packs inevitably caught and snagged as you hauled them up a rock and ice face. The level of precision this climb required reminded me of the hardest face climbs in Eldorado Springs Canyon. The inordinately thin ice is both the beauty and the difficulty of climbing this face, requiring considerable strength and endurance. It's not unusual to end up suspended by just one ice tool and the tips of your crampons while you carefully place an ice screw for protection. If you're climbing a frozen waterfall three feet thick, you can hack away with your ice axe to prepare a place for an ice screw. But on very thin ice the climber must work with care and precision. Over and over on that Kwangde climb, I delicately carved niches to place the tip of my ice axe an inch deep in the ice, moving slowly and surely so the ice wouldn't shatter. If I lifted my heel even half an inch, it might pivot the tip of my front points and pop my foot off the ice. Rotating the handle of my ice axe ever so slightly might pry it loose from the ice.

We ascended through the shadow. As expected, our first full day on the wall was a long one. Sunlight disappeared on the far peaks as we made it to our bivouac site. We chopped a tiny ledge in the ice and put up our hammocks. Today there are lightweight portable ledges that can be attached to vertical walls, allowing you to stretch out flat, but we had nothing so luxurious. Sleeping in a hammock was like being hung against the wall by the gathered corners of your bedsheet. It's hard on your shoulders, difficult to turn around or get into and out of, and it compresses the insulation in your sleeping bag—which means you spend the night uncomfortably cold.

Soon after I'd squeezed into my hammock that night, Jeff handed me a quart of hot lemonade he'd heated on our small pressurized-gas

stove. I held it to my chest, absorbing the warmth until it cooled enough for me to drink. My throat was parched; I hadn't drunk all day. I gulped it down and then we ate in our hammocks, two lonely figures, suspended against a vast wall, talking about the day, joking about the moment when we'd each have to relieve ourselves. I fell asleep listening to the wind scour the summit ridge far above us, while bits of ice that it dislodged pelted my hammock.

On the second day we looked up at a very long strip of ice ahead of us. It was obvious that we couldn't possibly make it in one rope length to the next belay point; the ice was too thin and the rock around it too compact, offering few cracks in which to place good protection for the belayer. With no alternative, we did something I'd never done: We knotted our two ropes together to cover the 350-foot distance to our next belay.

It was my lead. I began by moving up, then diagonally across the face, off the snow and onto ice. After 200 feet of moderately difficult climbing I slammed in a good piton and clipped the rope through a carabiner. I could now climb another 160 feet before the knotted rope would jam in the carabiner. Above me, the ice was much thinner and nearly vertical. I climbed upward until I began to breathe heavily and feel the strain in my arms and calves. Traversing a few feet to the rock, I managed to hammer in one more piton. Fifty feet higher, my pack, and the 350 feet of rope I was dragging, became a burden. I thumped in my ice axes and paused for a rest. One glance back told me how far I was from the last piece of protection: I was staring at a hundred-foot fall. I looked down between my boots and saw Jeff nearly 350 feet below.

There's a great irony in climbing: If you allow yourself to lose control on a climb because you're afraid to fall off, then you *will* fall off as a direct result of that fear. And it's no easy matter to will yourself *not* to surrender to your fear.

I almost said the words aloud: *This is what I came for.* The truth was, I *enjoyed* that situation, the demands it was placing on me, the extraordinary challenge of leading with two ropes tied together. I reveled in the exposure, the lack of protection. Standing there, gazing down between my boots at nothing more than thousands of feet of Himalayan air, I trusted absolutely my ability to maintain control of the situation.

My climbing technique twined perfectly with the mental focus needed to eliminate fear, and I experienced a certain equanimity. I was tethered only to my partner and to a climbing ethic that placed the full determination of my fate in my own hands. There was only one other person who could possibly have savored that moment in the same way, and I was looking at him between my boots.

For five years Jeff had been my ice-climbing mentor, and I knew he trusted me to be able to do this kind of climb. In that moment I saw that neither of us would let the other down. Here was the payoff of years on rock in Eldorado Springs Canyon and on ice above Telluride. Both of us had been looking for Kwangde, for just this kind of climb.

It was only fitting, then, that on this climb I captured one of my most cherished mountain images. I was chopping a platform out of the ice below my hammock, anchored to the nearly vertical face of Kwangde by a couple of carabiners clipped into an ice screw and a piton. It was hard work after an exhausting day of trading leads with Jeff. I turned around to rest a moment and, looking out over the surrounding peaks, I was stunned by the magnificent sight before me. The sun had gone down on almost all the peaks; there was no light on Ama Dablam or any of the other mountains below 25,000 feet. But on those higher giants, jutting at the upper atmosphere, the sun's last rays lingered. Glowing bright on the horizon were Everest, Nuptse, Lhotse, and Makalu, and above them, the silvery gleam of a full moon in the navy sky. I'd seen them all before but never like this.

I had a little pocket Rolei 35mm camera with a 40mm pop-up lens, loaded with Kodachrome ASA 64 film. There wasn't enough light for film that slow, so I had to use a very slow shutter speed, even though it meant risking a blurry shot. Kneeling down on the foot-wide ledge, I put my shoulder against the granite wall behind me, inhaled deeply, then held my breath and squeezed off a shot. In all, I took about six or seven shots before the light blinked out on Everest, just to be sure I captured the magical image of the moon rising over a ruby-red Everest.

On our last day we wanted to strike directly for the summit. But the rock slabs were too steep, the ice runnels petered out to nothing, and there were no cracks in the rock. We were forced to climb sideways in a long, rising, difficult traverse, moving across unconsolidated, loose

snow. In places, it was like trying to hang on to cotton candy. This was the most dangerous part of our climb, because traversing means risking a particularly nasty type of fall: a long pendulum swing across the face, bouncing and crashing against the rock and ice.

The sun was gone as I pulled myself from the face to the ridge that would lead us to the summit. For days we'd been protected from the wind on the sunless north face, but now a blast of fifty-mile-an-hour wind stung my face. Worse, on the exposed ridge, in the failing light, we could see no place to bivouac. We didn't have a tent with us, only hammocks, which were just waterproofed pieces of nylon. Jeff and I struggled to hear each other's shouts and suggestions. Given the force of the wind, we had no choice but to start climbing in the night, searching for a relatively sheltered spot where we could rest. At last my headlamp shone upon an enormous piece of rotten, old snow stuck to the ridge. In the darkness and the wind it looked like home. We dug out a space in the ice about the size of a double coffin, big enough for two men to lie in. After an hour of work, we crawled inside and pulled our packs across the opening, partially shielding ourselves from the icy blasts.

The sun had gone down hours before we reached the ridge. But the next morning we got our reward. Crawling out of our shelter, stiff and sore from days of hard climbing in the cold, blue shadows, the sunlight fell on us. The warmth and light were absolutely glorious. After a half-hour scramble, we were on the summit of Kwangde.

Descent is never as simple as it sounds. For us, on this trip, it meant fifteen rappels down a different route to reach the ground, then a long slog through a vast boulder field covered in waist-deep snow—and a skirmish with dense juniper bushes thrown in for good measure. Two more days passed before we made it back to our tents in the village of Hongu. As we strode into the village, there were great shouts of delight from everyone. Children came running, dogs barked. Our sirdar, Nima Tenzing, rushed up to hug us. We didn't understand what all the fuss was about.

When everyone calmed down, Nima explained they'd all thought we were dead. We'd promised to return in a week, and had been gone ten days because of the extra time we took examining the route and, at

the end, descending. They'd scrambled to the base of the north face while we were gone, found some things we'd discarded during our ascent, and assumed there'd been an accident.

Nima and his wife, Pema Chamgee, had been with us as members of the cook staff on Ama Dablam. Pema Chamgee rushed up to me, grabbed my hands, then gestured at the sky.

"David going summit?"

"Yes," I said.

Satisfied, she turned and bustled into the stone house to make sweet tea for us.

Climbing Kwangde with Jeff was my finest alpine experience in the Himalayas. It was a pure, unadorned ascent—just two men on a mountain. And a serendipitous reward lay in my camera: One of my photos of the moonrise over Everest came out beautifully, the moon floating above the world's highest horizon. The photo has appeared in many places over the years, including the cover of *American Alpine Journal*, *Climbing* magazine, a *National Geographic* book, and in several other books as well. Whenever I see it, I'm reminded of that great climb and the camaraderie I shared with Jeff Lowe.

Within a few months after the Kwangde climb I was happily back in the Himalayas, this time with a Panasonic Recam video camera, from the ABC-TV program *American Sportsman*. John Wilcox had hired me as the high-altitude cameraman on a team that would attempt to transmit the first live images from the summit of Everest. Our intent was to microwave the images down to the Mount Everest View Hotel seventeen miles away, where they would be recorded on videotape and flown to Kathmandu. From there the images would be uplinked to New York City. We weren't going to try a satellite uplink directly from Everest to the States because, back then, most expeditions made the summit around two or three P.M., which would be two or three A.M. in the U.S. There'd be no one awake to watch that live broadcast.

We'd planned to take a route from Tibet up to the West Ridge of Everest. On the Tibetan side, trucks could drive our equipment directly to Base Camp. But the Chinese wouldn't give ABC-TV a permit. So,

three weeks before departure, we were still scrambling around for an expedition to join. Those were the days when the Nepalese government issued only one permit per route per season on Everest. Gerhardt Lenzer, a German, had a permit and had sold it to an American expedition, who allowed us to join their team. Ours was the only expedition scheduled to climb the South Col route in the spring of 1983.

Due to the permit delays, our team straggled into Kathmandu a few at a time. Rick Ridgeway and Peter Pilafian, the other members of the ABC-TV team, got there before me and started the approach march to Base Camp with the German-American team. I got to Kathmandu about a week later, and it was there that I met Dick Bass, another late arrival. It was the beginning of a long, close friendship.

Dick Bass was an engaging conversationalist and a born storyteller. He had a receding hairline above a wide-open face full of confidence, and a fifty-three-year-old body as fit as you could find. He and his friend Frank Wells, who became president of Disney the following year (and died tragically in a helicopter accident in 1994), were members of the team. Dick owned a Utah ski resort, Snowbird, and had been one of the original investors in Vail, Colorado, because he loved being up in mountain air, in the wind and the snow. Both he and Frank were avid skiers and had recently gained considerable mountaineering experience. They'd tried Everest in 1982, on the north side, but didn't get very high up on the mountain. Now they were taking a crack at the south side. Frank had gone ahead on the approach march and, as it turned out, Dick and I were the last to fly in from Kathmandu to Lukla.

Our hike from Lukla to Base Camp was like stepping into a mountaineer's library. Dick told me about his many other climbs: Denali in Alaska, Aconcagua in South America, Kilimanjaro in Africa, and Elbrus in Europe. He'd climbed five of the seven summits, the highest mountains on each continent, and had been to 25,000 feet on Everest's north side, so he knew he'd function well at altitude.

Our climb would follow the same route that Tenzing Norgay and Ed Hillary had taken. Our team would establish four camps on the route over a period of five or six weeks. As Hillary and Tenzing had, we would adapt to the altitude as we climbed to progressively higher

camps, periodically descending to sleep and rest at the lower camps. Base Camp was located at 17,600 feet. Above it lay the Khumbu Icefall and after it, Camp I, at 19,500 feet.

There are few places in mountaineering as well known as the Khumbu Icefall. It is the gateway, the key, the first and most difficult obstacle to climbing Everest from the south side. It is the only route of passage into the Western Cwm, the great long valley that leads to Everest's final pyramid. The Icefall provides a narrow corridor to the higher slopes of Everest, but this corridor is a slow-motion cascade of ice. It is, in fact, a 400-foot-thick river of ice, slowly making its way downhill, turning the corner and heading out into the Khumbu valley.

It's so starkly beautiful that at times you can't believe there's any danger but the perils are many and varied. Without warning, huge sections of ice the size of a small apartment building shift and collapse, sending thousands of tons of ice crashing down. The circuitous route we would follow through that frozen maze was so convoluted we'd need 6,000 feet of rope to gain 2,000 feet.

The secret of safely traversing the Icefall is don't be at the wrong place at the wrong time. Read the terrain, judge every step, and move as quickly as possible—or as slowly as necessary. As a cameraman, I lost the luxury of spontaneous mobility. I had to linger in places for an hour or more, and not every shot I wanted was in a safe place.

Higher up the Western Cwm, at 21,300 feet, is Camp II, or Advance Base Camp. From there Camp III sits halfway up the Lhotse Face, at 24,000 feet. Camp IV, the last camp before we set out for the 29,028-foot summit, is at 26,000 feet, in the so-called Death Zone. There's so little oxygen above 25,000 feet that the human body is unable to adapt. Every moment spent at that altitude is time the body spends starved of oxygen.

As a late addition to the expedition, I didn't expect to reach the top of Everest. But the team was optimistic about their prospects. One member, Larry Nielsen, wanted to be the first American to climb Mount Everest without supplemental oxygen. Larry wasn't physically impressive but he had enormous stamina and drive. Frank and Dick were just happy to be on the mountain. They had an agreement with the climbing team that they would be last to make a summit attempt.

Considering they'd financed most of the expedition, it was a generous gesture.

We made steady progress up the mountain, through the Icefall to Advance Base Camp and on to Camp III. Several times we returned to Base Camp to rest and recuperate. We were slowly acclimatizing as we ferried loads to the higher camps. By early May the team was ready for its summit attempt.

As I climbed to the South Col, every step I took was the highest I'd ever been. I could glance to my left and see the top of Everest with its trademark plume blowing to the east. I wanted to go there, I wanted a chance at the summit. But as a member of the film crew, I wasn't slated to be on the summit team. My duties were to videotape the climbers' arrival on the South Col and then send them on their way the next morning with the microwave equipment.

I shared a tent with the Sherpa Ang Rita at Camp IV. He was taller than the average Sherpa, about five feet, seven inches, and wore a perpetually bemused look on his face. I liked him immediately. He put up with tight quarters crammed full of microwave gear, lithium batteries, cables, and cameras. One was a compact Panasonic video camera for use on the summit, which we had tested lower on the mountain.

On the day we reached the South Col and Camp IV, the high camp, I tried to transmit an image down to the Mount Everest View Hotel, but the Nuptse Ridge blocked the transmission. I was restless, full of anticipation. Gerry Roach, who'd been selected for the first summit attempt, had asked me to join the summit team. He had taken one look at the microwave equipment that his team was supposed to carry and wanted nothing to do with it; he said that was my job. He also wanted my help with the trail-breaking up high. Finally I was going to get my chance to climb Everest.

I was apprehensive as I packed the video gear that night. Going to the summit of Everest is one of the most important days in any climber's career. Sitting on the South Col, I had no idea if I had what it took to climb the summit pyramid looming above me. The reality hadn't fully sunk in yet; probably because I'd been the filmmaker so much of this trip, the climber in me hadn't had time to reflect. I tried

to concentrate on checking and rechecking the microwave equipment. That's what I was really there to do.

Climbers planned the summit day differently then. No one left the tent until it was light, at around five A.M. Today's climbers leave before midnight. This assures that your team can make the summit by midday and avoid the late afternoon weather problems that so often arise. We left our tents at five A.M. and started straight up the gully leading to the Southeast Ridge. I followed the leader of our group, Gerry Roach, who climbed with Ang Rita; Peter Jamieson, another team member, and Larry Nielsen took up the rear. There's a point on summit day where you can either take a small gully that leads away from the direction of your ascent and up to the Southeast Ridge, or you can just keep going straight up. We inadvertently did a new direct variation, up the gully, which unfortunately meant a lot of time-consuming strenuous climbing in waist-deep snow.

By the time we got onto the Southeast Ridge, at about 27,800 feet, it was early afternoon, and we were nowhere near the South Summit. As we climbed the steep slope through knee-deep snow a mist floated in around us, the sky darkened, and it began snowing lightly. I didn't like it at all. I knew that if we had to descend in a storm we wouldn't be able to find our way back into that gully. With our footprints covered, our return path would disappear.

I called down on the radio to our expedition leader, Phil Erschler, at Advance Base Camp and told him I was turning back.

"I'm not comfortable with this weather," I said. He told me to use my own judgment.

Alone, I climbed back down to the entrance of the gully about 150 feet, then unstrapped an aluminum snow stake from my pack and drove it deep into the snow. I tied a length of red 7mm rope to it to use as a hand line and a marker. Knowing that the crucial entrance point to the gully was now well marked, I felt more secure about a return in a late afternoon snowstorm. I reversed my descent and climbed back up to the ridge.

Soon I passed Larry Nielsen, who seemed to be hardly moving in his quest to climb Everest without bottled oxygen. I caught the rest of the group near the South Summit, at 28,700 feet. We all sat down to

rest while I radioed to Advance Base Camp to tell them that I'd re-joined the team. I could see through the thin clouds down the West Ridge to Pumori and far across to the white massif of Cho Oyu, the world's sixth highest peak. Ang Rita had left his oxygen bottles and mask on the route hours before, claiming they weren't worth the weight, and was moving slowly. Peter Jamieson wasn't moving much faster than Ang Rita.

Gerry Roach and I were doing well, though, so we took the lead across to the Hillary Step, a forty-foot prow of exposed rock and ice. After the steep ice runnels of Kwangde, the climbing here seemed rudimentary, just one foot after the other, and the exposure didn't bother me. By the time we'd surmounted the Hillary Step, the sky had cleared. There was only a slight wind. As we climbed, I began thinking, *I am going to climb Everest*, and I had this sense that my life would be different when I got back. I had a tangible, conscious feeling that what I was doing was going to change my life. It had been sixteen years since I'd first seen that image of Tenzing Norgay, and now I was about to be baptized in the snows of Everest.

Gerry Roach and I reached the top first; we gave each other a big backslapping embrace. Then, just as I've done on every other trip to Everest's summit, I dug into my pack and started assembling camera gear. I had part of the microwave equipment in my pack, Ang Rita had the rest, and when he arrived on top, we began to fit it all together. There were cables to power the camera, cables to power the microwave transmitter, cables to link the camera to the transmitter.

Finally, with all the gear assembled, Ang Rita sat on the summit, right on the top of Everest, 29,028 feet, holding the microwave transmitter. When I looked up from my viewfinder, I marveled at the sight before me. Ang Rita and I occupied the highest point; nothing loomed above but the rich blue, limitless sky. It was four P.M. and the sun was low. The light was dramatic, creating shadows, a beautiful time to be on top of a mountain. The slopes had a warm glow. For the moment, the summit appeared tranquil. It seemed part of a private panorama: The wind had stopped, the afternoon clouds were dissipating, and I could see into Tibet. I felt a certain peace, the kind you feel when you've

come home after a long absence. But I knew this feeling of well-being was just a trick of the light.

Peter arrived exhausted and sat down on the summit beside us. Raw from the cold, the wind, and dehydration, my throat rattled with each breath. When I spoke, the sound came out a muffled croak. "See that?" I said to Ang Rita, pointing to the distant Mount Everest View Hotel. "Aim the transmitter there. If you move it, they'll lose the signal."

He sat perfectly still and kept the transmitter trained on the target while I filmed an incredible shot. Just as I turned the camera from a panoramic shot of the Tibetan plateau, Larry Nielsen appeared. With the great cornices that overhang the Kangshung Face as a backdrop, he was laboring to reach the summit. Larry's steps conveyed an exquisite expression of the human spirit. Every step should've been his last. What the mind wills, the body will follow. Larry had long since depleted his energy reserves; his fuel to carry on was simply his refusal to admit defeat. I filmed his last thirty steps to the top and his victorious embrace with Gerry Roach. I knew he had pushed too far, but I admired his determination.

Before he reached the top, the audio transmission had failed because it was powered by normal alkaline batteries, and they were frozen. I was disappointed, but the result was more dramatic because all our audio was via walkie-talkie. I shoved the radio at Larry after he'd caught his breath. He managed just one short sentence: "Thank you everybody, now I just have to get down from here."

I was a little worried hearing that. You could tell from Larry's body language that the top of Everest had been his finish line, and we all knew it was a long way down yet. None of us wanted to spend any extra time up there, but before we left the summit, I took some still photos of the summit team.

We left at 4:30 P.M., meaning we had another two and a half hours of light. At the Hillary Step, the sky clouded up and it started to snow lightly just below the South Summit. All of us were without bottled oxygen now. Peter wanted to rest, but we coaxed him to keep moving.

Meanwhile, Larry was stumbling and having trouble descending. I asked if he was okay, and he said, "I can't see." I had no idea why he

couldn't see. I could only imagine that it had something to do with his oxygen-deprived condition. I immediately realized just how serious a problem we had on our hands: The rest of the team would have to get Larry down or he wasn't going to get down at all. It was as simple—and deadly—as that.

We wallowed in the deep snow below the South Summit and the light was fading. Peter would sit down and refuse to move, then Larry or Ang Rita would do the same. I knew, at this rate, we'd be out there all night. I told Larry to run his hand under the strap of my pack and hang on so I could guide him down. Down we went together, lockstep by lockstep. Every few minutes, we'd stop and rest until he was ready to move again. I kept searching for that thin line of red rope marking our turn off the ridge into the descent gully. I was worried I'd walk past it and down the wrong side of the mountain, everything looked so different coming down. At last, there it was. I grabbed it and Larry and I lowered ourselves down the gully.

It was almost dark by then. I was the only one who'd brought a headlamp. I switched it on to illuminate our way to the low-angled ice slopes above the South Col. Larry hardly spoke as we retraced our steps through the knee-deep snow that we'd broken through earlier in the day. After an hour, we sat down in the snow for a rest. It was comfortable, like sitting in an easy chair. I was worried Larry wouldn't want to get up. But he always summoned up the energy for a few more steps.

On the ice, just above the South Col, there is a series of small crevasses, no more than three feet wide and several feet deep, just slits in the ice. But enough to twist a knee or break a leg if you fall in. At each one, I'd stop Larry at the edge and say, "Larry, are you ready?" Then I'd count to three and we'd step across together.

Inevitably, he stumbled and pitched halfway into a crevasse, pulling me part of the way in with him. I had a good hold and hauled him out. It was almost comical: the two of us stumbling around like drunks, above the high camp. A few more yards and we finally reached the flat featureless expanse of the South Col. But where was the high camp?

The snow was blowing hard now, and I struggled to find features on the ground that might guide us back to camp. I knew we couldn't be

far. I was looking for two lone tents in that vast windswept blackness. I knew the snow was blowing over the South Col from west to east and that our camp was on the west end of the Col. So I turned into the wind, and with Larry clinging to my pack I pulled him along. Finally I glanced up and, like twin apparitions, there were the tents. My headlamp illuminated the brown nylon rippling in the wind. I'd walked right to our camp.

My first concern was getting Larry into a tent and warming him up. Stripping off his crampons and boots, I managed to stuff him into a sleeping bag.

"I'm not feeling so good," he mumbled, just before vomiting blood. I didn't know if the problem was in his lungs or his stomach, but I knew, at the very least, he needed water. So I crawled to my own tent to find a lighter, came back, and started a stove to melt ice for him to drink.

As I sat feeding him sips of water, I could hear the voices of the other climbers faintly above the gusting wind, lost in the snowstorm—trying to find these two tiny tents. But I couldn't leave Larry in this condition to go looking for them. I rustled around in his tent to find another headlamp, then hung it with my own outside the tent as a beacon. Within the next couple of hours Gerry, Peter, and Ang Rita all straggled in.

By morning Larry's condition had improved, but he was still having problems seeing. He made it down to Camp III under his own power and eventually to Base Camp. From there he was flown by helicopter to Kathmandu for a live interview with Bob Beatty and ABC-TV.

I left Base Camp on May 11. Dick Bass finally got his shot at the summit, but his team turned back below the Southeast Ridge, at 27,000 feet. He would have to wait another year. Frank Wells didn't make it above the South Col.

Larry's harrowing experience taught me a number of things. First, it was vital to leave the high camp far earlier to avoid a nighttime descent off the summit. Second, and even more important, I learned that even on Everest one should be willing to turn back if the conditions aren't right. If I hadn't been able to set that snow stake and rope, I would have continued down and never reached the summit. I was

young and strong, and had the kind of drive that gets people to the top of the highest mountain on earth. But I had also learned life's harshest lesson: Too much drive and ambition can get you killed.

Two years later, in the spring of 1985, I went back to Everest with Dick Bass again. This was his fourth attempt. Dick is one of those individuals who could have been a world-class climber, like Ed Viesturs or Reinhold Messner, if he'd wanted. He had the gift of utilizing the thin air of high altitude more efficiently than most. He's also meticulously organized, an important quality in mountaineering. Even so, his habits used to frustrate me. Sometimes, I couldn't get him out of the tent because he'd be double-checking to make sure both water bottles were full, or that he had his sun cream and spare goggles. But it's that kind of care that helps good mountaineers survive the unexpected.

In planning that 1985 Everest trip I began to realize my friendship with Dick Bass had taken on a father–son dimension. He was fifty-five and I was twenty-eight. Dick was very formal, like my father, confident, and self-assured; but he wasn't overbearing. I thought Dick saw a bit of himself in me, a young man with energy and curiosity. We had endless discussions and he never talked down to me. We had our tough moments, but they were fair moments of disagreement, which would always end with one of us saying politely but firmly, "Well, I just think you're wrong there."

The clearest difference between my father and Dick Bass was that Dick wasn't a violent man. My father was full of bravado, but I never saw him reckoning with the consequences of his actions. On the other hand, Dick accepted the responsibility of his actions and his words. Although Dick was a natural at altitude, very fit, and with the skills to climb Everest, he knew there were consequences to being on Everest, and he accepted them before he ever set foot on the mountain. As a result, I trusted that whatever happened our Everest expedition would prove to be a rewarding experience.

Dick paid $75,000 to share the permit of a Norwegian expedition. In addition to myself, our team consisted of Dick, four Sherpas, and Karen Fellerhoff, our Base Camp manager. We had to carry all our own

loads, including my camera gear, and we operated completely independent of the Norwegian team even though we shared camps with them. Our movements up the mountain had to be coordinated with the Norwegian team's leader, Arne Naess.

I'd agreed to film the Norwegians as part of our deal to climb on their permit. The day I arrived at Base Camp, I learned that several members of the Norwegian team were going to establish Camp II, Advance Base Camp, the next day.

"This is a big part of your expedition and of your story," I told them. "You should have it on film." Looking back, I can't imagine what possessed me. I'd just arrived at 17,600 feet and was offering to climb to 21,300 feet. The next morning a Sherpa and I packed up my 16mm filming equipment and headed up through the Icefall. We climbed into the Western Cwm, past Camp I, and up to the Nuptse corner. It was brutally hot, the walls of Everest and Nuptse and the floor of the glacier focusing all the sun's rays on us. My Sherpa companion stopped in his tracks and announced, "I'm not going any further."

He'd been carrying the camera battery, and the tripod and head. I thought to myself, *This is not the way this day is going to end, after all this climbing*. So I packed his load onto my load and continued without him. At Advance Base Camp I did my interviews, shot some film, and descended all the way back down to Base Camp. It was one of the toughest days I've ever had in the mountains because I wasn't acclimatized.

After a week of filming around Base Camp and in the Icefall, I moved up to Advance Base Camp. The Sherpas and Norwegians had begun putting in the fixed ropes to Camp III. The Sherpas came back into camp that night telling us there were bodies up there and they didn't want to go near them. Sherpas are superstitious of the dead and believe that touching a body brings bad luck.

In October the previous year, Dick and I had made an unsuccessful attempt to climb Everest. Toward the end of the expedition two of our teammates, Ang Dorje and Yogendra Thapa, had tried to reach the summit. Somewhere between the Southeast Ridge and the South Col, they had fallen and died. The Sherpas had overcome their dread and gone up to bring the bodies down. But unable to maneuver them down

the steep ice of the Lhotse Face, they had left the two bodies tied to a rock outcrop between Camp III and Camp IV called the Geneva Spur.

I went out to investigate the next day, and there, several hundred yards below the Lhotse Face, spread out on the glacier, I saw parts of Ang Dorje and Yogendra Thapa's bodies. Apparently the bodies, which had been lashed to the Geneva Spur, had blown loose and fallen sometime during the winter. Because they were frozen, they'd shattered like glazed statues during their 3,000-foot tumble. I felt numb. I walked around on the glacier, trying to put them back together so that each body could be wrapped up separately and buried in a crevasse—I thought a common grave would be too anonymous. I soon realized that my efforts to reconstruct them were futile.

As I gathered their remains and placed them together in the torn tent, one of the Norwegians came up with a camera. He was a photojournalist and asked me if he could take some pictures.

I refused without a moment's pause. "These were my friends," I said. "I don't see the value in photographing them like this."

He was quick to reply. "But this is something that happens on expeditions. It's worth reporting."

I shook my head. "Just because it happened, it doesn't mean everyone has a right to see it."

It was a very matter-of-fact conversation, but I was steadfast in my refusal. To me, taking pictures of this grim scene was voyeuristic, satisfying prurient curiosity about what someone would look like after falling down the Lhotse Face. I felt that if I'd let him take those pictures, I would have betrayed my friends' trust. The dead have a right to be treated with dignity.

As the Norwegian tried to reason with me, I kept thinking of Yogendra dancing to Nepali music. He had a wonderful laugh and a gentle face. If the Norwegian photographer had wanted to join me in honoring the lives of these two men, I would have welcomed him. Letting him intrude on their deaths was out of the question.

Just the same, I could understand the contradictions between my actions as a friend and climber, and his actions as a photographer. When I was there with the bodies of Ang Dorje and Yogendra, it seemed a solemn moment. Their deaths were a part of my life, not his. If they

had been his friends, I'm sure he would have waved away an intruding camera.

The photographer gave up and walked back to camp. I roped the tent together, bundled it up, and dragged it toward a deep crevasse in the distance. When I reached the crevasse, I asked the mountain and the wind that the two men be allowed to rest in peace, then pushed the large bundle over the edge and watched it fall into the depths of the glacier.

Ten days later, on a trip through the Icefall with Sherpas ferrying loads to Advance Base Camp, I fell through the thin ice on a frozen pond up to my waist in frigid water. Hauling myself out, I took off my double boots and poured the water out, wrung out my socks, and stood shivering. I felt like a complete fool. It was only a half-hour walk back to Base Camp, but I stubbornly had my sights set on Advance Base Camp. I counted on it being hot in the Western Cwm as it usually was, but found to my dismay that it was cool and windy that day. Still wet, I shook with the cold, and arrived at Advance Base Camp coughing and shivering.

A few days later the Norwegian doctor told me I had pneumonia, prescribed antibiotics, and advised that I go back down the mountain. Despite his advice, I had no intention of leaving. The Norwegian climbers were moving very quickly—and so were we. The first team had already reached the summit, leaving only one more team to make the attempt. Soon they'd be leaving and we would have to go with them. The Nepalese wouldn't allow us on the mountain after the permit holder had left. If we were going to make it to the top this year, we had to catch up with the last Norwegian team. Sick and miserable, I spent three days in my sleeping bag and waited for Dick to join me at Advance Base Camp. Once he arrived we prepared to make a big push to catch up with the Norwegians and join them at the high camp for the climb to the top.

I knew Dick was strong enough; I'd climbed with him on Everest in 1983 and 1984. In the interest of speed, we decided to bypass Camp III and make Camp IV in a single day. That's 4,700 vertical feet, a feat

rarely accomplished by anyone except Sherpas carrying loads in advance of climbers. We set out from Advance Base Camp in the early morning of April 28. By the time I reached Camp III, the Norwegian team was just leaving for Camp IV. I was relieved to have caught them, and rested while I waited for Dick. The Norwegians cautioned me about Dick climbing so far in a day and then left. I was more worried about myself than Dick. The long rest at Advance Base Camp had improved my health, but I wasn't as strong or as confident as I had been a week earlier. At least I had no fear of the unknown. I knew I could climb Everest, I knew the route, and I knew where to conserve and expend energy. I could never have continued on with Dick had I not climbed the route before.

We finally hauled ourselves onto the South Col just after dusk, completely exhausted from eleven hours of climbing. There was no way we would be able to recover and rehydrate in time to leave with the Norwegians, who were departing in four hours. We had enough bottled oxygen on the South Col, so Dick and I decided to spend the next day at Camp IV, trying to rest. By donning our masks and breathing bottled oxygen we could briefly ward off the debilitating effects of an extra day at 26,000 feet. (It also meant that I had respite from Dick's nonstop chatter.) We would start our summit push late that night. As we rested and rehydrated, the Norwegians climbed to the summit and we watched them stagger back to their tents one at a time. I was envious that they could now descend, exhausted but relieved of the tension and apprehension that precedes an Everest summit attempt.

Just before midnight three of us set off for the top: Dick, Sherpa Ang Phurba, and me. Thankfully, the trail the Norwegians had broken in the snow was mostly intact. Parts of it were drifted in, so Ang Phurba and I took turns breaking trail. The sun had just risen as we gained the Southeast Ridge, but as we broke trail and plodded up to the South Summit thin clouds billowed up around us. We got ourselves to the South Summit and stood staring at the traverse to the Hillary Step. There were no fixed ropes across the traverse and we weren't roped together. I was relieved to see that a fixed line hung forty feet down the Hillary Step.

1

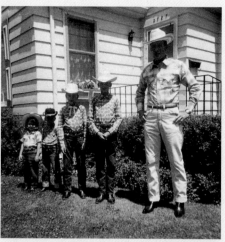

2

My father, William Breashears, and mother, Ruth, in Washington, D.C., 1947.

The Breashears family in Cheyenne, Wyoming, in 1961. *Left to right:* Lisa, me, Bill, Stephen, and Dad.

Boy Scout camp, Ben Delator, Colorado, 1969.

3

4

At age fifteen, departing for my
NOLS course in the Wind River
Mountains with my new Kelty
pack, July 1971.

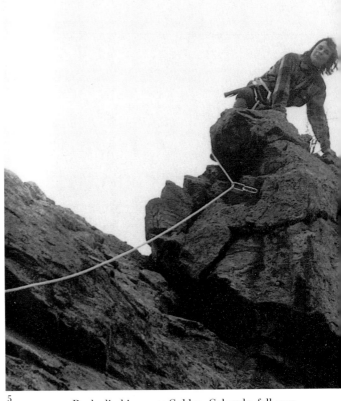

5 Rock climbing near Golden, Colorado, fall 1971.

Bouldering on Flagstaff Mountain, west of Boulder, summer 1975.

6 7

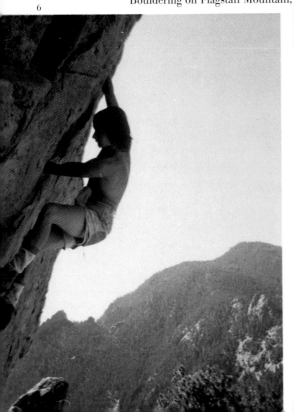

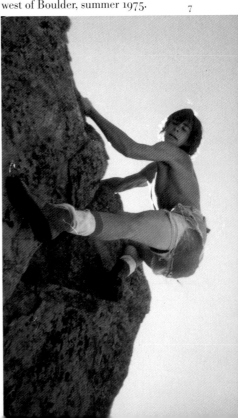

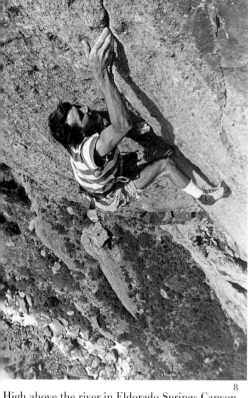

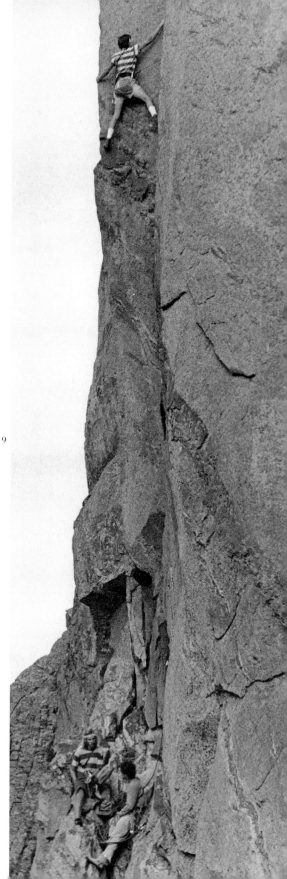

High above the river in Eldorado Springs Canyon, the first pitch of the Naked Edge, 5.11, July 1975.

At the crux of the first pitch of the Naked Edge.

Attempting the Psycho roof, 5.11, with Steve Mammen, Eldorado Springs Canyon, July 1975.

11

13

Left: Hanging from the fixed ropes on the Northwest Face of Half Dome, 1,500 feet above the ground. I was assistant cameraman to Tom Frost.

16

Waiting out the bad weather in Yosemite Valley, en route to filming on Half Dome, spring 1976.

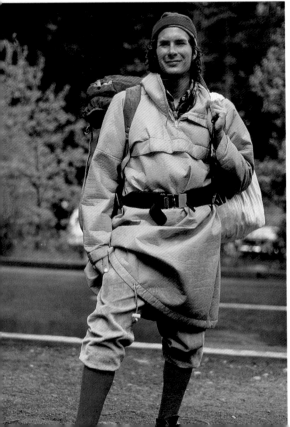

12

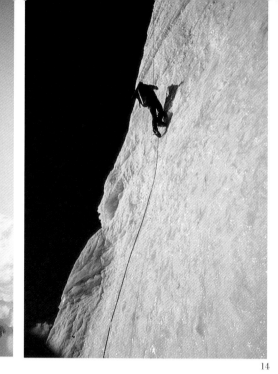
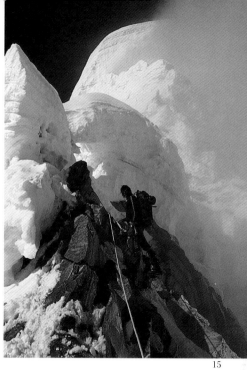

14

15

Above left: Climbing the fixed ropes below the ice head wall, 20,000 feet, on Ama Dablam.

Above center: Jumaring up the ice head wall, 20,600 feet, just below Camp III, April 1979.

Above right: Rappelling down the Yellow Tower, 19,800 feet, the day after our descent in the dark.

Below: The early evening view from Camp II on Ama Dablam, 19,600 feet.

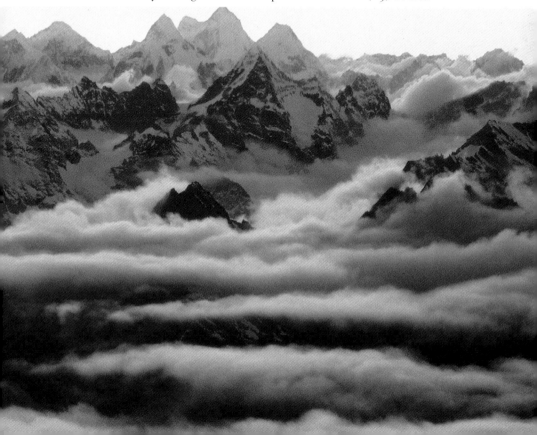

17

Above: Kangshung Face Base Camp, 17,000 feet, September 1981.

Above right: Receiving instructions in filmmaking from Kurt Diemberger at Base Camp with the Kangshung Face behind.

Right: The gigantic avalanche that fell 8,000 feet down the Kangshung Face, flattening Advance Base Camp at 17,700 feet.

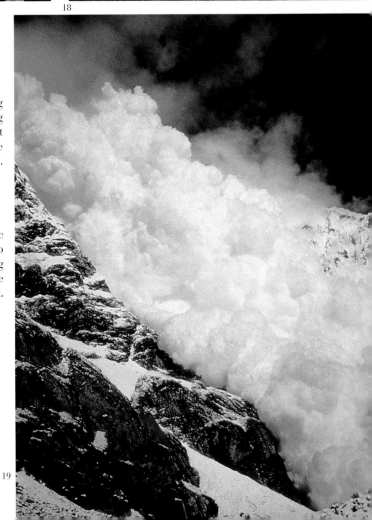

19

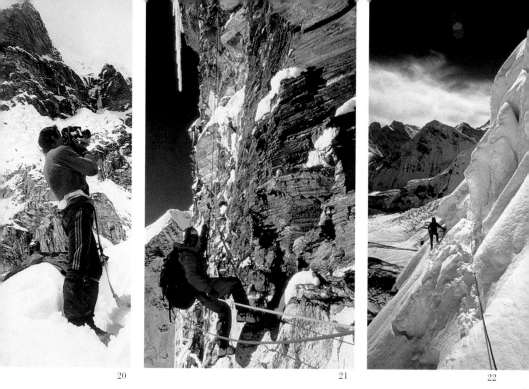

20 21 22

Above left: Filming on the corniced ridge at 19,000 feet. The Buttress is directly above my left shoulder.

Above center: Kim Momb on the free-hanging fixed ropes at the top of the buttress, 21,000 feet.

Above right: A team member traversing the fixed ropes at 19,400 feet,
above the Kangshung Glacier, September 1981.

Below: Climbing into the mist of the Bowling Alley, 20,000 feet.

23

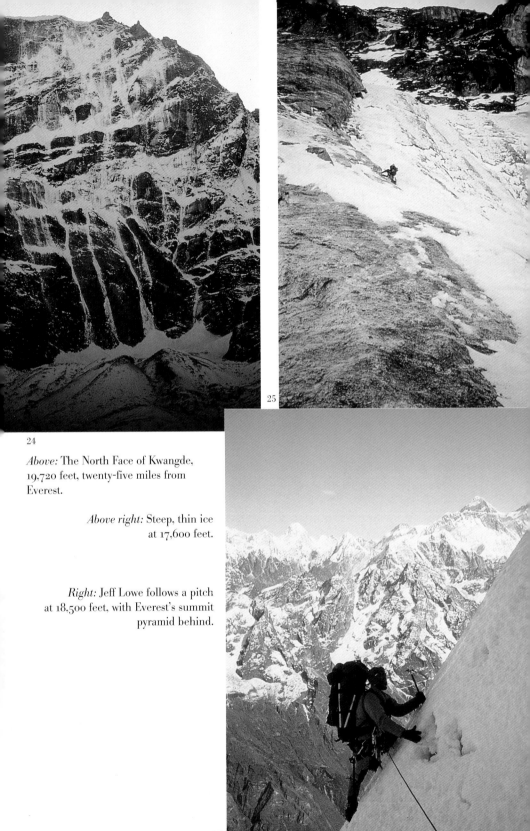

24

Above: The North Face of Kwangde, 19,720 feet, twenty-five miles from Everest.

Above right: Steep, thin ice at 17,600 feet.

Right: Jeff Lowe follows a pitch at 18,500 feet, with Everest's summit pyramid behind.

25

26

Sunset on the
Southwest Face
of Everest.

The 1983
German/American
Everest Expedition
at Base Camp,
17,600 feet, Nepal.

Climbers in the vastness
of the Western Cwm,
19,800 feet. The West
Shoulder of Everest is
to the left, Lhotse is in
the center, and Nuptse
is to the right.

27

28

29

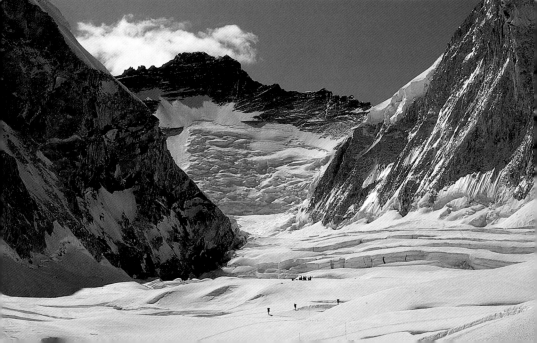

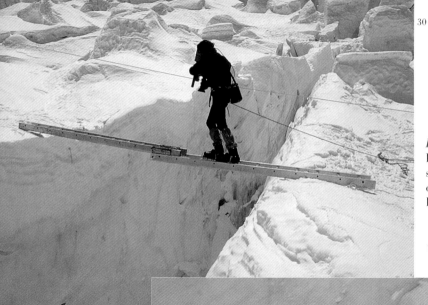

Left: Shooting a
POV (point of view)
shot of crossing a
crevasse in the Ice
Fall, 19,000 feet.

Below: Shooting the
up angle from inside
the same crevasse.

Below left:
Peter Jamieson and Ang
Rita on the summit of
Mount Everest, 29,028
feet, May 7, 1983. Ang
Rita, who is unfurling
the Nepalese flag,
would go on to climb
Everest ten times.

Below right: Gerry
Roach on the
uncluttered summit of
Mount Everest, the
same day, with Peter
Jamieson on the left.

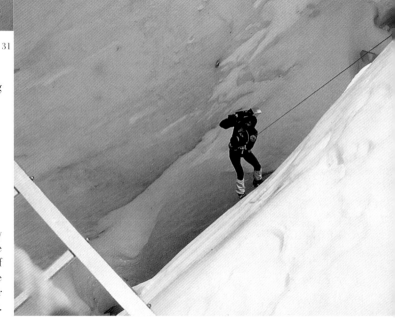

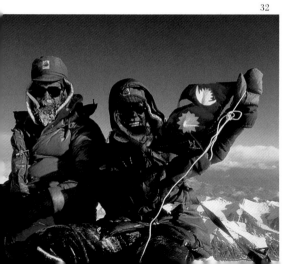

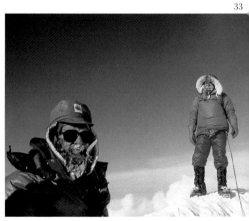

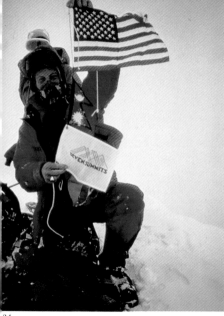

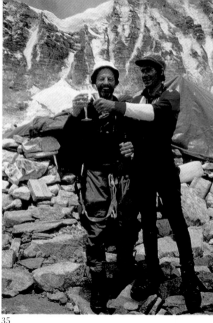

34

35

Above left: Dick Bass on the summit of Mount Everest, April 30, 1985. Ang Phurba stands behind him.

36

Above right: Dick Bass and I celebrating our summit success at Base Camp.

Right: Veronique Choa rock climbing on Cannon Mountain, New Hampshire.

Below left: Leading Drop Line, Franconia Notch, New Hampshire, winter 1983.

Below right: Soloing steep ice, Crow Hill, Massachusetts, winter 1983.

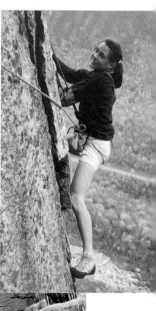

37

38

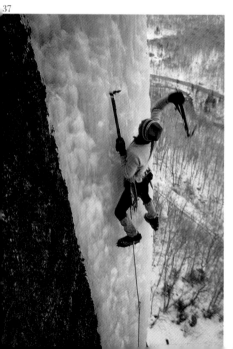

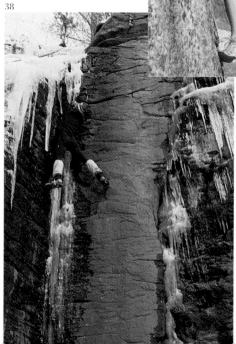

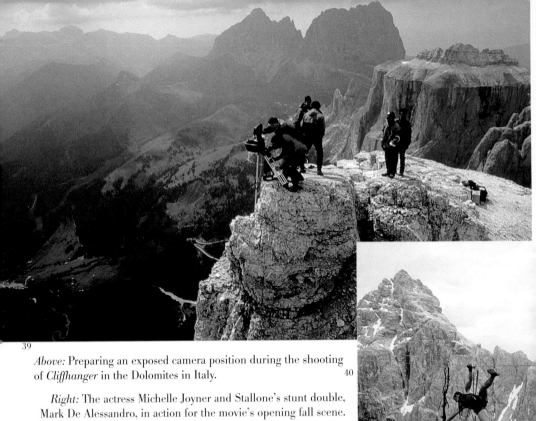

39

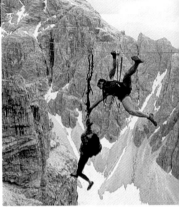

40

Above: Preparing an exposed camera position during the shooting of *Cliffhanger* in the Dolomites in Italy.

Right: The actress Michelle Joyner and Stallone's stunt double, Mark De Alessandro, in action for the movie's opening fall scene.

Below left: At my camera position on the wall of the tower of Torre Divise, a four-foot-by-four-foot aluminum ledge 500 feet above the ground.

Below right: My camera's-eye view between the towers as Gea Phipps is prepared for her 400-foot drop on the descender rig.

41

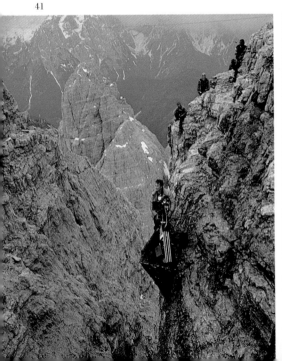

42

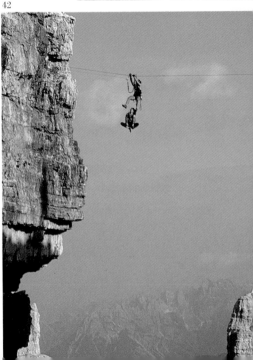

43 Araceli Segarra.

44 Jamling Tenzing Norgay.

45 Robert Schauer.

46 Ed and Paula Viesturs.

47 Sumiyo Tsuzuki.

48 Wongchu Sherpa.

49

The Sherpa camera team. Jangbu Sherpa is on the left.

Below: The *Everest* IMAX Filming Expedition at Base Camp.
50

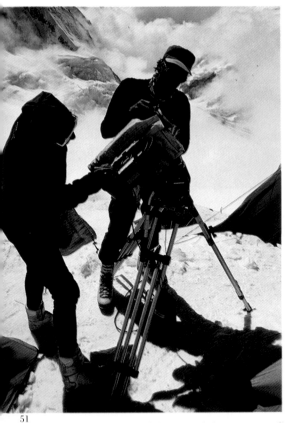

Above: Passing Rob Hall on fixed ropes below
Camp III, the last time I saw him alive.

Above left: With Robert Schauer and the camera at Camp III, overlooking the Western Cwm, 24,000 feet.

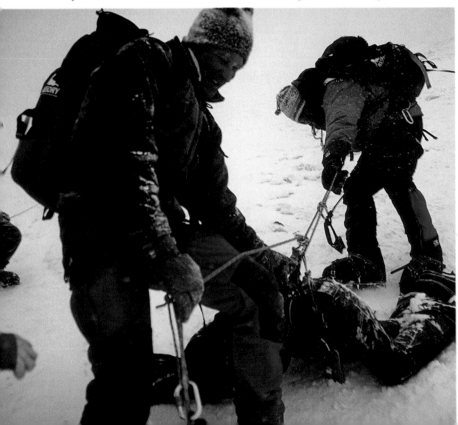

Left:
Bringing
Chen
Yu-Nan's
body down
the Lhotse
Face with
Ed Viesturs,
May 8, 1996.

54

55

56

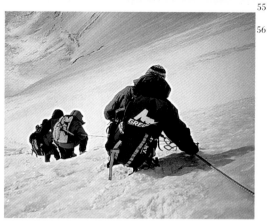

Above: In Rob Hall's Camp II communications tent talking with Rob, who is stranded on the South Summit, 28,700 feet, in the early morning of May 11, 1996.

> *Above right:* The first time I saw the severely frostbitten Beck Weathers after his ordeal at Camp III, May 12, 1996. I'm holding a cup of tea to his lips so he can drink.

> *Right:* Evacuating Beck down the Lhotse Face, May 12, 1996. Beck braced his frostbitten hands on my shoulders for support.

Below left: Sunset on the South Col at Camp IV with the summit pyramid behind, May 22, 1996.

> *Below right:* Jamling Tenzing Norgay approaching the Balcony, 27,600 feet, May 23, 1996. The South Col is below.

57

58

59

Our team on the traverse from the South Summit to the Hillary Step
and the summit slopes, ten A.M., May 23, 1996.

61

60

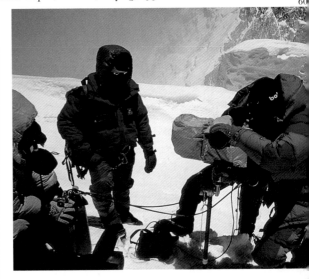

Above: At last, on the summit with the IMAX camera balanced
on a monopod, with Robert Schauer, filming the arrival of
Jamling Tenzing Norgay and Araceli Segarra.

Left: Ed Viesturs on the summit of Mount Everest,
29,028 feet, for the fourth time, his second ascent
without supplemental oxygen.

Dick had accepted that there would be no handrail for him and that I had no intention of slowly belaying him across the traverse: It simply wasn't safe or feasible. Being roped together here meant if either of us fell he would pull the other off to our deaths. He could either cross the exposed traverse as a climber, with his ice axe in hand and faith in his ability, or he could turn around and go down. I crossed the traverse first and waited for Dick at the Hillary Step. He came across slowly but without difficulty. Ang Phurba climbed the Step first and as I followed I untied a section of the fixed rope and threw it down to belay Dick up the Hillary Step because I now had a solid belay stance.

A mist had swirled in as we headed for the summit and it was impossible to see the upper mountain. Forty-five minutes later we all stood on top. I was too weary to celebrate and there was no view to revel in; we couldn't see more than a few hundred feet. I was concerned about Dick and only wanted to head down. It was noon, and he'd been using oxygen at a higher rate than I'd authorized, so by now he was low. At the top I took a few still pictures, and shot thirty seconds of 16mm film of Dick.

Suddenly, Ang Phurba, who didn't speak much English, indicated he was having trouble with his eyes. I'd seen him fiddling with his goggles on the way up, clearing snow from them. I figured that he sensed the onset of snow-blindness. He wanted to go down while he could still see. I asked him to leave his partially full oxygen bottle on the South Summit for Dick. Without another word he disappeared into the mist on his descent, and I didn't see him again until Camp IV.

I gave Dick my oxygen bottle on the summit. I hadn't needed bottled oxygen to descend in 1983 and I didn't need it now. I would move slightly slower without it, but it would still be easy to keep up with Dick. Looking into the mist I felt very lonely. Now it was just the two of us at the top of the world—we were utterly alone. As I descended behind Dick, he moved slowly but steadily, taking great care in placing his crampons. We dropped down the Hillary Step and retraced our route across the traverse. But a few hundred feet below the South Summit he ran out of oxygen again. Now he couldn't move more than fifty or sixty feet without sitting down to rest. Ang Phurba, in his rush to

reach the South Col before he lost his vision, hadn't left his oxygen bottle on the South Summit. We were now without bottled oxygen.

Dick had stopped talking, but at one point he stammered that he might be too tired to descend. It was an awful moment—I was completely unprepared to hear those words. It was only 1:30 P.M.; a half hour earlier he'd been moving well but now he didn't want to get up. Sitting next to him it occurred to me that I, too, was extraordinarily tired. I still had some remnants of pneumonia, and hadn't been breathing well all day. It was then that I remembered the bottle of oxygen I'd left at the gully just below the Southeast Ridge. I'd taken it off, left it, and put on a fresh one for the push to the summit. It was only one-third full. I told Dick we'd only rest standing up now. I thought as long as he was standing I could keep him moving.

Arm in arm, we began our descent, our efforts focused on getting to a yellow life-giving bottle 300 feet below. I wasn't sure it would be there. In desperation, Ang Phurba possibly had used it for his descent. After stumbling through the thick fog below the summit, I could suddenly see all the way down to Camp IV: We'd walked out of the mist. It was now a windless clear afternoon; it seemed almost warm. I reached the gully ahead of Dick and there lay that precious bottle. Dick took a few final steps and sat down. I maneuvered him between my legs and hooked up his regulator to the bottle and turned it on as he placed his mask back on his face. I kept giving him big reassuring hugs, telling him it was all going to be okay now. Within a few minutes his entire body language changed and he appeared remarkably rejuvenated. He stood up and we began an agonizingly slow descent to the South Col.

I didn't mind stopping to rest on the little terraces and ledges along the way. The day had been transformed by that bottle of oxygen and the sun was shining now. Still, I felt all used up and I was mindful how tricky the terrain was. Yogendra Thapa and Ang Dorje had fallen somewhere near the route we took. I was thinking about them as we descended.

Looking down the slope toward our camp, I saw a figure emerge from a tent and begin walking toward us. I couldn't imagine who it could be, as the Norwegian team had descended and Ang Phurba was

most likely collapsed in his tent. As the figure got closer I saw it was Ang Rita, and he was carrying a thermos. My friend from the summit two years earlier had waited on the South Col instead of descending with his team. It was a generous gesture and meant so much to me: He had been worried about us. When he reached me, I stopped in my tracks and sat down, 300 feet above Camp IV, and drank the sweet, milky Sherpa tea. Dick joined us, and we all sat, quietly sipping. The excruciating tension of the day began slipping away. We were safe. It was one of the happiest moments I've ever shared on a mountain, and Ang Rita is the person I've been most grateful to see, with his thermos of sweet tea.

By now I was getting a reputation as a man who could use both an ice axe and film camera with equal ease, and more opportunities to combine the two skills arose.

I went from body retrieval and my concerns with photographing the dead in 1985 right back to issues of body retrieval and photographing the dead in 1986. My assignment was to make a documentary about the early British attempts on Mount Everest for the BBC, focusing on the disappearance of George Mallory and Andrew Irvine on the Northeast Ridge of Everest in 1924. The film was called *Everest: The Mystery of Mallory and Irvine.*

On our film team for the BBC documentary, we had with us Tom Holzel, who wanted to find Mallory's camera. Andrew Harvard, my companion on the Kangshung Face, was our expedition leader and co-producer. Irvine's ice axe had been found on the Northeast Ridge many years before. In addition, a Chinese climber had reported seeing, on a terrace several hundred feet below the ice axe, a body which he described as "English dead." Tom knew that Mallory had been carrying a pocket-sized Kodak camera. Since no camera was found in the tent at Mallory and Irvine's high camp, it was reasonable to speculate that Mallory took it with him on the day of his summit attempt. If Mallory and Irvine had reached the summit, it was likely he had taken a summit photograph. A summit photo would prove he had beaten Hillary and Norgay to the top of Everest by nearly thirty years.

Tom was determined to find that camera and Kodak was happy to offer advice. They told us that because of the cold, dry conditions at 27,000 feet, there might still be a usable image on the film. If we found the camera, our instructions were to seal it carefully in a foil packet and bring it down the mountain and back to the U.S. for developing.

Everyone was excited about the project, but I was skeptical, not only that we could find Mallory's body and camera, but that there would be a summit photo as well. Given what we knew about Mallory and Irvine—the clothes they were wearing in that lethal cold and wind; the oxygen apparatus they were using; their rate of climb; and the difficulty of surmounting the Second Step, a steep cliff at 28,800 feet—I was sure Mallory and Irvine couldn't have made it to the summit. But even if we were unsuccessful at finding the answer to the most famous mystery in mountaineering, the search and the story were sure to make a good film.

I started the trip in London with British historian and writer Audrey Salkeld. We jumped in her old blue VW Bug and drove northeast to Cambridge to talk to the last person who'd seen Mallory and Irvine alive, Professor Noel Odell. Odell, who was in his nineties, told us of stopping to rest at 25,700 feet on the North Ridge and looking up to see two tiny figures, Mallory and Irvine, slowly climbing toward the Second Step, only 300 feet below Everest's summit. Then mist obscured his view and they were never seen again.

Audrey and I then drove south to the village of New Romney on the salt marshes of Kent. There we met the great pioneering Everest filmmaker Captain John Noel. He'd filmed the 1922 and 1924 British Mount Everest expeditions. The 35mm black-and-white footage he shot with his spring-wound movie camera is an unparalleled record of early high-altitude climbing. In 1913 he had illicitly traveled to within sixty miles of Everest, his face darkened in disguise, when Tibet was closed to foreigners.

Captain Noel was also in his nineties when we interviewed him. He entertained us with theories about the climbers' disappearance, his days on Everest, the special doubled-walled film-developing tent at Base Camp that he heated with stoves burning "dung—yak dung." It sounded almost charming in his British accent. He had a droopy eye-

lid, and he wore a fisherman's cap and several thick sweaters, but you could still see the power in his thick shoulders, and he was spry enough to climb up and down the steep ladder staircase to his bedroom on the second floor.

Now it was our turn to try to solve the riddle. China was by then regularly issuing climbing permits to foreign expeditions going through Tibet. The door had also opened for small groups of independent travelers. Half of our team flew into Kathmandu and drove trucks loaded with our gear to Shegar. I flew with the rest of the group to Lhasa. The last time I'd been in Lhasa, in 1981, we'd stayed in Guest House No. 3 in the army camp outside town. This time, we were in the new Lhasa Hotel, run by Holiday Inn. A huge covered entryway introduced the marble lobby with a giant mural of Everest on the back wall. It was everything my earlier stay in Lhasa had not been: luxurious with creature comforts. I would've preferred the army guest house.

On the way to the hotel, we passed three cross-country cyclists, a rare sight in that part of the world. They were wearing matching yellow cycling outfits, and pedaled early-model mountain bikes with knobby tires and panniers loaded with gear. As I walked into the sparkling lobby of the Lhasa Hotel, there they were again, covered with dust, unloading their bikes. I could see that one of them was an incredibly fit-looking woman in her early twenties. Her dark hair was about a half-inch long and she was gorgeous.

We were all staring at them, betting on whether they were Americans or not. I walked over.

"Are you the people we passed on the road coming in?"

She said they were. Her name was Veronique and she was from New York City. She was half-French and half-Chinese, had recently graduated from the University of Pennsylvania with an undergraduate degree in anthropology. Now she was traveling Asia with her boyfriend and another fellow. They'd put together some kind of charity trip, raising money by riding their bikes from Chengdu to Lhasa. They'd been riding for six weeks and were here for a brief touch of civilization, a shower and clean sheets, before they carried on to Kathmandu.

We were all impressed with how fit those three were, riding their bikes up from the lowlands onto the high Tibetan plateau. It was

tough going on poor roads and took a lot of guts to ride a bike across that part of Tibet. I don't know who invited them, but there was no question that we all wanted them to come to Base Camp. "Come on up to Base Camp and we'll show you around the mountain," someone said, and threw in the promise of a bottle of Johnnie Walker Red Label as extra enticement.

A couple of weeks later, they pedaled into our camp, crossing over the Pang La, a 17,200-foot pass. There wasn't a man on that team that wasn't enamored of Veronique, myself included. She was urbane and sophisticated, but here she was—at Base Camp—having ridden her bike across Tibet. It was an utterly beguiling combination. I enjoyed having them at Base Camp. Their unencumbered bicycle trek across Tibet reminded me of my ascent of Kwangde with Jeff four years earlier. Now I was on a mountain weighed down with responsibilities as director and cinematographer, with none of that youthful sense of adventure I'd found on the steep ice of Kwangde.

Veronique and her companions, Keith and Tim, were strong and well acclimatized from their weeks crossing high passes in Tibet. We invited them to come up to Advance Base Camp at 21,300 feet. It was a strenuous twelve-mile hike, but the route was easy; even the yaks go that high on the north side of Everest. They stayed a few days, joining us in our dining tent, introducing humor and a different view of adventure and Everest into our worn conversations. I was enchanted by Veronique's lack of artifice. She saw nothing exceptional about riding her bike 1,500 miles to Everest Base Camp and then hiking to 21,300 feet. She'd been raised to respect achievements of the mind, not of sinew.

I soon had to turn my eyes back to Everest. We had established a camp at 23,000 feet on the North Col, and it was time to continue on. Veronique's eyes were on Kathmandu, fresh food, a warm hotel, and the end of their adventure. I didn't want her to leave and tried to invent a position on the film crew for her. My effort had all the sophistication of a schoolboy with his first crush. As I stood at Advance Base Camp watching Veronique's distant figure recede down the moraine, I promised myself I would see her again.

Aside from Veronique, the person who has stayed on my mind from that expedition is Sherpa Dawa Nuru. He'd been on the Norwegian team in 1985, and because he was, I'd personally selected him for my team in 1986. If you stop long enough to listen, the mountains always have something to teach you. If I had to name the one thing I gleaned from Everest that year, it would be what I learned about wind. The winds in 1986 were ferocious; they showed us the power and fury of the mountain and how fragile we are.

It was now mid-September, which on Everest is ordinarily characterized by relatively calm weather, since the jet stream has moved off to the north during the summer. But not this fall season. The jet stream winds had moved south early, to stream across the summit like a huge river scouring the upper slopes. Jet stream winds are not like storm winds that come up suddenly. They're a constant force, relentless, unyielding.

We fought the wind every single day of that expedition. From Advance Base Camp, we looked up the Northeast Ridge in awe of the great sheets of blowing snow, ripped from the rock. Several attempts to establish Camp IV on the ridge at 25,500 feet had failed. Finally, I took three Sherpas with me, determined to get that camp in. At 25,500 feet, we climbed directly into the heaviest winds. The hours of pushing against the blasts were exhausting and, finally, near a spot where we knew the British team had camped in 1924, we found a patch of uneven, rugged terrain where we could pitch our tent.

It should be simple to get the tent out of the bag and assemble it. But at 25,500 feet, with no supplemental oxygen and the jet stream wind howling around you at sixty miles an hour, even removing the tent from the bag is a challenge. Then you have to keep track of the bag, pull out the fly sheet, put the fly sheet in a pack, and put rocks on the pack so it won't blow away. Finally, you pull out the tent itself and the poles, which are assembled crisscross to form a dome-shaped shelter that in theory can withstand high winds.

That evening, as the sun was setting, the three Sherpas and I knelt on the tent as it snapped around our legs, trying to assemble three different lengths of slippery aluminum tubing without dropping one

down the mountainside. We finally got the poles through the correct sleeves on the tent only to discover that we'd created a huge nylon sail. It took the four of us at least an hour to wrestle that tent to the ground and secure it.

Sometimes the best anchor for a tent is a human body. I crawled inside and realized that because I'd rested my weight on my right knee for the last twenty minutes as we'd finished putting up the tent, I'd cut off the circulation to my foot. I spent most of the night trying to warm it up. Sleep was impossible anyway. The howling of the wind as it scoured the vast North Face was unnerving. Every now and then we'd hear a crack or a pop, like a firecracker, against the fly sheet of the tent. I looked out and chunks of ice the size of Ping-Pong balls were whipping by the tent walls. We sat with our backs to the tent wall to keep it from bending in and collapsing, or ripping off the ledge with us in it.

In the morning the wind was still beating at the tent. We'd hoped to spend the night at this camp, then climb higher the next day to dump supplies at the high camp, Camp V. But we knew that in that wind, we simply couldn't climb any higher. Instead, we decided to leave Camp IV and go back to Advance Base Camp to wait for a break in the wind. As the three Sherpas and I started down the mountain, I looked back to see that the tent we'd struggled so hard to put up and anchor was already flattened by the wind and beginning to blow away.

At Advance Base Camp we continued waiting for the jet stream to move off the peak. It was now mid-October and we really couldn't expect much change. Dawa Nuru, Mike Yeager (a climbing team member who lived in Kathmandu), and several other Sherpas were up on the North Col at 23,000 feet waiting to make another attempt at establishing Camp IV. The wind was blowing loose snow directly over the North Col and depositing it on the lee slope, which was the slope we had to climb to reach the North Col camp. Even on clear days the wind-deposited snow builds up, creating a dangerous avalanche condition known as soft windslab.

Several days later four Sherpas decided to head down from the North Col. There'd been no radio calls, and as far as I knew, they weren't supposed to be descending. I looked up puzzled, to the North Col, over a mile away: Two Sherpas were standing motionless, a third

was climbing back up to the North Col, and the fourth was nowhere to be seen. Finally the Sherpa going back up reached the North Col and Yeager radioed down. There had been an avalanche and someone was buried. I started out immediately with Ang Phurba, the Sherpa who'd been with me on the summit in 1985.

Three hundred feet up from the base of the North Col, we found the Sherpas, fixed in their tracks. They'd been there for two hours, hanging on to the remnants of the fixed ropes. They were fearful that any movement would set off another avalanche.

I saw an arm sticking up out of the fresh avalanche cone at the base of the North Col. Ang Phurba and I scooped a few inches away from the face of the buried Sherpa. I turned his head, it was Dawa Nuru. His soft hazel green eyes were open. He was a really lovely man, a gentle man with a wife and three sons. I couldn't be sure exactly how he had died; it didn't look as if he'd suffocated. It was more likely he'd broken his neck. The avalanche hadn't fallen very far—probably less than 200 or 300 feet—and his body was just below the surface. I knew Dawa Nuru hadn't been dead for long because his eyes hadn't begun to cloud over. I was struck by how serene a person can look when they die. There was no look of horror on his face, no sign of pain, just a calm bewilderment.

I radioed down news of the death. We put his body into a sleeping bag and alternately dragged and carried him down to camp. Along the way I felt strongly that this event involved our whole team, our whole expedition, and that it needed to be documented. I went ahead to Advance Base Camp and set up the camera to shoot the group bringing him down. Completely wrapped and bound in a sleeping bag, Dawa Nuru was unrecognizable as they pulled him into camp. I would never have put a camera to his face in death but, somehow, to my own arbitrary way of thinking, it felt right to document his last descent from this mountain.

Back in Advance Base Camp we placed his body in a tent. I'd known Dawa Nuru better than any of the Westerners; it was I who had requested that he be here on this trip. I went into the tent and sat with him. We'd had such a tough time on the mountain with the weather and the wind and snow. It just seemed so awful to end like this. I sat for

a long time thinking about why this had happened, and why it had happened to him, but I didn't have any answers. I just sat there feeling ashamed and bitter. Ashamed that a fine man who was here only to earn a wage now lay dead. And bitter toward that remorseless, hateful wind. In the end I decided to go down the mountain with him, to help carry his body to Base Camp.

The next day we ordered yaks to be brought up, and in the meantime several Sherpas and I started down with Dawa Nuru's body. We could carry him only five minutes at a time and then we had to put him down and rest. The next day as we continued our descent the yaks met up with us and carried our friend all the rest of the way down to Base Camp. We sent word to the monks at the Buddhist monastery at Rongbuk, a few miles down valley. While the monks were preparing his body for cremation, the traditional funeral ceremony for the Buddhist Sherpas, we sent our jeep to a village to buy firewood for his pyre, because we were still above the tree line.

Before dawn, Dawa Nuru was placed in our jeep and driven several miles down the valley to the Rongbuk nunnery a few miles from the monastery. There, amidst the ruins created by the madness of the Cultural Revolution, the monks had prepared a four-foot-high pyre of carefully layered stacks of wood. The body of Dawa Nuru was placed on top and we gathered at a respectful distance. At sunrise, a lama lit the pyre. It was a crisp, clear, late-October morning. No one said anything, no one knew what to say. I had no morbid fascination with this dreadful occasion, just a deep sense of loss. The fire burned high and hot, a crescent moon hung overhead, and the air filled with the thick smoke of burning juniper. An hour later, all that remained of my friend were a few bones and some ashes.

I returned to Advance Base Camp and waited for the wind to abate, but I no longer had the will to climb or film. It had disappeared with the smoke from Dawa Nuru's pyre. We never got back to the North Col; in fact, we abandoned our camp there. As more snow blew over the ridge, the avalanche danger increased and we couldn't go back up and risk lives just to retrieve gear. It became clear that we wouldn't find Mallory, nor would we come even close to reaching the summit of Ever-

est. After sixty days of battling the winds and now our sorrow, we left for Kathmandu.

There I met Dawa Nuru's brother, who would help his brother's widow take care of her three sons. Our team leader, Andy Harvard, and I set up a fund for the boys' education, to which many have contributed. It was a moral obligation we both understood, the somber consequences of our expedition.

I tried over and over to understand Dawa Nuru's death. I reviewed all the events leading up to that moment, human and natural. From one point of view, the wind was the culprit. It had produced the dangerous snow conditions that led to the avalanche. I remembered crouching in the tent with my back to its wall at the high camp we'd tried unsuccessfully to establish, pummeled by each gust, feeling utterly helpless.

Death on Everest comes in many forms. It can come in the powerful winds that rake the summit. It can come from the thin air stealing your ability to heat yourself and to think clearly or simply sapping your will to survive. It can come in the form of an innocuous little snowslide like the one that took Dawa Nuru's life—a shrug of the mountain, a tiny slough of snow, and you are gone.

I thought about the powerful effect of the mountains on human imagination. If ever there was a mountain that can temper human arrogance and teach humility, it's Everest. Whatever name you want to give it, the Nepali Sagarmatha, or the Tibetan Chomolungma—the Mother Goddess—or the British surveyor general's name, Everest, the mountain is a massive, living presence that changes every day. With the terrible winds of 1986, it seemed that Everest was intent on showing us how fragile we truly are. Nor did the winds relent. Over the next year and a half, only two climbers would reach the summit of Everest.

STRANGE WINDS

Nameless Tower, Karakoram, Pakistan.

After Dawa Nuru's death I began to understand that even though I'd climbed Everest more than once, and might return to it again, it wasn't just another goal I could reach and then rereach, and then forget. I felt a deep inner pull toward Everest. It had become—and remains—my interior landscape. For me, the mountain had taken on a rich and vital life of its own.

Every aspect of the mountain fascinated me. In 1987 I was offered the chance to see Everest in a totally new way. The PBS science series *NOVA* was interested in a film I'd proposed about the mapping and measuring of Everest, and I was eager to be the eyes through which the world could step back and reexamine this magnificent mountain. The challenge was to try to see Everest the way Westerners had first seen it a century ago.

I found myself studying history, math, optics, and surveying techniques to understand the Western beginnings of the mountain, rooted in British colonial history. No matter where they extended their empire, the British immediately took surveys and made maps. Roads, railroads, and trade routes followed. If British mapmaking had strategic and commercial value, it also served to measure the planet. The Survey of India wasn't initially directed at finding mountains and assessing their height. It had to do with something called the Great Arc of India, that is, measuring an arc of longitude that would accurately describe the size and shape of the earth. The Great Arc project had been started by the British in the 1700s, in the southern tip of India. George Everest, surveyor general of India from 1830 to his retirement in 1843, oversaw the survey's progress north, to the foothills of the Himalayas. It was a singularly monumental undertaking.

My goal in filming the *NOVA* documentary was to see Everest the way the earliest surveyors viewed it, from one of the surveying towers constructed of mud bricks. Hundreds of thirty-foot towers, or stations, had been built throughout India for the sole purpose of achieving a line of sight with other stations or points not yet on the map. The British surveying teams placed an instrument called a theodolite on top of each of the stations to take their exacting measurements. Nepal was closed to Westerners, so the survey teams worked along the Indian side

of the India-Nepal border, in a region called the Terai. It was from there, in the winter of 1849–50, that they measured a blip on the northern horizon which they designated Peak XV. It was 110 miles away. At the time, they had no idea it was the highest mountain on earth, though a mountain worthy of that superlative had to be out there somewhere. The calculations from those measurements, which defined Peak XV as the highest point on the globe, would not come until six years later.

The discovery of the planet's highest point stirred imaginations around the world, but as far as the Survey of India could ascertain, the peak had no local name. In 1865, Andrew Waugh, then the surveyor general of India, named the peak in honor of his predecessor, George Everest.

For the first forty-eight years that Westerners were aware of the significance of its height, Everest existed as an abstract concept, an imagined mountain. There were no paintings or photographs, no shape or form for the mountain that rose to the point designated Mount Everest on the survey's map. It wasn't until 1903 that Claude White photographed the tremendous bulk of Everest from ninety-four miles away in Khamba Dzong in Tibet.

I wanted to peer up at that imagined mountain as those surveyors had, although my lens would be a telephoto lens rather than the lens of their theodolite, which inverted the image. Placed atop any one of the towers, my camera would re-create their initial sighting of the peak from 110 miles away. I was willing to do virtually anything to get that shot. During my research in Dehra Dun, the headquarters of the Survey of India, the surveyor general told me that some of the towers still existed. One in particular was said to stand at the northern border of the Indian province of Bihar, near the tiny hamlet of Nirmale. It's one of the poorest areas in India, impoverished and malaria-ridden. Before I went there, I'd been amply warned about bandits, called dacoits, who stalked the roads on motorcycles, setting up roadblocks and robbing travelers. But I was determined to find and climb the mud tower.

Edgar Boyles, my cinematographer, and I flew to the Indian city of Patna, on the Ganges River. Our plan was simple. We'd find a taxi

driver who would drive through the night to the survey tower so that I could capture on film a view of Everest at dawn.

Edgar and I went around kicking the tires of various taxis outside our hotel and talking to the drivers. Finally, waving his taxi driver certificate, one driver convinced us he could do what we asked. He had a fifteen-year-old boy as an assistant and an old Ambassador automobile. It had a domed roof, a domed hood, and a domed trunk—the signature taxi of India. We climbed in with the driver scornfully insisting, "Of course I know the way to Nirmale via Darbhanga."

Edgar and I piled in with our gear and we started off. The driver loudly proclaimed, "Now we are crossing great Ganga River." Within an hour, it was dark. I'm convinced that driving in the dark in India is one of the most dangerous enterprises on earth. Roads are narrow, with huge trucks and buses thundering by. For some reason beyond my comprehension, Indian truck drivers don't like to use their headlights at night. They turn them on if they think someone's coming, then they turn them off again. It's unnerving, and more than a little perilous.

After a few hours of blindman's bluff at fifty miles an hour, our driver pulled over.

"That's it. I'm tired. My assistant will now drive," he announced. With that, he and the boy switched places. Our driver curled up in the passenger seat and closed his eyes.

The young assistant was eager, although he could barely see over the steering wheel, and with every passing mile, Edgar and I grew more distressed. Every time an approaching truck turned on its headlights, the boy froze at the wheel like a deer caught in headlights and drifted into the center of the road. Again and again I reached up over the seat and yanked the wheel to pull us back into our own lane. It wasn't long before Edgar and I agreed that this wouldn't work for an all-night drive. We woke the original driver and, ignoring his furor at being awakened, insisted that he take over the steering wheel again.

I'd not been able to get a good map of northern Bihar, because Indian military regulations prohibited the sale of their best topographical maps. Maps of the border region were considered classified information, and yet, with the wonderful logic of bureaucracies, I'd been allowed to look at the map in a government office and trace its relevant

portions. I was making a film about mapmaking and here I was unable to get a decent map. From my tracing, I had only a rough idea of where we were supposed to be heading. About five hours into our drive, at three A.M., we stopped for a rest and I double-checked with the driver about our destination.

"Yes. Darbhanga. Darbhanga! We need to go to Darbhanga," I said encouragingly.

He'd assured me of his familiarity with Darbhanga, but now he looked at me as if he'd never heard of the place. I pulled out my map, but naturally—in a region where people don't rely on maps for travel—he had no idea how to read a map. His system was to navigate by place name, by going from one known location to another. I looked up at the stars to find north, looked again at my map—and knew something was wrong. A little further on I asked him to pull over at a truck stop.

It was an extravagantly filthy place and the night was steaming hot. Drivers were stretched out asleep on fishnet cots. Edgar and I started yelling "Darbhanga! Darbhanga!"

Amazingly, there was a young man there who spoke English.

"Where are you going?" he asked.

We explained. He shook his head. "My friends," he said, "you have been driving for hours in the wrong direction."

In a spirited conversation he managed to convince our driver of his error, and we set off in the opposite direction. Even though we had the right bearing now, our trip became more unbearable with each passing hour. The driver had decorated the rear window of his taxi with tiny Christmas-style lights, and every time he hit the brakes the lights began blinking, and a nearly unintelligible rendition of "Jingle Bells" screeched from the speaker. By four A.M. we'd gone dashing through the snow in a one-horse open sleigh a few hundred times.

Already the headlights had fallen off the car and been reattached. When we slammed into an unmarked trench in the road, the gearshift—mounted on the steering wheel—simply came off in the driver's hand. We drifted to a stop. Neither Edgar nor I was particularly surprised. We were exchanging *What now?* looks when the driver turned around, gesturing with the gearshift.

"It does not matter," he said. "We are out of gas anyway."

We'd coasted into a village with provisions for gas, but no gas was obtainable at that hour, our driver explained. Everyone was asleep. With no other options at hand, we decided to sleep, too. It was 100 degrees outside, and of course the car had vinyl seats, so we tried to doze off while lying in pools of our own sweat. At dawn we were able to buy gas, the driver managed to reattach the gearshift, and we were off once again.

During the last fifteen hours we'd gone from following a macadam road with potholes to a track that was little more than two ruts in the dirt. No one along this dirt track knew anything about the little town we were now seeking. We had finally passed through Darbhanga and were now searching for Nirmale. If the name sounded familiar, the people we asked couldn't describe how to get there, or we'd get conflicting advice about which way to go. We tried everything: the name of the town, the names of towns near it; we even tried to describe the brick tower we were looking for. Finally I realized the relic of the brick tower I was looking for, even if it did still exist, wouldn't mean anything to anyone around here.

We eventually found the village of Nirmale, but not the survey tower. It didn't matter because by the time we got there it was hours past sunrise, and the sky was hazy. Edgar and I both knew we'd not get our shot of Everest that day. We talked with villagers anyway, and they told us that the sky was hazy every day, except for a few days in the monsoon, just after a heavy rain, when it would be clear for a while. Another truth finally dawned on me. The Survey of India was conducted more than a hundred years ago, when there were 150 million people in all of India. There was no industry. Today, there are 300 million people in the Gangetic Plain alone, stirring up dust and burning fires and tilling the land. We were in the middle of it. Even if we had found the brick tower, we would never have been able to see Everest. We made the film anyway.

By 1990 it had been three years since my last trip to Everest. A British producer I knew, John-Paul Davidson, had gotten funding from the BBC and private investors to make a film called *Galahad of Everest*.

The story would retrace George Mallory's route. This time though, there would be a script of sorts—drawn from Mallory's diaries—and a British actor, Brian Blessed, would perform certain scenes on the mountain. John-Paul contacted me and asked me to organize and run the expedition, and to be the high-altitude cinematographer and assistant director as well. I was thrilled, not only to be back in Tibet and on Everest, but also to work on a project in which I might involve Veronique.

Veronique and I had seen each other only a few times since our first meeting in 1986, but I still thought of her often. Now and then our mutual friends gave me news about her. It was evident, from her bicycling to Base Camp at 17,600 feet and hiking up to Advance Base Camp at 21,300 feet, that this beautiful woman was unfazed by altitude and that she thrived on challenge.

We had talked a little at the foot of Everest in 1986, and over the next few years I learned that Veronique's father was from Hong Kong, her mother from France. She'd been raised on the Upper East Side of Manhattan, and spent summers in Spain with her French grandmother, who'd married a French baron. She spoke French, a little Mandarin, and quite a bit of Spanish. Following her bicycle trip through Tibet, she worked at the China Institute in Manhattan, and apprenticed with a painting conservator. It was clear she was extremely intelligent, and loved art the way I loved climbing. She was easygoing and a natural athlete. After returning from her trip through Tibet, she ran in the New York marathon, just for the fun of it.

In January of 1990, I asked her to join me on Everest as Base Camp manager and as my camera assistant. I pitched it as a physical and artistic challenge and she accepted. In reality, it was an intoxicating combination of romance and adventure. Together we planned the *Galahad* Everest expedition. To prepare her for the climb, we went to a fabled 400-foot ice climb in New Hampshire called the Black Dike. Black Dike had not been climbed until the mid-1970s. It was considered a test piece, one of those climbs that's so difficult most climbers feel they've graduated after doing it.

The afternoon before our ascent I instructed Veronique on a couple of short fifty-foot pillars of ice. She was strong and wiry, and had no

problem with the vertical ice. At daybreak we hiked up a scree slope and gazed up the intimidating, dark streak of ice. I wouldn't have been surprised or annoyed if she'd wanted to go down: This was no one's idea of a first ice climb. But with me leading she was willing to give it a go. I watched her and marveled. She was tenacious and completely at home in the vertical world. Her hands had gotten cold, but she didn't think the climb was difficult; in fact, she thought it was fun.

We spent the next month organizing and equipping our team. I completed arrangements to climb on an Everest permit already secured by Jim Whittaker's Peace Climb, a multinational group climbing on the North Col route of the mountain.

We met Brian Blessed in Kathmandu. He's a great character, a Shakespearean actor and a burly bear of a man with a strong, straight nose, a thick beard, and a booming, baritone voice. He has an incredible presence and loves an audience. For all the strength in his expression, there was also a mischievous glint in his eye that said it was all in fun. He'd pontificate mightily about something serious and then, as he left the room, he'd wink at you. He was passionate about his acting, and he was passionate about Mallory and Everest.

Yet for all his passion about the subject and the place, Brian Blessed was not a person who was designed for the mountains. At five feet, eleven inches tall and 250 pounds, this fifty-year-old man had rarely worn a pair of crampons, much less trained for Everest. But he was an actor, and now he was crafting Everest into his stage.

It was Brian's mad, unrestrained exuberance that made the whole trip as wonderful as it was. When I say there was a script, I mean there was the idea for one, and it resided mostly in Brian's mind. Each night Brian and John-Paul would huddle in one of their tents, poring over Mallory's diaries from the 1920s and plotting what we'd do the next day. I knew the terrain so well that I could guide them to the exact spots mentioned in the diaries. Where possible we had Brian stand in the same places that Mallory had, and he'd read from the diary, stop to meditate on the words, and then ad-lib in his rich, stentorian voice. I'd film him, with John-Paul coaching him on which way to turn for the best shot. People have asked me if Brian was able to assume the character of Mallory. I always explain that he didn't get into character—it was more

that he never got out of it. He came to the mountain with the quirks and eccentricities of a real mountaineer, and when we shot a scene, you could almost catch glimpses of Mallory's ghost in his performance.

Sometimes he was a little over the top. A friend of his had loaned him an antique ice axe, a piece from the period when Mallory climbed. We were shooting a scene in which Mallory was trying to come to terms with the deaths of several Sherpas in an avalanche during his expedition in 1922. Brian was standing on the glacier Mallory had written about, holding forth on the sadness, on the hopelessness of ever finding the Sherpas' bodies. Suddenly he fell to his knees in apparent despair and began slamming his antique ice axe into the hard, blue ice of the glacier, over and over again. We had to stop him before he broke the ice axe or his hand, or both, on that bulletproof ice. The scene was eerie for me. Not far from where Brian was re-creating Mallory's anguish about a killer avalanche was the spot where I had uncovered Dawa Nuru in 1986.

One of the sharpest memories I have of this expedition was of an event that occurred when we were waiting for our turn on the route at Advance Base Camp. Someone mentioned that an American was attempting to climb without bottled oxygen on the route we would be filming. The American was Ed Viesturs. He'd climbed in the Himalayas and had guided climbs throughout the world. I remember sitting at Advance Base Camp all that morning, with a 1,000mm telescope trained on Ed, watching the last two hours of his climb to the summit.

I had met Ed briefly in 1987 when we were both heading into Everest via Tibet, riding in Chinese trucks. Ed was affable, good-natured, and quiet. But that low-key exterior cloaked a thoroughly focused, highly motivated Himalayan climber. Watching him through the telescope, I was thrilled to see Ed make it to the top. He deserved it. This was his third try at Everest and I knew how hard he'd trained for his climb.

Our ascent was to be the antithesis of his. Like him, we were following in Mallory's footsteps up the North Col route, which in most places is broad and gently sloping. But we were intent on re-creating Mallory's journey, evoking his spirit while avoiding the omnipresent dangers.

We went back and forth from Base Camp to Advance Base Camp and up to the North Col camp at 23,000 feet and higher. It was during a rest at Base Camp that I met a remarkable young Japanese woman named Sumiyo Tsuzuki. She had come from Tokyo to attempt Everest with a wild, impoverished character named Misha, who was part-Iranian and part-German. Sumiyo and Misha were encamped in a ruined hermit's cell on a hill just above our campsite, and periodically we'd have them down to our dining tent for a meal. Misha was engaged in a dispute with the Chinese authorities regarding the validity of his climbing permit and it was obvious they weren't going to get very high up on the mountain that year. Sumiyo was almost silent, but I grew to value her unwavering, stoic support of Misha. I identified with the misfit named Misha. Six years later I would think of her again for the IMAX film expedition.

Brian and I made a good team. I understood a lot about the man. He felt the pull of Everest just as Mallory had, and as I did. He was entranced by the mountain and genuinely pleased to be there. One of our final shots was at 25,500 feet, the highest point Brian was capable of going. I wanted him to look up at the Second Step, the final obstacle to the summit, and talk about seeing the place where Mallory had disappeared sixty-six years earlier. Veronique and I were there with the 16mm camera and two Sherpas. Graham Hoyland, our sound recordist, was there with his equipment. Meanwhile, Brian did his usual meditation on Mallory's words and the scenery around him, taking it all in, waiting for the Muse to strike. When all was finally ready, he took his seat, looked into the camera, and began to weep, overwhelmed by the glory of the place and his gratitude for being allowed on this mountain.

Through everything on this expedition, Veronique was at my side, reveling in the beauty and the sheer challenge of Everest, as well as the challenge of climbing with Brian. We were on Everest for five weeks. Even at 25,500 feet she was her usual strong, energetic self, running around loading magazines, doing whatever it took to keep the project going. She wanted to be part of everything. All I could think was that she'd be the perfect partner for me.

It was June when we got home. John-Paul called and it became apparent we'd have to return to Asia after the summer monsoons

ended for more shooting with Brian. In the meantime Veronique and I set off for Pakistan on another project for my old colleague John Wilcox. With his new company, American Adventure Productions, he was producing shows for an ESPN series called *Expedition Earth*.

My friend and ice climbing partner Jeff Lowe was my co-producer on this film. We had come up with the idea of filming a free climb of a difficult, unclimbed route on a peak in the Karakoram called Nameless Tower. Jeff would be the talent, along with the French super-climber Catherine Destivelle. I would be the director, field producer, and director of photography. Veronique was the sound recordist.

Nameless Tower is one of the most impressive pieces of granite in the Himalayas, a 3,000-foot pinnacle, cut along the lines of the Washington Monument, at an altitude of 20,000 feet. We wanted to try a route on the east face, but the season was wet and the principal crack on the route refused to dry out. We switched to a drier route and started the whole process of fixing ropes and filming. It was dangerous hiking up to the base of the climb because pieces of rock were constantly careening down a gully, raining over us.

As you might expect from two of the best climbers in the world, Jeff and Catherine provided an elegant display of talent. On our summit day, though, something happened that was devastating. Our entire crew had worked hard for thirty days to capture the climb all the way to the top. On this day I'd managed to film a few spectacular sections of the ascent, but was saving a single, fifty-foot cartridge of 16mm film for the summit. Now, as we approached the crucial moment when Jeff and Catherine were preparing to climb the final fifteen feet to the top, the film cartridge jammed and I couldn't fix it. I spent ten minutes trying, but there was no way I could make it work. I ended up covering the summit ritual with still photographs—for a television documentary.

As we rappelled in the dark back to our bivouac site I was filled with contrasting emotions. We had succeeded as climbers, but I felt I'd failed the film with that defective cartridge. I knew there was going to be a lot of explaining to do when I saw John Wilcox. Far worse, Jeff and I had clashed over finances and other issues of responsibility. By the time we got back to the States we were barely on speaking terms.

The rupture with Jeff caused us both enormous pain. We had forged our relationship in the mountains. The bond had been unbreakable, I'd thought. We had approached Nameless Tower with a shared vision that would rely on our various abilities. And suddenly, all that was in shambles. I had trusted him on Kwangde and so I thought I could trust him in real life. That was the greatest shock—that real life could be quite different from vertical life.

Over the years our fracture would become worse before it finally got better. With time I began to see that anger is soul-destroying. Nothing can be gained from it. My father had been a violently angry person, and it had gotten him nowhere in life. The Nameless Tower incident mandated that I forgive and move on: On that climb the brotherhood of the rope had been a cozy illusion.

That autumn Veronique and I returned to Nepal to finish a few shots for *Galahad of Everest* before we left for Dharmsala in India to meet with the Dalai Lama. We traveled with Brian, John-Paul the producer, and some Tibetan friends to a hilltop west of Kathmandu overlooking the Himalayan range. This vantage point allows the most glorious views of the Himalayas anywhere in the range—especially at sunset.

This was the spot Veronique and I had chosen for our mock wedding. Mock only in the legal sense; it was quite a serious matter to the two of us. John-Paul read the Church of England wedding service, and Veronique and I were married as the sun set on the Himalayas. Surrounded by a small group of good people who cared about us, gazing across to the mountains where we had met and forged a relationship, Veronique and I acknowledged our love which had grown over that year. By the time our little ceremony was over, the pink glow on the peaks had disappeared, so we built a fire and filmed Brian and his tales of the Yeti.

A few days later, we visited the Dalai Lama in Dharmsala, an old British hill station in the foothills of the Himalayas where he lived in exile since the Chinese takeover of Lhasa in 1959. I filmed Brian sitting next to the Dalai Lama and receiving a *khata,* a scarf of blessing, to take on his Everest trip.

It was my first meeting with the Dalai Lama. It was reminiscent of my first visit to the Thyangboche monastery in 1979 on the Ama Dablam trip, only this visit was much more sociable. We waited in a simple receiving room, and when the Dalai Lama came in, I was startled by how soft and gentle his hands were, how he took my hands in his and held them for a long time. His demeanor was serene, conveying a sense of humility and something else—a kind of resolution.

We spoke with him both directly in English as well as through an interpreter. He was delightful, quick to laugh, and spoke easily about the Chinese and the occupation of his country; he spoke without bitterness or anger. It seemed as though he'd already forgiven them.

Through my camera lens, watching him speak with Brian or his monks, I had the sense that this man was a keen observer of human nature. Because his command of English wasn't always complete, the Dalai Lama's full intelligence was well concealed behind his contented countenance.

Filming this gentle man made me think of the many Tibetans who revered him. In 1981, at the Drepung monastery outside Lhasa, one of our group had pulled out a picture of the Dalai Lama. Then, it had been twenty-two years since the Dalai Lama had fled Tibet, yet the Tibetans' ecstatic response to this picture was the most spontaneous human act I've ever seen. Everyone around us was jostling to get a closer look at the picture, to touch it, to press it to their foreheads. It had been deeply moving.

Seeing the Dalai Lama was a worthy ending to what had been an erratic but enjoyable year in the Himalayas. As we packed our gear at the end of the shoot, Veronique and I discussed the trip, and talked about how we'd like to return to Everest someday soon. It would be four years before I was back on Everest again.

CLIFFHANGER

*A difficult hand-held shot during the filming
of* Cliffhanger *in the Dolomites, Italy.*

Veronique and I had been pleased to discover that we worked well together in spite of our mutual, acknowledged stubborn streaks. After *Galahad of Everest*, we spent much of our time out of the U.S. First we went back to Ama Dablam in the spring of 1991 for a John Wilcox documentary shoot for ESPN. In October, Veronique and I formalized our marriage vows in front of our families in a Boston church. Dick Bass was my best man. A few months later, in January 1992, we were back in Asia in Arunachal Pradesh, a remote region in northeastern India. We traveled up the banks of the Brahmaputra River to ride eighteen-foot rafts back downriver for a joint A&E and BBC documentary. The river was swift, deep, and cold. The enormous rapids capsized our inflatable rafts several times. In one dramatic scene I recorded the rescue of a team member who was swept off a raft in a dangerous rapid. It was my wife, and it was vintage Veronique. As they pulled her from the rapids she kept apologizing; she thought she'd ruined the scene. She never uttered a word about the near-drowning and the threat to her life.

Early in 1992 I heard through the mountain grapevine that Hollywood was finally going to make a big climbing movie. Entitled *Cliffhanger*, rumor had it that this would be Sylvester Stallone's bid to revive his reputation. It was to be a big-budget enterprise, reportedly $70 million. Best of all, scuttlebutt had it that the production company, Carolco, was hiring real climbers.

My close friend, Michael Weis, was traveling around the world with director Renny Harlin scouting locations for the film. Once the site was chosen, Michael would be in charge of crew and actor safety, and all climbing for the film scenes. He asked me to work as a rigger, fixing ropes and ensuring the safety of the film team, and to occasionally assist as second unit camera operator.

Word spread quickly among climbers, who realized they knew the story line and what it was based on. In Yosemite Valley, in 1976, an airplane filled with marijuana had crashed into a lake. Local climbers had covertly salvaged the cargo and sold it for profit. A legitimate profiteer of the crash was Jeff Long, who wrote the novel and screenplay *Angels of Light*. We all felt like instant insiders, knowing that *Cliffhanger* was a homegrown tale with origins in our own backyard.

Every hard-core climber I knew wanted to be part of the production. After years of climbing in poverty, they felt they had a right to get some work out of the movie. Beyond commerce, the movie raised our expectations. I heard more than one climber say he believed Hollywood was finally going to get it right, to show climbing as an exciting and exacting sport, and they wanted to be part of it.

For me, *Cliffhanger* was less an entrée into the feature film world than an insight into how that world worked. At last I was going to get an inside look at Hollywood: the studio system, the 35mm cameras, the complex technology. And I could watch the specialists work, from the director of photography to the property master, from makeup artists to stuntmen. I also needed the money. I knew from industry talk that work on a feature film paid two or three times my wage for documentary work.

Missing from my plans was Veronique. It was one thing to include her on location when we were working together, another to ask her to come along when there was nothing for her to do. I felt this wasn't fair to either of us. So when I left for the Dolomites in the Italian Alps, where *Cliffhanger* would be shot, Veronique remained in Boston to attend graphic design school and cook at the restaurant Biba. It seemed a good arrangement for both of us.

I flew from New York City to Milan. With a couple of free days before I had to report to the location, I rented a car and drove through a thick snowstorm to ski with a friend from the Ama Dablam expedition, Marie Hiroz, in Verbier, Switzerland. In the middle of that snowy night, in her shuttered, seemingly airtight guest room, one of the dreaded nightmares that I'd suffered as a child closed in on me. Half asleep and panicked by claustrophobia, I needed desperately to get out. In that disoriented state, all I knew was that a sliver of light gleaming through the crack between the shutters represented escape.

I don't recall kicking out the window, but I do remember awakening as I stood there, my right leg hanging above me partway out the window, impaled on a slab of broken glass.

Blood spurted from a huge gash in my lower leg. I tried tentatively to lift my leg off the glass, but in my contorted position, I couldn't do it.

So I just stood there, confused beyond rhyme, reason, or pain, too embarrassed to yell out for help.

"Hello?" I pleaded before Marie finally came in and switched on the light. "Hello?"

At the hospital an elderly Swiss surgeon reassured me that I would survive intact. "You have nothing to worry about," he said. "I'll make you as good as new." I dearly needed to hear that, since my foot was bandaged and elevated, and tubes were sprouting from my leg and arm. The glass had sliced veins, nerves, and muscles and had nicked my achilles tendon. In one deep gash a shard of glass had gouged the bone. The surgeon then gently tendered his prescription: a week of intravenous antibiotics in the hospital, then home for a month of convalescence. He made it clear that if I put weight on my right foot too soon, the forty internal sutures could tear. Forget *Cliffhanger*, he told me. I called Veronique, but revealed little of the seriousness of my mishap. A day later, in enormous pain, I checked myself out of the hospital. I wasn't about to forget *Cliffhanger*.

My rental car had a five-speed stick shift. I worked out a desperate combination of left-foot moves on the clutch and gas pedals and employed an emergency hand brake technique so I could drive. I had to cross a string of snowy passes to get back to Milan in time to meet the crew.

I jettisoned my crutches at the airport where I was to meet the production staff, then went looking, in vain as it turned out, for a cart on which to haul my two sixty-pound duffel bags of gear. With no cart to help me I had to drag first one bag, then the other, across the airport floor. Onlookers seemed amused by my plight, but indisposed to assist. I managed to get the bags positioned by the curb just as the production people showed up in the van to take us to the film site. I told them I had fallen and torn a calf muscle.

Trying to disguise my pain, I made my way into the lobby of the Alaska Hotel in Cortina where all the hired climbers were staying. Hobbling across the lobby, I recognized so many faces from the old clan at Eldorado Springs and Yosemite, I felt like I'd walked in on a high school reunion. Besides Michael Weis, there were great climbers

like Jim Bridwell, the pride of Yosemite, and Ron Kauk, my partner on Half Dome. Glad as I was to see them all on the crew, I couldn't stop to talk. I barely made it to my room, and then I spent every possible minute with my leg up and packed in ice.

Unbeknownst to me, a friend had called Michael Weis and explained the truth about my injury. I didn't know this until years later, but Mike protected my secret so I wouldn't lose my job on the crew. For the next two weeks he kept assigning me all the soft jobs. Each morning Mike would say, "Hey, David, why don't you go buy some production supplies at the hardware store." And as he handed me a list, I'd think, *Thank God I don't have to go out into the mountains yet.*

I was much improved in two weeks. I'd phoned Cliff Watts, a doctor I knew in Colorado, about my predicament and he prescribed the right pain medications and antibiotics, and advised me on the necessary therapy. Eventually I removed my own stitches. I suppose Michael saw me walking more normally. Anyway, he started to assign me duties on location like checking the safety of climbing, taking over some of the camera work. Often I spent the day flying back and forth from the base camp to the tops of cliffs in orange Huey helicopters or in smaller French Ecureuil Squirrel helicopters.

I didn't have much time to worry about my leg. I was part of a small army of people working on this film, and we each had a very specific job to do. We were ruled by a curious caste system. Time and again I was lectured on how important it was not to cross the invisible lines of responsibility. For example, a pile of equipment would need carrying fifty feet and I'd do it, only to have some crew member dress me down for overstepping the boundaries of my job description. I learned to keep my place.

I was part of the second unit crew under the direction of Phil Pfeiffer. Our job was to tackle most of the action and landscape shots. I rarely saw the first unit crew, which dealt with the drama and principal actors. I saw Sylvester Stallone only once, at a mountain safety meeting, but I regularly dealt with his stand-ins, the German climber Wolfgang Güllich and an American stuntman, Mark De Alessandro. Whichever one of them was currently working as his stunt double had to wear a prosthetic mask made to look like Stallone. It was glued on

and textured to blend with the skin. I could hear the man wearing it struggling to breathe through the tiny nose holes. The mask wasn't designed to be seen in close-ups, and when Wolfgang or Mark turned to look at me I was consistently startled by the grotesque sight.

I was still weak and hobbled from the ordeal with my leg. My wounds had healed on the surface but were tender and sore underneath. Hauling the heavy film equipment or climbing in and out of hovering helicopters I'd bash the injured part of my leg on a piece of metal or rock. The searing pain was so sharp and hot I'd yelp before I could restrain myself.

A few weeks after I started working on the climbing locations I got a chance to be the fake Stallone. The film's opening shot was supposed to show Stallone's character Gabe soloing up a huge, overhanging cliff with no rope. Since the doubles were working on other locations, Michael asked me to stand in for Stallone. Imagine that: I was being asked to portray an actor portraying a climber—nice irony. Quickly, the costumers dressed me in a green pullover and black climbing pants, and handed me a silver plastic toy gun which was some prop director's idea of a climber's rock drill. I also had a small radio attached to my belt so the camera helicopter and I could communicate. Then I rappelled several hundred feet down the face of a 2,000-foot wall of stone called the Tofana de Roza.

Once I reached the spot that had been selected for the shot, I clipped my waist harness into a bolt and a rusty piton. Then the crew on top of the wall pulled my rappel ropes back up the overhanging cliff. Suddenly I didn't like my situation very much. The piton was poorly placed, so I was mostly suspended by my waist harness from a single bolt that had been pounded into soft dolomite. To make matters worse, melted snow poured down the rock, soaking me in freezing water, and my calf was beginning to ache. Shivering, I hung in the middle of the cliff with no way to get off the wall until the shot was over and a rope could be lowered to me.

The scene was to be filmed from a camera helicopter, which would approach from a distance, then find me, a speck on the vast wall. When the voice on my radio called, "Action!" I was supposed to grab the rock and pretend to be climbing. Seemed simple enough. I heard

the helicopter's blades chopping the air behind me. The radio crackled, and I raised my arms overhead, feeling for holds. Icy water poured down my sleeves into my armpits and down my chest, but I continued my climbing parody.

"Cut," the radio voice said. "We have to do another take."

I heard the helicopter sounds fade, and tried to maneuver out of the dripping water. But I was constrained by the three-foot rope anchoring me to the bolt. The warmer the day got, the more the snow melted and the wetter I got. I entertained myself by watching the droplets fall free of the overhanging wall, imagining where they would hit 2,000 feet below. Finally, the radio voice gave me the command to climb again, and I went through the motions once more. A take, I thought. The Kloberdanz Kid stands in for Sylvester Stallone. A rope snaked down the cliff to me, and I climbed back up to the top, where they told me there'd been trouble with the camera in the helicopter, so my moment of cold, wet glory went unrecorded.

The logistics for filming the climbing scenes in the movie were impressive. Day after day, I was helicoptered to the top of the most incredible stone towers, where I joined as many as fifty or sixty other people. Up there, the crew set up large tents to house caterers and the continuous stream of delicious buffet food which arrived by helicopter.

In the midst of all this luxury, though, there was an air of danger. More than once, mists rose up around the rock towers, followed by horrendous lightning storms. Helicopters were our quickest and sometimes our only way down, but not in an electrical storm. One afternoon a storm blew up before the helicopters could get us off the stone pinnacle where we were shooting. Surrounded by thirty-foot steel towers rigged to hold cameras overhead, we were standing on the perfect lightning rod, and huge bolts of electricity crashed to the ground all around us. As each strike exploded like a bombshell, crew members would run in every direction. It was like a scene from a disaster movie. Those of us who were used to dramatic weather situations in the mountains tried to lie low and wait it out, but some of the less mountain-experienced crew members were whimpering and crying, struggling to stay under our only tent. Their fear wasn't unfounded; one of the climbers was hit by lightning—not once, but twice—and nearly thrown over the edge of

the cliff. Miraculously, he was only slightly injured. After about half an hour, the storm rolled on and the helicopters lifted us off the pinnacle.

Michael Weis oversaw the climbers who set up the outdoor stages for the climbing scenes and made sure all the gear could be removed without a trace once the shoot was finished. Steel towers were erected next to the cliffs to hold the cameras—and in some cases, the actors—during the climbing scenes. To install the big towers Weis's climbers would drill anchor bolt holes two to three feet deep in the dolomite, far deeper than the length of the bolts. At the end of the shooting, the bolts would be hammered even deeper into the wall, and the opening patched with a mix of ground dolomite and epoxy.

Once the steel towers were up, cables were run between them on which cameras could be mounted directly over the abyss. Easily the most memorable scene in the finished movie was the fall of a young woman at the very beginning. In the movie she's suspended from a rope, doing a Tyrolean traverse—moving from one tower to another along a cable—when her harness buckle fails and she plunges thousands of feet into the void. Parts of the scene were shot on an indoor soundstage in Rome with artificial rock and mirrors. But much of it was shot by my unit, the second unit, using both doubles and the real actors. It took three weeks of intense preparation to set up that scene and then wait for the right light for filming.

On the day of the shoot, Gea Phipps, a triathlete, climber, and model from Oregon, was made up to resemble the actress Michelle Joyner. I was assigned to shoot her stunt fall with one of four cameras positioned above, to the sides, and below the double. My camera, a 35mm Arriflex, was mounted on a tripod on a ledge deep in the chasm beneath her. My assignment was to shoot the fall from the side, tilting down as she fell. With an assistant cameraman, I climbed down to the ledge and set up my camera and tripod.

Until *Cliffhanger* the largest format I'd ever shot was 16mm, so handling this big camera was entirely new to me. Of course I wanted to prove myself by framing the shot perfectly, but beyond that, I was concerned about the risk I knew Gea was taking. She would be relying on cables and pulleys to keep her safe, a situation that went against my climber's grain. Her 400-foot fall would actually be a rapid descent on

a three-sixteenth-inch cable, which would later be digitally erased from the film. I knew the cable was more than strong enough to carry a static load heavier than Gea, but, like the early climbing ropes, the cable didn't stretch. And here was Gea, deliberately falling on a cable that had no give. If the spool of cable didn't reel out properly, or if it stopped abruptly, the dynamic load—her rapidly descending body—would snap the cable. Gea's fake fatal fall could easily become real. Looking up from my ledge and watching her buckle into her harness, I thought, *I wouldn't take a million bucks to do what Gea's about to try.*

Before Gea's fall we rehearsed by having a crew member drop a kicker dummy down the cable. The dummy weighed the same as Gea, and was equipped with pneumatically powered arms and legs that thrashed during the fall. As the dummy dropped past me, I tracked it through the viewfinder to get a feel for what I'd need to do in the few seconds that Gea dropped in front of me. I had to catch her in my viewfinder and then follow her, smoothly tilting the camera downward to catch the end of the plunge. I practiced moving the camera while keeping the dummy in the middle of the frame until the very end of its fall. Just before the cable braked and the dummy came to a dangling halt, I slowed my tilt and let the dummy drop off the bottom of the frame.

I rehearsed over and over without the dummy, too, finding my visual markers in the background to track where I was in the shot. Finally, high overhead, Gea traversed out on the cable. Everyone on the shoot grew quiet as we fastened our eyes on her. I listened for the commands on my radio, and the voice directing the cameramen to start their cameras was clipped and clear: "Camera A, turn over. Camera B, turn over." Each cameraman, myself included, radioed back, in turn, "Speed," "Speed," "Speed," meaning our camera was running.

A split second of silence passed. "Action!" the radio voice barked suddenly, and I could hear Gea on the cable for a microsecond before I saw her in my viewfinder, flying down the cable.

It was over in a matter of six seconds. I was confident I'd gotten my shot. But the important thing was that when I lifted my eye from the viewfinder, I could see Gea suspended above the void, safe and in one piece.

• • •

The movie was supposed to require two months of filming; it took four. During one period of good weather we worked for twenty-eight days without a rest. Usually, though, we had Sundays off. Some of the climbers would go climbing, but I rested my leg, often borrowing a production car and driving down to Venice for the day.

Venice and the Piazza San Marco were pleasantly deserted in April and May. I'd go out to the Lido with its beautiful white sand or search the restaurants for fresh seafood. I loved the museums, especially the Armory, with its lavish displays of medieval armor and weaponry. Antiquarian bookshops fascinated me, and I scoured them for old maps and charts. There was never enough time, it seemed, to do all I wanted to do in Venice. Monday mornings came quickly.

For all the work we accomplished, there was a lot of waiting around for things to happen. Days could become unbearably tedious as those of us in the second unit sat for hours waiting for the next explosion or collapsing bridge scene to be filmed. One day actor Michael Rooker—who played Stallone's friend in the film—got tired of waiting around. He'd learned to climb for this movie so he could do his own climbing scenes and wanted some action. He complained and, to make him happy, someone in the second unit handed me a 35mm camera with a long lens and a wide lens, and told us to amuse ourselves. We weren't meant to bring back any usable footage, but Rooker and I were determined to produce shots they would be crazy to discard.

We went up to Cinque Torres—Five Towers—a formation not far from where the film company was headquartered. I loved being out there, almost alone, in the mountains. Because I had no tripod to steady the camera, I built a cairn, a stone pile, out of rocks. While I trained the camera on him, Rooker climbed up and over me. We had a great time setting up a couple of other shots. There was no pressure as we were briefly detached from the seventy-person second unit film crew. If a piece of climbing looked interesting to us we shot it. And when the second unit director reviewed our footage the next evening he seemed pleased and a little perplexed. They used two of our shots in the film. Rooker and I were very happy with the unexpected results of our two-man film crew.

But I was still just a cog in a great machine, and I was reminded

of that one day in the bluntest terms. I was in a black tent on a platform with Phil Pfeiffer and his camera operator watching a video replay of Stallone's double Wolfgang Güllich. Suddenly, uninvited, I blurted out, "Well, you know, we can make this much more dramatic if Wolfgang moves over here and does a swing and kicks a little more."

Phil stopped the videotape and turned to me. "Step outside, please," he said quietly. We stood next to the tent, and he was very direct. "I am the director of photography," he said in a firm voice. "If I want your input I'll ask for it. Thank you very much." He turned and reentered the tent without me.

I knew that Phil was right. The problem was my own belief that I had any value on such a big shoot. It was only later after attaining Phil's kind of responsibilities on my 1996 *Everest* IMAX shoot that I came to realize how intensely personal a cinematographer's vision is. When you have a vision of what you want in a scene, it's distracting at the very least to have someone interrupt from the gallery. I know, because I was tougher than Phil when I held the reins.

In the end I received small, nearly unnoticeable credit for my work on the film. It came so late in the long roll of credits after the movie that my mother said she got tired of waiting to see my name and left the theater before it appeared.

In the final month of filming *Cliffhanger*, I'd received a phone call from David Fanning, the executive producer of the PBS series *Frontline*. I'd met David in 1988 while working on a BBC documentary he'd acquired for PBS called *Search for the Yeti*. Ever since, I'd been lobbying him to do a documentary about the Chinese occupation of Tibet. David now agreed the time was right. Over the phone he proposed sending me to Tibet with an Hi8 video camera. It would be a reconnaissance trip, he said, and he would reserve final judgment on the project until he saw the videotape.

I returned from *Cliffhanger* in July. Veronique had visited the location once, briefly, so we'd been apart for nearly four months in our short married life. Moreover, I had just committed myself to another film assignment that September.

While our separation pained me, I saw the Tibet trip as necessary. Film work tends to be feast or famine, and here was an opportunity not only to keep working, but to co-produce a one-hour program with television's premier investigative series.

Veronique was pleased with my assignment, but not pleased I'd be gone again so soon. After all, we had been together more before we were married, and since then she'd been living her own life, at the restaurant, at art class, at home. Suddenly I reentered her world like some vagabond lover, only to announce that I'd be off again.

It's only in the movies that a relationship ends after a dramatic fight. Real life isn't like that. Couples separate slowly, by emotional increments, until they find they're no longer a couple. It took Veronique and me several weeks to get used to each other again. For a couple of weeks after that we enjoyed something approximating normalcy for us. Then it was time for me to get ready for Tibet. I hauled out my gear again and spread it all over the living room floor. I prepare visually, not with checklists: I have to see everything out there in a big mess, and slowly I organize and pack it. I don't trust having it all packed up a week beforehand: It has to lie out until the night before I leave, until the very last minute. Veronique was subjected not only to the chaos of equipment, but to the blizzard of phone calls, faxes, and last-minute arrangements for visas and permits and food. I was looking ahead, ignoring the moment. I had no time for Veronique.

I might have taken her with me to Tibet. She loved it there. But for me, I knew, there were things to do alone and things to do with your wife. Also, I was back to feeling I was more myself when I was alone. For reasons I didn't completely understand, I was slowly distancing myself from Veronique. It was partly due to the fact that I've always thought it unprofessional for men to bring their wives or girlfriends along on film trips. To justify bringing Veronique to Everest and Ama Dablam and the Brahmaputra, I'd made her work harder and perform better than anyone else, and nothing was ever good enough. I told myself that the unbearable pressure I put on her was my duty to professionalism. In reality, at those times, when I was so uncompromising and harsh, I had almost become my father: unwilling to accept flaws in myself, unwilling to accept flaws in anybody close to me. I saw the pat-

tern, but didn't know how to address it. Rather than put Veronique through any more of that, I left her behind. We were quiet the night she drove me to the airport for my flight to Beijing.

Beijing had the look of a modern city since my last trip ten years earlier. McDonald's golden arches curved at the side of one street. There were hardly any blue Mao suits. Women wore makeup, short Western-style dresses and jewelry, and no longer confined themselves to the standard straight-cropped hairstyle and squared-off bangs. Five-star hotels teemed with businessmen, and on the sidewalk tiger bone and parts of other endangered animals were sold to the newly rich Chinese. The street life felt more like Bangkok or Hong Kong than the old Beijing.

Red Flag Over Tibet was a different kind of film for me. It offered a new use for my eye and my voice. It was not an adventure film, but it was definitely an adventure to shoot it. The risks this time around were not of falling off a mountain or being swept away by an avalanche, but of deportation or, worse, the arrest of Tibetan friends. It was a tense time in Tibet. My goal with *Red Flag* was to document the complex problems of the Chinese occupation of Tibet, both its past and its tumultuous present. David Fanning and I agreed that if we wanted to say anything important, the piece should be as objective as possible. There were already a number of films about the occupation of Tibet, but most were one-sided and oversimplified.

I traveled across China with two Westerners, John Ackerly and Rick Collins, who spoke a little Chinese. We took the train to Xining, where I videotaped some labor camps and prison factories. Then we went on to Golmud, past a great salt lake called Kokonor. Chinese police tromped menacingly through the train cars warning Westerners not to take pictures from the windows. We were just south of the 9th Academy, their Los Alamos for nuclear weapons research, development, and assembly, so we kept our cameras hidden. At Golmud we caught a bus south. It's a long, cold journey across the eastern portion of the Chang Tang, Tibet's desolate northern plateau. We pulled into Lhasa late at night.

In the past, on permit-paying expeditions, I'd arrived in Lhasa as visiting royalty, riding on modern mini-buses with panoramic windows,

in broad daylight. Liaison officers had rolled out the red carpet and extended the state's hospitality, complete with banquets. This time, surrounded by Tibetan pilgrims and Chinese immigrants, I reached the capital in the middle of the night, on a cheap bus. We heard whispers and murmurs about the Potala, and looked out the bus window at a dim shape in the black night: The monastery's hundreds of windows were empty except for a few flickering candles.

Lhasa had never been anything for me other than a way station en route to Everest. Now, for the first time, I was focused on this place and its people. The Tibetan Government-in-Exile has estimated that, since 1951, 1.2 million of 6 million Tibetans have died under Chinese occupation. But we weren't looking for killing fields or blood on the walls. We were focusing on cultural genocide. Beginning in the 1980s, the Chinese government opened their internal borders and hundreds of thousands of Han Chinese immigrants have poured into Tibet.

Thus Tibet had gone from being an occupied country to a colonized province. Now Lhasa had taken on the look and feel of a Chinese town, with a minority Tibetan underclass. I was astonished by the amount of new construction since 1983. Eight-story concrete buildings abounded, where one or two stories of whitewashed stone masonry had been the rule. There were taxis now, and greenhouses to grow fresh vegetables for the massive influx of Chinese. There were karaoke bars and Chinese restaurants complete with tanks of live fish to choose for dinner.

In the center of old Lhasa, the Barkor—the circular walkway around Jokhang, the holiest temple—had completely changed. The first time I'd set foot here in 1981, it seemed I was stepping back into a medieval city. Now the entrance to the Barkor had been rebuilt to look like a square in any provincial Chinese town. Surveillance cameras were attached atop buildings, panning for demonstrators. Chinese police and soldiers were everywhere, and military squadrons marched around the city.

Wandering the streets, there were places where I couldn't find anything that was Tibetan: no prayer flags, no traditional clothing, none of the dogs forever hanging around the monasteries. I had to look up at the empty Potala to remind myself this city was once the heart of

Tibetan civilization. Forty years earlier that huge white monastery on the hilltop above Lhasa had been a vibrant center of religion and government. Now, it had been looted and turned into a tourist attraction by the Chinese government.

I did most of my traveling in Lhasa on a Chinese bicycle, hopping off to get the shots I wanted. I devised a way of hiding my video camera inside a day pack with the lens exposed, mounting it on the back of my bike. With a little practice I could dismount on the side of the road by a line of marching soldiers and pretend I was working on my bicycle while the camera was running.

One day I was out riding on a new four-lane road with bicycle lanes full of Chinese pedaling to work. The roadside was lined with Chinese storefronts and gaudy neon signs. *There is nothing Tibetan here,* I was thinking. Then I saw him: a single Tibetan prostrator moving patiently against the steady stream of cyclists, making his way toward the distant Jokhang, one body length at a time.

He was a muscular young man, dust-covered, with short-cropped hair. Who knew how far he had traveled in his devotion? Some prostrators traveled hundreds of miles to get to the Jokhang. He wore a thick leather apron, like a blacksmith's, to protect his flesh and clothing as he flung himself facedown on the ground, stood up, advanced one body length, then flung himself down again. Pads protected his knees, and two wooden mitts with sheet metal nailed to the fronts shielded his hands.

I stood still, holding my bicycle beside me, my camera running. I was transfixed by this young man—by his faith and the power of religion. I'd never filmed a man in so poignant a context. This lone Tibetan pilgrim was prostrating, walking against a sea of humanity, oblivious to the invaders of his country. The bicycle riders flowed by him without a glance.

At it turned out, this trip was the first of two I made to Tibet for the *Red Flag* documentary. The footage I got on my reconnaissance led to a second, more substantial trip ten months later. Again, I found no place for Veronique on my extended return to Tibet. She didn't complain; I didn't apologize. We scarcely talked about it.

For this second visit I went with David Fanning and the man he'd selected to be the correspondent, Orville Schell. We wanted to make the piece credible and thoughtful. Orville wasn't a Buddhist scholar or a human rights activist. He didn't speak Tibetan. Rather, his knowledge lay in Chinese language and history. He spoke fluent Mandarin, and was a sinologist, a journalist, and an adviser to various U.S. administrations about China. Traveling through Tibet with these two thoughtful men, I gained a more balanced perspective on the complexities of the Chinese presence. Their insights were remarkable, and from them I was learning about the art and aesthetics of storytelling.

We talked constantly about the possible consequences of what we were doing, questioning our responsibilities and the ramifications of our actions. Western journalists had already filmed interviews with monks, nuns, and other Tibetan freedom activists for programs that had been broadcast with the Tibetans' faces fully exposed. It was like handing the Chinese authorities a map to the Tibetan dissidents, and many of these interviews had led directly to Tibetans being imprisoned by the Chinese. Our primary rule was to protect our sources at all costs. At the same time, as journalists, we needed to show the authenticity of the testimony we were gathering in our interviews, that we had real witnesses in Tibet. That meant risking repercussions from the Chinese for us and possibly for our sources.

At the end of our project we would be going home, but long after we were gone, the Tibetans could be paying for our intrusion, however well meant. This is an important irony for Westerners who are interested in revealing human rights abuses. I know of a Tibetan travel guide who was thrown in jail after Americans in his group had brazenly displayed their "Free Tibet" T-shirts. The Americans had already left the country, and apparently never knew the damage their errant behavior had caused.

We were very cautious while filming *Red Flag*. Our camera represented a chance for Tibetans to get the word out to the world about conditions in their country. We had many, many opportunities to record witnesses, but we passed up a number of interviews as too reckless for the subjects. For the interviews we did conduct, we went to great

lengths to disguise both the subjects and their immediate surroundings.

I remember one interview we had arranged with a monk. As in the American South during the civil rights era, many of the independence leaders inside Tibet are religious figures, monks and nuns. On the appointed evening we started walking in search of this particular monk at the mouth of the Barkor, just as night fell. Snowy remnants of the monsoon were still hugging the peaks around the Lhasa valley, while lightning flashed in the night. The air smelled like ozone and dust. Large puddles stood in narrow streets as thunder rolled through the darkness.

Parts of the old Barkor are a human-sized maze. It's easy to become disoriented, even in broad daylight. This night there was no moon; we passed from one Tibetan to another through a series of checkpoints, backtracking a couple of times to see if we were being followed. Finally we entered a monastery and were led into a room where I could feel the tension like a knot all around us: the monks, our guide, the visitors with the camera.

We'd used masks to disguise our subjects before, but tonight was different. I had to be more artful in the way I lit the two men to make sure that Orville and the monk were so brightly lit that the rest of the room fell into darkness. We didn't dare show a single reference point in the background that might later help Chinese authorities identify the monastery. Finally I settled on shooting at an angle over the monk's shoulder, with his robe draped over his head, shielding his profile. We taped his voice, but later manipulated it so that it was disguised as well.

The monk was a militant and thus an important contrast to the Dalai Lama's message of nonviolence. He declared that the Chinese understood only force, and the way to rid his country of them was through the barrel of a gun, intentionally quoting Chairman Mao. He was a powerful speaker, and his testimony would form a key part of our documentary. We finished the interview much later than we'd expected, and started back out of the Barkor.

A wicked thunderstorm was blowing when we left the monastery, and with every boom, the stray dogs that roamed the alleyways barked and howled. Rain poured down from the dark sky, soaking us to the

skin. I worried all the way back to our hotel, but not about thunderstorms. The material we'd just recorded was explosive. If the Chinese got their hands on our raw tape, it would mean trouble for everyone involved. I had left the interview tapes with a prearranged contact person inside the Barkor who knew how to forward them to *Frontline* if Orville, David, or I had any problems with the Chinese authorities at our hotel. Before leaving Tibet, when I was sure it was safe, I retrieved the tapes.

Filming for *Red Flag Over Tibet* took another four months. Besides my two trips to Tibet, we shot interviews in India, Nepal, and the U.S. At *Frontline*'s WGBH headquarters in Boston, I spent weeks gathering and reviewing every inch of historical film footage taken in Tibet that we could find. The final six weeks of editing were very frantic, and we ended up finishing the film just an hour before broadcast, in February 1994.

During this time Veronique and I had essentially become separate individuals sharing a living space. The post-production work took place in Boston but was so intensive and time-consuming I might as well have been in another country. I'd come home after long hours in the edit room and Veronique would be at work or at graphic design school. Still, she and I continued to care about each other. She joined me and David Fanning and his girlfriend to watch the television debut of our documentary.

Three weeks later, Veronique was back in art school and I was on a plane heading back to Tibet, Mount Everest, and the Kangshung Face.

The success of *Cliffhanger* had not led to more film work for me. In truth, it shouldn't have—I had contributed to about thirty seconds of screen time. Consequently, once *Red Flag* was finished, I was back to the freelance filmmaker's life, finding work project by project.

I'd been thinking for years of going back to the Kangshung Face of Everest with a small team. This time I wanted to try something a little different. I called it "Dispatches from Everest." The idea was that I'd record the action of a climb on a compact Hi8 video camera, then send

it out biweekly to air on network television with a live interview from Everest by satellite phone. The project needed an engaging personality as the central character, someone audiences would appreciate. We chose Sandy Hill Pittman, a New York adventurer and writer. She'd climbed six of the Seven Summits, the highest mountain on each of the continents, and had been on Everest the year before, reaching 24,000 feet before she and her party had to turn back.

Sandy's as impressive as any TV anchorwoman: strong, attractive, dynamic—and very confident. With her participation we'd gained a commitment from the NBC *Today* show to do "Dispatches from Everest," and that attracted a corporate sponsor for the expedition.

In the years leading up to 1994, the popular South Col and North Col routes had been attracting more and more people. During the spring and fall climbing seasons the traditional Base Camps leading to the north and south side routes resembled an army encampment, catering to a dozen or more expeditions and hundreds of climbers and support staff. Commercial expeditions were just beginning to offer the inexperienced a trip to the top of the world.

I wanted our expedition to this wild eastern face of Everest to be seen as a return to the mode of simple self-reliance and alpine skill. I kept it very small, just four Western climbers—five people including Sandy—and four climbing Sherpas. I chose three of the most experienced climbers in North America: Alex Lowe, Barry Blanchard, and Steve Swenson. We'd be climbing with Himalayan siege tactics, placing camps and fixed ropes higher and higher on the mountain. But we'd be lightweight and faster than the legions of climbers on the North Col and South Col routes. For our sirdar I chose an old and trusted Sherpa friend, Wongchu. He'd been hired as a cook in 1986 on the BBC film *Everest: The Mystery of Mallory and Irvine*. I'd been astounded when he spent twenty days straight at the North Col camp at 23,000 feet. He was a delightful man with a broad Tibetan face, who always seemed to think faster than he could speak. But he was a strong leader who had a great deal of authority with the Sherpas.

I chose a route different from the one we attempted in 1981. We would climb up a steep buttress, on a line farther west and in toward

the face. The climbing was less difficult, but the route was closer to where the 300-foot-high lip of the glacier was breaking off. With the glacial collapses closer and more audible, this route was much more threatening than the one in 1981.

There was one section, several hundred feet high, where we had to climb the fixed ropes suspended from vertical and overhanging ice. It was far more difficult—physically and mentally—than anything on the South Col or North Col routes. At 21,000 feet I was dangling from a rope, while to my right, a few hundred feet away, the glacier constantly shaved off huge chunks of blue ice. I never got used to the psychological assault. I'd hear *crunch,* and ten seconds later a great cascade of ice would pour over the cliff. It was the noise that was most unnerving.

Sandy was extremely well organized. She worked hard at Base Camp, helping dig tent platforms, cooking. Not having climbed in the Himalayas with her before, I'd prepared myself for the possibility she might not be able to get up the overhanging ice. But if Sandy was unnerved by the Kangshung climbing, she didn't show it. I really admired her grit and her stamina. A big part of my cinematic vision on this trip was to try to capture Sandy's personal struggle with the mountain. I positioned myself just above or below her, hanging from an adjacent rope, so that I could shoot her up close with a wide-angle lens, bringing the viewer right in on her experience.

Early one morning, four weeks into the expedition, I was in Camp I at 20,000 feet with Sandy and two Sherpas outside the tent, brewing tea for our breakfast. The usual morning display of avalanches was beginning as the sun heated the face. A little later, Advance Base Camp radioed up that the wind blast from an enormous avalanche had flattened their tents.

Sandy and I immediately got on the fixed ropes and rappelled down to Advance Base Camp. It looked like a hurricane had swept through the place. Wongchu and the Sherpas were walking around dazed. Nobody was hurt, but the whole site was a mess. Supplies had been blown a mile away. Dome tents had tumbled across the glacier. My tent lay 50 yards from where I'd pitched it. Fine pulverized snow had infiltrated everything, driven by the force of the 120 mph wind blast.

The kitchen tent, which had been anchored with big rocks, had ripped away, leaving the edges of fabric still pinned in place under the rocks.

I began to wonder if this was the right year for the Kangshung Face. Wongchu was so disturbed by all the avalanches he took a leave of absence, claiming he had a bad feeling about the face. He went all the way back to Kathmandu to consult his lama, a Buddhist priest, and ten days later reappeared in Base Camp.

"David, David," he said. "This face is no good. The mountain isn't happy."

The other climbers wanted to keep going. It was, after all, only May 1, and the monsoon—and its accompanying heavy snowstorms—wouldn't arrive for another three or four weeks. We'd come prepared for a certain amount of bad weather. However unwelcome, the avalanches were no surprise to anyone. We moved Advance Base Camp farther down the glacier to Base Camp, out of range of the avalanche wind blasts, and continued climbing.

That year, I learned some hard lessons about leading an expedition on Everest. I'd led film teams, but never a whole Everest expedition. In picking Alex Lowe, Steve Swenson, and Barry Blanchard, I'd chosen experienced and accomplished mountaineers who were better climbers than I. I sought out, listened to, and trusted their opinions. But I never showed my sincere respect for what they had to say. As a result, they were convinced that I wasn't listening to them. In addition, because I never delegated a task I could do myself—even if it meant my working hours longer than anyone else—I never relinquished my control of daily events. I overbearingly micromanaged the talent under me—and it rubbed them the wrong way.

I was constantly concerned about our safety. As expedition leader, the decision about climbing or retreating was ultimately mine. What none of the other climbers knew was that I had a dialogue running continuously through my head between what they were telling me and what I thought, an endless debate about whether or not we should continue. But I was afraid to voice my doubts and questions. I thought it might seem a sign of weakness or a lack of competence. In fact, I realized later, it's essential to express concerns, and most certainly those that involve the team's fate.

Halfway to Camp II we got a closer look at the snow conditions and saw the dangers that lay ahead. During our first load-carry to establish Camp II, we ran into waist-deep snow that was exhausting to plow through. Hauling oxygen masks, tents, food, and thirty-pound loads, we slogged upward, postholing through heavy snow. It was hard work and we had to rest every few yards. We finally reached the site for Camp II at 24,400 feet, erected a tent and cached our loads, then started down again. I was descending to Camp I with Barry Blanchard when, a hundred yards to our left, a section of the slope let go. A two-foot fracture line opened up, and down the slab went. It wasn't a huge avalanche, but if any of us had been on that section, there's no doubt we would have been killed.

That's when I started to think, *What kind of game are we playing here?* I knew from reading other expeditions' accounts that not only was the upper 1,600 feet of the Kangshung Face steeper, but it was on the lee side of Everest—meaning we'd be climbing in waist-deep wind-deposit snow, the kind of snow that killed Dawa Nuru in 1986, and all without fixed ropes or anchors. It would be a guessing game, played out while wallowing through an unstable sea of thigh-deep snow.

It was up to me to make the call as to whether the climb should continue or not, and that was a deeply awkward predicament. I was surrounded and advised by a team of renowned mountaineers. They each had vast experience in the mountains and had their own ways of judging the snow. But I was in charge.

Complicating my decision was the fact that we had accepted a good deal of money from our sponsor and the *Today* show to make this climb. They had paid to make our trip possible, and we hadn't even reached 26,000 feet. From a layman's point of view, if I called off the climb I was afraid it might seem we hadn't made a serious effort, despite overcoming all the difficult climbing lower down. I felt a keen responsibility to our sponsors, but I couldn't let money come before safety.

In October of 1986, when our Mallory and Irvine search expedition finally walked away from the North Col, it had been tough to leave. But the season was ending; the days were growing shorter and colder and the wind unceasing. And with the tragic death of Dawa Nuru our expedition had already ended in spirit.

By contrast, in 1994, we were climbing in the pre-monsoon season. Every day would be getting warmer and longer. No one had died or even been injured. We had plenty of food to stay another three weeks or more. We could have waited to see if the conditions improved. I felt a deep urge to go higher, get more video footage, get closer to the summit. But I thought the best decision was to leave.

My decision was disappointing to everyone, especially to Barry, who wanted to wait and give the route one more try. I promised Steve Swenson that we'd drop him off at the north side so that he could join an American North Col expedition we knew was there. On the way out, I reminded myself that the mountain would always be there for a return attempt, if I wanted one. I thought I'd learned from the Sherpas to be patient, to live *with* the mountain, to listen to it. Sherpas often make their decisions about the mountains based on what most Westerners would call superstition, and others call faith. In the Sherpa world you bring to bear a feeling about the mountain, along with all your mountaineering experience, in order to make a decision. Similarly, I rested my decision on intuition and experience.

Still, walking away from the Kangshung Face that spring, I couldn't shake the feeling that I'd collapsed the circus tent, pulled down the poles, and left too early. At any step I could turn around and view that stupendous, wild place where Kurt Diemberger had handed me the camera thirteen years earlier.

The weather was clear and the face looked benign, even inviting. A few days earlier I'd felt it was a death trap, one great deteriorating sweep of avalanche-prone snow. Now, the first hints of self-doubt crept in: Should we have waited longer? Was I a poor leader? Was I a coward? I knew this mantra from other failed expeditions. The endless, agonizing recycling of what might have been, soon followed by a litany of rationalizations and self-deceptions as you struggle to reconcile the void between the person you want to be and the person you fear you are.

IMAX®

With the IMAX camera at Mount Everest Base Camp, 17,600 feet.

CHAPTER TEN

My first priority when I returned home from Tibet in the summer of 1994 was to rescue my marriage. Beginning with *Cliffhanger*, through three trips to Tibet, I'd been separated from Veronique for almost half of our marriage. My focus had been completely on my work. I realized by then that I should have at least taken her along on several of those trips. I had been leading my own life while she made all the compromises, all the adjustments—not the least of which was moving from New York to Boston. Now she was living a life separate from mine.

We had always enjoyed climbing together, so I proposed that we take a climbing trip to the Grand Teton in Wyoming. Veronique was such a joy to be with in the mountains, always a graceful partner on the rock. My ulterior motive was that I thought it might help keep our marriage together if I took Veronique on a tour of my childhood—if she could see where and how I grew up. But instead of concentrating on Veronique and our relationship, I found myself fretting over the failures of the Kangshung Face expedition and looking for something serious to happen in my career.

Veronique and I got along beautifully while climbing the Grand Teton. Maybe I didn't need my freedom as much as I thought. But when I got back to Boulder there was a message at our hotel to call someone named Alec Lorimore. I didn't know him or the production company, but the message said that David Fanning, of the PBS series *Frontline*, had told them I was the man for a certain job they had in mind.

I called Alec. We chatted for a few minutes, then he said, "We're thinking of making a large-format film about Everest for IMAX. Can you put together a slide presentation for the annual conference of large-format producers, directors, and theater owners?"

Lorimore explained that he couldn't promise anything would come of it; they were just testing the waters. But as a freelancer without work, I was only too happy to pull some of my own Everest slides together and fly to France, where they were holding the conference that year.

I said yet another quick goodbye to Veronique, then flew to Paris and met Alec and the president of the production company, Greg

MacGillivray. Greg and I hit it off right away. He'd got his start as a teenager on homemade surfing films he shot with a 16mm Bolex camera. Greg felt about oceans the way I felt about mountains and climbing. Months later, after attending a gathering of climbers, Greg leaned over to me and said, "You guys are just like us surfers. I remember that surfer subculture when I was in my twenties—it was just like these climbers." Without ever having climbed, he instinctively understood the essence of the craft, and he was passionate about the challenge of filming Everest.

"Let's do it, David," he said during our first meeting. "Let's be the first to get these great, big, glorious sharp images of that mountain up on the giant screen." I thought that for someone who makes films at sea level that was easy to say.

I knew nothing about the specialized large-format industry, and Greg knew nothing about high-altitude filmmaking. The IMAX screen—eighty feet wide and six stories high—offers a stunningly sensual panorama that fills your peripheral vision. A whale could be shown life-sized. The trade-off was that the film was so bulky, it took a projector the size of a VW Beetle to handle the film reels. And because of the reel's diameter, and the overwhelming impact of the giant-screen images, large-format films generally lasted forty minutes or less.

I gave my Everest slide show at the large-format film conference in France. Then Greg stood up and presented a proposal to the audience, made up mostly of potential exhibitors. There was no rush to be first at our feet with checkbook in hand. The subject matter—a mountain climb—seemed to have a certain appeal, but people were skeptical of the costs and risks. A little later, walking around the convention center, I went to the Imax booth, and got my first glimpse of an IMAX camera. Our proposed film project nearly ended right there.

It was Imax's smallest camera at the time, and it was a monster of a machine. I truly couldn't believe my eyes. It was the size of a microwave oven and weighed seventy pounds loaded with one film magazine and fitted with a lens and battery. One magazine held 500 feet of film, weighed 4.5 pounds, and lasted all of ninety seconds. By contrast, 400 feet of 16mm film weighs a little over one pound and lasts eleven

minutes. The weight factor aside, each magazine change would mean manually feeding a big loop of film through complicated mechanisms inside the box, a task I couldn't imagine doing bare-handed at minus 20 degrees. Finally, the camera had to be mounted on a tripod and tripod head—a contraption that itself weighed eighty-four pounds.

There was no way in the world such equipment could be hefted to the top of Everest, and I told Greg so. He didn't buy my skepticism, nor my descriptions of how stressed a climber was at 29,028 feet. He was, after all, used to working mostly at sea level. I was willing to evaluate the large format's possibilities, but Greg needed to accept the difficulties of shooting at such altitudes. We soon came to an accommodation.

Through fifteen years of documentaries, I'd been trying to convey the experience of Everest to people back in the U.S. But no matter how compelling my images were, I had to shrink Everest to fit a television screen. I was intrigued with the idea that for once, with the large format, I might not have to dwarf the mountain's majesty in order to share it.

While I was also excited by the challenge of learning this type of cinematography, I knew very well the limits of what one could haul above 25,000 feet. In all my trips to Everest's summit, I'd never even carried something as large as a full-sized 16mm camera to the top. I'd always used specialized lightweight video or 16mm cameras on summit day. I wasn't interested in putting anyone's life at risk trying to ferry this impossibly heavy piece of machinery through the Khumbu Icefall, much less to the summit.

"Why not a 35mm camera?" I asked. A feature film camera would weigh a fraction of the IMAX camera. Everything would be lighter, from the lenses and batteries to the tripod and film. A 400-foot roll of 35mm film weighs only three pounds, and lasts four and one half minutes. For two thirds the weight, he'd get three times the footage. Then the 35mm film could be blown up to fill the huge screen.

But to Greg it was unacceptable to enlarge a 35mm image to fit that huge screen. For one thing, a 65mm frame has ten times more negative area than a traditional 35mm frame. That means the image is ten times sharper. A blown-up 35mm frame would look grainy. I had to admit that he had a point.

By the end of our first conversation, both of us were burning with the same vision of this large-format process on Everest, but there seemed no way around our opposing requirements. He wanted it big. I wanted it light. Finally we went to the engineers at Imax to see if they could help us reinvent the camera, that is, create one that would fit Himalayan specifications. We needed the camera drastically lighter, and able to run without a heating system after sitting overnight in a tent at minus 40 degrees. The knobs and lens mounts would have to be large, accessible, and sturdy, so that when I was tired, and my hands were stiff with cold, I could flick a switch and know the camera would work. And I had to be able to manipulate the knobs with mittens on.

My liaison at the Imax corporation was an engineer named Kevin Kowalchuk. He and his supervisor, Gord Harris, came up with a design team and a plan to modify a Mark II IMAX camera with a body made of magnesium, which is lighter and stiffer than aluminum. Wherever possible, he hollowed out parts of the camera. Special drive belts of polyurethane would be flexible even in subzero temperatures, and lubricants in the motor and lenses were good down to minus 100 degrees. The design team replaced the motor and adapted it to have a start-up time of three seconds to allow frozen gears and film to ease into motion. Extra-large control knobs were added to simplify operation at high altitude. Lithium battery packs, good down to minus 40 degrees, were commissioned and specially designed by Automated Media Systems in Boston. Finally, we selected a film stock made of Estar, a plastic similar to Mylar, that wouldn't crack in the cold like conventional acetate stocks.

The modified and reengineered IMAX Mark II lightweight camera body weighed twenty-five pounds, the maximum weight a very strong Sherpa could be expected to carry above 25,000 feet. With battery, the lens, and a loaded film magazine, the whole unit weighed forty-two pounds; Kevin had the Imax engineers strip almost thirty pounds from the original. We hadn't tested it yet, but we were beginning to think we could consider Everest in this format.

As the engineers were modifying the camera, I was being modified into a large-format cinematographer. Greg flew me out to Laguna Beach where we watched some large-format movies on the small

screen in his screening room, and we talked about the differences between shooting in the large-screen format and 16mm or 35mm formats. The difference could be summed up in one word: size.

In my previous work, I'd always liked the cinema verité experience. I'd get up close to my human subjects to see emotion on their faces, to show the world from their point of view. On the failed Kangshung Face trip, I'd been right at Sandy Pittman's side, my camera trained on her boots scraping the rock and her crampons penetrating the ice.

I realized that that technique wouldn't work on such a large screen. The image of a woman's face as she gasped for breath on the high slopes of Everest, projected six stories high, wouldn't convey human struggle. It would look like something out of a King Kong movie. I was going to have to adjust my approach from the personal to the epic. The mountain would look spectacular on an IMAX screen. But conveying the personal drama of the climbers would be a constant challenge.

Another challenge I'd face would be in the way I moved the camera. One of my favorite climbing shots is to tilt the lens up a big mountain wall and find a tiny figure in the vertical landscape, then slowly zoom in. But in the large format, tilting the camera up is rarely done. It doesn't work because you'd have new information entering from the top of that huge screen, which means the audience would have to lean backward and look up to find the information six stories above them.

It required an artistic leap of faith for me to visualize what ordinary objects would look like on the screen. We had hoped to launch the Everest shoot in the spring of 1995, but we postponed the expedition a full year to finish funding the $7 million budget. That gave me time to field-test the camera.

Veronique was the type of woman who couldn't begrudge my enthusiasm—no matter that its cost was the strength of our marriage. She loved to see me inspired, and so the field test goodbye was only slightly bittersweet. I was too wrapped up now to be concerned, anyway.

I flew to Nepal in the spring of 1995 and met Kevin and our production manager, Liz Cohen, a high school friend, in Kathmandu. The purpose was to take the camera on a 160-mile shakedown trek both to

test it and to get some footage to raise production money and interest in the project. For twenty-eight days we hiked through the Khumbu valley, setting up the camera, taking shots, breaking it down, and moving on. We wouldn't go above 18,200 feet on this trip, so I set an accelerated pace to mimic the harder work we would encounter at higher elevations the next year. I wanted to see how well the equipment functioned, how well the Sherpas carrying the various pieces worked as a team, and how well I adapted to the camera in the field.

Every time I turned it on, the camera roared and clattered so much I thought it was going to fly apart. Gobbling more than five feet of film a second, the thing was noisy, obtrusive—and still large. It took four Sherpas to carry the camera and its gear.

As I shot roll after roll of film, I became better acquainted with the camera. I shot cloud formations and camp scenes, the monks at Thyangboche monastery. One day I was lowered out on a rope strung between the walls of a small gorge, 150 feet above the Imja Khola River. I had to learn how to assemble and operate the camera while suspended in midair at 13,000 feet if I expected to do it while standing on Everest. I also had to count to myself while I filmed, something I'd never do with a regular camera. But it helped me conserve film as the camera chewed it up at its alarming rate.

Along the trail, as our team stopped to rest one afternoon, another group joined us. Among them was a pleasant, American-educated Sherpa in his late twenties. He told me his name was Jamling Tenzing Norgay and that he was a mountaineering guide. I'd heard he was in the area and was hoping to meet him, as he was the son of Tenzing Norgay, my childhood hero. Looking closely at Jamling, I could see the reflection of his father in his eyes. I knew straightaway that Norgay had to be in our film.

I explained about large-format films and said, "I'm here testing this thing. We'd like to make one about Everest."

As I gathered my gear to leave, Jamling said, "I've wanted to climb Everest for a long time," and added, "I'd be interested in joining your team."

Our team pressed on to Base Camp at the foot of Everest. The few acres of glacier rubble were jammed with more expeditions and

climbers than ever. Nonetheless, I was excited to be back at Everest again. The story of Everest lay right in the lap of the South Col route, where Tenzing Norgay and Ed Hillary had first climbed the mountain. Looking up, I thought that only with this camera could I capture the epic scale of the Everest experience as I had known it.

I'd hoped to take the camera into the Khumbu Icefall to get some shots of the ice and climbers from other expeditions, but the Nepalese Ministry of Tourism refused to give me a permit. I was in an awkward bind. I needed footage of the Icefall to show potential backers of the film but I didn't dare violate the ministry's order. If I tried to sneak in, there was a chance the liaison officers would catch me. If one of them went to the Nepal bureaucracy with tales of any transgression, I knew we'd never be allowed back to shoot the film.

Ed Viesturs was resting at Base Camp before his summit bid. The last time I'd seen Ed was in 1990 when I'd watched through a telescope as he climbed the North Col route without bottled oxygen. He told me he was guiding commercial clients for a New Zealander named Rob Hall, who had founded a guide service called Adventure Consultants. Ed's girlfriend, Paula, was staying at Base Camp.

Intensely curious about the IMAX camera, Ed immediately volunteered to give up his rest day and climb for my shoot near the mouth of the Icefall, where we didn't need a permit. I was enormously grateful, and told him to think about joining our *Everest* IMAX Filming Expedition if I returned to shoot the following year.

By the end of our test trip, I was comfortable that the Sherpas could handle all the camera's heavy components, and Kevin had learned more about additional camera modifications that we would need. We returned to the States like veterans: Our team could set that camera up—put it together, mount it on the tripod, load and thread the film, aim, and shoot—in five minutes flat. The camera, which had seemed hopelessly cumbersome, even threatening, at the outset, had become a friendly piece of gear. I'd even come to appreciate its mechanical roar.

Back in the States, I flew to Laguna Beach to view the unedited footage with Greg. Sitting in his screening room I was a little discouraged. Watching the Himalayas flicker on a screen eight feet high didn't

impress me very much, but we couldn't rent an IMAX theater just to please me. I still had a lot to learn, but Greg thought I had a good feel for the format. While the Imax engineers continued to refine the camera, Greg edited the footage down to an eight-minute promotional piece to show at the next annual conference for large-format filmmakers. It seemed the Everest film might see the light of day, after all.

Testing the camera, hanging around Base Camp, talking with Ed Viesturs—all of these moments had ignited the Everest passion in me again. I was home for only two months before I left Veronique again, this time to attempt an ascent of the North Col route without supplemental oxygen. Maybe I was just trying to get away from our failing marriage. Whatever my reason, I flew back to Tibet, this time with a video camera and a knee brace—I'd injured my knee water-skiing near home. With David Fanning's encouragement, my plan was to shoot a video diary while climbing Everest. I hired Wongchu and two other Sherpas, Jangbu and Lhakpa Gyalje, for my climbing team.

We set up our Base Camp near a small pond of glacier melt next to the site being used by an expedition of Spanish climbers. From across the little pond I could see the other team and almost hear their conversations. The heart of that team was an exuberant, powerful young woman named Araceli Segarra. She was a constant source of good-fellowship and had a great trilling laugh.

The snow simply wouldn't stop on Everest that year. Nevertheless, my Sherpas and I made it above the North Col and angled up a great hump of a slope called the Whale back toward Camp V. The snow was up to my stomach, and with every step I had to scoop up armfuls of it and stomp it flat to make a platform on which to stand while I dug the next step. I remember laughing wryly at myself; I'd never felt more like the mythological Sisyphus, pushing my rock up the hillside only to have it roll back down again.

As we climbed at 24,500 feet toward the rocks below Camp V the entire slope shifted abruptly, settling with a huge *whumpf.* The slope hadn't released, but the Sherpas and I immediately turned around and headed back to our tents at Advance Base Camp.

A week later we climbed back to North Col. It was then, on the way down, that I was almost killed. It happened about a thousand feet directly above where Dawa Nuru had died in the avalanche in 1986. I was behind Wongchu, traversing through thigh-deep snow, clipped to a thin, 7mm fixed line. Wongchu had made it across to the North Col, when suddenly, thirty feet above me, I saw a three-foot-deep fracture line unzip and the whole slope cut loose.

My first reaction was not fear, but surprise. I yelled, "Hey, what's happening?" little knowing that Wongchu would spend the rest of the trip mocking my tone of voice in his accented English—*Hey, what's happening?*

In a surreal moment, the snowfield slowly moved downhill, not so much like an avalanche as a cold white quicksand—and it started to pull me down with it. Wongchu was already across at the North Col, and one of the other Sherpas, Jangbu, was safely waiting back at the anchor. There was nothing they could do to help me, and nothing I could do to help myself. The deeper the snow mass dragged me, the more the fixed line stretched and tightened. I knew the rope would eventually break and I would be slowly sucked into a white void.

Suddenly my body popped free of the snow. The slab slid out from underneath me and poured over an ice cliff, thundering down a thousand feet. I should have been on it. When I'd gathered my wits and dragged myself out of the snow, I called over to Wongchu, "Let's go get the tents, we're going home."

A few days later, Araceli's Spanish team was hit by a massive slab avalanche, killing one of its members. I hiked over to their camp to offer my condolences to her and the others. As she and I talked, an entire world of emotions flickered across her face, from disbelief to grief, and finally resignation. I'd never seen such an honest but hauntingly open display of human feelings. No actor could have summoned them—or shown them—so easily and with so much grace.

Shortly after I returned home, I went to the large-format film convention, held that year in Galveston, Texas. We showed our eight minutes of Nepal footage. For the first time I was seeing images I'd shot that

spring in the Himalayas and on Everest projected on an IMAX screen sixty feet high. The Himalayas looked magnificent. I sat there trans-fixed. I could only imagine what the Icefall or traverse to the Hillary Step would look like on that vast screen. I remembered feeling that dis-tinct sense of awe at a landscape only once before: when I was a boy and my parents took me to see *Lawrence of Arabia.*

There still wasn't much excitement about Everest. People ques-tioned why we wanted to make this film and whether we could make it at all. I had to resist repeating Mallory's quip, *Because it's there.* A few people who saw it were interested, but there was a strong sentiment among some of the museum and theater directors that a movie on Everest just wouldn't work for them.

Veronique was waiting for me. It was now September, and even though she knew that in six months I'd be returning to Everest, she made one last, loving effort to connect with me. She rented a house for us on the island of Nantucket where we could be alone together for a week and hopefully sort things out.

Nantucket was peaceful, and nearly deserted except for the locals. We walked on cobblestone streets and along the beach and ate the bluefish we caught off Great Point. We relaxed and got to know each other again, delighted by the intimacy. But in the middle of the week, I checked my phone messages. There was a call from National Geo-graphic TV offering me work on a film about a recently discovered Inca mummy and human sacrifice on Mount Ampato in Peru.

I felt I had to accept. Greg was still polling responses from the Galveston screening, and I couldn't be sure the Everest project would really happen. I watched Veronique's face fall as I cut short our Nan-tucket holiday to leave once again.

"Don't worry," I assured her. "I'll be back in time for your birth-day at the end of October. I promise."

The Ice Maiden, as the 500-year-old mummy of the Inca girl was called, had already been removed from Ampato by the time our Na-tional Geographic film team arrived. I'd never been to the Andes, but I'd read about the Inca and was curious about their practice of human

sacrifice on the high Andean peaks. As the shoot unfolded, scientists found two more mummies on the 20,700-foot mountain. Recent activity from a neighboring volcano had sent plumes of ash drifting over onto Ampato. The ash absorbed the sun's energy, melting snow off the mountain's summit, revealing the Ice Maiden. Our team excavated two other child sacrifices lower down. But these remains were not mummified.

On Everest, I'd dealt with climbers killed in accidents, their bodies left behind without ritual or ceremony. Here, bodies had been offered to the mountain for a reason. Five hundred years earlier, Inca priests made expeditions to Ampato's summit. Their high camps were eerily similar to camps I'd made. Priests and their entourages had carried clay pots for cooking, firewood, poles for tents, and hundreds of pounds of grass to insulate them from the snow and the cold ground. They'd cut staircases into steep, hardened mud, and lined the stairs with grass to keep from slipping. Then, in a ritual called the *capacocha*, the Inca sacrificed their young to the mountain gods. It was the supreme form of sacrifice, and was done to help bring rain for crops to feed the people. I thought about that and the contrast to the deaths on Everest.

The National Geographic shoot took a week longer than expected, and by the time I returned to Boston, I had missed Veronique's birthday.

She was gone when I returned to our apartment. Not out, but gone; I could sense it as soon as I saw her. Her manner conveyed it all too clearly; this time she wasn't letting me back in as she had so many times before. After two unbearable weeks, we finally sat down to talk. Her voice was quiet, even sad, but also firm. "We planned a life together," she said, "but you're not here."

We packed up a Ryder rental truck with all her possessions and said our goodbyes. I began missing her the moment she drove away. I wanted to shout at her to come back, but I didn't know how. We had promised to stay friends—but that didn't make the pain go away, not for a long time. I missed her, and I felt guilty. With Veronique, my sin was cowardice. I realized that by running incessantly from our relationship

I'd forced her to do the breaking up, to make the decision to walk out, because I didn't have the heart, or stomach, to do it myself.

And so I was miserable and lonely. Our apartment felt emptier than the vast emptiness of Tibet. Over the next few months, my sadness was mitigated only by preparations for the IMAX camera shoot, and I threw myself headlong into these. Greg still hadn't given me a definite go-ahead, but we tentatively aimed at the spring of 1996 for my return to Everest. While Kevin Kowalchuk continued winterizing the camera, I began recruiting climbers, calling all over the world to get just the people I wanted. There would be two teams, the climbers and the film-makers, and they had to work well together.

The first person I called for the climbing team was Ed Viesturs; he had the strength, the expertise, and the experience. I asked his girl-friend, Paula, to be our Base Camp manager. Then I went to Jamling Norgay, Araceli Segarra, and Sumiyo Tsuzuki, the Japanese climber I'd met on the north side of Everest in 1990. Everyone accepted immedi-ately.

For my camera assistant I needed someone whose talents would not only complement mine, but who could also replace me if I got sick or injured. I knew exactly who to call: Robert Schauer, an Austrian mountaineer and filmmaker I had met when he came driving into our Kathmandu hotel courtyard thirteen years earlier. Liz Cohen, who had worked so hard during our test shoot in Nepal, agreed to return as pro-duction manager.

Last, my great Sherpa friend Wongchu agreed to head our team of Sherpas.

Everything was falling into place, except that my life with Veronique was over. My apartment was filled with equipment and pa-perwork, but there was no life there, just a kind of blank existence. I felt better once my team was in place: When you're down and out, sur-round yourself with people you like.

And keep busy. Every hour of every day I was at the center of a maelstrom of details, applications, budgets, meetings, and endless phone calls. Finally, in January of 1996, the camera Kevin had been refining was ready to be tested one last time in Toronto. The Imax cor-poration had arranged for us to test the camera equipment in a cold-

chamber big enough to park a pickup truck inside. The day before I came up Kevin put all the camera gear in the chamber so it would be frozen—film, lithium batteries, and camera—for twenty-four hours at minus 50 degrees.

Outside the chamber I put on my down suit, hat, and boots, and walked into the room. It felt as cold as a distant galaxy in there. We turned the camera on, and tried to work the focusing mechanism on one of the lenses. It was stuck because the cold had caused one metal piece to contract against another. The engineers would have to modify the lenses once again.

Loading the film into the camera was the real test. I'd learned from the field test in Nepal that gloves, even thin silk gloves, could leave fibers inside the camera body that might show up on the film. The only way to prevent that was to take my mittens and gloves off every time I reloaded. My bare hands quickly turned white in the frigid air of the chamber, but I was able to load the film and start the camera. It was so cold, the liquid crystal display on my Sony video camera froze solid.

When I walked out of that chamber and closed the door, I felt like it was a new day. I had complete faith in the camera and my ability to use it. Now it was time to go up the mountain again.

THE CRUCIBLE

Everest 1996. Rob Hall's team, Scott Fischer's team, the Taiwanese, and the South African teams climbing the fixed ropes of the Lhotse Face from Camp III to Camp IV, May 8, 1996.

CHAPTER ELEVEN

"I think he's dead," Jangbu radioed from the Lhotse Face.

Robert and I looked at each other in disbelief. It was a beautiful sunny day during which we'd watched an astonishing sight: fifty-five clients, guides, and Sherpas slowly climbing the fixed ropes to the high camp on the South Col at 26,000 feet. Early that morning, a Taiwanese climber had slipped and fallen into a crevasse at Camp III. As Jangbu helped evacuate him down the steep ice of the Lhotse Face, Robert and I had trained our telescope onto the rescue team. Now all we saw was a motionless figure slumped against the slope. "I think he's dead," Jangbu radioed again.

Every Everest expedition begins at a different point for me. Sometimes it starts with the departure from home or the landing in Kathmandu or Lhasa, with my first step on the approach march, or when I reach the foot of the mountain and pull off my pack. At some point in time you leave one territory and cross a threshold into a new one. You begin to sense the mountain, to imagine what's ahead.

It was the end of March 1996, when our *Everest* IMAX Filming Expedition walked into Base Camp, at 17,600 feet. There would be ten other teams sharing the south side of Everest that year. Not far from our camp stood Scott Fischer's Mountain Madness camp, prominently displaying a Starbucks banner. A short distance up the glacier, Rob Hall's New Zealand camp was announced in big white letters painted on a large boulder. These were the season's two major commercial expeditions, each with clients paying sums large and small to be guided on Everest by professional climbers. Elsewhere, national flags flew among the long strings of colorful prayer flags that are the centerpiece of each Base Camp. More than 300 people would inhabit this swath of rock-strewn glacier for the next sixty days.

Since 1983 the scene at Everest's Base Camp had evolved from a rarely visited encampment into a bustling—if temporary—village among the rocks and ice. Base Camp had become an adventure travel destination and the once-rare tourist was now a common sight. A remote cor-

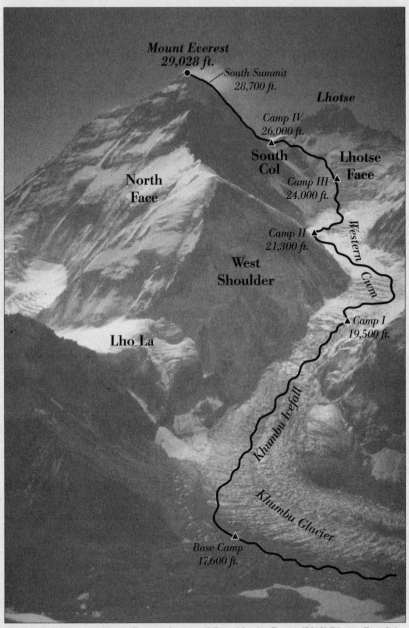

The South Col route on Mount Everest, the route followed by the *Everest* IMAX Filming Expedition

ner of Nepal had become a communications testing ground, outfitted with enough computers, radios, phone/fax machines, satellite links, and Internet connections to communicate with anyone in the world. Certainly I'd brought in my share of technology and gadgets over the years, especially this year with a forty-two-pound IMAX camera.

In recent years, eager for foreign currency, the Nepalese government started selling a dozen or more South Col permits—at $70,000 each—for every pre- or post-monsoon climbing season. Compare that to twenty years ago, when one permit per season was offered for $1,500. Back then you felt a sense of privilege climbing in the Himalayas. But now getting to the top of Everest has become common. Over half of the 846 individual ascents made since Hillary and Tenzing first "conquered" the mountain in 1953 have been done in the five-year period between 1991 and 1996. A powerful appeal of climbing Everest is that it creates a sense of exceptional and unique accomplishment. But, ironically, with so many people ascending to the summit, no longer was the South Col climb exceptional or unique.

Each expedition is like its own ship, ruled by its own chain of command. Collectively, we are not bound by any formal shared code of conduct, but we are bound by the so-called brotherhood of the rope. Expeditions now arrive and find themselves in immediate competition for such basic resources as flat tent sites. In 1996 there were ten Everest expeditions needing space on a thin slice of the Khumbu Glacier. While there is an appearance of international bonhomie, behind the scenes the leaders and guides of different expeditions subtly jockey for position.

Our expedition immediately got to work erecting tents and building Base Camp. After a week, we had begun adapting to the altitude and were starting to make day-long forays into the Icefall leading up to Camp I (19,500 feet). Like all the other expeditions gathering at the southern foot of Everest that spring, we were repeating the South Col formula that has been used by thousands of climbers ever since Hillary and Tenzing pioneered it forty-three years earlier.

From Camp I, on top of the Icefall, we would enter a mile-deep valley known as the Western Cwm. Carefully wending our way across the sprawling, crevasse-ridden Khumbu Glacier, we would traverse the

Cwm between the high walls of Everest to our left and Nuptse to our right. It was a journey that usually took a fit climber three hours. Camp II, our Advance Base Camp, lay at the edge of the glacier on a moraine at 21,300 feet near the base of Everest's Southwest Face. After a four-hour climb up the 40-degree ice of the Lhotse Face, we would chop tent sites for Camp III at 24,000 feet. An exhausting six-hour slog higher up, Camp IV, the high camp, sat atop a wind-blasted mesa called the South Col (26,000 feet). From there, it was a very long day to the summit at 29,028 feet and then back down to Camp IV, returning, ideally, before dark.

A typical expedition took five weeks to establish and stock successively higher camps and to properly acclimatize its climbers. For this film trip, I'd built a five-week summit schedule that could be extended to eight weeks. Arriving in late March, we hoped to reach the summit in the first week of May. That would still give us a space of three weeks before the onset of the monsoon, which normally rolled in from the Indian Ocean the last week of May, ending the climbing season. If there were any delays in our climb and we missed our first summit bid, there would still be time for a second attempt.

While we were getting our sea legs in the Khumbu Icefall, Robert Schauer and I started filming our four "actors," Araceli Segarra, Ed Viesturs, Sumiyo Tsuzuki, and Jamling Norgay. In selecting our team, I'd chosen my own island of people to get stranded with. Long expeditions lend themselves to cabin fever. I'd learned to surround myself with people who brought not only extraordinary climbing skills, but also humor, optimism, and independence. Each of the members knew me. Now they got to know one another.

In terms of bonding, meals could be just as important as climbing together. Dinners really stood out with this group. The cuisine was as tasty as it was international. Araceli's parents owned a bistro near Barcelona, so we were well stocked with a fine Serrano, or dried ham, prepared by her mother. Araceli generously shared her treasure. Sumiyo brought unagi (smoked eel) and plum wine from Tokyo, and Robert had smoked meat and pungent Austrian cheeses to share. Jamling sometimes found the swirl of flavors too rich, and quietly excused himself to have some tsampa (ground roasted barley) with the Sherpas

in the cook tent. The only constants at our dinner table—pieces of sheet metal covered with a cloth—were humor and opinions.

Ed was a person I'd always wanted to be. He was a mountaineer's mountaineer, and belonged to the great tradition of high-altitude climbing that included Hermann Buhl and Reinhold Messner. Low-key, powerful, and confident, "Steady Ed" was reliable and resourceful. As he had successfully done twice before, Ed would be climbing Everest this trip without supplemental bottled oxygen.

For him, eschewing bottled oxygen had nothing to do with trophy hunting. Rather it was a philosophical statement, an expression of human capacity pushed to its physiological limits. If you think about it, climbers who use bottled oxygen aren't rising to the mountain, they're reducing it by several thousand feet. What I liked about Ed was not only his message, but its delivery. He leads by example, not word. Here was a climber and purist, not a risk-taker. In Ed our film story had its seasoned veteran. There was no question Everest occupied a major part of his life. The expedition was also serving as his honeymoon with his bride—and our Base Camp manager—Paula.

Araceli contrasted with Ed's venerable presence. She reminded me of when I was young and had come here wide-eyed, mesmerized by the Himalayas. Just the same, she was no neophyte. Like Ed, Araceli had a very craftsmanlike approach to climbing. Starting with a foundation in spelunking, or cave exploration, she'd perfected her rock, ice, and alpine skills in the Alps and on the big walls of Yosemite. She had climbed the difficult south face of Shisha Pangma, 26,391 feet, in alpine style, without fixed ropes or fixed camps. For a twenty-six-year-old, she had enormous experience and a distinctly fresh approach. The very word Everest would light up her eyes. A Spaniard—or, by her own proud accounting, a Catalana—she brought to the film a Spanish exuberance for life. She also brought the sensibility of a woman, which was to listen to the mountain, listen to the wind, and take the path of least resistance. Finally, Araceli possessed one of the most expressive and photogenic faces I've ever seen. On the north side of Everest in 1995, I'd seen the full range of her emotions after the death, by avalanche, of one of her climbing partners.

For me, Sumiyo represented the iconoclast. As a woman in

Japan's male culture—where so many women must conform to tradition in their roles as either housewives or secretaries, and conformity is so prized—Sumiyo had dared to step out and become a Himalayan climber. She, too, had served her apprenticeship in the mountains, climbing Cho Oyu, a 26,906-foot peak, and attempting Everest twice before. Like Araceli, Sumiyo helped broaden the traditional, masculine perspective of "conquering" Everest. It was important to me that half our climbing team was female. Half our audience was likely to be women, and I wanted this film to have characters who might directly inspire young girls.

The other Asian climber on this Asian mountain was Jamling Tenzing Norgay. Jamling embodied my connection to this mountain—it was his father's image and example that had drawn me here in the first place. Through Jamling, our film was instantly infused with Everest's history. As a Sherpa, Jamling manifested the contributions his culture has made to almost every expedition that's ever set foot on the mountain. A skilled mountaineer and our climbing leader, Jamling would reveal Sherpas as experts, not just load-carriers for Western expeditions. He gave us a Buddhist perspective, too, showing the Sherpas' respect and reverence for nature and for the deities that reside in the mountains. Not least of all, for me, Jamling brought to our film the story of a man who was coming to terms with his father's legacy. He wanted to follow in his father's footsteps, not his shadow.

There wasn't a prima donna in the bunch. None of us harbored any illusions about who the real diva was. Everest would take center stage. When the screen is six stories high, as I had learned, the format doesn't lend itself well to individual drama, nor to close-ups of a human face. Our purpose was to blend the human quest with Everest's presence and power. We wanted to make the mountain itself a character, to show its personalities, its moods, its light, and its wind. Because film and shooting opportunities would be increasingly limited the higher we went, everything had to be carefully orchestrated. Shots had to be planned in advance, and that meant drawing on a detailed, collective memory of the mountain's features at different points and different times of day and night. Having shot so much footage on this route, I had a good bank of images in my mind. But I wanted one other

man's memory and assistance for the film, too. That was Robert Schauer.

I'd met Robert as he emerged from his red Austrian six-wheel-drive Pinzgauer assault vehicle in the Star Hotel courtyard in Kathmandu thirteen years earlier. He'd driven the bizarre vehicle across Central Asia, from Austria to Nepal. His climbing résumé was staggering. He was the first Austrian to climb Everest and had climbed five of the world's tallest peaks. More importantly, he was the most accomplished mountain cinematographer in Europe. We'd crossed paths over the years, and I'd attended his international mountain film festival in Graz several times, and in Skardu, Pakistan, on my way to Nameless Tower, he had driven up, again in his Pinzgauer, looking for a few rolls of 16mm film. This was our first chance to work together.

Over the coming months, Robert and I would work side by side, shoulder to shoulder. We knew Everest as filmmakers, and Robert's recall helped make an impossible film schedule become reality. From Base Camp to the summit, he would be there with me for every single shot, resetting the aperture on the lens, rechecking the focus, counting out loud the seconds or talking with me about the story. On *Cliffhanger*, I'd been part of a huge crew with specialists who attended to such details. On this film, with a format ten times larger than that of *Cliffhanger*, it was just Robert and me tending that camera on the mountain. It would have been impossible to find a person with a better combination of Himalayan climbing and filmmaking experience along with Robert's patient, understanding manner.

We were supported at Base Camp by two large-format pros from MacGillivray Freeman Films. Steve Judson was the editor, co-director, and co-writer of our film. He came into Base Camp with Brad Ohlund, a seasoned cinematographer and our technical consultant. Greg had wisely decided in the month before our departure from the U.S. that I did not have the large-format experience to be left alone with such a demanding project. Steve helped direct the film and story as far as Base Camp and departed after ten days. Brad stayed at Base Camp from beginning to end. His large-format experience was a tremendous resource to me when I had questions about framing and composition. Most importantly, his duty was to keep the $186,000 machine tuned.

The tuning was vital to our success. The camera's many rapidly moving parts had to be calibrated exactly or they might scratch the 65mm film emulsion. A scratch would produce shavings and, as I'd noticed in the test shoot a year earlier, the slightest shaving or fiber from clothing or dust in the air, dubbed "hair," would show up on a large-format screen the size of a beachball or boa constrictor. On a normal Hollywood shoot, the director and cinematographer could look at dailies, or the processed film of a day's shooting, and catch the problem in time to reshoot the scene. On Everest, with the Imax processing lab on the opposite side of the planet, we didn't have that luxury. Every two weeks or so, the exposed film traveled to the U.S. via yak, light plane, and commercial jet. There Greg would view the processed and printed film in his screening room in Laguna Beach and fax his film report to us. By then, the camera had usually moved higher, and reshooting a scene would interrupt the rhythm of the expedition. So we worked hard to get it right.

This was no ordinary shoot. The camera's size and weight were unlike any used on Everest before. There was little chance of picking up shots as they spontaneously occurred. We had to anticipate every shot well in advance. We might be climbing through a location five or six times, for example the Icefall, but would have the camera with us for only two or three of those trips. We couldn't have the Sherpas carry it back and forth, up and down the mountain, like a lighter-weight 16mm camera. Knowing that, we made the most of our initial days in the Icefall.

It was on April 7, scarcely a week into our expedition, when we got word that a Sherpa with Rob Hall's Adventure Consultants commercial expedition had plunged into a crevasse on his way to Camp II. There were several unsettling aspects to this. First of all, the glacier between Camps I and Camp II is riddled with crevasses which have to be rediscovered every season, then wanded, or marked with bamboo wands, and sometimes bridged with aluminum ladders. The route finding was done by climbers, often Sherpas, who should be roped together for safety. Not only was it early in the season and the glacier was still relatively unexplored and lacking bamboo, but Rob's Sherpa, Tenzing, had been unroped. Then we heard that Tenzing wasn't up there help-

ing mark the route for crevasses and fixing rope—he'd been sent by Rob to drop a duffel bag at the best tent sites at Camp II, thereby claiming them for Rob's expedition. Meanwhile, Adventure Consultants hadn't even arrived at Base Camp yet. Rob Hall and his guides were still a day's walk down valley in the campsite called Lobuche.

Rob was proud to convey to his clients that his outfit always had the best tent sites and the best Sherpas. He knew exactly where he wanted his Base Camp cook tent and exactly where to put his Camp II dining tent. He had it all figured out. But at the time, all we knew was that a Sherpa named Tenzing had broken through a thin layer of sun-hardened snow concealing an immense crevasse. He should have been dead. But 140 feet down, miraculously, a snow ledge arrested his fall. Three feet to either side, and his Sherpa companions would never have found him. They hauled him out and brought him to Camp I, where he lay injured, unable to descend.

Early the next day, Rob arrived in our camp asking for assistance. I knew him from previous expeditions and trips to Nepal, and we respected each other. He was tall and thin, with wide shoulders, a black beard, and had the kind of tightly controlled ambition you'd expect of a company president. Like me, Rob's first taste of the Himalayas was as a young man on Ama Dablam, just a year after I'd climbed it. He'd first climbed to Everest's summit in 1990, and had begun his guiding company with a friend named Gary Ball. In 1993 Ball died in Rob's arms, of high-altitude pulmonary edema, on Dhaulagiri, one of the world's highest peaks. Adventure Consultants survived, in part with the high-altitude guiding services of Ed Viesturs. But in 1996, Ed was on my team. Like Scott Fischer, this year Rob was depending on the guiding services of a man who had never climbed Everest.

Rob left his expedition behind at Lobuche, and quickly came up to patch together an evacuation for his Sherpa employee. Since he and his group had not yet acclimatized, they couldn't go very far above Base Camp, much less rescue their man stranded above the Icefall. Rob was going from camp to camp enlisting Sherpas from other expeditions. He wanted the services of six of our Sherpas. Frankly, I was appalled. He was the leader of a team and hadn't even been here for a near-disaster. You don't just dial 911 up there at 19,500 feet. It requires

some amount of authority and skill to be able to organize the rescue of one of your teammates: You have to set up the satellite telephone, call for a helicopter, confirm that you'll pay the expenses, or, in this case, recruit an evacuation team. That's the role of the leader.

If I'd been in Rob's shoes, I would have asked for help, too. But I wanted to make sure he really needed the help. Once, in the fall of 1984, a Czech team used the Sherpas on my expedition for a rescue, just so the Czechs could save their strength for their own climb. If Rob's Sherpa staff was really shorthanded, then I had no problem sending our guys up. I wanted to be certain of the necessity and of Rob's organizational plans for the rescue. It's dangerous, backbreaking work bringing a man in a stretcher down through the Icefall. And I wanted to make sure our Sherpas would be properly compensated for working on one of their precious rest days.

After consulting with Wongchu, our sirdar, I told Rob the Sherpas wanted to be paid for their time, roughly $6 per day. Rob reacted with indignation. I explained that it was the Sherpas' rest day, an important lull in the action for them to recover from the rigors of load-carrying. It was the day they relaxed, bathed, and washed clothes. They simply wanted to be paid for their time. If he didn't pay them, our expedition would have to. I couldn't order them to participate in a dangerous rescue if they didn't want to. It was, after all, his teammate who was injured. He relented.

Tenzing was safely evacuated by a team of twenty-five Sherpas, including six from our team. It took over ten hours to portage Tenzing, by stretcher, through the Icefall. Rob's clients arrived at Base Camp the next day.

As April unfolded, each expedition methodically moved its own supplies and personnel higher. The weather grew warmer, the days longer. On occasion I bumped into a number of old friends moving up and down the mountain, among them Pete Athans from Boulder, who had climbed Everest four times, Sandy Pittman, my Kangshung Face companion, and Jon Krakauer. We rarely socialized. There wasn't time. I was consumed with my expedition, the filmmaking, and our schedule. We barely said hello. That may sound odd—old climbing partners camped within a hundred yards of each other not sharing meals or

spending free time together. Each expedition had its own orbit. Each revolved around its own group dynamics. All you had to do was look at the way camps were set up in Base Camp to understand this. It was like an archipelago with individual tents arrayed around the communal centerpiece of the dining and cook tents.

The teams were self-contained, with their own food, medicine, fuel and oxygen supplies, latrines, dining tents, and kitchen tents. Some were better appointed than others. Rob's were probably the best-organized camps, which I admired. His dining and kitchen tents were lit with solar-charged lights, not the kerosene lanterns that gave off fumes and caused headaches. He had tablecloths laid over rocks with little snacks and tea bags for his clients. His Sherpa cook staff kept a two-burner propane stove going most of the day, with kettles steaming away. Clients could fill their water bottles with water they knew was boiled clean.

At Base Camp, and also at Camp II, the dining arrangement was crucial. Napoleon had it exactly right: An army marches on its stomach. Served in a clean, well-lit space, warm food can do more than anything to bolster morale. On Everest, that space is within tent walls.

Only twice did the expeditions come together. The first time was on April 10, after a theft. There was a standing tradition for the Icefall that at the end of each day climbers would store their crampons, harnesses, and headlamps at the base of the Icefall for the night. In all the years I'd been going to Everest, this was how it was done. There was no reason to be carrying that kind of personal gear for the ten-minute walk back to your tent at Base Camp, and there was no history of anything ever having been stolen. But one morning we discovered a number of items had been taken.

This was no petty theft. There are very few things more personal to a climber than his or her crampons and harness. These are tools that have been carefully adapted to your own body, customized to fit just right. Crampons, for instance, have to be assembled and fitted to your boot. Stealing someone's crampons and climbing harness was tantamount to a horse theft a hundred years ago. For my part, I lost my best crampons to the thief or thieves. Robert lost his, too. I had a spare pair of older crampons, but they were nothing like my prized black Grivels.

Luckily, Sandy Pittman—who always went well prepared—had brought an extra pair of that very same model, and loaned them to me.

Ed Viesturs and I talked with some of the other leaders in camp, and we decided to hold a meeting in our Base Camp dining tent to address the theft. We didn't expect to find the thief, but we did want to set up what would amount to a neighborhood crime watch, to let people know they should be more careful. Word went through Base Camp and most of the expeditions sent representatives: their leader, deputy leader, and their Sherpa sirdar. It was a beautiful, warm afternoon. My big green Bulgarian army dining tent was filled with people, and our cook staff served tea and snacks.

As the meeting began, some immediately pointed the finger at the porters who were constantly bringing loads up from the valley. But we quickly got past the most convenient scapegoats and acknowledged that it could just as well have been Western trekkers stealing souvenirs. Then we started talking about the evolution of climbing on Everest. At that point Scott Fischer brought up the issue of private property higher on the mountain.

As the founder and chief guide for Mountain Madness, based in Seattle, Scott was heading the second largest commercial expedition that year, right behind Rob. I hadn't seen Scott much for the past fifteen years, and he was little changed. If you wanted the archetypal Everest mountaineer to walk into your photo studio, it was Scott. He was tall, with a blond ponytail and a great horseshoe-shaped jaw. Scott had an absolutely formidable physique that made clients feel comfortable being around him. We were the same age and had both started our mountain training with the National Outdoor Leadership School in Wyoming.

Scott and Rob made for an interesting contrast in styles. Rob was very analytical, precise, and ran a tight operation. For him, his abilities and knowledge of the mountain were the keys to success. Scott was much more freewheeling. His leadership style exhibited great faith in the human spirit, as if to say to clients, *I'm not going to hold your hand all the way, I'm not going to map it out for you, there's something in this experience for you to sort out on your own.* It was Scott's nature to leave a few bases uncovered.

Scott pointed out that high on the mountain, where supplies and energy are limited, there was an increasing tendency for under-equipped teams to "borrow" crucial supplies. In his firm but laid-back way, Scott said, "That's not right. If you put something on the mountain, it's yours."

Then Rob delivered his own message. "I don't mind being the mountain's policeman," he said. "I'm a great guy to have as a friend, but I'm a bad person to have as your enemy. If anyone leaves garbage on the mountain, even so much as leaves one paper wrapper, you're going to answer to me."

That rankled me. We'd gone from cautioning about theft to Rob declaring himself the mayor of Base Camp. I didn't like the implications of that, and said, "Rob, since you care so much about keeping the mountain clean, does that mean we won't see white paint all over the rocks at your Camp II site?"

He was taken aback that anyone would challenge his authority, and, after a pause, finally blamed his Sherpas for painting "New Zealand" on the boulders at his Base Camp site before he arrived. Points had been made, but that wouldn't give us back our gear. We discussed how the assembled teams could work together so we could stay out of one another's way. I voiced concerns about the god-awful noise our IMAX camera produced and apologized for periodically disturbing the peace. The meeting broke up shortly afterward.

Over the coming weeks, even though we were sharing the same route, the same camp spots, and the same fixed rope, the expeditions operated separately.

Nineteen ninety-six was, for me, meant to be the culmination of a dream. As a climber, I'd been to the top of Everest twice. A third ascent didn't much matter. As a filmmaker, I'd filmed the summit, and ordinarily, more footage wouldn't have mattered a great deal. But this time was different because of the large format. This time I felt the camera might actually show the gravity of Everest, its majesty and challenge and beauty. Here at last, on a giant screen, would be an image to truly match the mountain.

And I was certain that in exploring the terrain of that mountain, we were really exploring a far more mysterious terrain—the landscape of our souls. I saw 1996 as the chance of a lifetime to express the mountain experience, to share the serenity of chasing away the darkness. This film was my great opportunity to capture the transcendence of the mountain and the hope and awe it inspires.

On a typical day, our film team would wake before dawn, eat, and depart. As the deputy leader, Ed would have laid out the day's loads for his team of seven climbing Sherpas. These fifty-pound loads were to stock our upper camps with food, bottled oxygen, and other supplies. Robert and Brad organized loads for the film team's five Sherpas. The Sherpas helping the camera crew were often freighted with even more weight. The camera body alone, without a lens, weighed twenty-five pounds. Two nonrechargeable lithium batteries—one, plus a spare—weighed seventeen pounds. The tripod, which had to be stout enough to anchor the heavy camera, weighed thirty-seven pounds, and the metal pan and tilt head, fixing the camera to the tripod, weighed another forty-seven pounds. For the summit ascent, we would carry an eight-pound monopod to balance the camera. Our daily allotment of four rolls of film, plus magazines, added forty pounds. Then there were the rocks. Sometimes the Sherpas had to gather large rocks so that we could stabilize the camera and tripod. I remember having to pile rocks on top of the camera to shoot the wind ripping snow off the face of Nuptse. Even at a hundred-plus pounds, the assembly needed to be stabilized. Once magnified onto a large-format screen, the slightest jiggle would create sickening leaps.

The mass of equipment would have been daunting to handle at sea level. But at 24,000 feet and higher, it took on the dimensions of the proverbial albatross. I came to dub it the Pig, in part a carryover from what rock climbers disaffectionately call their haul bags on big wall climbs, and in part for the enormous amount of film it devoured. It took a whole new discipline to shoot with the Pig. I was used to handling a lightweight videocam or 16mm camera. This was like a ball-and-chain.

More confounding than the camera's weight was the rapid speed

at which the film passed through the camera. The IMAX Mark II raced 65mm film through at 5.6 feet per second, four times the speed of 35mm film. At that rate a 500-foot roll of film, weighing four and a half pounds, lasted all of ninety seconds. An hour of Hi8 videotape costs a few dollars and weighs a few ounces. You can zoom in, zoom out, pan left, pan right, waste all the tape you want. But an hour of 65mm film stock is worth $20,000 and weighs 180 pounds. It was especially precious after we left Base Camp, because it had to be transported on foot by Sherpas through the Icefall to the higher camps. That meant my shot selection and storytelling were greatly curtailed. There were many, many shots I wanted. But I had to discipline myself not to take them. Some shots would have been magnificent. But if they lacked story value, I couldn't afford them. There was no room for waste.

And then there was the brute labor of setting up. With practice, it took an average of ten minutes just to get the camera up on its tripod and loaded. Higher up, above the South Col, it took twenty minutes. By the time we shot and broke down again, three quarters of an hour would be gone. It was brutal work at that altitude, very tiring. On average, each exhausting setup would produce less than thirty seconds of footage which might or might not be used in the film. Filmmakers are accustomed to shooting much more footage than shows up on the silver screen. A ratio of 20:1 is not unusual. Our ratio diminished the higher we went: from 10:1 at Base Camp, to 1:1 on the summit.

Robert and I knew exactly the kinds of shots we wanted to represent the hazards and beauty of the chaotic jumble of the Icefall's 2,000-foot-high river of ice. We planned to film Sumiyo climbing an aluminum ladder over a gut-tightening crevasse. I went ahead to scout with Robert. The Icefall is in constant motion because gravity tugs it down one or two feet a day toward Base Camp. Pieces as big as houses sink and disappear into the bowels of the stretching and groaning glacier or collapse without warning onto the fixed ropes, burying them under hundreds of tons of ice.

We found a level platform overlooking a steeply angled bridge made of three sections of ladder bound together with rope. Jangbu—the powerful, enterprising Sherpa whom I'd selected to lead our team of film camera Sherpas—arrived with the camera. Right behind him came

the rest of the camera equipment on the backs of Muktua Lhakpa, Thilen, Rinji, and Dorje. While Robert and I assembled the camera, Jangbu screwed two ice screws into the ice, one to anchor the camera, the other to anchor me.

The final step was threading the film, which I did religiously. Loading this camera was a very tactile experience. To do it correctly, I needed to feel the film and the camera mechanism with my bare hands. With the film flying through the camera at 5.6 feet per second, a malfunction could have damaged the camera, ending our filming for the day or for weeks. If an image was going to be unusable, I wanted it to be because of a mistake in executing a shot, not because my gloved hands performed clumsily or left "hairs" in the camera.

I wanted to show Sumiyo climbing the metal ladder with the Icefall behind. Then I would pan and tilt down, revealing the dizzying depth and span of the chasm she was crossing. This reveal shot involved Sumiyo climbing the ladder rungs, pausing, and looking over her shoulder that was nearest to the camera. I didn't want to reveal her perilous position too soon, so I needed to let her get part of the way up. But by the two-thirds point, the viewer would feel her journey was finished, robbing the shot of its suspense. With the camera off and Sumiyo resting and waiting at the base of the ladder, I rehearsed the pan and tilt four or five times, finding visual markers to let me know where I was in the shot, then drifting to a halt on the lip of the crevasse. Meanwhile Robert counted the seconds out loud so I could time the shot.

There were a host of do's and don'ts unique to the large format, rules that involved headroom in the frame, the speed of the panning and tilting, and so forth. I was engaged in an ongoing struggle, a creative tug-of-war. All my training in 16mm filmmaking had taught me to look at a series of shots in a particular way: establishing shot, medium shot, close-ups, and cutaways—the grammar of film. Now, I had to rethink the most basic elements of composition and framing to get images that would work on the giant screen. It was a struggle to manage that big camera, a bigger struggle to think creatively in that rarefied air, and an even greater struggle to sort out which creative impulse I was going to listen to: the one I'd learned over the last twenty years or the one I'd learned in the past fourteen months.

Our film was about four people climbing Everest, not forty. On occasion a caravan of climbers would come marching up behind us, appearing in the frame. Several times climbers appeared over the lip of an ice wall and innocently rappelled into our scene. We tried to be courteous and usually stepped aside. Sometimes we asked if they could wait a few minutes until the shot was over. The best strategy was always to anticipate the approach of other people and just wait. It was especially wise to wait when you spied Sherpas descending from an upper camp, because once unloaded they would barrel down toward Base Camp and didn't like to stop. We were on the Everest freeway, waiting for traffic to ebb.

It was difficult to know when these "extras" were anywhere within view. An image that would be projected sixty feet high had to be scrutinized through my two-inch viewfinder. If a climber were to appear five feet high on the screen he or she would represent only one-sixteenth of my viewfinder. Climbers who politely waited out of view for us to finish often peeped around the ice walls to watch the action. Through the viewfinder their heads had been completely invisible to me.

After a few minutes of rehearsing the camera movement, it was time for Sumiyo to climb the ladder. I started the camera. The sound rose from a low hum to a mechanical roar as the camera came up to speed. On cue, Sumiyo clambered up the rungs, paused, and looked down. I did the camera tilt, revealing the abyss. We took the same shot twice, then packed up, did our idiot check to make sure nothing was left behind, and went higher in the Icefall to find another, different shot.

The stop-and-go pace didn't come naturally to the independent-minded athletes I'd recruited as our talent. Their tendency was to just climb. But they were unpretentious, patient, and generous with the slavedriver behind the camera. The Pig became the focus of our attention. Getting it in place, setting it up, and executing the good shot: Everything revolved around that noisy piece of film-eating equipment.

Methodically Robert and I took care of our list of shots. We built our story with "reading the map" and "writing in the tent" and "dining at Advance Base Camp" scenes. We got master shots of tents rippling, avalanches, and clouds. The weather was good that trip and we filmed

the play of sunlight on fluted, backlit ridges as gusts of snow created shadows. Those little pieces were abstracts, a way to render the wind.

During our shooting in the Icefall, we saw a number of people who were clearly not prepared to be on this mountain. Their skills were minimal. Climbers scooted across ladders on their rumps or they crawled. People tripped and fell on their own crampons. One day Robert and I found a man hanging below the route, suspended by the rope, above a crevasse. He was semiconscious, and we dragged him out. Clumsiness is one thing. Inexperience with basic ice climbing technique and glacier travel is different. The Icefall lies at the bottom of the mountain, after all. Every one of these people still had two vertical miles to go.

In the third week, Sumiyo cracked a rib with a violent, high-altitude cough. It was not an uncommon problem on Everest, and with proper care she was expected to recover. Other than this, our team remained very healthy. Everyone was acclimatized and strong.

By late April we had climbed to Camp III, at 24,000 feet. The first time we went to III was to acclimatize and fashion tent platforms from the ice. Camp III was a meager, crowded way station, one that had to be reclaimed from the mountain every season. Ed and I spent hours chopping out the ledge for our tent. It was strenuous, tedious work, the last thing one wanted to do after the grueling first trip to Camp III. Tents have a way of needing much more space than one initially estimates. We took turns chopping, shoveling, and resting. The deeper we chopped into the ice slope the taller the rear wall became and the more we had to chop to gain the same amount of floor space. Twenty swings of the axe and rest, twenty more swings, rest again, chest heaving, always trying to catch your breath. At least we would be going down after our tent was up.

It was wonderful to inhale the relatively thick air of Base Camp the next day. On Everest we followed a simple rule of acclimatization: climb high, sleep low. After our first push to Camp III we descended to Base Camp. There we could eat, and easily digest, fresh foods prepared by the cook staff, then bathe and sleep soundly. Such were the benefits of the oxygen-rich environment of 17,600 feet, which contains only one half of the oxygen at sea level.

On a clear night we did a time-lapsed shot of the moon rising over the west shoulder of Everest. It was so still and quiet you could hear the creaking of the glacier and the murmur of voices inside the tents. In the foreground, tents at Base Camp were illuminated by lanterns, glowing bright against the moonlit Icefall. The clouds swirled in and covered the moon. Later the editors used the scene to create a sense of impending disaster.

I wasn't worried about the clouds that night. As the expedition leader, I oversaw the movement of our team and supplies up and down the mountain. As director and cinematographer, I was responsible for obtaining the images and story that would allow Greg to produce the film we envisioned. There were many things that could conspire to disrupt or halt our filming expedition: weather, illness, an accident, a camera malfunction, a dropped lens, or a lack of will. I was worried about what lay ahead.

Our second visit to III was devoted to filming. We stayed two nights this time, to further acclimatize. The whole team did well, even Sumiyo, whose rib seemed to be healing. Because of the camera's weight, we left it—the tripod and head, batteries, lenses—and other gear in our tents and descended all the way to Base Camp for a final rest.

We were all healthy although Sumiyo still had a nagging cough. Ed confirmed that most of our supplies were in place at Camp IV. The camera equipment was stored and waiting at Camp III. Wongchu and I selected the Sherpas for the summit team. We spent the next few days resting, eating, and sleeping. Then we checked our barometer, listened to the Radio Nepal weather forecast, and watched the clouds. It was time for our summit attempt.

On May 5 we left Base Camp. Today would be a relatively relaxed five-hour climb to Camp II, with none of the interruptions and burden of filming. Jangbu and the other Sherpas went ahead with the last loads for Camp IV. They'd already been hard at work stocking our little outpost at the South Col with oxygen cylinders, tents, food, fuel, and batteries and film for the camera. Chyangba, our cook, rose early, as he had every morning, to light incense and juniper at the stone altar. He

always said a few prayers and threw a little rice beseeching the mountain gods to grant us safe passage. Chyangba, like me, tended to worry a lot. He was never happy when his team was on the mountain. The rest of the Base Camp team offered hugs and handshakes to wish us safety and success. The sun was just lighting the peaks high above camp as we turned toward Everest.

I climbed through the Icefall, now familiar with every turn, dip, and twist, knowing which ladder bridges were loose and dangerous, which fixed ropes had become unreliable as the sun melted their metal anchors out of the ice. I hurried past places where the ice towers were poised at such crazy angles that I questioned their ability to defy gravity even a moment longer. It was pleasant to be unencumbered by the impulse to stop and shoot, the camera equipment having been left at Camp III. As I wandered through the ice maze, careful to conserve energy with every step, my thoughts were of my team, above and behind, and what a tremendous privilege it was to share this experience with them. Through the rigors of filming on Everest with the IMAX camera, and with my preposterous demands, no one had faltered, no one had complained. It suddenly hit me that the unprecedented nature of our endeavor and the big camera had brought us close together. I sensed that our shared experience would, years from now, be more important to me than all our hard-won images.

In the Icefall you notice the immediate: an abstract contortion of blue-green ice, a sparkling field of sunlit ice crystals, the spiral of snow lumps descending into a crevasse's unknown blackness. It's a dangerous place yet I've never felt at risk there. It would not achieve any further measure of safety to feel fear there. The Icefall has a life of its own. It shrugs its shoulders and 100 tons of ice crash down, regardless of the presence of climbers on the route. Under great stress and pressure, the Icefall creates a subtle sense of tension, more than fear, that dissipates the moment you emerge from the final vertical ladder section onto the gently undulating terrain of the Western Cwm.

The Western Cwm is a vast, quiet valley with a floor of reflective snow and ice. On a windless, cloudless day with the early May sun almost directly overhead, the Cwm can become brutally hot, a gigantic reflector oven. Twice in the Cwm I've been unable to move, stopped in

my tracks, waiting for a puff of wind or a thin cloud to obstruct the sun. It's an astounding irony—the ambient air temperature is below freezing but it's too hot to move. That's the radiant power of the sun at high altitudes. Camp II, a tiny blip on the distant moraine, never seems to grow closer. Out here in the middle of the glacier, you can look straight up 8,000 feet and see the jet stream nipping off Everest's summit. On this day, I thought as I had every day for the past year, *Can we do this?*

We spent the next day at Camp II, resting, eating, rehydrating, and making one last check of our personal equipment. Robert confirmed with Wongchu that all our film equipment was in place at the high camps. Ed and Jamling conferred with the Sherpas to make sure we had forty-two bottles of oxygen at the South Col. Then we all sat down in the dining tent and went over our filming and climbing strategy for the summit attempt. We didn't have a predetermined turnaround time for the summit day; we would make that decision at the appropriate moment, taking into consideration the weather and the strength of the team.

On May 7 we left Camp II and climbed to Camp III for the third and, we presumed, last time. Our plan was to push higher on the morning of May 8, cross the great sulfur-colored Yellow Band at 25,000 feet, and continue up to Camp IV on the South Col. Late that same night, we planned to depart for the summit and return eighteen hours later, on May 9, to Camp IV.

According to plan, Rob Hall and Scott Fischer—with their combined teams, plus the Taiwanese and South Africans who were tagging along with or without Rob's and Scott's blessing—would climb up to Camp IV on the same day we came down from the summit. They were scheduled to reach the summit on May 10.

A few days before we started up, a Swedish soloist named Göran Kropp had made a splendid attempt at getting to the summit. But just an hour shy of the top, judging his energy reserve with the kind of cold calculation that only comes with long experience at high altitude, Kropp had turned around and descended. He had bicycled 7,000 miles across Europe and Asia, alone, and had climbed to 28,500 feet with no Sherpa support or supplemental oxygen. Just a few hundred yards from his objective, he'd taken his own measure and decided, *Another day.*

Kropp's was a radiant example of self-discipline and moun-
taineering instinct. Getting to the summit is only half of any climb. Get-
ting back down is everything—the finish line is at the bottom, not on
the top. It's never an easy decision to turn back. But such a decision
greatly honors the mountain and yourself.

Kropp's failure meant we would be the first team to reach the
summit this year. The upper slopes wouldn't be prepped for this sea-
son's crop of climbers. Because of the varying skill and comfort levels
of their paying clients, Rob and Scott would be fixing ropes on their
summit day, stringing them from anchor to anchor as a running
handrail over the difficult or exposed sections. By contrast, there would
be no fixed ropes on our summit day. Any fixed ropes from last season
were likely to be buried and that was fine with us. I was used to climb-
ing the route above the South Col without fixed rope, although a tat-
tered piece of old line always hung from the Hillary Step. That's how
I'd done it with Dick Bass, that's how Hillary and Tenzing had done it.
Our plan was to climb to the South Summit, then use our ice axes and
skills on the traverse to the Hillary Step. I knew each member of both
our film and climbing teams would be comfortable climbing unroped—
otherwise they didn't belong up there. A few sections of the climbing
are exposed but are not even moderately difficult by today's moun-
taineering standards. Of course, the lack of oxygen adds to the chal-
lenge.

On the afternoon of May 7 we occupied Camp III, crawling into
our tents perched on icy ledges. We were surrounded, on one side by
tents of the Taiwanese expedition, and six feet away by those of the Yu-
goslav camp. There was camp debris all around us, everything from
scraps of ruined tents to garbage and urine stains.

We filmed a little that afternoon then prepared camera loads for
the Sherpas to take the next morning, laying the load between the tent
walls and the ice. At last we climbed into our tents. Unfortunately, dur-
ing our return up the mountain to III, Sumiyo had cracked another rib
during a convulsive fit of coughing. Though in pain, she was deter-
mined to keep going, and for the time being I reserved judgment on
her condition, hoping for the best.

We passed a tough night, buffeted by a gusty wind. It was bad

enough trying to sleep at high altitude. This night had the added discomfort of what Robert dubbed the Kathmandu–Lhasa Express, the Tibetan wind swirling across the Lhotse Face.

There are different kinds of wind at night. With one, your tent just vibrates. Another shakes the walls, as if somebody were standing outside trying to rouse you. Then there are strong, hard gusts that deform the shape of the tent until you have to lean your shoulder against the wall or push back with your hands. On release, it gives a loud popping sound as the wall sucks back.

That night it was a serial, repetitious beating by the wind, not one that threatened to destroy the camp, but one that ruined all sleep. It would lull, so quiet I could hear the wind tearing across the Lhotse Face, like a freight train, up high. And then it would hit. The wind periodically beat Camp III until dawn.

The sun was still an hour away, but as the tent wall lightened with the dawn, the wind moved off. We could still hear it, lashing the Southeast Ridge and the Lhotse towers. Looking out, we had a perfect view of the ridge 3,000 feet overhead, and there was enough of a plume blowing to tell us the mountain needed more time. It was still early May, and every week that passed meant another week for the jet stream to move north off the peak and for things to settle down. Usually a narrow window of better, if not perfect, conditions would open in early to mid-May. The wind would diminish, somewhat. Every day we waited would be to our advantage.

That morning, we had to assess a number of factors: some cinematic, some practical, some personal. I had wanted the day we left Camp III for the South Col to be a great day. It is a given that you don't sleep much at the South Col camp because of altitude and fatigue. It would be a mistake starting out from Camp III already late at seven A.M., feeling sleepless and on steep terrain.

As Ed, Robert, and I chewed through our options, I looked down into the Western Cwm and saw more than fifty-five people starting out across the glacier, coming up from Camp II. Most of them were climbers we'd never met and whose abilities and experience were unknown to us. They looked like a string of ants. Some we'd probably seen struggling in the Icefall. Others, like the Taiwanese team under

the leadership of "Makalu" Gau Ming-Ho, had been rescued off Denali in Alaska the year before. A few had lost fingers or toes to frostbite. Then there were the South Africans. Their lack of skill aside, the group had been gutted by internal dissent. And here they were, all heading straight for us. We knew from their schedule that they were only one day behind. If our summit bid was delayed by a day as we sat out high winds on the South Col, it would mean being joined by that large group.

That wasn't the Everest experience I wanted, personally or professionally. Knowing the terrain from the Southeast Ridge to the Hillary Step very well, I could imagine the traffic jam that would ensue. People going up would meet people going down, all trying to use the same rope. Each time, someone would have to unclip to get around someone else, then clip in again—time-consuming and dangerous work. I knew from experience that there isn't strength in numbers on Everest.

Just as important, a day's delay meant having dozens of extras in our film on summit day, none of whom had appeared throughout the earlier story. At best our summit footage would be strangely cluttered. At worst, there might be so many people swarming up the summit ridge that we couldn't even get a clean shot of our protagonists.

And so we went down. It wasn't a difficult decision because it wasn't a final one. We weren't going home, just down. It wasn't my call alone. I talked to Ed and Robert that morning, and we all came to the same quiet, sober conclusion. Ed felt very strongly that the weather was still unsettled—that our window hadn't arrived. There was nothing to be lost by going down except a little bit of pride and some time, which wasn't yet crucial. We were entering the second week of May. Two weeks remained before the monsoon's probable arrival. There would be one more opportunity. We had the resources to wait. I'd planned this expedition to be able to stay until the permit was up on June 1 even if we needed to make two separate attempts at the summit above the South Col. Yet, in spite of our considered reasoning, we also knew that waiting can take a different kind of toll.

Acclimatization is a mysterious art, like a kind of alchemy. By climbing and sleeping at progressively higher altitudes—then recover-

ing at a lower altitude—you begin to adjust, if not adapt, your body to the lack of oxygen. Everyone adjusts at different rates, which makes the formula highly subjective. Some don't adjust at all. There comes a point, however, when your body stops adjusting and begins deteriorating. In the thin air above 17,600 feet, the oxygen-deficient atmosphere is not life-sustaining. Your body literally consumes itself for energy, a kind of slow biological death. It's not unusual to lose twenty percent of your body mass after five weeks on Everest. Higher, around 25,000 feet, your body breaks down at a more rapid rate. It's for this reason that some call it the Death Zone.

Once the decision was made, we simply disengaged from our goal. There was no reason to remain at Camp III, so we stored our camera equipment and promptly descended. Rappelling down the ropes, we began to meet the front end of the approaching climbers. That's when I had my first good look at this year's aspirants. I knew a few of them. Some of the clients were just fine up there. Jon Krakauer was strong and moving quickly. Sandy Hill Pittman appeared fresh and confident. She knew this terrain well, having been to Camp III this season as well as three years before.

But a number of the clients were already faltering. It was clear from their body language, and easy to decipher. You can tell much by how someone hunches over his or her ice axe or slumps on the fixed ropes, by how few steps they take before stopping to rest, and the energy and confidence of those steps. As we descended past them, some of these climbers looked as though they were already at their limit. On some faces I saw an odd expression—a mix of desperation, innocence, and hope. One look, and you knew a lot of them had no idea what they were in for. From this point on they would essentially be on the move for fifty-five hours, with almost no sleep, and they would become increasingly hypoxic. Their ability to do what would ensure their safety at lower altitudes, which is to rest when tired, then stand up and keep moving, would be radically diminished.

What worried me was that many of these people lacked any real apprenticeship in the mountains. They hadn't mastered fundamental skills. They might have been guided up the lesser peaks of the world, but being guided creates a guided person's mentality. You haven't learned to look

after yourself. If someone says they've had the experience of standing on top of a 22,000-foot peak, I want to know the quality of that experience. Have you ever had to keep track of your mittens in the night in a storm? Have you ever had to find your way in a whiteout? Have you ever had to turn and face wind-driven snow without goggles? Have you cooked for yourself? Have you even performed the most basic task of putting up your own tent? In an extreme situation, are you self-reliant?

Some of the clients had jumped straight onto the highest mountain on earth. More troubling, the lack of apprenticeship and experience also meant the lack of a mountaineering ethos. The most fundamental aspects of climbing are trust, respect, and self-reliance. A tacit understanding with your companion is that you are experienced enough to know your limits and to not endanger others. These aren't common courtesies—they're moral responsibilities. When you're calling on resources that aren't there, then you're not only a threat to yourself but a threat to the people around you. To me that's the ultimate act of irresponsibility, putting others at risk for your ego and desire. Climbing Everest should be an act of self-awareness, not luck.

As we went lower, the wind stopped and the day turned beautiful. Near the bottom of the fixed ropes I reached Rob Hall and stopped for a few minutes. He and Robert Schauer had already spoken, I later learned. Rob had expressed concern that our descending team might dislodge pieces of ice onto his clients, and his conversation verged on a lecture. Meanwhile, several of us were already having to dodge ice dislodged by Rob's clients who had moved overhead on the ropes.

My conversation with Rob was superficial. He was alone in the middle of his group, clients far ahead and clients far behind. At that moment I could see why he inspired such great confidence. Dressed in his red Patagonia bibs, Rob looked diligent, competent, and in complete control. He was always well organized. The handset for his radio was attached near his shoulder on his pack strap so that he didn't even have to remove the radio to use it. Rob conveyed an absolute sense of care and guidance. His clients were provided with a very strict regimen—they weren't left to drift through the world of unknowns, nor to make decisions on their own. They were told where they were going to

sleep, how much they should drink every day, what time they should leave camp in the morning.

Rob was curious about why we were going down. There wasn't a lot to say. Two separate sets of experience and judgment stood face-to-face there. I told him it had been too windy the night before and too cold to get the early start we'd wanted, that we didn't like the weather. I didn't mention to him our discomfort with having so many people crowding up the route behind us. I took a few photos of him, then headed off. I felt embarrassed explaining to Rob why we were heading down now that it was a warm and sunny day. So many decisions in the mountains rely on the subtleties of intuition. How do you say to someone, "It just doesn't seem right"? That would fly in the face of his decision to continue on up.

At the bergschrund—an ice wall—where the Lhotse Face meets the Khumbu Glacier, the ropes ended and the slope leveled out. I started down the Western Cwm at a fast clip, all the way passing climbers coming up. Nearing Camp II, I was surprised to see the last of the climbers just leaving. It was already ten or eleven in the morning, and they were heading into the heat of the Western Cwm. At the very end of the line was Scott, running sweep.

Scott wore his characteristic grin, looking happy to be in the mountains climbing Everest. Rob's opposite, he didn't have a radio in sight. He was so delighted to be guiding with "the big boys"—that's what he'd told Ed—referring to Rob Hall, Pete Athans, and Ed Viesturs. He took life one step at a time, and you wondered how far ahead he was looking. We talked a little, again superficially. He, too, was curious about our decision. I told him what I'd told Rob, it'd been windy and we hadn't liked the weather.

Scott said, "Well, we'll get to Camp III and see how things are. And hey, if the weather's bad, the weather's bad. If it's good, it's good. We'll see."

One of the other guides told me that day, "We expect to get everyone up." And I remember thinking, *That's optimistic.*

We reached Camp II by noon. We could have continued down to Base Camp for a rest, but we stopped here. Part of our thinking was to

wait and see if we might resume our summit bid in another few days. It was a gorgeous Himalayan afternoon with mists slowly creeping up the Western Cwm. There was no real reason to go anywhere. We sat around and watched the climbers through our sixty-power Leica telescope as they moved up to Camp III.

The next morning, May 9, we woke at a leisurely pace. Again we could have headed down to Base Camp where the air was relatively rich at 17,600 feet. Sleep would be deep there, and we could be eating cheese omelets and fried potatoes. Instead we rested at Camp II, lounging around, watching the long string of climbers inching toward the Yellow Band below the South Col. Though I knew we'd made the right decision, it was still slightly demoralizing to be down at Camp II on such a beautiful day. There was a bit of envy mixed in, because if those climbers in our telescope got to the top in two days, they'd be going home that much sooner. As we sat around, one thing made me feel right about our decision to descend. We all agreed—none of us had ever seen so many people, bunched so close together, hanging from the same ropes. It made no sense to me that they would put so much collective weight on individual anchors. It was as if they didn't realize their safety depended on a few ice screws twisted into the skin of the mountain.

Early that morning, Jangbu and several Sherpas had left on one of their big round-trips carrying loads from Camp II to Camp IV and back to Camp II, all in one day. Now that we had a few extra days, we wanted to send a few more supplies up to the South Col camp. The Sherpas preferred the strenuous round-trip, which would have been impossible for most Westerners, because Camp II was much more comfortable than Camps III or IV, and they wouldn't have to spend the extra hours at the higher camps cooking for themselves. It also meant triple pay.

The weather was fine and the Sherpas made fast time. Early in the morning at Camp III, a Taiwanese climber named Chen Yu-Nan crawled out of his tent to relieve himself, but he neglected to put on his boots or clip into the rope. Wearing only smooth-soled inner boots, he slipped and plunged seventy feet before a small crevasse intercepted

his fall. He should have fallen 1,500 feet down the Lhotse Face to the glacier below. Jangbu, who had just arrived at Camp III, witnessed the accident. The other climbers were still in their tents.

Jangbu immediately reported the news to the Taiwanese leader, Makalu Gau. The two men went back to the crevasse and lowered a rope to Chen, who pulled himself out. Undoubtedly embarrassed and in shock, Chen insisted he was fine and ready to proceed to Camp IV and the summit. But when Makalu Gau radioed down to Wongchu at Camp II (Wongchu was acting as sirdar to both our team and the Taiwanese expedition), he was advised to leave Chen at Camp III breathing supplementary oxygen, which Chen refused. It seemed unusual that an expedition leader was asking advice of his sirdar, who was almost 3,000 feet below.

After putting Chen back in his tent, Makalu Gau and his Sherpa team started up to Camp IV. I didn't hear about any of this until a few hours later, around one P.M., after Jangbu and our other Sherpas had already gone up to Camp IV and were on their way down again. By that point, Chen was being escorted slowly down from Camp III by Passang Tamang, a Taiwanese team Sherpa, and Chen's condition was worsening. He spoke no English, making it hard for the Sherpa to know what was wrong. Wongchu radioed Jangbu requesting that he quickly descend the fixed ropes to assist in the evacuation. Only then did Wongchu tell me about Chen.

Ed, Robert, and I began to monitor the situation through our telescope and with the radio. As Chen descended on the ropes, Makalu Gau—partway up to Camp IV—radioed down to Chen. Again Chen assured his teammate that he was fine, and Makalu Gau continued up. But not much later, he began flailing his arms in the air irrationally, still refusing to use oxygen.

A half hour after that, Jangbu radioed to us in intermittent calls: "He sat down," then, "He fell asleep," and then, "We think he's dead." I instructed Jangbu to feel Chen's neck for a pulse, then to take off his own glacier glasses and hold them right under Chen's nose to see if there was any mist from Chen's breath. "No," said Jangbu. "He's dead."

Unwilling to move the corpse, the Sherpas resumed their descent, leaving the body tethered to the fixed rope 300 vertical feet above the

bottom of the Lhotse Face. For them it meant bad luck to see a body on the mountain, much less to touch one. Through our telescope, we could clearly see Chen hanging from the rope, motionless. Ed, Robert, and I immediately started up from Camp II with a coil of rope, hoping he had collapsed and was only unconscious.

An afternoon squall began to blow swirling snow. Moving quickly, we reached the forty-foot bergschrund and clipped into the rope. A few minutes higher, we reached him. We were still thirty feet away, but I could tell he was dead by the way his contorted body hung from the rope. One hundred feet above Chen, a Sherpa was standing still, unwilling to descend any closer or to unclip from the rope and climb around.

We went closer and turned him over. The man's eyes were still open, and a yellowish fluid was coming from his mouth. There was a look of slight bewilderment in his eyes, almost identical to the expression I'd seen on Dawa Nuru's face after I excavated him from the avalanche on the north side of Everest ten years earlier. It wasn't a look of pain. The bewilderment seemed to say, *I can't believe I'm dying like this.*

Ed shouted at him loudly, trying to trigger a startle reflex. But he was dead. While Ed lowered him, I guided the body. It was awkward, strenuous work, especially getting down the bergschrund, which was steep and irregular. His crampons and one arm kept hanging up on the ice outcrops. I wanted to treat the body delicately, but had to manhandle it several times, yanking and twisting the body to unhinge it from the sharp ice protrusions. Sometimes he was right in my lap. I hated the odd angles the body took.

At the base of the bergschrund, a couple of his fellow Taiwanese climbers from Camp II were waiting with a sleeping bag and more rope. By this time the mists billowing up the Western Cwm had turned into a ground blizzard. We tied Chen inside the bag and began dragging him across the Western Cwm back to Camp II, a funereal march in the frozen white of a tumultuous storm. It was difficult to see, and we navigated the crevasse-ridden glacier wand by wand.

I felt terrible about this man's death. He had died, staring into the eyes of strangers with whom he shared no language, unable to say

goodbye to the people he loved. He was going to die anyway—the internal injuries he had sustained were obviously too severe to have been treated by anyone on the mountain or at Base Camp. But as his pallbearer I felt acutely aware of the loneliness of his last minutes.

As we got closer to camp, the storm began to clear. We got to the edge of Camp II but no one wanted the body in camp, especially the Sherpas. On the spot, we made a clinical decision. Knowing it would be easier to manipulate the body through the Icefall the next day if he was frozen, we left him out on the ice for the night. I looked up and could see some of the climbers still making their way to the South Col.

I was filled with dread. I had just recovered the body of a man whose face and name I didn't know. There had been no real reason for this man to die. The slightest mistake, a farce of an error, had started his dominoes collapsing. It took so little up here to tip your destiny. People tell themselves that Everest is a dangerous place. For some people that makes the mountain more appealing. Only a few of the people inching toward Camp IV that late afternoon really understood the indifference Everest holds toward human life. You can climb that mountain a thousand times, and it will never know your name. Realizing your anonymity, accepting it in all its terrible consequences, is key to a mountaineer's humility, key to a climber's self-awareness.

It was six o'clock by the time Ed and I returned to the orange tent that was our Camp II dining tent. The weather had cleared, and into the early evening with the telescope we could still spy people arriving onto the South Col. They should have been reaching Camp IV at three o'clock, not six, because within a few hours, at eleven P.M., those same exhausted climbers would be departing for the summit.

At dinner our team was all assembled. We were tired and emotionally drained by the death. Even those who hadn't gone up or seen the body lying outside camp were affected. We said a few words about the general lack of experience of the climbers on the mountain, but no one wanted to jinx them with our apprehensions.

As I went back to my tent, I could see a few tiny pinpoints of light high overhead, at the edge of the South Col. Except for the stars those headlamps resembled, it was dark up there. I closed my eyes that night knowing that men and women of four different expeditions were reach-

ing into their hearts and preparing for their climb to the summit. In a few short hours, while I slept, the climbers at Camp IV would start in motion.

We woke late, after dawn, on May 10. It was another designated rest day for our team. The day before, on his way to Camp IV, Jangbu had reported strong winds above 25,000 feet. This morning was beautiful, however, not a cloud in the sky. High overhead, the summit pyramid was crystalline and still, without a hint of a plume.

Robert set up the telescope at Camp II. Through a fluke of topography, you can look 7,400 feet straight up Everest's Southwest Face to the traverse from the South Summit to the Hillary Step, 300 feet below the summit. The traverse appears as a crescent of snow against the dark blue sky and is the only place you can glimpse climbers on summit day. We knew that the Adventure Consultants, Mountain Madness, and Taiwanese teams had been climbing since before midnight, but it was still too early for us to be able to see them on the highest part of the mountain.

It was a lazy morning for us. Since each expedition communicated on different radio frequencies, we didn't receive any dispatches directly. We had no idea what kind of progress the climbers were making. We could make certain assumptions. In a group so large some people would surely have turned around by this time. Those last 3,000 feet above the South Col are many times more strenuous than any other climbing on the route.

Occasionally Wongchu or another Sherpa would go over to Scott's campsite to hear radio reports. Sumiyo and Jamling wandered over to Rob's campsite, which lay a little closer. Then around noon we spotted the first climbers profiled along the white crescent. The telescope was so powerful and the day so clear that we could just make out the minute, brightly clad figures laboring 7,400 feet overhead. At about two P.M., we got word that Anatoli Boukreev and Neal Beidleman, both guides for Mountain Madness, and some others had reached the summit.

That meant several things. They would have installed fixed ropes for clients to follow along. And, if they were the first on top, it was already getting late. It was none of our business what Rob or Scott had

decreed as their turnaround time, but we knew they would have one and that it was probably one or two o'clock. That would leave only a window of thirty to ninety minutes for their clients to finish the climb.

It was windy up high, but not fiercely so. As the condensation rises up the Kangshung Face on the Tibetan side, it creates a strange boiling effect above the crescent's skyline. You can measure the wind pretty effectively by watching how it blows that boiling, whitish nimbus. We estimated the speed at about only thirty miles per hour, very normal for the beginning of an afternoon on Everest.

But an hour later, at three P.M., we looked up and could see climbers still forging across the traverse to the Hillary Step. Ed and I were alarmed. We knew that it would take at least another hour for them to reach the summit, that they wouldn't descend back across the crescent to the South Summit until at least four P.M. That still left the descent to Camp IV, a matter of three to six more hours, depending on the remaining strength and willpower of the climbers. Before our eyes, we could see people willfully giving away their small margin of safety for success on the summit. What they were sacrificing was the ability to return to Camp IV in the safety of daylight.

It can't be overstated how light provides an asylum up there. Light gives you more than just vision and the ability to see your path or the promise of a camp down below. It fundamentally binds your morale; that's what they were giving away. Night creates a different mountain. Unless you've managed to memorize the labyrinth, really gathered the landmarks into your mind, you can be lost in an instant.

All of this was playing out in lovely, sunlit conditions. Tiny figures slowly continued across the crescent toward the summit. We could only imagine the bottlenecks at key passages. Later we'd learn of the traffic jam at the base of the Hillary Step, when a dozen or more climbers came to a standstill waiting in queue to use the single rope. Jon Krakauer would relate the horror of standing at the top of the Hillary Step while his oxygen ran out, unable to descend because of the people coming up. Even had we known, there wouldn't have been anything we could do to speed their progress.

We later learned that twenty-three climbers reached the summit that afternoon. At Camp II, we were in disbelief. At three o'clock some

climbers were still struggling to the summit, Scott Fischer and Rob Hall among them. At 3:40 P.M., Scott radioed to his Base Camp manager and reported that his entire team had reached the top. Makalu Gau arrived a little later. Last to get up was Rob's client Doug Hansen. Rob had waited for Doug near the summit. It was shortly after four o'clock.

About this time a mass of clouds was building to the west. The cloud bank started crawling up the Western Cwm toward us, darker than the normal afternoon clouds. These had the look of thunderheads, dark purple, almost black. Our view of the summit was obscured and we went inside our dining tent.

At Camp II, the storm was little more than another squall. It was quiet enough so that we could hear the wind starting to howl across the Southeast Ridge. This wasn't the jet stream hum. It was a localized weather pattern. High wind—whether it was mixed with snow or not—is a common afternoon feature. It would have been extraordinary to not have wind playing on the Everest heights. What made it ominous today was that there were people climbing in that dark broth.

At five P.M. Ed's wife, Paula, called from Base Camp. A member of Rob's support team had come over to our camp with dire news. They had picked up Rob's voice. "I can get myself down the Hillary Step, but I don't know how I can get this man down," he was quoted as saying. "I need a bottle of gas, somebody please, I'm begging you."

As Paula conveyed the news to us, we couldn't quite comprehend it. A nightmare was unfolding. Rob was trying to rescue a client, Doug Hansen, just below the summit of Everest, with the storm and night closing around them and their oxygen running out or depleted, on the edge of a ridge that fell one and a half miles to either side. In 1983, I'd led a nearly blind, debilitated Larry Nielsen down from the South Summit, but I hadn't done it in a wind like the one we could hear up there.

Paula called up to us again that night, around eight P.M. The very front few of the returning climbers were starting to filter back into Camp IV, those who'd tagged the summit and come back down—like Jon Krakauer—or who had turned around in the early afternoon. The rest were missing in action. No one knew who had returned, or how many.

Ed, Robert, and I knew how desperately fatigued each would be. You return from your summit day used up—at best. It really is one of

the supreme challenges for the human body. You haven't slept for two days or more. Your stomach is empty. Your strength is gone. Once inside your tent, you don't want to go outside. That's on a good day. This was night. A bad night.

I went to bed hoping for the best but preparing for the worst. I could hope that Andy Harris or Mike Groom, Rob's guides, had brought Rob the extra oxygen, revived their client Doug Hansen, and descended safely. We all wanted to believe that all the clients and climbers would file into Camp IV over the next few hours and that everyone would be safe. It would go down in the books as one of those big seasons on Everest with nearly two dozen summiteers. More than anything, though, my mood was one of denial. I simply couldn't acknowledge that a dozen or more people were in a fight for their lives high in the dark wind-blasted night above me.

Next morning, at 5:30 A.M., Jangbu violently shook my tent and said, "David, David, get up, you must come to Rob's camp." In the blue dining tent that doubled as Adventure Consultants' communications tent, Ed and I found a distraught Finnish climber named Veikka Gustafsson. Like Ed, he had a close friendship with Rob and had climbed other Himalayan peaks with him. Veikka had been up all night monitoring the radio for any further news. He told us that an hour earlier, Rob had broken the terrible silence to ask, "Won't somebody come and help me?"

It was one of the most chilling moments of my life.

Rob was a powerful man. He was eminently capable, organized, and widely experienced. He functioned superbly at high altitude. If anyone belonged on this mountain, it was Rob, always in command of himself. And yet he'd lost control.

We kept vigil through the morning as Rob's sporadic radio dispatches came through. His voice was thin and hoarse. It seemed to come from a shadow of the man, not the man himself. I couldn't reconcile the voice I was now hearing with the cheery, confident leader I'd passed two days earlier. I knew, from the sound of his voice, that I'd never see him again.

Won't somebody come and help me?

I tried to imagine myself saying those words. To climb is to be

free, to rely on yourself. As a mountaineer, I'd spent my lifetime building skills and judgment and physical abilities that I'd hoped would save me from ever having to say such awful words.

"Doug is gone," Rob had reported. We didn't know what that meant. The last we'd heard, Doug needed oxygen. Now he was, what, dead? Fallen off the mountain?

Rob had made his emergency bivouac just below the South Summit, at the start of the traverse to the Hillary Step. Ed and I knew exactly where he would be sitting, and why. Just below the South Summit, at the start of the traverse, is a slightly protected crook in the ridge. He had chosen his defense against the wind as well as anyone could in those conditions.

Ed got on the radio, repeatedly urging Rob to stand up and get moving.

"Where's Harold?" Rob asked. Harold was Andy's nickname. Rob sounded disoriented and confused.

Ed didn't hesitate to lie. "Andy's down here with us," he assured Rob.

Several hours later, near nine o'clock that morning of May 11, Rob was still sitting at the South Summit. Thirty-four hours after leaving Camp IV at the South Col, he was still without shelter. Rob was asking the same questions. "Rob," Ed said. "Just get yourself down."

To our knowledge, at least seventeen people had not returned to Camp IV as the morning sun began to warm Camp II. The sky was clear and innocent, but the wind was roaring high overhead, ripping snow and mist across the Lhotse spires. Looking up, I felt helpless and ignorant. What was going on up there?

There was no communication at all with anyone from Scott's expedition. Finally information began to trickle down, much of it from Jon Krakauer. Even in his state of exhaustion and shock, Jon was one of the first—with a Canadian physician named Stuart Hutchison, Jon's tentmate—to begin feeding down bits and pieces of what it was like up there. We began to assimilate the facts: Scott Fischer and Makalu Gau had never returned to camp. Andy Harris had possibly descended and walked off the Lhotse Face.

Between his failing batteries, the sound of the wind, and the

chaos at Camp IV, Jon's reports were truncated, like pieces of slashed newspaper. His radio had been strong in the beginning, but later started to break up. It seemed no one knew where anyone was. The tents were being flattened in the wind. Communication with another tent twenty feet away was nearly impossible. Going outside to take account of who had returned and who hadn't was even more difficult. But after three hours of gathering little pieces of information, here's what we knew: Rob was stranded on the South Summit. Doug Hansen was dead. Andy Harris was missing. It was assumed he had walked off the Lhotse Face after Jon Krakauer had reported seeing him just above the South Col. Scott Fischer and Makalu Gau were sitting on a ledge at 27,200 feet without a radio. We didn't know if they were dead or alive. Two other clients from Rob Hall's team had been left on the far side of the South Col, a few yards from the Kangshung Face, and were presumed to be dead. Everyone else had straggled back into camp, but there was great concern over their condition: frostbite, exhaustion, dehydration.

I instructed Jon to break into our expedition's supplies and take whatever he needed, batteries, oxygen, fuel, food. Over the past weeks, our Sherpas had been stockpiling supplies at Camp IV for our summit attempt. We had forty-two oxygen bottles cached in duffel bags by our tent, and a small bag of spare AA lithium batteries inside the tent. Even though I guided Jon on a search of the tent, he couldn't find the batteries. We were getting more concerned he might get cut off.

It was essential that we keep communications open, and so I approached the South African team at Camp II. Like forgotten characters, the South African climbers at Camp IV had postponed their summit bid of May 10, and remained in their tents. While all this was going on, they were lying in sleeping bags. I contacted their leader at the South Col. They had fresh batteries and a radio that would keep the lines open.

But when I asked that Jon Krakauer be loaned the radio for this emergency, only a few feet away from where survivors of the storm lay huddled and crying, the South African leader, Ian Woodall, refused. We weren't even asking him to get out of his sleeping bag, just to loan a radio. He refused.

Meanwhile various rescuers were heading out from Camp IV. Two Sherpas, still exhausted from their climb to the summit two days before, climbed up toward the South Summit with thermoses of tea and oxygen bottles, hoping to reach Rob in time. Three other Sherpas set off to find Scott and Makalu Gau, who had spent the night huddled on a ledge 1,200 feet above camp.

Dr. Stuart Hutchison recruited several Sherpas and walked through the wind a few hundred yards across the South Col plateau to where two people still lay. They had been part of a desperate, lost group, including Sandy Pittman and Neal Beidleman. Presumed dead, they had been left on the brink of the Kangshung Face. But Stuart wanted to make sure. He found them, a Japanese woman, Yasuko Namba, and a Dallas pathologist named Beck Weathers. To his horror, both were still breathing, but only barely. It was decided that given their condition, there was no hope for survival. With such slender human resources available, there was nothing Stuart could do. They were left where they lay, and, once again, reported dead. Beck's wife was informed by telephone that her husband was dead.

On the day before, May 10, Pete Athans and Todd Burleson had reached Camp III, with a fellow guide and their clients. Hearing of the disaster above, Pete and Todd immediately suspended their own expedition and headed up into the wind. By eleven o'clock, they reached the South Col and found Camp IV devastated and in tatters. Going from tent to tent, they saw climbers huddled, unable to move. The two guides quickly began bringing order and relief, delivering oxygen bottles from our expedition to the exhausted survivors "like pizzas," according to Pete, plus brewing tea and soup.

As they revived the climbers, Pete and Todd encouraged them to descend. Another night at the South Col would only deplete them more and strain the camp's meager resources. Neal Beidleman started down the ropes toward Camp III, escorting all the clients who could come with him.

At the same time, we were starting up toward Camp III. Before heading up, we'd tried to coordinate the communication net and get as much information as possible. There was no point in heading up the

mountain without knowing what was needed. This wasn't about going to the rescue, it was more about positioning ourselves to assist the survivors on their way down. Once they reached us, or we reached them, they would be either dead or alive. We wouldn't be saving lives.

Ed, Robert, Araceli, and I headed out from Camp II. Veikka Gustafsson went along with us. Jamling and Sumiyo stayed at Camp II to monitor radio calls coming in to Scott's and Rob's camps and then relay that information up to us.

On our way to Camp III, we got occasional updates on the radio from Paula at Base Camp. Three Sherpas had managed to bring Makalu Gau down from his ice ledge, and he was severely frostbitten. But they'd had to leave Scott up there, eyes fixed, jaw clenched—dead. I got the awful news over the radio and relayed it to Ed. Scott's death hit us hard, especially Ed, who'd climbed K2 with him in 1992. Our friend was gone. We stood there and cried.

After a few moments we managed to turn back to our task. Continuing higher to Camp III, we began meeting the first of the survivors as they descended. The Sherpas came first, hurtling down the ropes, just getting the hell out of there. Next came two of Scott's clients, Charlotte Fox and Lene Gammelgaard. It was one of the most bizarre experiences I've ever had. They were almost giddy, like they were in some mind-altered state. Charlotte kept going on and on about reaching the summit on her thirty-ninth birthday. It was surreal. There was an uneasy mix of elation that they were alive and a sense that something terrible had happened. They continued down the ropes to Camp II.

I was climbing a little behind Ed and Veikka when Paula came on the radio again—the bad news only got worse. The Sherpas trying to rescue Rob Hall had turned around, 700 feet below the South Summit. The winds had continued with great ferocity. Exhausted and freezing, they had been unable to go any farther. Rob was marooned at the top of the world, beyond reach.

I yelled up to Ed with the terrible news. He waited for me to join him. It was such an unbearable moment, almost impossible to comprehend. Rob was still alive and able to speak but unable to move. The Sherpas had been his last hope. No one has ever survived two nights

out above 28,000 feet. The radio call was his death knell. Ed and Veikka knew they would never see their good friend again. They both stood there weeping, clipped to the fixed ropes.

Our sense of hopelessness was overwhelming and humbling. With a glance up and to our left, we could see to just below Rob's position, 4,700 feet above us, but he might as well have been on the other side of the planet. I felt as if I couldn't share their grief with them. I hadn't known Rob as well as they had, and I had already accepted his death. Earlier in the morning, when I had first heard Rob's weak, pathetic voice calling from the South Summit, I knew I would never again see him alive. I turned my thoughts to those we could help.

We got to Camp III and I stuck my head into one of the tents. Four of the survivors were in there: Sandy Pittman, two other clients, and Neal Beidleman. They were lying in one another's arms, draped in a pile. They looked like the back end of a death march, shell-shocked, ravaged. They'd all been out in that wind and their faces were drawn, and slightly discolored with frost nip. They'd been up now for sixty or seventy hours without much sleep.

When Sandy saw me, she burst into tears and said, "I'm so glad to see you." She kept saying, "It was horrible. It was horrible what happened up there."

Then Neal Beidleman told me, "This isn't a rescue. This is not a rescue. We're getting down fine."

I understood his pride. But I don't think he yet understood what the situation was. Or perhaps he was in a state of denial. In any case, none of us had mentioned a rescue to him.

We immediately set to work, firing up the stoves to melt snow and make tea and warm Kool-Aid for them. We wanted to rehydrate them, get some sugar in their blood, warm them up, then get them back on their feet and moving down the ropes again. There was no sense having them spend a night here at Camp III. At Camp II, 2,700 feet lower, they'd be able to sleep much better, and people could feed them and tend to their frostbite. Once Sandy and Neal and the others were feeling better, they continued descending.

The IMAX camera lay inside a tent with rolls of film, batteries, the

tripod, the monopod, everything. We had a lightweight digital video recorder in there, too. But from the moment I'd first heard Rob's voice on the radio, we were no longer a film team.

As evening arrived, Rob Hall made a final radio call from his tiny perch below the South Summit. His wife, Jan Arnold, who was pregnant with their first child, had been patched through via satellite phone and radio from New Zealand. "Hi, my sweetheart," he said. His words were almost slurring. "I hope you're tucked up in a nice warm bed. How are you doing?"

Jan made her voice positive and strong, even though it was clear Rob could never make it through another night. "I can't tell you how much I'm thinking about you," she said. "You sound so much better than I expected. Are you warm, my darling?"

Their exchange went on. "I love you," Rob signed off with Jan. "Sleep well, my sweetheart. Please don't worry too much."

That afternoon we got another radio call. Up on the South Col, someone referred to as "the dead guy" had staggered into Camp IV. When they finally mentioned his name, I had no idea who he was. But I would come to be very familiar with the man. There was no greater miracle that year than Beck Weathers resurrecting himself from the dead.

Beck had been part of that lost band groping through the blizzard. Along with Yasuko Namba, Sandy Pittman, Neal Beidleman, Charlotte Fox, and others, Beck had huddled at the edge of the Kangshung Face. Their oxygen supply was gone. They were blinded by the night and storm. No one knew where camp might lie. But sometime after midnight, the sky briefly cleared and Klev Schoening, a client of Scott's, "saw the way home." He and Neal assembled those who could walk and staggered straight into the howling wind toward camp.

Yasuko, Sandy, Beck, Charlotte, and another client, Tim Madsen, were left behind. Things couldn't have been any more grim. Then Beck took off one mitten to warm his hand inside his parka, and the mitten blew away. His fingers instantly numbed with the cold. He couldn't zip

his parka shut again. Within moments the wind ripped away his body heat, and Beck began a rapid tumble into hypothermia, delirium, and unconsciousness.

Neal and Klev had found camp, and Anatoli Boukreev followed their directions back to the stranded group. Anatoli had managed to rescue three of the remaining five. But Yasuko was unresponsive, and Beck couldn't be found. That was the first time Beck was written off as dead. The second time was the next morning, May 11, when Dr. Hutchison pulled away the ice from Beck's and Yasuko's faces, and they were judged so near death as to be beyond help.

By his own telling, Beck returned to consciousness late that same afternoon, May 11. He saw a vision of his family and mobilized himself. Hallucinating, he staggered across the rock-strewn South Col and—through sheer luck—strayed into camp. At first, Todd Burleson thought the mutilated figure—his face swollen, one arm bared and frozen solid in a semi-salute—must be Scott. Realizing it was Beck, Pete and Todd placed him in a tent. The wind was raging. Everyone was traumatized and in a hypoxia-induced haze, and now Beck arrived in a horrific state. Beck was put into two sleeping bags with a tank of oxygen turned to full flow and some hot water bottles, then left for the night by himself.

The news that Beck was still alive inspired the final rescue attempt of the day, this time by Anatoli. If Beck could have survived after having been pronounced dead, then maybe Scott was still alive. Maybe the Sherpas had made a mistake. On the South Col, Pete Athans tried to discourage Anatoli from making another rescue attempt. Pete had spoken with the Sherpas who had gone up to rescue Scott. They confirmed that Scott's eyes were fixed and open and he was dead. At five P.M. Anatoli went anyway. Scott was his good friend.

The day before, Anatoli had acted like anything but a commercial guide. As Scott's senior guide with the Mountain Madness expedition, and by far the strongest man up there that day, Anatoli was supposedly charged with the safety of their clients. But he insisted on going to the summit without supplemental oxygen. This added one more ascent of Everest without bottled oxygen to his previous two, but it also impaired his ability to keep warm and to stay with the clients. According to ac-

counts, he didn't even carry a pack above 27,600 feet that day. He had no supplies for himself, much less for any stranded or flagging clients. And because of oxygen deficit, his body chilled faster. In Anatoli's mind, this justified his rapid, lone descent back to Camp IV, hours ahead of everyone, and well ahead of the storm. His excuse for leaving his clients was that by returning to Camp IV he could replenish himself and be ready for any possible rescue. But he had no radio. There was no way he could have known if a rescue was needed. In spite of my respect for his unquestioned strength and experience, I believe that because of his "oxygen-free" ascent, he forfeited his ability to remain with his clients.

It can't be denied, however, that once he was apprised of the lost, wandering climbers late on the night of May 10, Anatoli performed heroically. Repeatedly he ventured into the raging storm. Single-handedly, he saved the lives of clients Sandy Pittman, Charlotte Fox, and Tim Madsen. Now, on May 11, he was acting with great courage again, soloing up to try to save Scott. But the Sherpas' reports were correct: Scott was dead. Anatoli took a few personal effects for Scott's family, then tied a pack to Scott's face and chest with a piece of rope.

Todd and Pete radioed down that Beck probably wasn't going to make it through the night. Even if he survived the night, it seemed certain Beck would never have the strength to descend the Lhotse Face, and there was no chance of lowering him the whole way. Alone in a tent, Beck couldn't open the water bottles to drink because of his hands. As his arms warmed up, they swelled and he tried to chew off his wristwatch knowing it would constrict his circulation. It only got worse. Beck screamed helplessly as the wind blew his tent doors open, then blew the sleeping bags from his body.

On the morning of May 12, just before leaving the South Col, Jon Krakauer peered inside the tent, expecting a corpse. But once again Beck had refused to die. Jon alerted Pete, who brought hot tea, and injected Beck with a syringeful of dexamethasone, a steroid with a miraculous ability to revive hypoxia-stricken climbers. To their surprise, Beck was able to stand and even walk. He was not going to be left behind again. At 10:30 A.M., Pete and Todd started down with Beck. Ed Viesturs and Robert Schauer went up the ropes to meet them at the Yellow Band, at 25,000 feet, to assist with Beck's descent.

Waiting at Camp III for Ed and Robert to return, I wasn't sure what to expect. I'd been told of Makalu Gau's and Beck's grisly frost-bite injuries. Makalu Gau's rescue team descended past Camp III first. As they passed by, Makalu looked at me. We knew each other slightly. I asked him how his feet were doing and he said, "Fine." (He lost most of his toes later.) He said, "How's my nose?" I looked at him and said it was fine. But it was black as charcoal, flush to his face.

While Ed and Robert were gone that morning, I called down to Base Camp to report what was happening. Paula was handling the radio and we started talking. She'd known Rob well. She and Ed had been on an expedition to Everest with Rob the year before. She'd known Scott, too. And over the past two days, she'd been down at Base hearing all the radio calls, including that last wrenching call from Rob to his wife. Paula was afraid. She was probably more afraid than those of us who were up there able to take part, to do something. At that point, she said, "We're going to have to think about what we're going to do next when you get back down to Base Camp."

My response was something I immediately regretted. I felt vul-nerable. I'd held Chen's body in my arms. I'd heard Rob dying. I'd got-ten the call about Scott's death. And all these other people. And now this guy named Beck was coming down the ropes toward me. Her fear brought out my fear, and I reacted.

"Well, Paula," I said, "this isn't your decision. You're not part of that debate."

I wasn't just blunt. I was harsh. Brutal. I didn't want the discus-sion to be starting yet. I didn't know my own thoughts about what was to come next. How could I?

"You're going to have two choices," I said. "You can either sup-port us, or you can leave."

I signed off. I knew it had been a terrible thing to say. I treated Paula like an interloper. In my mind, I segregated her from "us," rele-gating her to a Base Camp member, not a climber. Already it was be-coming clear we would be in for a great deal of soul searching in the days to come. Knowing the kind of dialogue I tend to have with myself, and how I'd walked away from this mountain before, I just couldn't stand to open the floodgates of introspection yet.

I wondered if I had developed that style of leadership—a tyranny over my team, even over their emotions. As Ed's wife, Paula had every right to question what was to come. Each of my teammates had that right. The decision that was mine alone was not whether we should think of carrying on our ascent of Everest, but whether I was going to impose on my team an unforgiving, unfeeling form of leadership. I'd learned well in my youth that my response to crisis was to wall off the outside world, to keep moving ahead. Was I going to do that again?

In the early afternoon, Beck arrived, assisted by Ed and Robert. I was horrified by the sight of Beck's gloved hands. They were stiff and unmoving, like steel claws. His cheeks and nose were black with frost-bite. I refueled Beck with a cup of hot black tea with sugar. He couldn't hold the cup, so I held it for him. He was in remarkably good spirits. He said, "Guys, I'm gonna lose my hands, but I just might see my wife and kids again, if I can ever make it down."

Underneath the optimism, I heard his doubt, and it struck me. This man had repeatedly been left to die up there. No one had embraced him with all-out hope. "You can do it," I told him.

"If you think I can do it, I bet I can," Beck replied.

Beck was not sure he could face the long trip down the Lhotse Face to Camp II but it was not an option for him to remain at Camp III.

Ed and Robert took turns supporting Beck from behind, holding on to his harness. We were all clipped into the fixed ropes. I went first, with Beck just behind. He braced his forearms on my shoulders as we started down. One glance to my left or right and I was staring at Beck's frozen claws, just inches away. The sight of those useless appendages and the utter helplessness of the man was deeply unnerving.

Beck didn't have the strength, nor the eyesight, to pick his foot placements. On the low-angle sections covered with a little soft snow, Beck could walk on his own. But on the steeper sections, the ice was hard and blue, requiring a good stomp with your crampon points at each step. Sometimes I had to turn and set his boots with my hands. I kept waiting for him to complain. He never did.

It wasn't long before I began to understand how remarkable this stranger at my back really was. We'd just started down, when Beck said, "You know, David, I paid $65,000 to climb Everest. And when I left

Dallas, I said to my wife, I said, 'Peach, $65,000 to climb Everest! It's costing me an arm and a leg!'" Then he added, "But I guess I bargained them down.'"

I was astounded. This man, this mutilated survivor, was telling me a joke? About his own injuries? He was a pathologist. He well knew what lay in store. Both hands were frozen through to the bone. He knew he'd lost them. He still had no idea about his face. We weren't about to tell him. He probably would have simply invented some jokes about that.

It went on, pretty much nonstop the whole way down. He was funny as hell. He compared our little string of climbers to a conga line. He wanted to sing "Chain of Fools." It kept his mind agile and his body moving.

He didn't complain. He was so thankful. He had a profound effect on me. After all that death, after being judged dead himself, not once but three times, this man's spirit was transcendent. He was a gift for all of us from that tragedy. Out of all that horror emerged this great spirit. He never should have survived. How can I say that? Because Rob Hall didn't survive. Because Scott Fischer didn't survive. They, too, spent the night outside, exposed to the elements. But neither of those experienced, resourceful men had been able to survive. Beck had, though. His first night was spent lying on the edge of an abyss, and his second was spent screaming in a tent with the doors blown open, exposed, his sleeping bags torn away. The very fact of his survival was astounding. He came out of the horror with his humanity and intelligence intact.

The stresses of high-altitude climbing reveal your true character; they unmask who you really are. You no longer have all the social graces to hide behind, to play roles. You are the essence of what you are. And if I can be one tenth of what Beck was that day, I will have been a worthy man.

We reached the glacier in the Western Cwm and Beck was weary. But we kept him moving. A physician, Ken Kamler, and others were waiting for Beck at Camp II. They immediately started the tortuous process of thawing his arm and hands in cook pans of lukewarm water.

That night, plans were discussed for Beck's and Makalu's evacuation. We dreaded having to evacuate them down through the Icefall,

but arranging a helicopter rescue seemed out of the question. Piloting a helicopter up to 20,000 feet, much less having it land and take on extra weight, was considered an impossibility. No helicopter had come that high on Everest in twenty-five years, ever since an Italian helicopter had crashed on the glacier below Camp II.

The next morning, at six o'clock on May 13, we got Beck on his feet again, and started down toward Camp I and the Icefall. Once you begin thawing frostbitten tissue you shouldn't let it refreeze. We needed to get Beck and Makalu down and off the mountain as soon as possible. Makalu Gau was semiconscious and frostbitten, and couldn't walk, so a group of Sherpas dragged him in a makeshift sled. The frozen body of his teammate Chen was also dragged down.

A few hundred feet above Camp I, the teams evacuating Beck and Makalu Gau had stopped, having received the remarkable news that a helicopter was on its way for Beck. Lt. Col. Madan K.C., a Nepal army pilot, had agreed to attempt the dangerous landing. He'd off-loaded his co-pilot, and all but five gallons of fuel, to cut down weight. Suddenly the helicopter rose from the depths of the Icefall. It flew over us and continued toward Camp II, before turning back toward our small party. He had appeared so quickly we'd had no time to select a landing zone.

Ed and I quickly found a good relatively flat spot between two big crevasses, but we had no way to mark it. It was Araceli who thought of the solution, volunteering her bottle of red Kool-Aid. I poured a small red X in the snow as Ed tied a scarf to a bamboo glacier wand and held it up as a wind sock to inform Colonel Madan of any shifts in the light wind.

Madan circled, surveying the landing site, and then made his first attempt to land. Just as he started to touch down, the tail settled awkwardly and he lifted off, circling to try again. On his second try, Madan warily rested the skids on the hard snow while continuing to apply almost full power to the spinning rotor blades. He gestured emphatically with his upraised index finger: Only one passenger could go. Jon, Pete, Ed, and I had already decided that that would have to be Makalu Gau, who was semiconscious and strapped into a stretcher with severely frostbitten feet.

With Makalu Gau tied in behind Colonel Madan, the helicopter

lifted off with a low, loping creep. Beck's spirits sank visibly. By heli-
copter, he'd be back in Kathmandu within the hour, warm, drinking in
oxygen-rich air 15,000 feet below. Now we faced an ordeal in the Ice-
fall that could last all day and half the night. Beck's hands were a prob-
lem, but he was alert and able to walk, and we felt he could have made
it through the Icefall under his own power.

To our enormous relief, the courageous pilot returned a half hour
later, once more tentatively settling onto the Kool-Aid stains. Pete
Athans and I got Beck on board. The helicopter lifted, pitched forward,
and then disappeared over the rim of the Icefall. Suddenly it was dead
silent. Our narrow part of the Western Cwm had been filled with the
roar of a straining helicopter. Now you could hear your own breathing.
As the helicopter disappeared down valley, part of my heart went with
Beck. And I thought part of his stayed with us.

REDEMPTION

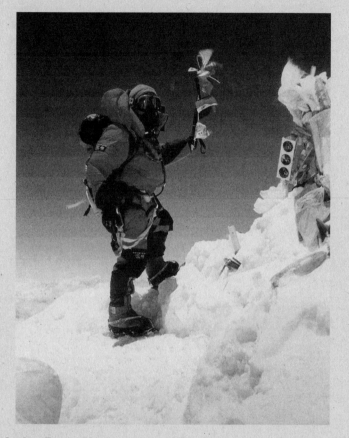

*Jamling Tenzing Norgay on the summit of Mount Everest, May 23, 1996,
forty-three years after his father and Edmund Hillary made history.*

CHAPTER TWELVE

On the day Beck and Makalu Gau were flown out, several helicopters flew around Base Camp getting aerial shots. One landed and let some journalists out for just a few minutes. They staggered around at 17,600 feet, took a few still photographs, and got back on the helicopters.

We had little idea how the world media was responding to these events, until we got a call from the ABC news program *Primetime Live*, saying Diane Sawyer wanted to talk to us. She interviewed me for about a half hour, then interviewed Ed. We talked about what it must have been like in that storm, and about bringing down Beck. It was a difficult conversation. My throat was raw and I was mentally drained from the nightmare of the past four days. I choked out the words while trying to imagine that the events I was describing hadn't really happened.

Greg MacGillivray called to express his company's deep concern about our safety and welfare. There was no pressure from him to complete the filming. "You can stay and finish it, if you want," he said. "We'll support you. But it's your decision." Not once did he discourage us from packing it in and leaving. We could go up or we could go home. Greg even said that we could come back and finish the filming next year. I appreciated that. However, until we assimilated the tragedy and sorted through our thoughts, there was nothing I could tell him.

The living returned to Base Camp, and on May 14 we attended a memorial service at Scott's Base Camp. It was only the second time people from all the expeditions had gathered together. Climbers and friends spoke and wept and remembered. Some of the tributes were eloquent, others awkward. There was no real orchestration to it. People took their time. Sherpas lit juniper branches in a *lhap-so*, an altar built from the stones strewn across the glacier. This was where, in the opening days, a ritual puja ceremony had been held to ensure the safety of Scott's team. Now the Sherpas said prayers. Offerings were made. A lama read from his scripts. Then someone recited the Lord's Prayer. *Our Father, who art in heaven. Thy will be done.* Then everyone dispersed and started to pack up.

Overnight, Base Camp turned into a ghost town. Where a tent city of 300 people had been, there were suddenly just empty campsites. Stone circles on the ice circumscribed the outline of tents no longer

there. A couple of other groups doggedly hung on. Otherwise we were alone. Now began the debate. Should we go home? Or should we try for the summit and go up and try to finish the film?

It wasn't a debate among the members. It was a debate in our individual souls. Each of us had to plumb our own beliefs. Each had his or her own way of dealing with the trauma. Before the remnants of the Adventure Consultants team broke camp, Ed went up and got rip-roaring drunk with them.

I tried to act capable and unaffected. But I was frightened and confused. I felt very vulnerable, very humble. Scott's and Rob's deaths were too close, not in terms of friendship but in stirring my own sense of mortality. We were close in age, experience, strength, and resolve. I could imagine finding myself in their situation, unable to survive that terrible night. I could rationalize the deaths of the inexperienced climbers, but not theirs. The mountain had ceased to be a source of joy for me. Suddenly the wind seemed louder, the cold colder, my legs weaker, and the mountain higher.

Over the next few days we sat around, in the dining room tent, in our personal tents, outside in the sun, thinking and talking. I knew two things. However much I wanted to complete the film, this season Everest had changed me. I could not and would not prevail upon my teammates to go up. And, as leader, I had the authority to say enough's enough, let's go home. No one would fault me for that. There wasn't a person on this planet who would say we should've stayed.

I tried to listen to the team, to hear what they were thinking. We had lost twenty-four oxygen bottles and precious time and we were traumatized. Back home, people on the periphery—mothers, fathers, sisters, wives—were frightened. I could only imagine what reports they were reading in the media. I would have called my wife, but Veronique was gone from my life. I wanted to call my mom, but decided against it, not wanting to hear any concern in her voice. So I called no one.

There were emotional reasons to go home, but—barring the jet stream—no logical ones. The fact was, our tents were still standing and no one on our team had been injured. We had worked hard to be fit, ready, and well positioned. And we had filmed every part of the ascent except the summit push above Camp III.

I know Ed was talking with Paula about what came next. Araceli spoke to her mother in Spain. Jamling called his pregnant wife, Soyang, in Kathmandu, and she consulted a respected lama, who performed a *mö*—a divination. He cast dice and pronounced the weather would be good, a summit bid would be safe.

In my own way, I asked for a *mö*, too. I contacted a London-based weather service to begin tracking the jet stream. There was very little regional data for them to come up with an accurate forecast. But at the very least it might provide us an overview of our options. The winds at the summit would not abate. Whether it was real or imagined, after the storm the wind seemed much stronger to me.

It was not the notorious jet stream that had generated the May 10 storm—that had been a localized weather cell, a relatively small, fast-moving storm. But with the jet stream still locked on to Everest, our weather was likely to remain unsettled. The seasonal pattern was for it to move to the north, which usually promised less hostile conditions, but some years it just never budged from the Himalayan range. If this were one of those seasons, I wanted to know. That could end our contemplation of the heights right there. Essentially, we heard very little that was new or different.

In the end, there was no vote. We just decided to go back up. No one ever said, *We've got to finish this film.* That was secondary to anyone's decision, including mine. We were refusing to have Everest taken away from us by the tragedy. We wanted to salvage something from that season, find the slightest salvation in all the horror. I think we all wanted to prove to ourselves what Ed had said at Base Camp: *Everest isn't a death sentence.*

Once the decision was made, our drive to complete the project—both the climb and the film—returned. There were two obstacles remaining, oxygen and wind. Our stockpile of oxygen bottles had been more than halved by the survivors' needs. Of the forty-two bottles we'd cached at the South Col, eighteen remained. We needed to find more bottled oxygen.

We had a small reserve at Base Camp. Some of the departing teams bequeathed to us bottles they'd left on the mountain. After talking with Sherpas who'd been sent up to retrieve the gear from Rob's

and Scott's expeditions, we learned that Scott's team had left a few bottles at the South Col. In the end, we had enough for one attempt, but not enough to wait out a storm on the South Col.

The wind continued to blow relentlessly. The London weather service couldn't predict when, or if, the jet stream was going to move north off the mountain. With the monsoon clouds just a week or two away, we couldn't afford to sit at Base Camp and wait. So, on the chance a weather window might appear, we decided to go up to Camp II and wait.

It must have been especially hard for Ed to leave Base Camp. Paula was leaving that morning—she had decided to accompany her friends in the Adventure Consultants team down valley to spend a few days at Thyangboche before returning to Base Camp. The thought of Ed climbing without bottled oxygen, where strong men climbing with it had perished a few days before, deeply upset her. We headed back up the mountain intensely aware of what was up there.

The groomed route through the Icefall was nearly empty and starting to disintegrate. The Sherpas who'd been hired to maintain the ladders and rope sections wanted to go home. Throughout the season, these Icefall Sherpas had constantly been maintaining the route, sometimes resetting the ropes when colossal sections collapsed. Now, with the late spring sun beating down, ice screws were melting out of the ice. Aluminum pickets driven into the snow lay on their sides, exposed. I started across a ladder and instead of a handline I ended up with an armful of rope. The place felt like it was coming apart.

Well rested and acclimatized, we managed to climb through the Icefall and bypassed Camp I, getting to Camp II that same afternoon, May 17. The weather was fine at that altitude, but lying in my tent I could hear the incessant whine of the jet stream 5,000 feet overhead. I put on headphones and listened to music to drown out the sound. But in the night when I awoke to relieve myself, its resolute drone was still there, along with the haunting image of Beck's frozen hands.

Finally, on May 20, Base Camp radioed that London forecast some improvement. We were clinging to bits of hope, anything that signaled a positive. We didn't see any evidence of a break in the wind, but

there comes a time when it's easier to be on the way up than lying in your tent agonizing.

We headed up to Camp III on May 21. At the head of the Western Cwm, we clipped into the ropes anchored to the Lhotse Face and started up the bergschrund. On these same ropes Ed and I had helped to evacuate Beck just over a week ago. A few days before that, we'd brought down Chen's lifeless body.

Moving up the icy slopes, I wasn't thinking as a cinematographer or director, but as a leader. The camera was waiting at Camp III, but for now I concentrated on the safety of my team. I watched for any hint of a flaw in a teammate's performance. With the disaster still so vivid, any weaknesses, real or perceived, in the team were magnified in my mind. My primary concern was Sumiyo, who continued to suffer spasmodic coughing fits, straining her diaphragm muscles. She was moving slower than normal, but doggedly continued higher. I was not optimistic about her prospects, knowing there is a world of difference between the climbing at 24,000 feet and the regions above 26,000 feet. But for the time being, I gave her the benefit of her own perseverance.

Camp III was a completely different place, skeletal, desolate. The last time we had been there it had been a transit station for shocked and frostbitten survivors, crowded with tents. Now the other expeditions' tents were mostly gone. Bare, leveled patches gaped in the ice where friends had once camped. You could tell where the tent entrances had been by the yellow stains of urine, locked in the ice. In fact, the detritus of dozens of bygone expeditions lay partially exposed. Where tent floors had frozen into the ice, the nylon remains flapped in the wind, some faded as white as prayer flags.

We crawled into our tents, out of the wind. Robert and I immediately gave the camera a thorough checkup. It was in perfect condition. As we had just before the disaster unfolded, Robert and I prepared the camera loads for the next morning and laid them outside, between the tent wall and the mountain. That night, I listened again to the din of the winds high overhead.

The next morning, May 22, we were out of our tents before the sun hit. The Sherpas arrived from Camp II and Robert and I sorted out

the camera equipment loads. Sumiyo started using bottled oxygen. Privately, I had already made the decision that she wouldn't be climbing above the South Col, but it was important that she make it there to monitor the radio during our ascent. Unlike the guided expeditions, we would not be using bottled oxygen here, nor would we arrive on the South Col, at 26,000 feet, to thermoses full of hot tea prepared by the Sherpas. That was the realm of the client. A fundamental ritual of survival in the mountains is the preparation of one's meal, which starts with the gathering and melting of ice for water. At this altitude it's time-consuming and tiring, but it's part of being a mountaineer. Despite the tragedy, I thought that we still had to stack the odds in favor of the mountain, otherwise where was the challenge?

At eleven A.M. we gained the Yellow Band, the 200-foot-high stretch of limestone that angles across the Lhotse Face. We stopped to film Ed collecting geological samples. This was our first filming since before the storm, and I was relieved when the camera worked beautifully.

Continuing higher, we reached the Geneva Spur, a steep rib of rock that slices straight down the Lhotse Face from the South Col. We traversed leftward across its loose, rocky face, along a narrow snow gully the width of a footpath. The path started out quite exposed. It was well marked by a set of knotted ropes, some ancient and bleached, some laid by recent climbers.

Abruptly the traverse reached the Spur's outer edge, and the whole upper pyramid of Everest loomed before me. This was where the bodies of Ang Dorje and Yogendra Thapa had been tied off by the party of descending Sherpas in 1984. When I raised my eyes to the summit, a stunning plume warned that the winds were still blowing hard high on Everest.

The route continued along an undulating traverse that ended upon the South Col. Camp IV was still out of sight, and I dreaded what we were going to discover there and beyond. I looked back and saw Sumiyo struggling to catch up with us. Her will was stronger than her flesh, but I knew there was a limit to even that.

Late that afternoon, May 22, we reached Camp IV on the plateau between Nepal and Tibet. The wind had shredded the tents which had

been left behind after the tragedy. Our supply tent was deformed, but still intact, despite having stood on the South Col for almost three weeks. Here and there, shredded fabric flapped among the rocks and discarded oxygen bottles. It was blustery. But, surprisingly, the wind wasn't howling. You could actually stand upright and erect your tent.

We'd been on the mountain for almost sixty days. At the South Col, rest is elusive, if not impossible. You arrive worn and depleted from the long trip up the Lhotse Face, and within hours it's time to start for the summit. There was so much to do. We had checklists, pieces of camera and climbing equipment to inspect, clean, and inspect again. Except for Ed, we'd all be using supplemental oxygen for the ascent.

As the sun dropped, the team settled in for a few hours of rest. I had one last unpleasant task to perform. I had to tell one of my team members that she was out. Sumiyo couldn't go with us to the summit. I crawled into the tent she was sharing with Jamling, and procrastinated for a few minutes. Jamling left the tent. I'd known Sumiyo since 1990, when we met on the north side of Everest. She had a special place in my heart. I'd chosen her for this project. I wanted her to make the top of Everest. We had lots of footage of her, and it would have been better for the film to show her on the summit. But I wasn't thinking as a filmmaker, I was thinking as a mountaineer.

Sumiyo knew why I'd come into her tent. Cutting her from the summit bid was heartbreaking for me. Now I could see what Rob or Scott or any other leader would have faced. Sumiyo pleaded. She told me she'd lose face back in Japan. She mentioned all the hard work it had taken her to get this far and that she hadn't been climbing slowly because she was tired, only to conserve her energy for the summit attempt. But she was too slow and still coughing hard. I would not risk her life by having to park her at the South Summit while the rest of us went on. A team is only as strong as its weakest member. I couldn't threaten the safety of the rest of the team with her potential collapse.

Sumiyo could have defied me. She could have gotten up the next morning and put on an oxygen mask and a bottle and gone anyway. But she didn't. I'll always be thankful to her for that.

I went back to my tent. Robert finished loading the film magazines we'd be taking along. I zipped the camera and lenses in their

cases and placed them in the vestibule of the tent. It was seven P.M. I lay back against our piled gear and tried to rest. We were poised, the last-minute details taken care of. I closed my eyes, but couldn't relax. There was a sense of apprehension, an undercurrent of dread. We knew what lay out there. Araceli had broken into tears down at Camp II, confessing "I don't want to climb a route with dead people on it."

In my mind, I ran through all the possibilities of our summit day. When I got to the end of one scenario, I would work through another. I knew that the effects of hypoxia and sleep deprivation and the tug of Everest could cloud my decision making. I wanted to have rationalized a decision for the most likely scenarios of the day down here in the relative warmth of my sleeping bag and the security of my tent.

I still couldn't shake the image of Beck's frozen hands. I had to load the cold, steel IMAX camera bare-handed. Beck had exposed one hand for a matter of moments, just long enough to tuck it inside his parka. And that had triggered a chain reaction of events: the glove blowing away, his fingers freezing, his inability to close his parka again. It wasn't so much the specter of losing one's hands that haunted me, as the total loss of control that Beck—and Rob and Scott—had faced. The thought of being unable to hold an ice axe or grip the rope to save the rest of your living body was horrible.

What frightened me most about their long ordeals was that they hadn't fallen off or been hit by a rock or suffocated in an avalanche. There had been nothing quick about their suffering. They had reached an impasse, stopped, and sat down. Awake, conscious, they had known what was happening to them. They had been unable to help themselves. Unable to move. Rob had sat for a night and a day and part of another night, and not moved six inches. He had sat there and looked at his hands and radioed down that they wouldn't work to hold a rope. His own hands were dead to him.

As I sifted in my mind through the various scenarios, Robert and I planned the day's shooting. There were only three places we could stop and safely assemble the IMAX camera—on the Balcony, the South Summit, and the summit. Due to weight, our camera team would be taking only three rolls of film, each just ninety seconds long. So I knew

that three times that day Robert and I were going to have to assemble the camera. Three times I'd have to expose my hands.

We had a small video camera in the tent with us, and I'd considered bringing it along. It would add a few pounds to the load, but could serve as a way to record the climb if the IMAX camera failed. I made the decision to leave it behind. Exhausted, at the edge of my working capacity, I would surely get enticed by the relative ease of shooting with the video camera, and I could justify not setting up the IMAX behemoth, maybe even abandoning it altogether. I had no problem with jettisoning the IMAX camera if we hit a storm or someone collapsed. It was a lifeless thing. I had no attachment to it. If anything, I had come to despise it.

But we had come too far to simply get some videotape. This expedition wasn't about getting me on top. It wasn't even about getting my team on top. We'd come here to share the summit with the world. With one final monumental effort, we could capture the full majesty of this great mountain experience on 65mm film.

At eight P.M., Robert and I sat up and started the summit day ritual, firing up the little stove with its hissing blue flame, feeding some ice chunks into the pot to make hot liquid, and going through our checklist of climbing and camera gear one final time. The tent wall shuddered now and then, nudged in random bursts of wind. We drank and ate what little our appetites would allow, fully aware this was the last we'd have of nourishment on the way to and from the summit. Around ten P.M., Ed came over and talked through the tent wall, saying he was on his way, then he set off alone. Like Anatoli, he would be climbing without supplemental oxygen. But unlike Anatoli, Ed had no clients. The rest of us, using bottled oxygen, would be starting an hour behind Ed, and planned on catching him near the Balcony, or higher on the Southeast Ridge.

Just before eleven P.M. I unzipped the tent door and crawled outside. I carefully clipped on my crampons and stood up. The sky was clear and moonless and filled with stars. It was bitterly cold, minus 35 degrees. Light puffs of wind scattered the loose snow. I looked up for the circle of light from Ed's headlamp. It was there, bobbing up and

down with each of Ed's steps. He was higher than I thought he would be, making good progress. I softly mumured to myself, *Go, Ed, go.*

Then I walked around shouting at the tents, "Time to go, out of the tents." I had selected two bottles of oxygen and checked—again—that they were full. I had spare mittens, spare goggles, my ice axe. And my compass was fixed with a heading from the base of the distant gully to where I stood, so that even in a storm I could find my way back to this campsite.

The Sherpas came over and Robert and I distributed the camera gear. Around me were teammates occupied with their own thoughts of survival, their own checklists and priorities. We were all in an intense state of focus. We had assembled our little armada. It was pointed in a direction, at long last ready to get underway.

We started off. The South Col is a level platform, and it feels unnatural to be in crampons staggering around on a flat rock pile, especially in the dark. There's none of that instant assumption of the climbing skills like when you get out of your tent on the angled ice at Camp III; no pitched slope to orient you to up or down. That was a deadly problem for the descending climbers on the night of May 10, because without compasses in the whiteout, the flatness had offered no clues for which way to go.

I crossed the plateau and reached the first slope of ice, the incline at first annoying. There's a rise up onto the shelf made of hard, blue ice. It's off-angle, so you can't front-point it, yet steep enough so you can't place your feet normally. You end up duckwalking, with your feet pointing outward, on crampons dulled from scraping around on rock.

There's an awkward uncomfortable hour as your body tries to sort out what you're doing to it. You're starved for oxygen, severely sleep-deprived, dehydrated, and malnourished. And suddenly you're commanding your body to work as hard as it's ever worked—or harder. The climbing is robotic—methodical and solitary. All you hear is your deep rhythmic and ragged breathing as you draw air through the oxygen mask. Occasionally the crampons make a squeaking noise on minus 30 degree snow. No one talks, as talking expends energy. It's critical to conserve energy up here. You try not to expend one more molecule of it than you have to. Finally, I settled into a rhythm.

Two hours higher I noticed a blue object in my headlamp, to my right. I knew it was Scott. He wasn't curled in a protective, fetal position. He was stretched on his back. His right leg was cocked with one arm crossed over his chest. Wind-blown snow, and the pack that Anatoli had roped over his head with bright orange rope, blocked Scott's face. I was thankful for that.

I'd known Scott would be here, and I knew Rob would be lying higher on. We knew where Yasuko lay on the South Col, though none of us had gone over. Three hundred feet below Scott, I'd passed a body lying atop the rocks, its covering of sun-bleached nylon indicating it was someone from a previous year. And while doing a brief survey of Camp IV, Robert and I had discovered yet another anonymous body. It was an open graveyard up here. Maybe at lower altitudes it would have been unbearable. At this moment, I felt no emotion. The body and mind had retreated into survival mode. In the dark, wrapped in my down suit and oxygen mask, I was insulated from the external world and from Scott. I moved on.

Occasionally I saw Ed's light flicker overhead when he turned to look back. For the most part I kept my head down, focused within my own cocoon of light. Now and then I looked below to see how far back the slowest Sherpa was.

I reached the Balcony ahead of my group, at 27,600 feet, as dawn was starting to lighten the night sky. I sat down to rest and wait for my team. My feet were numb. I could no longer feel my toes. Your body has its own set of priorities and rules at 27,600 feet. Its most fundamental impulse is to survive. To survive, the primary organs need oxygen, but there is very little oxygen in the bloodstream. In a decision you can't control, your body shuts down the capillaries in the feet and hands, shunting the blood it craves to the heart, lungs, and brain. The blood, thickened from extreme dehydration and the production of extra hemoglobin, only compounds the circulation problems.

I unzipped my borrowed overboot and took off one boot, carefully tied it to an ice axe, took off the inner boot, and rubbed my foot until the circulation returned. Then I did the same with my other foot, sometimes glancing up the Southeast Ridge to monitor Ed's progress. All the while Jangbu and the other Sherpas were slowly arriving with different

parts of the camera. Robert and I had agreed that the dawn view from the Balcony would be one of our three shots.

The sunrise began to unfold, from flaming orange to hues of red and pink—and the camera body still wasn't there. The Sherpa carrying it, Gombu, was having a rough day. Throughout the expedition I'd let the five camera Sherpas decide among themselves who carried what. Now I saw they'd given the heavy twenty-five-pound camera body to the weakest of them because he was the least likely to argue. He was way behind. I tried to scream down, "Hurry, please hurry!" But all that welled up through my parched throat was a hoarse croak. Anyway, it didn't matter, he couldn't hurry. On this day everyone operates at maximum capacity.

A half hour later the camera still hadn't arrived. I watched in frustration and disbelief as the vivid pinks and reds of sunrise faded to the harsh white light of early morning. Finally, Jangbu, in his first Herculean act of the day, descended 200 feet to retrieve the camera from Gombu, who was now barely moving. When he returned, Robert and I began assembling the camera, gathering the various pieces from four different packs. It took me several minutes of intense, fatiguing concentration to load and thread the 65mm film. Every few seconds I had to remove my chilled fingers from the metal camera body and rewarm them inside my down suit. It was a clear windless morning and the temperature had warmed to minus 20 degrees.

Then Robert and I lifted the forty-two-pound contraption onto its red nylon camera pack. I balanced the camera, framed the shot, and went over the checklist with Robert again. After a few almost inaudible instructions to Araceli and Jamling, I hunched down, stuck my eye to the viewfinder, and switched on the camera. With a low-pitched whine it came up to speed, devouring 5.6 feet of film per second. With a gesture from Robert, Jamling and Araceli plodded up the Southeast Ridge. Ten seconds into the shot, I noticed they had strayed off the ridgeline. Viewed through the lens, it looked strange, as if they were descending. The shot wasn't working. Robert continued counting off the seconds. I gave them another ten seconds, fifty-six feet of film, to straighten their ascent and then shut down the camera. I was incredulous, twenty seconds of precious film wasted, and the shot was unusable. Furious, I

stood up, ripped off my oxygen mask, and demanded they go back down and climb toward me again, in a more direct line.

They complied, descending to a drop in the ridge, turning around, and plodding back up again. And what a glorious shot it was: Araceli in yellow and Jamling in red, their faces hidden behind oxygen masks, resolutely climbing toward the camera on the crest of a side-lit ridge. The Kangshung glacier was 10,000 feet below. The peak of Makalu, 27,766 feet, fifteen miles away, rose directly behind them. And seventy-eight miles away on the eastern horizon was Kanchenjunga, the world's third highest peak. The highest Take Two in history.

I swiveled the camera and trained the lens to the southwest horizon and exposed the last twenty seconds of the roll. Then Robert and I packed up the camera, and cached the 500-foot roll of exposed film. We would collect it on the way down. Ed had now climbed even further ahead of us. I sent Jangbu up to try and catch Ed and have him wait at the South Summit, 1,100 feet above the Balcony. Then I set off behind Jangbu.

Recent wind and snow had buried most of the rope that Rob's and Scott's teams had fixed, but we strayed across pieces of old rope anchored to the rock outcrops below the South Summit. Nearing the South Summit, I rested and looked up. A hundred feet above me, Jangbu suddenly pulled loose a piece of ancient, sun-weathered fixed rope that he'd just used to haul himself up onto the rock ridge, and threw the useless line to the side. This left me without a direct line up the rock ridge, meaning I now had to break a new trail to my right, through waist-deep, unconsolidated snow. Eleven years earlier with Dick Bass, we hadn't felt the need for fixed ropes up here. For the next half hour, I labored, scooping snow down from the steep slope in front of me with my hands and forearms, and stamped, then stepped up, gaining ten inches. Repeating the sequence, again and again, I marveled at the prodigious strength of Ed Viesturs, who had been breaking trail for seven hours without bottled oxygen.

A little higher I reached the South Summit, at 28,700 feet. Ed was there. He was sitting with Rob in the notch between the South Summit and the traverse. I climbed down to them. We didn't say much—by now I could manage only a raspy whisper and Ed had to get moving. He'd

waited forty-five minutes for me and didn't have my advantage of bot-tled oxygen. He was getting cold. We looked up the ridge and puzzled over where we might find Doug Hansen, but he was nowhere in sight. Rob had only said "Doug is gone." That could have meant many things. And we weren't expecting to find Andy Harris. Jon Krakauer had last seen him on the South Col the night of the storm, before he was re-ported missing. I indicated to Ed that I would see him on the summit later, then he started across the traverse.

I sat next to Rob for a while; he was facing the east, tucked into a hollow in the ridge, with his back to the wind. His shoulders and head were buried in drifted snow. In his struggle to survive it was obvious he'd done all the right things. He had placed several oxygen bottles within arm's reach and removed his crampons to help keep his feet from freezing. His ice axe was planted vertically where it wouldn't be lost in the wind and snow. He'd applied his formidable willpower and mountaineering skill in creating a haven from that awful storm, but no-body could have survived in those conditions. Another ice axe stood next to his.

There was an odd peacefulness to the scene: The morning was sunny and calm, and Rob looked as though he'd lain down on his side and fallen asleep. Around him the undisturbed snow sparkled in the sun. I stared at his bare left hand. It was totally exposed. I wondered what a mountaineer with Rob's experience was doing without a glove. But most unsettling was his hand's color and texture. It looked warm and undamaged, not at all like the frightening charcoal black frostbite injuries I'd seen on Beck and Makalu Gau. I wanted to reach out and touch it.

Sitting next to Rob I tried to sort through a mixture of emotions: sadness, anger, admiration. There wasn't one particularly overwhelm-ing emotion, not up here, just an undercurrent of thoughts. I kept ask-ing, *What happened, Rob? You were always so careful, what happened?*

I gazed up across the traverse to the Hillary Step and tried to imagine that unspeakable night: Rob struggling in a howling gale, in the dark, trying frantically to revive Doug Hansen, pleading with him to get up and move across the dark wind-blasted void. Calling for help, and for more oxygen, Rob was unable to see more than a few feet into

the stinging wind-driven snow. I can't imagine a lonelier task: Rob straining in the din to hear the radio calls from his trusted friend, Guy Cotter, who implored him to abandon Doug. Rob could have saved himself, I'm sure of that, but he chose to stay with Doug, long after all hope of saving him had vanished. I admired him for that and I asked myself if I would have had the courage to do the same.

But I was also angry that Rob had allowed, or even encouraged, a client to climb far too high, far too late. It was an act of great heroism for him to stay with Doug, but looking after his clients was a responsibility he had acknowledged when he accepted their money to lead them into harm's way. And Rob had always assured his clients that they were in the most capable hands on Everest.

Sitting there I realized how similar we were. We were both familiar with this mountain and used it for personal gain. Each of us wanted to share the Everest experience with others. Rob offered a real-life, high-altitude experience with the summit of Everest almost guaranteed. I loathed the crowds of inexperienced climbers swarming the slopes of Everest, yet I'd spent my professional life popularizing the mountain in film and videotape. My ascent of Everest in 1985 with Dick Bass had certainly set loose the imaginations of a cadre of woefully unprepared dreamers. And here I was again, now one of a crowd, determined to immortalize the Everest experience in the world's largest film format. I saw myself lying there.

Some of the other climbers and Sherpas started arriving, snapping me out of my reverie. Jangbu called down and I climbed back up to the South Summit. I'd given instructions before I left the Balcony to have a different Sherpa carry the camera. As I peered down the Southeast Ridge I could see that the Sherpas had again saddled the slow-moving Gombu with the camera. I turned to Jangbu, who'd reached the South Summit, and rasped, "I need that camera." In his second Herculean effort of the day, Jangbu descended again for the camera.

Meanwhile, Robert and I were trying to discuss the situation. In addition to the summit and Balcony shots, we'd agreed the South Summit was the most important shot of the day. From there you get a spectacular view, looking across the stupendously exposed traverse along a knife-edged ridge to the Hillary Step, with the summit pyramid rising

above. On either side the ridge drops steeply away 7,000 feet. To get through my worst moments following the tragedy, I'd invented a scenario in which Robert and I finally got this jaw-dropping shot. That vision held the sound of the wind and my self-doubt at bay. It was the shot I most cherished on this day.

By now I'd completely lost my voice. My throat was so parched and full of hardened phlegm that I was having trouble breathing. Every time I tried to swallow or talk a searing pain ripped through my throat. I was never more in need of my voice and now I was reduced to a raspy whisper. I didn't tell Robert, but I simply didn't have the will or the heart to assemble the camera and shoot with Rob lying fifteen feet below. Rob's death had made this hallowed ground. If there was one lesson to take from his death it was to keep moving, don't get up there too late. I told Robert I'd meet him on top, that we could film the traverse on the way down. The camera still hadn't arrived as I started across the traverse.

It was disappointing to find fixed ropes here, taking all the challenge away. That's the intent of the guided expeditions, to eliminate most of the challenge, reducing Everest to the ability of the average client. But you cannot eliminate the effects of thin air or the folly of thinking you can guide other people's destiny when all hell breaks loose up here.

As I climbed past the spider's web of decaying ropes that now grace the Hillary Step I kept glancing around corners and into slots in the rock for signs of Andy. Nothing. I plodded on toward the summit, the cold, super-dry air from my oxygen bottle scorching my throat with every breath. At 10:55 A.M. on May 23, I took three final steps and embraced Ed on the summit. He took the radio from my pack and called Paula at Base Camp to tell her we'd made it. I couldn't speak, nor could I convey my utter relief that this moment had finally arrived. It was a wonderful moment. Ed and I knew what it meant, we didn't have to talk. We'd been through so much this season, and yet here we were. He took off his gloves and handed me his camera and I took a photo of him. Ed had waited for me on the summit as he had waited lower down

several times throughout the day, during his unfathomable achievement of breaking trail without bottled oxygen. Now he had to descend. Ed and I had made a promise: Since Paula was waiting in Base Camp, on this day he would not wait for the camera, but immediately head back to her. I gave him another hug and he started down the summit ridge. I was alone on the summit, staring at the prayer flags, bent aluminum surveying tripods, and laser prisms that now adorned the top of Everest.

Araceli, Robert, and Jamling arrived, along with the Sherpas. While we waited for the camera Araceli was patched through by radio to Catalonia. Jamling spoke to his wife in Kathmandu, who was anxiously waiting for word of the climb. Apparently she didn't share Jamling's enthusiasm for the high peaks. Hearing that they were at the top, she said, "Now no more!" and instructed him to be careful on the descent.

At last the camera body arrived. We had only one 500-foot roll of film for the summit shots. Robert and I assembled the camera on the incline of wind-hardened snow just below the summit. We worked slowly and methodically just as we had for the past sixty days. If we dropped a single piece of the camera equipment, there would be no summit footage, nothing to show for the years of planning, effort, and worry. Bare-handed, I threaded the film again. Then, at the apex of the world, Robert and I went over our camera checklist one last time:

1. Tighten magazine take-up pulley to activate camera buckle switch
2. Connect magazine drive belt
3. Tighten feed slack knob on magazine
4. Manually advance film to check thread/loop size
5. Close camera, cold-crank if required
6. Insert power cable
7. Flip power-on switch
8. Camera jog if necessary
9. Camera ready to run
10. Reset counter
11. Check focus
12. Check exposure

13. Check frame line and flare
14. Ensure magazine cover does not interfere with pulley
15. Take a good picture with story value

Finally we hoisted the forty-two-pound behemoth onto the light-weight summit monopod and readied to shoot. Robert braced his shoulder underneath to help steady the camera. The camera had never failed us: *Please give us just ninety seconds more*, I thought as I flipped the power switch. The camera roared to life and Jamling and Araceli embraced on the summit. I shut down the camera after Robert counted twenty-five seconds. A few minutes later, I switched on the camera again as Jamling placed offerings on the summit: a stuffed toy elephant from his infant daughter, prayer flags, pictures of his mother and father and of His Holiness the Dalai Lama. Then I pivoted the camera around for a shot down the summit ridge and across the billowing clouds. I listened to the last feet of film roll through the camera, then it automatically shut down. That was it, we were finished, now we could head home.

It was 12:30 P.M. We packed quickly and the team started down. Before I left the summit Ang Rita arrived, thirteen years after we had stood together here, each for the first time. It was Ang Rita who had pointed the microwave transmitter toward the Mount Everest View Hotel in 1983. On an exposed slab of rock fifty feet below the top I gathered a fistful of pebble-sized souvenirs. After a quick final glance to the summit, I turned and hurried down.

Just above the Hillary Step I passed the Swedish climber Göran Kropp, who was climbing without bottled oxygen. He was not nearly as strong as Ed and it unnerved me when, slumped over his ice axe, he looked up and slurred, "I'm so afraid of dying." I cautioned him and continued down. I stopped again at Rob's body, wanting to take something down for his unborn child. His ice axe was standing there within reach but I couldn't bring myself to take it. Two hours lower I stopped alone at Scott's body. I could see our tents down on the South Col. There was no wind; I could relax now. My only thought was, *Scott, what are you doing here? You were so strong. Camp's only an hour away.*

As I staggered back to our tents on the South Col, Sumiyo came

out to greet me with a mug of hot tea. It was an awkward moment. The day had been windless and clear; I knew that she was upset. I waited until everyone was accounted for, then crawled into the tent and collapsed into my sleeping bag. We'd been on the move for fifty-two hours with three hours of sleep, and very little to eat and drink.

The next morning Jamling awoke snow-blind and had to descend with a Sherpa escort. The rest of the team staggered and wandered around Camp IV. It was all we could do to get the camera set up, much less shoot the scenes. For minutes at a time, Robert and I just sat on a rock, staring at the IMAX camera. It looked preposterously huge and cumbersome on its seventy-five-pound tripod and head. We picked it up and staggered fifty feet in slow motion across the Col, then had to set it down and rest before carrying it again.

At last, finished with all our duties on the South Col, we started across the Geneva Spur. While descending the fixed ropes near the top of the Yellow Band, at 25,300 feet I passed a lone figure. He shook my hand firmly and offered congratulations. It was Bruce Herrod, a gentle, pleasant man with a bushy black beard and a big smile. He was a photojournalist member of the South African team that was on its way up to the South Col to try for the summit again. I had a short talk with him. He seemed fit, and was very excited. I was impressed by his enthusiasm—especially in contrast to my fatigue. With the bodies of Rob and Scott still emblazoned in my mind I took care to remind Bruce of the hazards of climbing too late, and of the likelihood of afternoon cloud buildup this late in the season. We shook hands again and I wished him good luck. Lower, I passed the South African expedition leader, Ian Woodall, sprawled on the rocks of the Yellow Band. He looked feeble, completely spent, an absolutely pathetic figure. I took one look at him and thought, *This man should go down, now. High-altitude climbing isn't his game.* But however inept, he was the leader, so had no inclination to heed my advice, whether I offered it or not.

We reached Camp II by early afternoon, having stopped in Camp III only long enough to pack up and leave loads for the Sherpas coming up to clear camp the next day. The following day we filmed a few scenes we'd missed due to bad weather and the tragedies. In the evening Base Camp informed us that Ian Woodall, Cathy O'Dowd, and

298 · DAVID BREASHEARS

three Sherpas had reached the summit earlier in the day, at ten A.M. On their way down, they'd passed Bruce Herrod climbing upward alone, moving very slowly. At 5:15 P.M. on May 25, Bruce made a radio call to Base Camp. He was at the summit and was about to head back down. It had taken him seventeen arduous hours to get there from the South Col. The next morning as we dismantled Camp II, and prepared for our final trip down the Western Cwm and through the Icefall, we learned that Bruce had not returned to the high camp. A tragedy, a triumph, and now another tragedy.

Later that day before departing the Icefall and entering the sanctuary of Base Camp, I prevailed upon my team to stop for one final shot. We were all together, the film team, the Sherpa camera team, and the climbing team, just as we had been during our first trip into the Icefall, almost sixty days ago. I asked them to turn and climb as if they were on their way up early in the season, full of expectation, with their eyes turned to Everest, as though nothing had happened. When we were finished, I thanked everyone, then we turned and walked out of the Icefall.

EPILOGUE

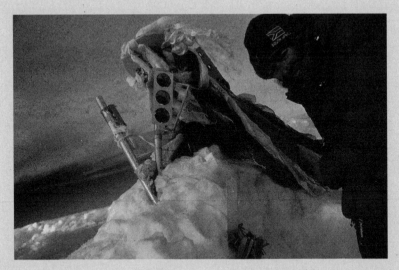

*Bruce Herrod's summit self-portrait and last photograph,
Mount Everest, May 25, 1996.*

I returned to Everest the following year. This time I was to film a documentary for the PBS science series *NOVA*. Accepting the assignment was, for me, as much about coming to terms with the 1996 disaster as it was about filmmaking. Many of the survivors had sworn they would never return to Everest. But the question remained, Was I done with Everest, too?

In all honesty, I had my reservations, but they weren't about climbing itself. I was disheartened at the circus the media had made of the tragedy over the past year and deadly tired of being pestered to provide its cameras and columns with ghoulish facts or critical observations. I longed for the moment I could leave Everest peacefully, unencumbered by tragedy, feeling that special kinship with the mountain and the people I knew who had climbed it. But in the spring of 1997, I was still unreconciled with the events of that dreadful season.

I brought with me some of the same climbers who'd been with me on the summit of Everest in May 1996, including Ed Viesturs and two of the same Sherpas, Jangbu and Dorje. I was also taking Pete Athans, the four-time Everest climber who had helped bring Beck Weathers down the previous year. The documentary, entitled "Everest: The Death Zone," was about the deleterious effects of high altitude on the human body, especially on brain functions. I was to be not only the filmmaker, but also a guinea pig for a battery of medical and cognitive tests to be conducted at various altitudes.

This year the climbing was more difficult for me. I'd lost my hunger for the summit, and had to call on a completely different part of my psyche to move upward. There was nothing instinctive or natural about being there. It's not as if I were trying to get back on a horse, as I'd done in my youth when I'd fallen off rock climbs in Colorado. I hadn't fallen in 1996. This was about salvaging my idea of the mountain.

I wasn't alone in my ambivalence; we all seemed to be wondering just what, apart from the assignment, we were doing there. None of us wanted the 1996 tragedy to be our lasting impression of Everest. And yet none of us could figure out how to resolve the memory.

Worse, we seemed destined for another year of disasters. Once again our team established camps up to the South Col, surrounded by

international expeditions and too much traffic. The pattern of deaths began all over again. Mal Duff, an expedition leader who'd been on Everest the year before, died of a heart attack at Base Camp. There were more storms and more deaths over on the northern, Tibetan side. A helicopter crashed at the base of the mountain. The pilot, Lt. Col. Madan K.C., who'd so heroically evacuated Beck Weathers and Makalu Gau, was lucky to survive the crash. Then a Sherpa plunged down the Lhotse Face.

So once more we lay awake in our tents, listening to the jet stream swirl around the summit with its low, menacing hum. We'd been ready to make our summit bid since the first week of May, and by May 18 we were ready to go home. Perhaps it had been a mistake to come, after all.

As a way to laugh off our dark mood we conceived of a high-altitude twelve-step support group, Everest Anonymous. Ed had been to Everest nine times. This was Pete's thirteenth trip, and my eleventh. The rationale was simple. The human mind tends to blur negative or painful experiences, even vows never to return to the mountain. But when you're sitting before a cozy fire in Boston or London, it's tempting to say, *Oh, sure, I'll go back to Everest.* Everest Anonymous members promised periodic telephone calls to remind you of your pledge never to return to the place.

The jet stream moved north the next day. On May 22, Ed and I set off for the top again. Last year we'd turned back rather than risk becoming entangled with the crowds of climbers heading up the mountain. Once again we faced the prospect of a tangle of climbers on summit day. There were two inexperienced teams shadowing our team, one Canadian, one Malaysian. So, hoping to avoid any possible imbroglio, we decided to leave even earlier than usual, at ten o'clock that night.

The mountain shimmered under the beam of a full moon. Not needing my headlamp, I climbed following my shadow cast on the snow. During the post-monsoon season following the disaster of 1996, foul weather had prevented any expeditions from going above the South Col. That meant we were among the first teams to revisit the final slopes in 1997.

Except for Scott's body, still wrapped with a pack and rope the way Anatoli had left him, the summit slopes were mercifully free of the tragedy. When we reached the South Summit, Rob had disappeared from sight, shrouded by a tall drift formed around his body. Andy Harris and Doug Hansen may lie near him, though we'll probably never know.

By the time we reached the South Summit the sun had risen. Near the base of the Hillary Step we found the last vestige of the 1996 disasters, the body of Bruce Herrod, the photojournalist who'd been with the South African team.

Bruce was hanging upside down near the bottom of the Hillary Step, like Captain Ahab lashed to his White Whale. Evidently he'd slipped toward the end of his rappel. He'd taken the precaution of clipping his figure-eight rappel brake into the fixed rope, but something had gone amiss. We hoped he'd hit his head and been spared a long struggle to right himself again. His arms hung downward and his mouth lay open. His skin was black from exposure. I didn't look at him for long. Like the entire grim season we'd all been a part of a year ago, the corpse seemed a grotesque public spectacle.

Unnerved, I climbed on around Bruce, leaving him roped in place for the time being. We soon reached the summit, one year to the day since Ed and I had last scaled it, and immediately went to work videotaping and conducting the cognitive tests. We spent a precious forty minutes here on top of the world, in the wind and bitter cold. For me, the purpose of the tests was more than science. I was seeking clues to the behavior that cost the men lying not far from here their lives. These were things I needed to know—and knew I might never fully understand.

There was one last piece of business to take care of on the way down. Before leaving for the summit we'd been in communication with Sue Thompson, Bruce's girlfriend in England. She had asked us to search for Bruce's camera or at least retrieve some memento from his body if we found him. A year before I couldn't bring myself to take Rob Hall's

ice axe even as a keepsake for his unborn daughter, and I'd come to re-gret it. This time I was determined to find something for Sue.

By the time I descended the Hillary Step, I learned that Pete had sifted through the personal effects in Bruce's pack on the way up. Given the ferocity of the winds at that level, it was a minor miracle that the pack was still attached to his body. More remarkable, one of the pockets yielded up a small camera.

Pete had then cut the rope suspending Bruce with his Swiss army knife, and Bruce's body had plummeted from view. A slice of the blade, and the final casualty of the 1996 disasters vanished into the abyss.

We finished the descent and said our goodbyes.

I still felt unfulfilled; incomplete. Then, a few months later, Sue sent me a copy of a photo Bruce had taken on the final day of his life. It was a self-portrait, taken on the summit, and may be the most poignant summit shot ever taken. In it Bruce is bending over, looking into the camera an arm's length away. You can tell that he's put considerable care into the shot. He's framing his own face while still capturing the final few feet of the pyramid behind him, with its array of survey prisms and prayer flags. The sun is low, the sky an unearthly blue; it's the hour of golden light. He's taken his oxygen mask off, and his teeth gleam white in his black beard.

You can see the fatigue in his face. But behind the tiredness is a clear expression of triumph, even joy. And therein lies the eternal tug of Everest, the sense of unworldly adventure that brings sober men and women halfway around the world and out into the midnight snows to climb its majestic heights.

I recognized something very familiar about this scene; yet I also felt an acute sense of displacement. I've always looked to the sky, the snow, the clouds for that light. I've climbed to the highest reaches of the planet in search of it. But when I looked closely into Bruce Her-rod's eyes, facing his own camera lens, I saw what I might have known all along, and it is this: The risk inherent in climbing such mountains carries its own reward, deep and abiding, because it provides as pro-

found a sense of self-knowledge as anything else on earth. A mountain is perilous, true; but it is also redemptive. Maybe I had dimly understood this when, as a rootless boy, with no earthly place to call my own, I deliberately chose the iconoclast's rocky path of mountain climbing. But in this moment of pure clarity I realized that ascending Everest had been, for me, both a personal declaration of liberty and a defiant act of escape. Now, suddenly, I felt an inexpressible serenity, a full-blooded reaffirmation of life, on Everest's icy ridges.

At last, I was ready to descend the mountain and go home.

ACKNOWLEDGMENTS

I never imagined when I began this book that it would be as arduous and rewarding as climbing Mount Everest. For me, writing this book was like undertaking an expedition to an unknown world. It has consumed more time than I ever imagined and I have relied extensively on individuals more skilled in the craft of writing than I. What I have enjoyed most is the sense of camaraderie I shared with all the talented people who worked so hard to make this book readable and pleasing to the eye. The words and pictures between these covers are the result of a collaborative effort and I have many to thank.

I am most indebted to my longtime friend Jeff Long, who urged me to write this book and who structured the narrative in its early stages. We spent many hours together during which he elicited and recorded the dialogue that is the foundation of this book. My agent, Susan Golomb, was an early proponent of the book and led me through all the twists and turns of the publishing world with a remarkable degree of grace and diligence.

I am particularly grateful to my publisher at Simon & Schuster, David Rosenthal, who believed there was merit in a book about my life as a climber and filmmaker, and for the matchless support and unflagging guidance I received from my editor, Marysue Rucci. I am also thankful for the careful efforts of Lydia Buechler, my production editor, as well as those of Jeanne Marie Gilbert, Pam Novotny, Fred Chase, Katy Riegel, Roberta Spivak, Nicole Graev, Leslie Friedall, Ernestine Gamble, Tracey Guest, and Jackie Seow, who designed the jacket cover. Mark Goodman's valuable changes to the text improved the book considerably.

For all the individuals who contributed to the success of the *Everest* IMAX Filming Expedition, you have my profound gratitude. I am especially grateful to Robert Schauer, Ed Viesturs, Araceli Segarra, Jamling Tenzing Norgay, Sumiyo Tsuzuki, Wongchu, Jangbu, Audrey

Salkeld, Paula Viesturs, Liz Cohen, Brad Ohlund, Dorje, Thilen, Muktu Lhakpa, Lhakpa Dorje, Rinji, Gombu, Karsang, Roger Bilham, Jenny Dubin, Jyoti Rana, Chyangba, Lhakpa Gelje, Liesl Clark, Janine Duncan, Kevin Kowalchuk, Gord Harris, Lhakpa Norbu, Stuart Cody, Lt. Colonel Madan K.C., Colonel Vishnu Basnet, and Mountain Hardware and Gregory Packs. Special thanks to Lisa Choegyal of Tiger Mountain, Mahadev Sharma at Peak Promotion, and Peter Bodde of the American Embassy in Kathmandu, without whose efforts our expedition would never have been issued a climbing permit.

For providing patient advice and inspiration I am grateful to Andrew Harvard, Broughton Coburn, Charlie Woodworth, Jon Krakauer, Audrey Salkeld, Tom Hornbein, David Fanning, Orville Schell, Norbu Tenzing Norgay, Dick Blum, Erica Stone, Kevin Mulroy, Peter Miller, Michael Weis, Pamela Peters, Julia Collins, Jeff Brewer, Joan Faber, John Ackerley, Peter Hackett, David Schlim, Al Read, Veronique Pittman, Beck Weathers, Paige Boucher, Greg Lowe, Danny Oaks, Van van Meter, Jim Erickson, Sandy Hill, Tom Holzel, Brad and Barbara Washburn, Pat Ament, Tom Frost, Pete Athans, David Roberts, Rick Silverman, Elizabeth Hawley, John Wilcox, Tim Cahill, and Charlie Houston.

For invaluable assistance in organizing the *Everest* IMAX Filming Expedition I'm indebted to Greg MacGillivray of MacGillivray Freeman Films and members of his staff: Steve Judson, Debbie Fogel, Myles Connolly, Chris Blum, Robert Walker, Matthew Muller, Linda Marcopulos, Bill Bennett, Janna Emmel, Teresa Ferreira, Alice Casbara. Special gratitude is due to Kathy Almon and Alec Lorimore, without whose support and friendship I never would have set off for Mount Everest with an IMAX camera. It's important to note that while I was responsible for all the images recorded on Mount Everest and in Nepal, the aforementioned individuals created the large-format film *Everest*.

I also wish to acknowledge Richard Gelfond and Brad Wechsler of the Imax Corporation for permitting me the use of the IMAX trademark in my filming expedition name, and also Mary Ruby of the Imax Corporation for her role in facilitating this.

The majority of photographs in this book were supplied by past climbing companions who generously took the time to search through their collections. For this I'm grateful to Dudley Chelton, Robert Schauer, Ed Viesturs, Jeff Brewer, Greg Lowe, Jeff Lowe, Ward Woolman, Peter Lewis, George Meyers, and Louis Reichardt. Paul Roberts, Robert Moisan, and Paul Smith at Newtonville Camera were helpful in preparing prints for review. I'm also grateful to Chris Curry, the University of Colorado Archives, the Royal Geographical Society, the 1981 Kangshung Face expedition, Larry Nielsen, Severine Blanchet, Sumiyo Tsuzuki, Galen Rowell, and especially Sue Thompson for allowing me to reproduce Bruce Herrod's summit self-portrait.

Additional thanks are due for the friendship and support of Kathy Harvard, Jason and Lisa Densmore, John-Paul Davidson, Brian Blessed, Graham Hoyland, Bart Lewis, Ann and Ad Carter, George Bell, Paula Apsell, Gary Neptune, Richard Palmer, David Rose, Carol Derry, Dick Derry, Johnathan Derry, Eve Minkoff, Pasang Kami, Pertemba, Diane Doucette, Judi Wineland, Jim Morrissey, Todd Burleson, James Brundige, Dana Welch, Phil Axten, Rodney Korich, Steve Mammen, Robert Godfrey, and Rick Wilcox. I'm indebted to Alexander Mah for helping to retrieve my manuscript from the bowels of my computer on several occasions and to Chloe Johnson, whose daily visits broke the hours of tedium in my office.

Above all, I am most grateful to Liesl Clark. Without her constant encouragement, insightful comments, and endless hours sitting by my side editing and reediting the manuscript I would never have finished this book. I do not have the words to adequately convey my gratitude.

PHOTO CREDITS

INDEX

ABOUT THE AUTHOR

David Breashears is a filmmaker, adventurer, and mountaineer whose work has taken him to remote locations throughout Tibet, China, Nepal, India, Pakistan, South America, and East Africa. He has worked on such feature films as *Seven Years in Tibet* and *Cliffhanger*, and he coproduced the award-winning documentary *Red Flag Over Tibet*. In 1983 he transmitted the first live pictures from the summit of Mount Everest and in 1985 became the first American to twice reach its summit. He is the recipient of four Emmy awards for achievement in cinematography. In 1996 he codirected, photographed, and coproduced the acclaimed large-format film *Everest* and contributed his still photos from that climb to the bestselling book *Everest: Mountain Without Mercy*. In 1997 he coproduced and photographed "Everest: The Death Zone" for the PBS science series *NOVA*, marking his fourth ascent of the world's highest mountain. When not climbing, David Breashears calls Boston his home.